HANDBOOK OF JAPANESE ART

HANDBOOK OF JAPANESE ART.

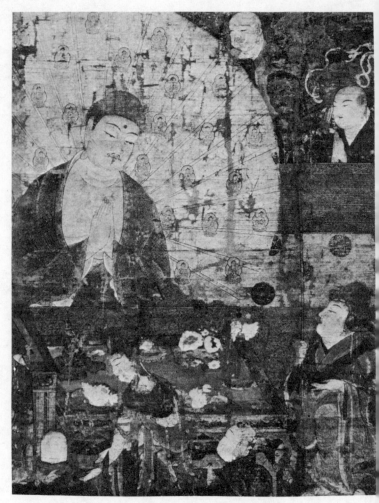

Frontispiece. Resurrection of Buddha (N.T.)
Kyoto Onshi Museum of Art

HANDBOOK
OF
JAPANESE ART

by

NORITAKE TSUDA

Former Lecturer on Fine Arts at
New York University

with 355 illustrations

CHARLES E. TUTTLE COMPANY
Rutland, Vermont & Tokyo, Japan

Representatives

Continental Europe: BOXERBOOKS, INC., *Zurich*

British Isles: PRENTICE-HALL INTERNATIONAL, INC., *London*

Australasia: BOOK WISE (AUSTRALIA) PTY. LTD.
104-108 Sussex Street, Sydney 2000

Canada: HURTIG PUBLISHERS, *Edmonton*

Published by the Charles E. Tuttle Company, Inc.
of Rutland, Vermont & Tokyo, Japan
with editorial offices at
Suido 1-chome, 2-6, Bunkyo-ku, Tokyo, Japan

© *1976 by Charles E. Tuttle Co., Inc.*

Library of Congress Catalog Card No. 74-78152

International Standard Book No. 0-8048-1139-3

First edition, 1941 by
Sanseido Company, Ltd., Tokyo
First Tuttle edition, 1976

0270-000401-4615
PRINTED IN JAPAN

CONTENTS

Map showing the distribution of Japanese art

ix

PUBLISHER'S FOREWORD
TO THE NEW EDITION

This valuable book, first published in 1941 and long out of print, deserves the high reputation that it maintains among readers who are fortunate enough to own copies of the original edition. It offers the Westerner a comprehensive view of Japanese art through Japanese eyes—a view, in a word, that is the most revealing of perspectives. At the same time it provides him with a guide to the places in Japan where the best and most representative creations of Japanese art are to be seen. It surveys the full range of achievement in painting, sculpture, architecture, ceramics, lacquerware, woodblock printmaking, metalwork, textiles, garden making, and other artistic fields. It is indeed everything that its unassuming title implies: a handbook of Japanese art.

Readers of an earlier generation found the book particularly useful as a guide to aesthetic appreciation and to an understanding of the technical aspects of Japanese artistic creation. It goes without saying that these qualities of the book are no less impressive today. It was the author's aim to make the art of his country more easily comprehensible to visitors from the West, and the reader will agree that he succeeded admirably in carrying out the task that he had set for himself.

The publisher takes great pleasure in making the book available once again—this time to a new audience. He is certain that present-day readers will find in it the same virtues that attracted those who read it and made use of it when it first appeared.

PREFACE

I have been making the study of art my specialty for a long time in order to find out the close relationship between color, forms and spirituality.

I am glad to have this opportunity to give some of the results of my study to the public, hoping that this may contribute something to the elevation of esthetic appreciation and to better understanding between the East and the West.

I am gratefully indebted to Baron Ino Dan, former Professor on Art in the Tokyo Imperial University; Mr. Naohiko Masaki, President of the Imperial Fine Art Academy; and Mr. Shigekichi Mihara; for their highly important suggestions on various points. My grateful acknowledgments are also due to Professor Masaharu Anesaki, Professor Emeritus of the Tokyo Imperial University, for his corrections of the title of each chapter and other valuable suggestions.

I have gratefully to acknowledge the painstaking work of Mrs. May F. Kennard, Teacher of English literature at Tsuda College and Tokyo Woman's College, and Mr. Drew W. Kohler, who undertook the correction of my grammatical mistakes and the reading of the proofs.

I feel likewise grateful to the following gentlemen who gave me great encouragement in the preparation of the manuscripts for publication: Mr. Setsuichi Aoki, Secretary of the Society for International Cultural Relations: Mr. Mikinosuke Ishida, Librarian of the same society; Mr. Masuzō Inoue of the Board of Tourist Industry; Mr. Kuraji Takahashi of the same board, Mr. Shirō Hirai and Mr. Tetsu Ōtawa.

Grateful acknowledgment is also due to the Society for International Cultural Relations, Tokyo, for sympathetic aid given to me.

<div style="text-align: right;">Noritake Tsuda</div>

115 Tabata, Tokyo
March 19, 1935

PREFACE TO THE SECOND EDITION

I am glad that this manual has been welcomed among readers in this country and abroad since the first edition was published last Spring. I have taken this opportunity to revise the spelling of Chinese names, the italicizing of Japanese words and the Romanization of Japanese proper names, and to improve some of the illustrations.

<div style="text-align: right">Noritake Tsuda</div>

June 3, 1936

PREFACE TO THE SECOND EDITION

I am glad that this manual has been welcomed by many readers in this country and abroad since the first edition was published last Spring. I have taken this opportunity to revise the spelling of Chinese names, the rubricing of Japanese words, and the Romanization of Japanese proper names, and to improve some of the illustrations.

Nathalie Paull

June 1, 1956

LIST OF PLATES

NOTE. In this economical reprint edition, the color plates of the original edition are reproduced in black and white, but the following list has not been altered, since the text contains references to these plates that might otherwise be confusing to the reader.

LIST OF PLATES

xvii

LIST OF ILLUSTRATIONS

xxii

xxiv

Abbreviation : N. T.=National Treasure

———◇◆◇———

PART I

ABRIEF HISTORY OF JAPANESE ART

PART I

A BRIEF HISTORY OF JAPANESE ART

CHAPTER I

INTRODUCTION

It was on December fifth, in the year 1933, that I was invited to a luncheon in tea-ceremony style at the villa of Baron Masuda in Odawara. I arrived there about noon. The gate of his garden was open and a gardener led me through a long path of the garden to a waiting place called *yoritsuki*. Mr. Matasaku Shiobara, proprietor of the Sankyō Pharmacy Company, was already there, shortly afterwards joined by Mr. Edwin Lowe Neville, the counsellor of the American Embassy at Tokyo, and Mr. Saisaburo Nishiwaki, proprietor of the Nishiwaki Bank. The waiting place comprised only two small rooms, one with four and the other, two mats. On the desk ledge of the larger room was placed a gold lacquer ink-stone box of the Kamakura Period for our appreciation. Meanwhile the elderly Baron Masuda appeared at the entrance of the waiting place and announced that the tea room was ready. He said nothing more but immediately retired.

We all came out, and proceeded along the clean garden path. The stepping stones and rocks were all freshly watered. Crimson leaves that still remained on the trees were falling down to the ground in spite of no breeze touching them.

We next entered the tea room, where our host was waiting for us. In the alcove of the room was hung an autograph of a high priest mounted with rare printed brocade, called *inkin;* and on the hearth was placed an iron kettle called *ashiya-gama*, the design of which is said to have been drawn by Sesshū, a great master of priest-painters in the fourteenth century. The kettle is said to have been once used by Jō-ō, the great tea-master in the sixteenth century.

Our host came out and exchanged greetings with each of us. Then he engaged himself in making a fire in the hearth so as

to have hot water in the kettle. The room was so small that we filled it and it was quite secluded from the outside world. We were all silently attentive to every movement of our host.

When our host had finished his work at the hearth, Mr. Nishiwaki, who occupied the seat of the principal guest, asked him for the privilege of examining the incense-holder in which was kept the incense which our host emptied into the hearth. Mr. Nishiwaki, after he had seen it, passed it round to the rest of us. It was a small porcelain box called *gōsu*, and is said to have been loved by Fumai-kō, an eminent tea-master.

After this, the meal was served by the host, assisted by a female servant. Several rare utensils were used which all of us had the opportunity of examining and appreciating.

When the meal was over, our host asked us to rest for a while. We went out to the garden and took seats on a bench in order to enjoy the garden and fresh air. Shortly afterwards we heard the pleasing sound of a gong. This was the signal to tell us that the tea room was ready for the second session. We all returned to the tea room, and were served with thick green tea from a tea-bowl of rare value. In this session we had the opportunity of seeing the unique examples of a tea-bowl, a tea-caddy, a tea-spoon and a water-jar.

After the second session was over we were led by the host through the garden to the main house. Here, in a spacious and brighter room, open to an extensive view of the garden, we were again entertained with lighter tea, and were shown a few selected masterpieces of painting.

In such esthetic entertainment we spent the whole afternoon, enjoying the hospitality of our host, and the beauty of art and nature, entirely secluded from the outside world of worries and depravity.

Such is the way in which the Japanese collector appreciates art with his friends. This method was initiated in the fourteenth century by the Shogun Yoshimasa, pioneer patron of the tea-ceremony. He collected rare specimens of painting and minor arts, and appreciated them with his chosen friends when he held

the tea-ceremony in his villa, the Silver Pavilion, at Higashiyama in Kyoto. Therefore this method is closely related to the development of tea-ceremony.

However, it is limited only to privileged collectors. The majority of the people cannot afford such luxury as that described above. More than this, the real appreciation of art has nothing to do with the possession of the things themselves unless one has developed his innate ability to perceive beauty.

Therefore there is another field in the appreciation of art in which every one may enjoy the beauty of things to which he has on legal right of possession. This is a very important factor which may serve for the advancement of human culture.

Now our present problem is how to appreciate Japanese art in such a way as to make it most serviceable for the betterment of human life.

It will therefore be necessary at the beginning of our study that our readers understand the general attitude of Japanese people toward foreign art.

The history of Japanese art shows clearly that the Japanese people are very susceptible to foreign culture. When foreign art has seemed new and more valuable than their own, they have been very eager and serious in introducing it. Sometimes they have gone so far that for a time they have even forgotten their own arts; but they came back in time to normal, assimilating the others only to create thereby a new art. This is a most conspicuous feature of Japanese art history.

Such an attitude toward foreign art has been a perpetual source of the development of Japanese art through the ages.

When we look back over the entire length of our history, we see that the different arts of different periods reflect important aspects of life and culture that have developed without losing their own individuality under foreign influence.

How and where to study Japanese art? This will be the first question our readers wish to have answered. In Japan there are three important centres of old art. They are Tokyo, Kyoto, and Nara. In Tokyo there is the Imperial Household

Museum; and important private collectors mostly live there. In Kyoto and vicinity there are many Buddhist temples where not only Buddhist art, but also different kinds of lay art may be seen. In the Kyoto Onshi Museum of Art are placed on view a large number of important treasures of art, which are borrowed from many monasteries in Kyoto and its vicinity. Lastly, in Nara, we are able to see early Buddhist art in the Nara Imperial Household Museum, and in such large monasteries as the Tōdai-ji at Nara, and the Hōryū-ji in Yamato.

In the study of Japanese art the most difficult thing is to understand the complicated esoteric symbolism of Buddhist art. Especially iconographic manifestations of Buddhist doctrine are extremely difficult for even Japanese students to understand. But their symbolism had a deep meaning in the religious life of the Japanese people, and is worth the difficulty of studying. Here we see spirituality expressed in a tangible form, which will greatly instruct us in human behavior, and will elevate our manner of living.

This manual is devoted to help these difficulties and to answering the question of where and how to study Japanese art.

CHAPTER II

THE ARCHAIC ART

(Previous to the Introduction of Buddhism in 552 A.D.)

1. PREHISTORIC POTTERY

From the New Stone Age sites of Japan are found two dis-

Fig. 1. Jōmon-doki Pottery
Tokyo Imperial Household Museum

tinct kinds of pottery with respective characteristics of design and decoration. The earlier kind is called the *jōmon-doki* pottery and the later one is grouped under the name of the *yayoi-shiki* pottery. The *jōmon-doki* pottery vessels often have angular edges and handles modelled into various forms of animal heads. (Fig. 1) The color of this kind of pottery is generally dark gray; the designs are composed of curved lines arranged artistically, and the ground surface has often the impression of a mat. The other kind of pottery belonging to the later stages is usually of a reddish color and seldom has any design. Even when design is present, it is composed only of zigzag lines or a few wavy ones (Fig. 2). That the earlier pottery is entirely different from the later will be seen in our two illustrations. The *jōmon-doki* pottery is much decorated and its beauty appears in the design, while the *yayoi-shiki* pottery is simple in decoration and beautiful in form. This essential difference is no doubt due to the different aesthetic attitudes of the different people who had different cultures.

A great number of interesting examples found in prehistoric

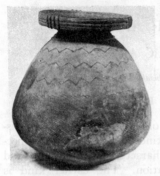

sites all over Japan are collected in the Tokyo Imperial Household Museum; the Institute of Anthropology, Tokyo Imperial University; the Institute of Archaeology, Kyoto Imperial University; and in the Prince Ōyama Institute of Prehistoric Investigation, Tokyo.

Fig. 2. Yayoi-shiki Pottery
Tokyo Imperial Household Museum

2. PREHISTORIC BRONZE IMPLEMENTS

The Bronze Age in Japan was short. Its area was limited to Yamato, Izumo, to the neighboring districts of both these provinces, and to the northern part of Kyushu. The bronze implements found in these areas are arrowheads, bells called *dōtaku*, halberds and cris-formed daggers. Though insignificant in number, they are amply deserving of notice in point of quality, because they reveal to us the intermediate stage between the art of the New Stone Age and that of the Protohistoric Period. A number of fine examples of such bronze implements are collected in the Tokyo Imperial Household Museum.

Among them the most interesting relics are the bronze bells (*dōtaku*) which are entirely different from any temple bell of the historic period. (Fig. 3) They have an oval section and a fin-like border running down the side. The fin-like border often carries decorative knobs of circular shape. The bells vary in size from five or six inches to four feet

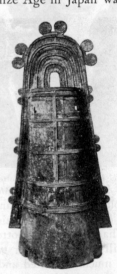

Fig. 3. Dōtaku-bell
Tokyo Imperial Household Museum

and six inches. According to Professor Chikashige's chemical analysis, the alloy of the *dōtaku* bell is composed of the following elements.

Copper	68.96	Iron	0.04
Tin	15.45	Nickel	1.35
Lead	5.63	Arsenic	a trace
Antimony	8.32		

The art of casting the *dōtaku* bell may have been learned from China; but the designing has been ascertained to be original to Japan, because no prototype that served as a model for Japanese copyists has been found in China or Korea. Therefore the Japanese archaeologists regard the *dōtaku* bell as a unique development peculiar to the Japanese. It is unearthed by itself, but sometimes as many as ten or more bells are found at a single excavation. The largest number have been discovered in the Yamato district, the central sphere of early Japanese culture.

Primitive pictures presented in relief on *dōtaku* bells are valuable as affording glimpses of contemporary life. In one picture a man with a bow is aiming at a deer, and in the other a wild boar is hemmed in by five dogs, and their master armed with a bow is standing by. From these pictures, it seems that ancient Japanese hunters used bows and dogs. In the third picture there is a multitude of deer, symbolizing abundance of forest wealth. In the fourth is a string of fish, suggesting the importance of this foodstuff to primitives. In the fifth are represented three boats, one of which is distinct enough to show a bow and a stern rising like those of a gondola. The sixth concerns agricultural activity. Two men are using a pestle with a mortar between them. The seventh represents a dwelling house which gives a good idea of the architectural style in the age of the bronze bell. The house is of wood and is extremely high-floored, having a perched-up appearance; and a ladder is provided for ascending to the elevated floor. Such are the fragments of information squeezed out of the bronze bells; but they illustrate a graphic art of hoary antiquity in Japan. In Fig. 4 we have reproduced an example of the pictures of a hunting scene on a *dōtaku* bell.

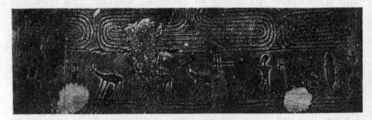

Fig. 4. Desiga of a Dōtaku-bell
Tokyo Imperial Household Museum

3. GENERAL SURVEY OF THE PROTOHISTORIC ART

After a short Bronze Age, Japan ushered in the Iron Age, the third stage of culture. The protohistoric age covers from the earliest time when the Japanese nation was consolidated in Yamato, down to the thirteenth year of the reign of the Emperor Kimmei (552 A.D.), when Buddhism was first introduced into the court.

In this period there was no organized religion peculiar to Japan except Shinto, the cult of ancestor worship. The Japanese nation was then an assemblage of families descended from the same parent stock represented by the Imperial Family. Thus the Japanese race, which constitutes one large family, boasts descent from common blood; it speaks a common language, and worships the same ancestral divine spirits. It is ruled by the Imperial House, which is invested with supreme power by virtue of divine and patriarchal right. So from the first the national polity assumed a patriarchal form.

The principal pursuit of the people was agriculture. However, as in the manufacturing industries, a division of labor was practised. There were spinners and weavers of cotton and silk, polishers of gems, workers in gold, silver, copper, and iron, forgers of arms and armour, makers of earthenware and dressers of leather, all forming themselves into guilds (*be*), each of which carried on its own industry from generation to generation.

Almost all the relics from this period are found in burial mounds. The burial mounds have various constructions and shapes. Some are merely heaps of earth over coffins; but those built for Emperors, chiefs and nobles are large mounds with several stone chambers, and the outside is encircled with a moat.

On evidence furnished by objects discovered in the burial mounds, we find that, after passing out of the bronze age, the race became skilled in the working of iron, with which they made arms and armor which they decorated with gilded and incised patterns. In the art of pottery they seem also to have been so advanced as to use the wheel for moulding the shape of the ware. In the art of casting and gilding bronze, also, they show a wonderful workmanship, producing mirrors, horse furniture and personal ornaments. In precious stones also, their workmanship was excellent and they produced beautiful necklaces; and in the later years of the period, they were able even to produce white and blue glass. The largest collection of the protohistoric art is owned by Imperial Household Museum, Tokyo.

4. PROTOHISTORIC POTTERY

All the burial mounds have yielded a considerable amount of pottery. The vessels are most numerous and they are burned more or less hard. They are usually of a gray color, never glazed or painted; and almost invariably made either partially or entirely on the potter's wheel.

The decoration of this pottery is of a very simple and rude character, and is generally confined to arrangements of straight or curved lines scratched in the clay when soft with a single pointed tool or with combs having a varying number

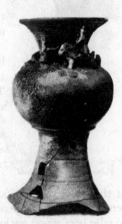

Fig. 5. Mortuary Pottery
Tokyo Imperial Household Museum

of teeth. More rarely figures of men, animals, and birds are modelled rudely on the shoulders of vases. (Fig. 5)

In the art of pottery, another important feature is the clay figures which were set up on the burial mounds at the funeral ceremonies. Figures representing men and women are most numerous. (Fig. 6) They are all of coarse red terra-cotta. But they are illustrative of the contemporary customs and manners. Terra-cotta figures of horses also were set up frequently along with human figures. Some other animals, birds, and houses are found also. They are all intended for the services of the dead in a future life. Some of the sarcophagi are made of similar terra-cotta, but except for very rare specimens, they show hardly any artistic merit.

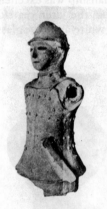

Fig. 6. Armed Clay Figure
*Tokyo Imperial Household
Museum*

5. PROTOHISTORIC ARMS AND ARMOR

Swords, helmets and armor are among the most important objects from the burial mounds.

It is important to note that the swords have only one cutting edge, and especially that they all have a perfectly straight back. Thus they are distinguished from the swords of later times, all of which have a slight curvature. These swords are of two kinds, long and short, the former being most numerous. The length of the long blades, from guard to point, varies generally from 2 feet 6 inches to 3 feet, and that of the short from 1 foot and a half to 2 feet. Some swords are remarkable for their richness of ornament. In some cases, the handle is of wood enclosed in plate copper, coated with gold, and decorated with fine punched scrollwork. The pommel is of a curious form, and consists of the same metal expanded into a large bulb-like head. The guard is also of copper coated with gold, and

is generally pierced with trapezoidal apertures. Three broad bands and two rings encircle the wooden scabbard, the latter having loops for the attachment of the cords by which the sword was suspended. In some other swords, the greater part of the body of their scabbards is sheathed with gilt copper, which is beautifully ornamented with bosses in *repoussé* work. In the Imperial Household Museum, there are several fine examples of such swords. The picture reproduced in Fig. 7 shows a proto-

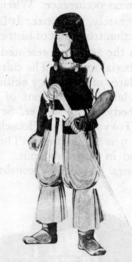

Fig. 7. Protohistoric Armed Man
Tokyo Imperial Household Museum

historic armed man carrying such a sword. In some other cases, the pommel of the sword is modelled into a ring, and in the ring is the head of a phoenix, or there are two heads of conventional dragons with a ball between them. Such pommels are all made of gilded bronze. Our illustration in Fig. 8 shows excellent workmanship. Its artistic expression is full of life. The imagination has created beautiful form and color.

Armor is by no means of

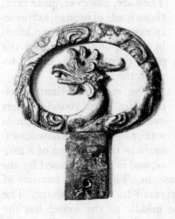

Fig. 8. Gilt Bronze Pommel
Tokyo Imperial Household Museum

common occurrence. When found, it is usually made of iron; very rarely, of bronze. It is entirely different in form and construction from that of historical times, but it agrees very closely with the armor represented on the terra-cotta figures set up on the burial mounds. The cuirasses are formed chiefly of horizontal plates of iron, very skilfully forged. Their shape is of a solid corselet, the right front of which opens on a hinge to admit the body of the wearer. Several fine examples are on view in the Tokyo Imperial Household Museum. The reproduction in Fig. 9 is one of them. There is another kind of armour also found in burial mounds. It is a scale armor, called *keikō* or *kakeyoroi* in Japanese, consisting of small scales, presumably attached to a cloth foundation in the fashion of the European jazerant.

Fig. 9. Iron Cuirass
Tokyo Imperial household Museum

The helmets are also formed of iron or bronze plates riveted in the same way as in cuirasses. They are, however, quite rare; those made of bronze, extremely rare, They are of two kinds in shape; one round, and the other pointed in the crown toward the front.

The most excellent specimen (Fig. 10) of round helmets ever found in burial mounds was exhumed at Kiyokawa-mura in the province of Kazusa, and is now possessed by the Tokyo Imperial Household Museum. The helmet consists of many small gilt bronze scales riveted to form its shape. The gilded bronze belt encircling the middle of the vessel has the eleven signs of the zodiac in fine chiselled work. A gilt bronze poll projects from the middle of the crown, having tiny holes at the point as if it had once a plume, The visor also is made of

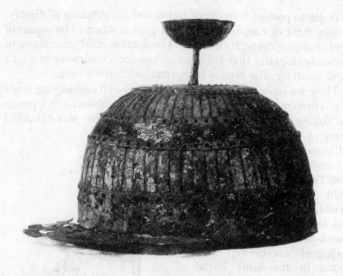

Fig. 10. Gilt-bronze Helmet
Tokyo Imperial Household Museum

gilded bronze with a perforated design representing a cloud.

6. PROTOHISTORIC HORSE FURNITURE

Horse trappings are among the most important relics of metal work that are artistic in shape and decoration. They are made of iron or bronze. Some of them are gilded, coated with gold, or decorated with inlaid design.

The most artistic workmanship is applied to bit cheek-pieces or *kagami-ita* and harness pendants or *gyo-yō*. Although quite rare, stirrups, saddles, bosses, and buckle-shaped ornaments are exhumed.

Some bit cheek-pieces are flat plates with a beautiful curved outline, and are of a unique construction in metal work. Each consists of a plate of hammered iron, to the exterior of which,

in order to protect it from oxidation and for purposes of display, a thin sheet of copper coated with gold is attached by means of studs running round its margin. There are several other forms of these cheek-plates that are more or less decorated, some of which have small circular bronze bells attached to their rims.

Here we have an excellent specimen of a bit cheek-plate made of gilt bronze backed with an iron plate. On its surface is a graceful foliage design in open work (Fig. 11). This was exhumed from a burial mound at Mikoya in the province of Tōtōmi and is now on view in the Tokyo Imperial Household Museum. A harness pendant of gilded bronze, no less beautiful than the above cheek-plate, with similar technical excellence, was found in the same burial mound and also can be seen in the same museum. (Fig. 11)

We have here a picture illustrating an ornamented horse of this age, inferred by Mr. Morikazu Gotō of the Tokyo Imperial Household Museum, through archaeological evidence gathered in the museum. (Fig. 12)

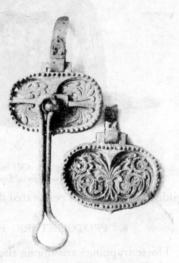

Fig. 11. Bit Cheek-plate and Harness Pendant
Tokyo Imperial Household Musenm

7. PROTOHISTORIC BRONZE MIRRORS

The bronze mirrors from the Japanese sepulchres give the clearest evidence that the protohistoric Japanese were indebted to the Chinese for models of advanced art. They are all circular mirrors, many of them ornamented with elaborate designs

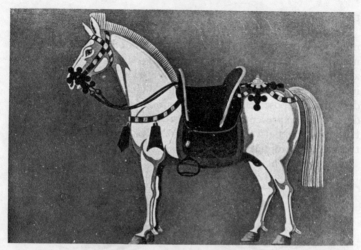

Fig. 12. Ornamented Horse showing Protohistoric Horse Trappings
Tokyo Imperial Household Museum

in relief. Their designs, though so peculiar as sometimes to be fantastic to the highest degree, reveal to us, each on its own part, some phase of ancient ways of thinking. They are a unique, though unwritten, record of Chinese mythology, philosophy, folklore, and religion.

The general arrangement of design is made by concentric bands of various widths. In the outer bands are generally a zigzag or other geometrical designs. The principal design is found on the broadest band of

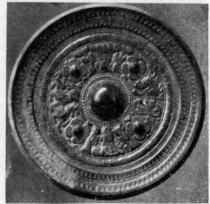

Fig. 13. Bronze Mirror
Tokyo Imperial Household Museum

the inner sections.

In the Tokyo Imperial Household Museum are collected numerous examples of the Han mirrors found in Japanese burial mounds. The mirror reproduced in Fig. 13 is one of the finest among them. This mirror was discovered at Samita in the province of Yamato. It measures about 8 inches in diametre. The design is composed of deities and animals around the centre. The deities are represented in two groups, each group forming a triune figure. Between the two groups of deities are interposed two fabulous animals and a carriage drawn by animals.

Fig. 14. Deity on the back of a Fig. 15. Fabulous Animal on the
Bronze Mirror back of a Bronze Mirror

In the designs of all such mirrors, the deities and animals play a principal rôle. The animals are usually fabulous and mythical. The four sacred animals of the four cardinal points are often represented. They are the Dragon on the East, the Tiger on the West, the Bird on the South, and the Tortoise, entwined with a snake, on the North. The signs of the zodiac are also sometimes represented. Among the deities, some are undoubtedly meant to represent Si Wang Mu, the Mother of the West, and Tung Wang Fu, the Father of the East. Rarely, the symbol of P'ênglai shan, the Everlasting Land of Happiness, is represented. So the design on the mirrors is of a highly religious nature. In Fig. 14 we have a typical example of a triune deity which is often met with on such mirrors; and in Fig. 15 we have an example of a fantastic animal design in which we see much imagination.

Some of the bronze mirrors have inscriptions in Chinese ideographs, which are generally composed of lucky phrases. They

are, therefore, not so valuable as later inscriptions, which record historical facts.

These designs and inscriptions bear strongly the marks of the Chinese Han bronze mirror. Many of them seem to be from exactly the same mould as was used in China. Such a fact leads us to suppose that many Han bronze mirrors were imported into Japan in the Protohistoric Period. Many, like the Han mirror, were certainly cast in Japan, and quite a large number of such specimens copied in Japan from Chinese mirrors are exhumed from the tumuli. In the later years of the Protohistoric Period the fine design of Han mirrors degenerated very much, and the style of the Six Dynasties mirror came in.

At any rate, Japanese bronze mirrors from burial mounds, usually represent Chinese bronze mirrors of the Han and Six Dynasties. But on the other hand, a new style developed, which is peculiar to the Japanese. It is called "bell-mirror" or *rei-kyo*. This mirror is decorated with five or six bells set along its brim. After all, the mirrors from the burial mounds are entirely different from the mirrors of the T'ang Dynasty which were introduced to Japan in the eighth century.

The bronze alloy used in making such mirrors includes tin and copper as its principal constituents, in the proportion from 25% to 27% of tin, and 60% to 70% of copper. The reflection of the bronze mirrors was effected only by polishing them without applying any mercury on the coarse surfaces as was done with later metal or glass mirrors.

The shining surface of the mirrors, which once reflected the faces of our protohistoric people, is now almost gone, but the designs on their backs still reflect the life and thought of the people who used them.

8. PROTOHISTORIC PERSONAL ORNAMENTS

Personal ornaments consist mainly of beads of stone and glass, and rings and fillets of metal.

There are various kinds of beads; but "tube-beads" or *kuda-*

tama and "curved-beads" or *maga-tama* are most common. The tube-beads are well-cut and polished cylinders of jasper of a fine green color, about one inch in length. They are pierced from end to end with a carefully drilled hole. The curved-beads are the most important of the ancient stone ornaments. Their shape is that of a comma with a thickened tail. A hole is pierced through the head, so that they may be strung with cylindrical or other beads to form a necklace. Ordinarily they are from about half an inch to one inch and a half in length. The stones of which they are made are rock crystal, steatite, jasper, agate, and nephrite.

The glossiness of these polished stones permitted different shades of colors to be selected according to the different tastes of the people who followed the popular custom of wearing necklaces.

Personal ornaments of metal consist chiefly of rings of copper or bronze sheathed with gold or silver.

The penannular rings are called *kin-kwan* when sheathed with gold, and *gin-kwau* when sheathed with silver. They are numerous and widely distributed.

The picture reproduced in Fig. 16 illustrates personal ornaments worn by a protohistoric lady. She wears a gold ear ring, arm ring,

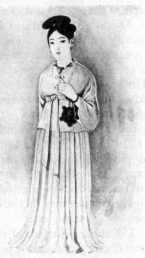

Fig. 16. Protohistoric Lady
Tokyo Imperial Household Museum

and necklace, and carries a bronze mirror attached with bells. A number of fine examples of these personal ornaments are collected in the Tokyo Imperial Household Museum.

CHAPTER III

EARLY BUDDHIST ART

(*The Suiko Period* 552-645)

I. GENERAL SURVEY

By the Suiko Period is meant the interval from the official introduction of Buddhism in 552 to the Taikwa innovation in 645. This period is also designated as the Asuka Period because the Asuka district of Yamato was the cultural centre of the period.

Buddhism, which is said to have been first introduced into China in the middle of the first century, began to be a force in China only some three centuries later. Indeed, it was during the time of the Chinese Six Dynasties that Buddhist images and temples were erected in great numbers, and there was much activity among the native scholars in translating the Buddhist sutras.

In this period Buddhism reached Korea, and was carried thence by the king of Kudara to our court in 552, or, as some scholars believe, fifteen years earlier. Thus the influence of the Six Dynasties of China was felt by Japan most strongly during the era known as Suiko.

When Buddhism was first introduced to Japan, the Emperor Kimmei was inclined to accept the new faith, but the question of its adoption caused a hot discussion between the two powerful families, the Soga and Mononobe. The former family was in favor of it, but the latter was strongly opposed to it and urged that it would arouse the wrath of the ancient national gods. Finally the Emperor decided to steer a middle course and allowed Iname, the head of the Soga family, to believe in it privately as he desired. The dispute, which was as much political as religious waxed hotter and hotter, and at last the head of the Mononobe family was defeated and killed by Umako, son of Iname. Thus, about thirty-six years after the introduction of

Buddhism, the anti-Buddhist influence was destroyed; and Buddhism continued to gain earnest adherents, among whom the most eminent was the Crown Prince, Shōtoku Taishi the second son of the Emperor Yōmei.

The illustrious administration of this highly intelligent and energetic Prince materially strengthened the hold of the religion on the people and advanced the general culture of the country. He compiled and had promulgated a constitution of seventeen articles, the first written law of the country. In it, he inculcated reverence for the teaching of Buddha, which he had made to harmonize with Shintoism. He travelled throughout the Kinai provinces, encouraging the erection of temples, for which he created the profession of painters to depict Buddhistic images. Also, he promoted literature, setting an example by his own literary works, introducing Chinese music into the country.

Under his administration Buddhism became the established religion of the state. There were 46 monasteries, 816 priests and 569 nuns. The largest and most famous monasteries were the Hōkō-ji, the Hōryū-ji and the Shiten-nō-ji. The erection of these and other great monasteries was regarded as a very important affair of state.

The Buddhist sites of this period are most densely distributed in the district of Asuka in the province of Yamato, where there still remain large pillar stones of various temple buildings erected in this period.

But the Hōryū-ji monastery is the only place where one can see the temple architecture, Buddhist sculpture, and allied arts in wood and metal in the original conditions of the Suiko Period. It is, indeed, only in this temple that the early adolescence of Japanese culture can be seen in its original environment.

2. PAINTING

It is quite obscure what kind of painting had developed in the protohistoric period, except for very primitive ornaments, rarely painted on the walls of chambers in some burial mounds. They

consist mainly of totemic symbols and geometric patterns in red, green, white and yellow. When we consider the highly developed workmanship of the protohistoric period in metal and stone, it seems that besides such primitive patterns, there may have been more decorative painting.

Now, with the spread of Buddhism in this period, the Chinese style of painting began to extend its influence. Before the reign of the Empress Suiko, when the Emperor Yūryaku invited artisans from Kudara, one of the Three Kingdoms of Korea, an artist came accompanied by painters, potters, saddlers and brocade weavers; and in the reign of Shushun, Kudara sent a painter called Hakura. These painters seem to have been engaged in decorative work.

In the 12th year of the Empress Suiko, there were the Kibumi painters, and the Yamashiro painters. They were relieved from certain taxes and allowed to make their profession hereditary.

The art of painting brought in by Koreans of this period was modelled on the Chinese school of the Six Dynasties, as was that of the sculpture. In China at this time, the art developed highly, and such famous masters as Lu

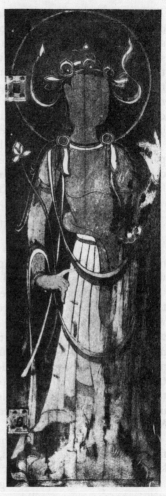

Fig. 17. Painting on a Panel of
Tamamushi-no-zushi
Hōryū-ji monastery, Yamato

T'an-wei, Chang Sêng-yao and Tsao Chung-ta appeared in suc-
cession. It is said that they produced pictures of Buddha and of
sages, which were full of life and movement. But today we can
see none of them. We are, however, very fortunate in being able
to see their style in the pictures painted on the famous Tama-
mushi-no-zushi, or Beetle-wing shrine, preserved in the Hōryū-ji
monastery of Japan. The shrine gets this name from the irides-
cent wings of an insect called *tamamushi* (beetle) which are laid
beneath the open work bronze fitting at the edges and sides.

The faces and limbs of Bodhisattvas and men painted on the
panels of this shrine are slim; and both the composition and
coloring are simple. But such are the characteristics of the
figures painted in this period. (Fig. 17)

3. SCULPTURE

The art of sculpture in this period made remarkable develop-
ment in the reign of the Empress Suiko. The Suiko sculpture
was made chiefly of wood and cast bronze.

Among the Buddhist statues that have come down to us from
this period, the number of bronze statues far surpasses that of
wood, the former numbering some 65 and the latter only about
20; and most of them belong to the Hōryu-ji monastery of Ya-
mato and to the Imperial Household. Those owned by the Im-
perial Household formerly belonged to the monastery. Some of
those of the Imperial Household collection are placed on view in
the Tokyo Imperial Household Museum. Some of those belong-
ing to the temple are exhibited in the Nara Imperial Household
Museum.

Among the existing Buddhist figures of the Suiko Period, we
find Kwannon most numerous, and next in order, Miroku, Ya-
kushi, Shaka and Shiten-no or Four Guardian Kings.

The early works of these figures are almost Egyptian in their
stiff impassiveness as will be seen in the example shown in Fig.
18; and in style they remind us of the statues of the North Wei
Dynasty of China.

It should be noted that they had traditional methods of representing different members of the Buddhist Pantheon in order to express different spiritual activities.

In the statues of Shaka and Yakushi, no stress is laid on any one part of the iconographic representation, but all the attributes of Buddhist faith are included. This is the reason why they lack vividness of powerful expression in any particular part.

The type of Bodhisattvas was almost feminine in form and expression. In the figures of Kwannon or Miroku, the shape of face, the hang of drapery, the attitude of hand and fingers and the whole posture suggested the womanly loving-kindness of the Bodhisattva, as will be noticed in Fig. 19.

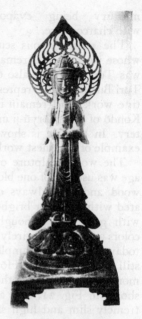

Fig. 18. Kwannon
Imperial Household Collection

As to the technique of casting bronze statues, we may judge from those remaining today. An inside model of a Buddhist figure was first made of earth, and then the model was coated with wax. The carving of the figure was done on the wax that had been thus applied to the earth model. The finished surface of the wax was then coated with a fine paste of earth; and then the wax was melted out by heating. Into the cavity thus made, melted bronze was poured to cast out a figure. Protruding hands were cast separately and attached to the body afterwards. After casting, the surface was made plane with files, chisels, drills, and other necessary tools such as are used in the sculpture of today, and the details were then chiselled with fine lines. Almost all the bronze figures of the Suiko Period seem to have been gilded. The gold was applied with mercury, that is, gold amalgam, the

mercury being evaporated
with charcoal fire.

The most famous sculptor
whose work is still remaining
was Tori who was also called
Tori Busshi. His representa-
tive works still remain in the
Kondō of the Hōryū-ji monas-
tery. In Fig. 20 is shown an
example of his finest works.

The wood sculpture of this
age was usually of one block of
wood and was always decor-
ated with colors or brightened
with gold foil, although the
colors are almost entirely gone
today. The best examples are
still extant in the Hōryū-ji
monastery, and one of them is
shown in Fig. 21. It is an ex-
tremely slim and high statue,
measuring about 6.8 ft. in

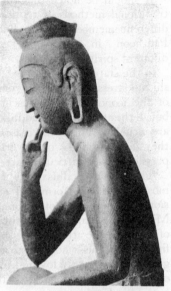

Fig. 19. Wooden Head of Miroku
Kōryū-ji, Kyoto

height and expressing supreme feeling which transcends all
human care. The posture, flat, thin and upright, with the regu-
lar pleat of the skirt, and the long side sweep of the scarf, all
unite harmoniously as if about to ascend to heaven through the
highest point of the oval shaped halo. The feeling one gets of
them is that of mysticism and sublimity.

4. INDUSTRIAL ART

In connection with the development of Buddhist architecture
and sculpture, metal work and wood carving made remark-
able progress; and textile work also began to make a new
start.

We have seen already that in the Archaic Period, swords, ar-

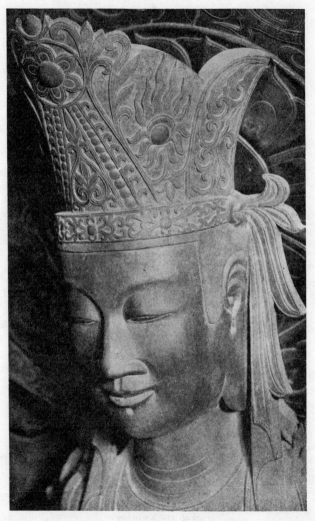

Fig. 20. Head of a Bodhisattva, by Tori
Hōryū-ji monastery, Yamato

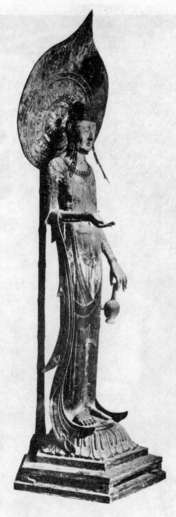

Fig. 21. Kwannon
Hōryū-ji, Yamato

mor, and other weapons were produced in abundance, and that metal work had already made good progress, which was further accelerated by the necessity of casting Buddhist images and their paraphernalia. The excellent workmanship of metal ornaments is shown in gilt-bronze banners and the metal fitting of the Ta-mamushi-no-zushi or Beetle Insect Shrine in the Kon-dō of the Hōryū-ji monastery.

The gilt-bronze banners, belonging formerly to the Hōryū-ji monastery, are now owned by the Imperial Household. They are so made as to be hung from the ceiling. A grand banner among them measures 23 feet in height; and the top is in the form of a canopy from which are hung draperies and pendulums. All these banners are decorated with angels drawing back long draperies and honey-suckle designs, together with Buddhist and animal figures. (Fig. 22) They are all pierced and the details are chiselled with hair lines. The figures and scrolls are grouped harmoniously, showing wonderful gracefulness of curvature, through which the faithful may commune with the Bud-

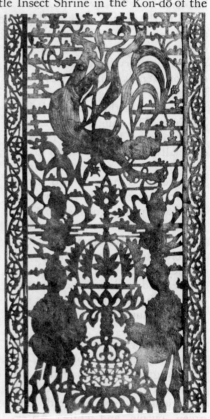

Fig. 22. Part of Gilt-bronze Banner
Tokyo Imperial Household Museum

dha in Heaven. These gilt bronze banners are now in the Tokyo Imperial Household Museum.

The pierced metal fitting of the Tamamushi shrine of the Kondō is much finer and more delicate; and it is more decorative in design, although the technique is the same as that of the gilded banners.

As to the textile work of the period, we see an authentic example in the embroidered tapestry of the Chūgū-ji nunnery of the Hōryū-ji monastery. It represents Paradise or Tenjukoku, and was made in 622 in the reign of Suiko, on the occasion of the death of Prince Shōtoku. The embroidery was executed by court ladies. The tapestry originally consisted of two parts, each measuring 16 feet in length. The ground is made of two tissues —purple gauze and yellow *aya*. Buddhas, men, goblins, palaces, flowers, and birds are represented in threads of many colors such as white, red, blue, yellow, green, orange, and purple. Little by little the tapestry has decayed, and there now remain only fragments. But the color still remains beautiful, showing its durable quality.

In the Hōryū-ji, as well as in the Imperial Household collection, are some fragmental pieces of thin silk embroidered with angels in threads of various colors such as red, blue, green, purple, and white. An example is shown in Fig. 23. An angel is coming down from heaven, sitting

Fig. 23. Angel in Silk Embroidery
Tokyo Imperial Household Museum

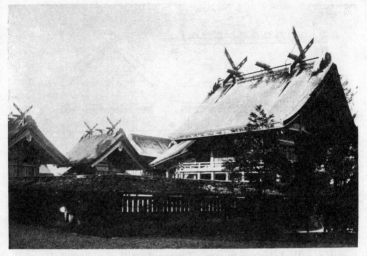

Fig. 24. Izumo Taisha
Gov. Rys. Photo.

on a lotus seat, and drawing back a long scarf in the air. The general composition is very decorative, the end of the scarf being transformed into a floral design, such as the honey-suckle peculiar to this period.

5. ARCHITECTURE

Before Buddhism was introduced, the architecture in Japan was quite archaic, and there was no distinction in the style of buildings for shrines, palaces, and commoners' dwelling houses. Therefore, the most archaic style of Shinto architecture, called *taisha-zukuri* (the great shrine style), was identi-

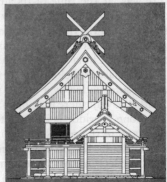

Fig. 25. Taisha-zukuri Style

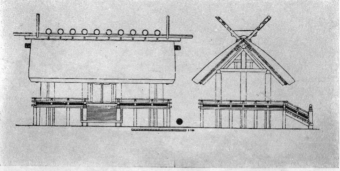

Fig. 26. Shimmei-zukuri Style

cal with that of the primitive dwelling houses that had existed
already. The Taisha Shrine of Izumo still keeps this archaic
style of primitive Shinto architecture. (Figs. 24, 25) On the
other hand, there was a more advanced style of Shinto archi-
tecture, called *shimmei-zukuri*, This style still remains unchanged,
as is now well illustrated by the shrine of Ise. (Fig. 26)

In the period of Suiko, the Chinese and Korean style of archi-
tecture was introduced into Japan, and the Japanese architecture
was quickly revolutionized. This Korean or Chinese architec-
ture was, at the time of its advent, a style that was developed
almost perfectly; in simplicity and directness of construction, in
subtlety and rhythm of line, and in dignity of massing, it showed
all the evidence of the supreme degree of civilization that was
attained in China in the last quarter of the sixth century.

A monastery belonging to this period, as a rule, faces south
and is surrounded by a square wall with a gateway on each side.
Inside the wall there is an open corridor enclosing a square court.
The long corridor is interrupted in the front by a central gate-
way, and in the rear, by a lecture hall. In the square court stand
a stupa and a Kondō or Golden Hall. Outside the court and be-
hind the lecture hall stand a drum tower and a bell tower facing
each other. The central group of buildings is surrounded on the
north, west, and east by three *viharas* or houses for priests.

There are also a refectory and a bath-house. Several other build-
ings such as a Sūtra-library (Kyōzō) which is in fact attached
to the

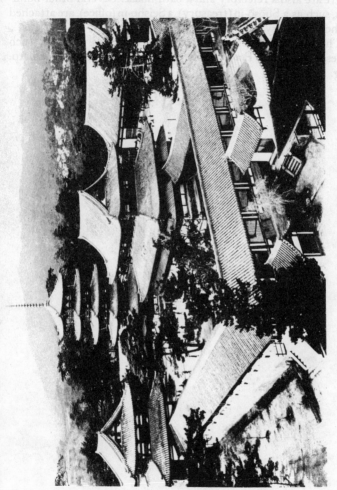

Fig. 27. General View of the Hōryū-ji Monastery, Yamato

There are also a refectory and a bath-house. Several other buildings, such as a Shōsō-in (treasury), a Seisho-in (office), are attached to the monastery.

The best and oldest example of monasteries built on such scales in the Suiko Period is the Hōryū-ji monastery in Yamato. (Fig. 27)

CHAPTER IV

BUDDHIST ART UNDER THE INFLUENCE OF T'ANG ART

(The Nara Period 646–793)

1. GENERAL SURVEY

With the advent of this new era the art that had attained great development during the reign of the Empress Suiko now had to undergo a marked change because of political innovations and the effect of foreign intercourse.

In this period, Japan for the first time came into direct contact with China which had been newly consolidated under the T'ang Emperors. Intercourse was no longer confined to accredited ambassadors, but there was a mutual flow of monks, teachers, and traders who plied between the two countries. The art of this T'ang Dynasty had a great influence on the Japanese art of this period.

China was consolidated in the Sui Dynasty following the Six Dynasties, but it remained for T'ai Tsung, the great Emperor of the T'ang Dynasty, to use this consolidation as a basis for the extension of his power. He was a great general and a romantic character; his conquests extended far along the caravan route towards India. Trade centres on this route, like Turfan and Khotan, were in a flourishing condition, and sea communication, as well as that by land, was, if not regular, at least frequent.

In the corresponding age in Japan, the Emperor and Empress respected both Buddhism and Confucianism, the former as the spiritual guide of the masses, and the latter as furnishing administrative principles, so that the two attained great prosperity side by side. The activity of the Buddhist movement at this period was shown in various directions: in the erection of many monasteries, such as the Yamashina-ji, Sufuku-ji, Daian-ji, Taima-ji, and Yakushi-ji; in the creation of numerous Buddhist figures in

metal, wood, and embroideries; and in the reading of Buddhist scriptures at Court and among the people in order to invoke blessings for the people. All such Buddhist activity imparted a powerful impulse to the development of art and industry, which burst into splendor in the reign of the Emperor Shōmu, in the eighth century.

During this period, through China also, there was conspicuous Persian influence. This was seen first in decorative art in which attempts were made to reproduce a Persian design composed of birds and animals among grape vines which was familiar to the Persians of the later Sassanidae; or a design composed of lions in a hunting scene, strongly retaining Mesopotamian character- istics. Of such Persian designs we shall treat later.

Also in the T'ang Dynasty, the Gupta style of the Buddhist art of India was more fully introduced into China. In the regin of the great T'ai Tsung, Hiuen Tsang came back from an eighteen year's stay in India laden with the knowledge imparted to him by the holy men there. He brought paintings and images, and a whole library of the sutra.

Though India was the greatest source of knowledge and the desired goal of the monks, it was not always necessary to go so far afield. India had come up the road cleared by China, and we read of an artist, Wei-ch'ih I-sêng by name, who came from Khotan in Turkestan. In the T'ang capital he enrolled many pupils who afterwards became famous.

From recent discoveries in Central Asia it is clear that the Indian art of this period, or slightly before, was prevalent there. It shows great similarity to the paintings in the caves of Ajanta in India. In Central India, the technique of the full gradation of colors and the modelling of flesh of the Gupta school developed.

In Japan, all this was felt, during the second half of the sev- enth century, and so strongly, that the art is clearly marked off from that of the former Suiko Period. This will be seen in ex- tant examples of sculpture and painting.

In the year 710 the capital was installed at Nara, where it lasted until the year 794 when it was removed to Kyoto. This

period, from 710 to 794, is sometimes called Tempyo, and the period preceding the Tempyo is called Hakuho, but we here include both periods under the same heading called Nara.

The centralization policy adopted in the reign of Kōtoku (645–654) eventually reached a culminating point in the reign of the Emperor Shōmu (724–748), who, blessed with peace and prosperity, succeeded to the Imperial heritage. The civilizing influence that China had already exerted continued in this reign.

Nara of that day presented an appearance very much like that of the great Chinese Capital, Chang-an. Indeed, China was to Japan what Athens was to Rome.

China was then an extremely rich and strong nation, and her capital was the very centre of all the civilization and culture under the sun. Therefore Persians, Armenians, and Indians all brought their religions, works of art, and many kinds of merchandise to her capital. It was at this time that Nestorian Christianity was propagated in China. The people in the capital were leading very luxurious lives. Even a petty house-maid wore a silk dress. Japan sent her envoys, priests and students to China to learn the culture that was flourishing in the Chinese capital. They brought home the best of this culture and replanted it at Nara. How bright and resplendent the results were may be gathered from a poem composed by a poet of the day:

"Bright and gay, Nara, the Capital, is now at its best; like the cherry in full bloom!"

The most wonderful social aspect of the Nara Period was the strong influence of Buddhism upon all the affairs of state. Indeed, in the first half of the eighth centry, Buddhism was most intimately and consummately connected with the court and the state.

The most prominent figure in Tempyo Buddhism was the Emperor Shōmu who, being a most ardent believer in Buddhism, even tried to conduct the administration according to Buddhist principles, instead of by law. In fact, all the official monasteries in the capital, as well as in the provinces, were erected in accordance with his ordinances.

The greatest of the monasteries built by him was the Tōdai-ji,

the Central Cathedral at Nara. In 752 it was dedicated to the Buddha Vairochana.

This Buddha still stands, and is popularly known as Daibutsu or Great Buddha of Nara. In the course of its erection, the Emperor issued the following Imperial Ordinance on the 1st of April, 21st year of Tempyō (749).

The Ordinance reads as follows:

"While we (the Emperor), inheriting the sovereignty in succession to the Sun in Heaven, are making every effort to make our mind one with the Heart of Heaven and Earth, there has been bestowed upon us a gift of gold, said to have been found at Odanokori in the province of Michinoku in the eastern part of the Empire. This has caused us to think that the words of Buddha provide the most excellent of all instruction for securing the welfare of the empire. Therefore we have distributed the manuscript called Saishō-wō-kyō (Suvarnaprabhâsattamaraja-sutra) in every province; we have managed to erect the image of Buddha Vairochana, supplicating the help of the deities in Heaven and Earth; for the same purpose we have also worshipped the souls of our Imperial ancestors, while at the same time we have invited many people who have joyously united in the pious work. All these efforts have been made in order to ward off calamities and to procure peace and happiness. Meanwhile the people have felt doubt about the success of the erection of the image of Buddha. But the gold was bestowed on us and this gift we regard as a testimony of the marvellous teaching of Buddha, as a sign of the gracious good will of the deities in Heaven and Earth, and of the lovingkindness of our Imperial ancestors."

With such devotion and with the greatest efforts, the erection of the Great Buddha was completed and the dedication ceremony was held in 752.

This ceremony was an epoch-making event in the history of Japanese Buddhism. The whole court attended it and thousands of priests in beautiful robes are said to have participated in it.

The great image of Buddha stood brilliantly in the centre. Golden and silk banners of gorgeous colors and beautiful designs

were suspended in rows. Beautifully mounted manuscript copies of scripture were unrolled and read in rhythmical tone by hundreds of priests. All sorts of music and dances, introduced from India, Annam, China, and Korea, were performed. It was indeed a highly international function.

The richness and splendor of the ceremony can be imagined from relics of the objects that were used on the occasion, which are still preserved to this day in the Shōsō-in treasury at Nara.

Near Nara, the capital, were such great official monasteries as Hōryū-ji, Yakushi-ji, Gangō-ji, Tōshōdai-ji, and Saidai-ji. Every province had a provincial monastery or Kokubun-ji and a nunnery to correspond. The governor of each province had to pay the highest respect to the provincial monastery as the centre of social life. Today there still remain many sites of these provincial monasteries, protected by the government as historical monuments.

As the erection of a monastery was an important state affair, the making of manuscripts of Buddhist scriptures became also no less an important business of the state.

In the reign of the Emperor Shōmu, in the middle of the eighth century, there was in the central government a special department, called Shakyōsho, or a department for making copies of Buddhist scriptures under a chief who was styled *Shakyoshi*. The noble style of penmanship, the care taken to make exact copies of the text, the use of decorated paper, the provision of beautiful cases and covers to preserve the copies, all testify to the reverence for the Buddhist holy scriptures. All these manuscripts consisted of rolls, a long sheet of paper being wound around a central rod. A great number of the manuscript copies made in this period are still preserved in the Shōsō-in treasury at Nara.

Of the motives which impelled persons to make copies of the manuscripts we learn something from the colophons. The colophons consist mostly of prayers and of notes on the circumstances of the making of copies. These motives may be classified under six heads, or the attainment of six objects:

1. Long life for the Emperor and prosperity for the nation.

2. Perfect enlightenment and spiritual welfare of the deceased Emperors in the next world.
3. Perfect enlightenment and spiritual welfare of ancestors and deceased parents in the next world.
4. Welfare of all people and other living creatures.
5. The fulfilment of a vow made by some high priest.
6. Recovery of the sick.

In many of the colophons we find the names of the donors, among whom we may note: Emperor, Empress, princes, high priests, and high officials. Sometimes we find the names of many persons who had co-operated.

In the Buddhist manuscript called Kwanzeon-bosatsu-juki-kyo the Emperor Shōmu writes as follows:

"In the ancient classics and in history, so far as we (the Emperor) know, we find nothing better than Buddhism, for it offers long life to us and welfare to the nation. Therefore we put our trust in Buddhism, and we have accomplished the work of copying all the manuscripts. Those who read the manuscripts ought to be sincere and to pray that the nation and all living creatures may have long life and happiness. Those who hearken to the precepts of Buddhism will never be degraded to the lives of lower animals but may ascend to the land of enlightenment."

It must be noted that every prayer written at the end of a manuscript sought from Buddha some reward, varying in kind, for the meritorious work of making the copy.

To the encouragement of Buddhism by the government, the country owes the development of architecture, sculpture, painting, and other arts—either pure or applied. Morally, aesthetically, and as a factor in material civilization, the part which Buddhism played was of far-reaching consequence.

Meanwhile, Chinese literature also made a striking advance; and encouragement was given to revere Confucianism and to study Chinese classics. Nor did Japanese classics now flourish less; in fact it was about this period that many poets of the highest order appeared. The immortal collection of poems called "Manyōshū," the oldest anthology in Japan, was indeed the

production of this age.

In short, India was now looked upon as a heavenly kingdom, and China as the centre of civilization. Politics and religion, art and literature, music and sports, dress, customs, and all other things were fashioned after those of China. At the same time we see in the art of this age that the Japanese genius was expressed consciously in the way it adapted these foreign arts to Japanese ideas.

2. PAINTING

The pictorial art of the Nara Period made remarkable development, keeping pace with sculpture and architecture. There were two styles that stimulated and moulded its development: the original Chinese line composition, which was introduced through Korea and was developed in colors in the reign of the Empress Suiko, and the Indian chiaroscuro style which was introduced from the early T'ang Dynasty.in the reign of Tenchi, and which is represented in the precious fresco painting of the Hūryū-ji monastery.

The reign of the Emperor Tenchi is memorable for various kinds of official reorganization intended to patronize and encourage arts and crafts. A special art department was first established in the Court, and four painters and sixty artisans were appointed. This official encouragement stimulated the development of art, pure and applied, that of the latter being especially noteworthy.

In the reign of the Emperor Shōmu, the pictorial art was carried to a high level. The documents preserved in the Shōsō-in treasury at Nara tell of a special art commission being appointed, and of the division of artists and artisans according to strict rules. There are itemized accounts of the cost of painting many images and designs, with the names of more than one hundred artists on the payroll, including those of draughtsmen, colorists, and supervising artists.

The Treasure Lists of the Hōryu-ji, Saidai-ji and other monasteries attest to the existence in those days of a large number of pictures now irreparably lost. The Donation Record of the Tō-

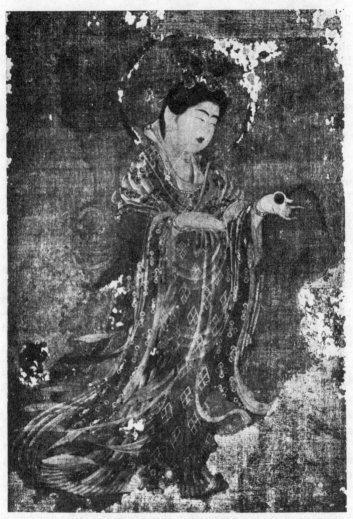

Fig. 28. Kichijō-ten, the Goddess of Beauty (N.T.)
Nara Imperial Household Museum

dai-ji mentions fifteen folding screens with pictures; the Treasure List of the Hōryū-ji contains standing figures of Buddha and ten disciples, and another standing Buddha presented in 732 by the Emperor Shōmu. The Saidai-ji catalogue mentions over ten Buddhist pictures, some as large as 16 ft. by 10 ft., and the catalogue of the Taian-ji mentions ninety-four Buddhist figures drawn in the year 740 by the same Emperor.

A marked improvement was then reached in the use of colors, the number of which greatly increased. In an old document, kept at the Shōsō-in treasury, as many as seventeen different kinds of colors are mentioned. On the whole the tone of the color of this age was bright and rich.

Although the pictures mentioned in the documents are now nearly all lost, there still remain such important examples as the fresco painting of Hōryū-ji, Kichijō-ten, or Goddess of Beauty, of Yakushi-ji and some other paintings in the Shōsō-in collection at Nara.

The best example of Buddhist paintings of the Tempyo Era is Kichijō-ten, the Goddess of Beauty, from the Yakushi-ji monastery preserved in the Nara Imperial Household Museum. It is painted in colors on hempen cloth and measures 1.8 feet in length. (Fig. 28) The goddess looks like the picture of a noble lady. Her curved eyebrows, full cheeks, and graceful pose suggest beautiful womanhood as conceived by the Chinese of the T'ang Dynasty.

A similar type of beauty of the same period is often met with in fragments of paintings discovered in Central Asia, which are now scattered abroad. A fine specimen of this kind is in the British Museum. Beauties of a similar type are found also among mortuary clay figures discovered in Chinese tombs of the T'ang Dynasty.

In the art of engraving we can see pictorial representations of many Buddhist figures. Good examples of such pictures can be found on the bronze petals of the huge lotus throne of the Daibutsu of the Tōdai-ji temple and on the fragment of the bronze halo of the Nigatsu-dō, Nara. The angels on the halo are more

excellent for their graceful and rhythmic lines than the Buddhist
figures on the petals of the throne of the Daibutsu. The angels,
their flying mantles, and bits of floating clouds are delineated
with fine cut lines on a gilt bronze surface, and their interstices
are filled with fine dotted lines. Our reproduction in Fig. 29,
being the impression of the engraving in black and white, gives
quite a different feeling from what we get from the halo in the

original. But we can see in it
the most lovely and delightful
lines which are used quite suc-
cessfully in bringing down the
"angelic sphere of another
world."

All that we have described
above is the pictorial art that
was influenced by the new
ideas introduced from the
T'ang Dynasty of China. But,
besides this, there was an older
style; that is, the Six Dynas-
ties style. Its best and only
existing example is the Kwa-
ko-Genzai-Ingwa-Kyo sutra,
parts of which are owned by
the Hō-on-in of the Daigo-ji
monastery and by the Jōbon-
Rendai-ji of Kyoto, and the
former is preserved in the
Kyoto Onshi Museum of Art.

Fig. 29. Detail of a Bronze Halo (N.T.)
Higatsu-dō, Hara

3. BRONZE SCULPTURE

The style and form of the Nara sculpture is very different
from that of the Suiko Period; it has curves much fuller and
more rounded, showing the influence of the Gupta school of In-
dia, which was introduced into China before it reached Japan. In

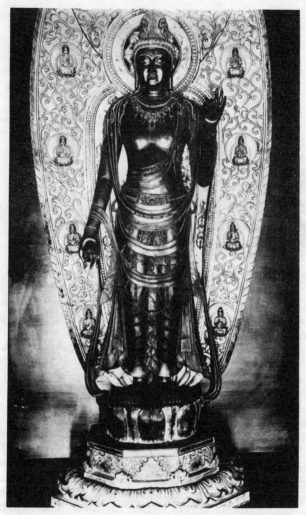

Fig. 30. Shō-kwannon (N.T.)
Yakushi-ji, Yamato

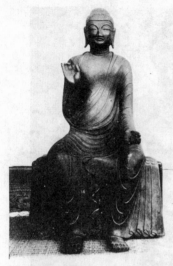
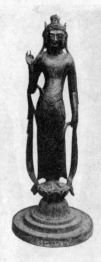

Fig. 31. Shaka-muni (N.T.) Fig. 32. Shō-kwannon (N.T.)
 Jindai-ji, Musashi *Kakurin-ji, Harima*

this period the erection of large Buddhist figures was much
more frequent than in the preceding Suiko Period, and a good
number of them still remain. Bronze, wood, clay, and dry-
lacquer were used as the medium of sculpture, but bronze was
used more in the early years. Dry-lacquer and clay were used
later.

Speaking technically, all the great bronze figures were cast,
and small figures were often represented in *repoussé*. They were
both gilded.

The bronze statue of Shō-kwannon (Fig. 30) of Tōindō in
the Yakushi-ji monastery is an important example of the T'ang
style made in Japan in the early Nara Period. It measures 7
feet in height; its posture is stern and majestic. The proportion
is beautiful, as well as the realistic form of the body, which has
especially beautiful curves around the hips. The thin trans-
parent drapery is so filmy that one may feel the pulsating

warmth of the body. Such gracefulness is the most conspicuous characteristic of the T'ang sculpture of China.

The bronze statue representing Shaka-muni Buddha (Fig. 31), example of the bronze statues produced in the second half of the seventh century. Its height is 75 centimetres. Its graceful posture and the rotund form of body owe much to the style of the Gupta School of India, and at the same time it is a representative work of the early Nara sculpture in Japan.

The bronze statue of Shō-kwannon (Fig. 32) of the Kakurin-ji temple in the province of Harima, is also an excellent example of the bronze statues of the early Nara Period. It measures about 90 centimetres. Although it shows the influence of the Chinese style of T'ang sculpture, it is highly Japanese in expression.

The statuette of Amida Trinity in the Kondō of the Hōryū-ji monastery is one of the most famous bronze statues produced in the early Nara Period.

The finest and the most representative example of the Tempyo sculpture, that is, of the first half of the eighth century, is the Yakushi Triad enshrined in the Golden Hall of the Yakushi-ji monastery in Yamato.

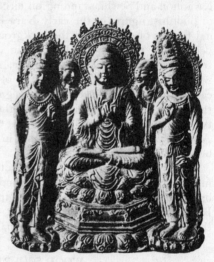

Fig. 33. Amida Triad with Two Disciples (N.T.)
Imperial Household Collection

Examples of Buddhist figures in *repoussé* work are preserved in the Hōryū-ji monastery and in the Imperial Household collections. Their shapes

are beaten out of thin bronze plate on a metal mould, and the whole surface is gilded. Among them are two fine examples, both of which represent Amida triad with two Buddhist disciples. (Fig. 33) They are so exactly similar to each other that they might have been made from the same mould. They measure 38.5 centimetres in length and 31.5 centimetres in breadth. This seems to be the largest size *repoussé* work of this period. The central figure is the Buddha Amida with both hands brought together in front of the chest in the attitude of the "sacred wheel rotation" which denotes preaching or exposition of the Buddhist doctrine. The rotund body and calm expression of the middle figure, the graceful hip-sway and attentive posture of the Bodhisattvas, Kwannon and Seishi, standing on either side, are typical styles of Buddhist figures of the early Nara Period. The two additional figures of disciples in the background constitute a grouping peculiar to this period. The origin of this grouping can be traced back to the Gadhara sculpture. As such figures in *repoussé* were made cheaply and a number of replicas were produced easily, they may have been quite insignificant at the time when they were made. But this shows us the important fact that this type of figure was popular; and that the faith in the Buddha Amida became much more popular in this period than it had been in the Suiko Period.

The erection of the famous Daibutsu, measuring about 16 metres in height, was indeed a wonder in the art of casting bronze, and an epoch-making event in the history of Japanese Buddhism. But it has suffered great repairs several times, so that it is now difficult to see its original magnificence.

4. WOOD SCULPTURE

The wooden sculpture of the Tempyo Era was usually made of *hinoki* (a kind of white cedar) and, rarely, of camphor wood. It was generally carved out of one block of wood, as in the Suiko Period, and often included the pedestal, which was shaped into a lotus cup. When the carving was finished, the whole surface

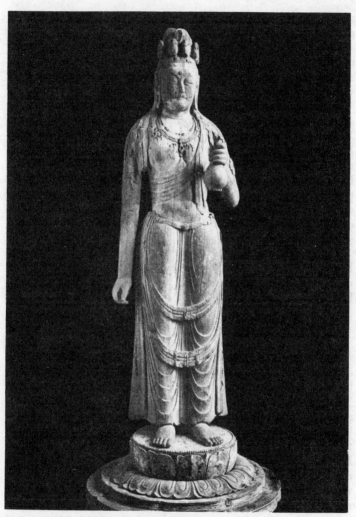

Fig. 34. Eleven-headed Kwannon (N.T.)
Nara Imperial Household Museum

was thinly coated with gesso or *gofun*; then all the details were painted in various colors.

However these colors are now nearly all gone from any relics of Tempyō sculpture; they retain only some traces of gesso, although the plain wood finish thus disclosed shows excellent workmanship.

A beautiful example of the Tempyō wooden sculpture will be seen in the statue of the Eleven-headed Kwannon (Fig. 34) of Yakushi-ji monastery, now placed on view in the Nara Imperial Household Museum. It is a standing figure of graceful posture, measuring 190 centimetres in height. It holds a vase in the left hand at the side of the chest and the right arm is calmly suspended along the side. The well-built body with sensuous beauty and the fluent lines of drapery represent the characteristic feature of the Tempyō sculpture. Its sensuous gracefulness expresses spiritual magnitude.

Other fine examples of wooden sculpture from the Tempyō Era can be seen at the Shinyakushi-ji at Nara and Tōshōdai-ji monastery in the suburb of Nara and also at the Nara Imperial Household Museum.

5. DRY-LACQUER SCULPTURE

In the eighth century, the use of bronze and wood in sculpture declined and the new materials, clay and dry-lacquer, began to be used in their places. Indeed, the highest development of Tempyō sculpture was attained by using clay and dry-lacquer, and many masterpieces remain in good condition. The use of dry-lacquer or *kanshitsu* is a process of Chinese origin. In the manufacture of dry-lacquer statues, different methods were used. By one method, a wooden or clay model was made first as for casting, and then a thick coating of clay was applied, the whole, when dried, being cut off into several parts to obtain convex moulds. The hollow surfaces were coated with mica; and lacquer juice—first of finer consistency and next of coarser quality—was gradually poured into these moulds. All the parts of a statue

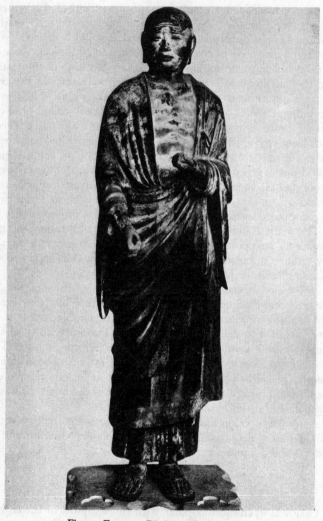

Fig. 35. Furuna, a Disciple of Buddha (N.T.)
Nara Imperial Household Museum

thus made were joined together by sewing with thread; then the design, as a finish, was lacquered on the surface, and finally painted as required. In another method, a skeleton of wood was covered with pieces of coarse cloth soaked in lacquer juice which could be made to harden into the primary blocking of the statue and then all the details were modelled on the surface in the wet material, quite as in the manner of modelling clay. However, the most practical of all the methods was the so-called "hollow statue" process, in which a model of clay was made and covered with lacquered cloth. When both clay and lacquer had hardened, the inside of the figure was dug out, leaving a hard shell, which would not warp nor split. On the surface thus obtained were elaborated all the details of the statue by lacquer mixed with "makkō" or powdered incense wood. The hollow inside was then supported with a wooden frame to give it more stability.

The main Buddhist statue, Fukū-kensaku-kwannon, of the Hokke-dō chapel (Sangatsu-dō) at Nara, is an example of the dry-lacquer statue of the Chinese T'ang Period as modified by its assimilation in Japan.

In Fig. 35 we have reproduced the figure of Furuna, one of the ten great disciples of Buddha Shaka-muni. This is an excellent example produced in the eighth century in Japan. It measures about 150 centimetres in height. The spirituality of the great disciple is symbolized cleverly by making him slender. The face is especially wonderful for the meditative mood which is seen in the slightly knitted brow, as well as for the refined expression of lovingkindness that is moving in his heart. Thus is symbolized his individual personality.

A number of other fine examples of masterpieces in dry-lacquer will be found in the Nara Imperial Household Museum and in the Tōshōdai-ji monastery near Nara.

6. CLAY SCULPTURE

Clay was even more popular with the sculptors of the eighth century than dry-lacquer, and the plastic genius of these artists

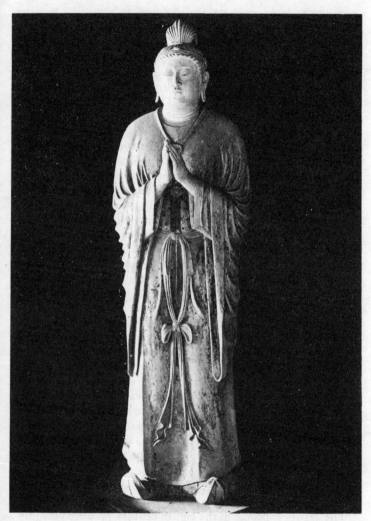

Fig. 36. Clay Statue of Gakkwō (N.T.)
Hokke-dō, Nara

is shown by many excellent examples which remain in good condition today in spite of the fact that the images were never hardened by fire. In the manufacture of clay figures, a wooden frame was made first, and then the frame bones were bound with straw cord. Next, the clay, mixed with straw fibre, was shaped into the outline of a figure, and then all the surface work was elaborated with a finer finish clay. The finish clay was composed of fine sifted Nara earth mixed with finely shredded paper fibre and particles of mica. It is of a beautiful light silvery-gray. The clay was applied little by little with the fingers so that it might dry easily. It takes a polished surface that hardens with mere drying, and resists ordinary atmospheric disintegration.

The earliest Japanese example of Buddhist clay figures that have come down to us are the small figures which were made in 711 and are installed in the five-storied stupa of the Hōryū-ji monastery, as is recorded in the history of the temple.

The clay and dry-lacquer statues of the Tempyō Era are represented at their best in the Hokke-dō chapel at Nara. On either side of the main figure in the chapel stands a clay figure. One of the two, the image of Gakkwō, is particularly fine, surpassing all the rest in the chapel. (Fig. 36) It measures 2.6 metres in height, and stands calmly with hands clasped in prayer. That the technique of clay-modelling had reached a stage of almost superhuman perfection will be seen in its well-rounded and quiet attitude, which expresses inner spirituality. The refined dignity of the divine face, which is miraculously combined with human beauty, cannot be surpassed by any other statue. The deeply modelled drapery folds seem as fine as the best of archaic Greek.

A number of examples of masterpieces in clay will be found in the Nara Imperial Household Museum, and in the Hokke-dō and the Kaidan-in of the Tōdai-ji monastery at Nara.

7. TEXTILE ART

The Japanese people in the eighth century produced magnificent industrial arts which were harmonious with their highly

artistic Buddhist images. The faithful could appreciate the arts in the monasteries with all their hearts and souls and could get near to the true meaning of beauty, which cannot be touched with the hands nor possessed by legal rights. The decorative arts used in the Buddhist services were of the highest kind produced in that age. They must have enriched the imagination of the people and given them expectation for their lives, both in the present and in the future. In the early Nara Period, all the painters, weavers, smiths, casters, potters, and lacquerers were appointed under Imperial patronage. The decorative designs composed by them were generally continental in style; and most highly developed in the reign of the Emperor Shōmu (724–748). A large number of good examples produced by them are preserved in the Shōsō-in treasury, the wooden storehouse built in the same age at Nara.

Of these extant examples of the industrial art from the Nara Period, textile fabrics, metal work and musical instruments are most notable and worthy of special attention.

The development of textile art in the eighth century was greatly influenced by the Chinese. It was, however, deeply indebted to the foundation made in the preceding periods. It had begun already in our prehistoric age, as was the case with that of other primitive peoples. In the art of weaving, the principal materials used first were fibres of hemp and other plants; and from very early times men had a knowledge of raising silkworms. The Emperor Yūryaku (457–479) had encouraged the industry of sericulture, and in 655, in the reign of the Emperor Kōtoku, a bureau of weaving, the *Oribeno-tsukasa*, was established. In 711, in the reign of the Empress Gemmyō, textile experts called *ayashi* were sent from the bureau of weaving to twenty-one different provinces throughout the country in order to propagate the advanced art of weaving twill (*aya*) and brocade, and it was enacted that these twenty-one provinces were to send in textile fabrics for *corvée* and annual tribute. Undoubtedly this regulation gave a great impetus to the silk industry. In addition to these historical records, the collection of textile

fabrics in the Shōsō-in and the Tokyo Imperial Household Museum, show most eloquently how prosperous the art was. They include a marvellous variety of products. Among them are brocade (*nishiki*), twill (*aya*), gauze (*ra*), silk (*kinu*), rough silk (*ashiginu*), etc. Indeed they are extremely important materials in the history of Oriental textiles.

Speaking of ornament, it is interesting to note that some of the designs were developed from the same source as were those silk fabrics discovered in Persia and Antinoe in Northern Egypt, which were produced in the corresponding period, that is, from the sixth to the eighth centuries. In the sixth century, the Emperor Justinian imported the Oriental method of silk industry to Byzantium and made Constantinople the centre of silk supply for Europe. Meanwhile, in Chang-an, the capital of the T'ang Dynasty of China, every kind of beautiful silk developed in Western Asia became known. From China, Japan learned the new development of textile fabrics, and the best technical perfection. This fact shows how people in the West and the East loved the beauty of decorative silk as we do today, and we see that beautiful and good things find their way everywhere.

As to the technical process of brocade weaving, there were two distinctly different methods. In one process the design and ground were woven so as to stand out with warp thread only, and the woof did not show at all on the front surface of the brocade. This process seems to have been the earlier method. The other process is the style in which the designs are with the woof, similar to the modern brocade weave. This process seems to have been developed later; it survives in two different kinds of brocade produced by it. One is similar to tapestry weave (*tsuzure-nishiki*) and the other to ordinary Japanese weave (*yamato-nishiki*). The designs in the ordinary brocade weave are mostly plain and distinct with vivid colors, while the designs shown by warp thread only are less sharply defined and their character is free and less rigid.

Aya (twill) in most cases is covered all over with twill, or the design only is in twills, and the twills in the design run counter to those on the ground so that the design stands out in any light.

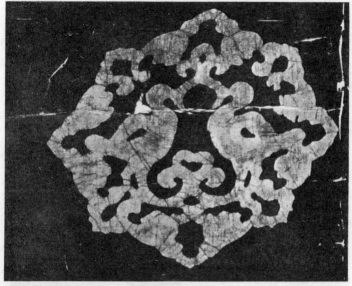

Fig. 37. Rōkechi
Shōsō-in Collection

The designs used for *aya*, broadly speaking, are similar to those on brocade, but for practical use they are generally smaller and often form the ground pattern. The dye used is generally weak and quiet in tone.

There are two distinct names given for silk; one is *kinu*, which is finer and better silk, and the other *ashiginu*, which is coarser in quality. The plain silks were, of course, for practical use and were produced abundantly; and some were dyed in plain colors or with designs in batik.

Ra is a kind of gauze and is also called *usumono*. Whenever it was required to have a ground pattern, a special loom was used so that it invariably produced a lozenge pattern. Accordingly, the patterns of *ra* in the Shōsō-in collection consisted of small lozenges, double or multifold lozenges, four small lozenges forming a larger one, or "pine-bark" lozenge. The fabrics so figured

were dyed and sometimes decorated further with embroidery.

Dye-stuff used in the dyeing was obtained principally from vegetables, employing wood ash, vinegar, etc. as mordants. A marked development was made in the use of colors; in an old document kept in the Shōsō-in, as many as seventeen different kinds are mentioned. But the principal colors used in the textile fabrics were red, blue, yellow, purple, black and dark brown; and all these colors are wonderfully well preserved, resisting prolonged action of sunlight.

Red included crimson, scarlet, and sapan (*suhō*). The safflower was used for crimson; madder (*akane*) as a material for scarlet. *Suhō* was obtained by boiling sapan-wood in water.

Blue included clear blue (*heki*), dark blue (*kon*), and light blue (*hanada*); and green was derived from blue. The principal material for them was poligonum tinctrium (*ai*). For clear blue and green, Miscanthus tinctorium (*kariyasu*) or Phellodendron amurense (*kiwada*) was required.

Fig. 38. Kyōkechi
Shōsō-in Collection

Yellow was derived from Golden florida (*kuchinashi*), *kariyasu*, *kiwada*, etc.

Purple was obtained from *shiso* (Lythosperm erythrorzon); and black was taken from *tsurubami* (a fruit of the wood nut Corylus heterophylla) and mud.

The principal methods of dyeing were *rōkechi*, *kyōkechi* and *kōkechi*. In the method called *rōkechi* (batik), the design is first put on with wax and the pattern is obtained by removing the wax afterwards. The peculiarity of this style of dyeing is in the interesting markings in the design produced by natural cracks in the wax put on the silk, which take the dye, giving a touch of elegance. (Fig. 37) In the method *kyōkechi* the silk is clamped between two boards on which is a pierced design through which the dye is applied. (Fig. 38) When a symmetrical design is required, the silk is folded double; when four symmetrical patterns are wanted, it is quadrupled; and, when the silk is required to have the same pattern scattered over it, it is folded as many times as required, clasped between boards tightly, and dyed. One

peculiarity of the products of this style is the blurred effect along the edge of the design, giving a touch of neatness. *Kōkechi* (tie-dyeing) is the method in which the silk is tied tightly with thread and dipped into the dye. The wrinkles in the gathers cause an interesting gradation with the undyed parts held tight under the thread.

The designs, full of rich and bright colors, show a wonderful variety. Their motifs may be divided into floral, animal, plant, and landscape. A large number of them show a Chinese influence, but some of them are distinctly Persian. A typical

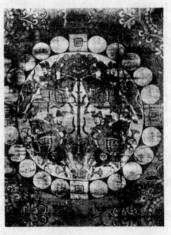

Fig. 39. Part of Tapestry with Hunting
Pattern in Persian Style
Hōryū-ji, Yamato

and widely spread design of Persian origin is a hunting scene.

In the Hōryū-ji we have a fine specimen in which the design is
composed of four lion-hunting equestrians on winged horses,
having a large tree in the centre, all encased in a roundel
studded with stars. (Fig. 39)

8. METAL WORK

The metal work had a long history already in the Nara Period
and a remarkable development had been made, especially in
casting and goldsmith work. The first authentic record of metal
extraction in Japan was in the third year of the reign of the Em-
peror Temmu (673–685) when silver was produced in Tsushima
Island. Then, in the fifth year of the reign of the Empress Jitō
(691), silver was forwarded as a present to the Court from the
province of Iyo. From Tsushima came gold in the reign of the
Emperor Mommu (697–714), and then from Musashi copper was
presented. However, there remain only a few great works from
the early years of this period, and it seems that after the epoch-
making cast of the Daibutsu, gold and copper were used up and
it seems to have been possible to produce only minor articles.

In the Imperial Household collection is a jug with dragon head,
which was formerly kept in the Hōryū-ji temple, measuring 1.8
feet in height. (Fig. 40) It is made of bronze and gilded; and on
the body is chiselled the figure of a winged horse, typically Per-
sian in design. Its shape is extremely elegant and the execution
wonderful.

In the Shōsō-in collection are preserved more than fifty
beautiful mirrors. All of them are extremely fascinating. They
are of polished bronze like those of Egypt and Greece. Their
shape is either a disc or eight-petalled flower form, both held by
cords attached to the knobs at the centre of the back. They are
quite thick and heavy, the largest measuring about ten inches in
diameter, and are kept in wooden cases, beautifully lined with
padded brocade. As to the technical process, some designs are
cast in the same mould; but others are incrusted finely on a
lacquer ground. The designs are composed mostly of animals,

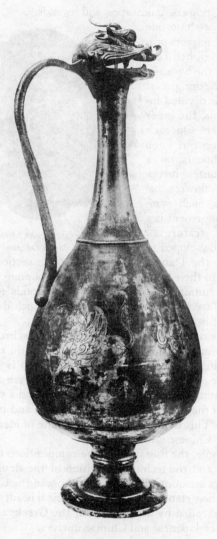

Fig. 40. Gilt-bronze Jug
Imperial Household Collection

clouds, birds, flowers, landscapes, and legends.

In Fig. 41 we have one of the typical mirrors produced in the eighth century. It is in the Shōsō-in collection. The design cast on the back is divided into two sections, the inner and the outer. On each side of the central knob perches a phoenix on a flower, confronting its opposite, with flowers between them. Such symmetrical arrangement is a characteristic feature of the designs developed in

Fig. 41. Bronze Mirror
Shōsō-in Collection

China during the T'ang Dynasty. In the outer section birds with floral sprays in their beaks are flying around among flowers and animals are running between the birds. Clouds formed into floral shapes are floating between flowers. Such designs were most popular in this period.

Exquisite workmanship of metal inlay on a cast bronze ground will be seen in the eight-petalled-form mirror in the Shōsō-in collection. (Fig. 42) Around the middle knob is represented water in fine silver inlay. Along the water are represented land and mountains in gold inlay and on the land a saint is playing music. In the sky, cranes are flying about and bits of cloud are floating. This design represents the state of ideal happiness conceived by Chinese saints.

On the whole, the fine spirit of the composition, the richness of the color, and the technical precision of the designs applied to the mirrors are quite different from those of the Chinese Han mirrors. In their elaboration and symmetrical beauty, they have never been excelled by any mirrors of the Greeks and Romans, or by any later Japanese and Chinese mirrors.

Fig. 42. Part of Bronze Mirror with Inlaid Design
Shōsō-in Collection

9. MUSICAL INSTRUMENTS

In the musical instruments of the Shōsō-in collection we find some beautiful examples of highly decorative ornaments, which illustrate the motif and technical excellence of the carved and inlaid work developed in the Nara Period.

One of the most beautiful instruments is a seven-stringed psaltery. The surface and back side are all laquered black and inlaid with gold and silver plates cut into figures, animals, flowers, birds, and butterflies. These designs are first incrusted and then polished off evenly. The principal design is enclosed in the square on the upper part. (Fig. 43) In the enclosure three saints are sitting among the trees and flowers, each playing a different musical instrument. Flowers bloom on the ground, and a large peacock spreads its plumage as though about to dance. From the upper corners two saints are coming down, each of them riding over

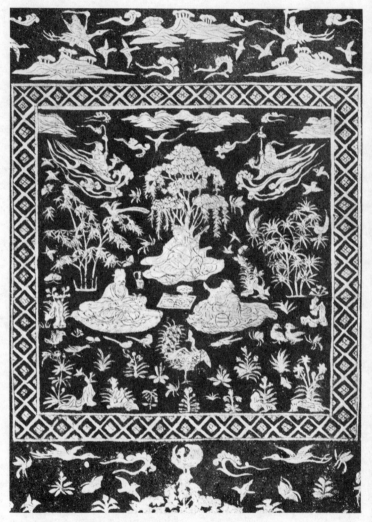

Fig. 43. Design on the Upper Part of a Psaltery
Shōsō-in Collection

the clouds on a phoenix to join the music party below. In the middle part, under the strings, is painted a long stream of water, symbolizing the melodious murmuring sound of a river. The back side is also decorated with flowers, phoenixes, and two large dragons. But more than to anything else we should like to call attention to the following inscription on the back: (Fig. 312)

"The sound of the psaltery washes away evil passions. The quietude of a righteous mind comes in and a sublime feeling prevails.

"Vulgarity runs away, and capriciousness is here restricted. Joy and harmony in the righteous way, but not too much pleasure."

Here we see the Chinese attitude towards music and the beauty of nature, which became the fountain head from which Japanese taste was derived later. As a whole, the design represents the ideal state of happiness conceived by Chinese sages in association with the exalted rhythm of music played by them.

There is a musical instrument known as *biwa*. (Fig. 44) The back of the instrument is made of sandal wood inlaid with flowers and birds in mother-of-pearl, the pollen of flowers being made of transparent tortoise shell, under which is applied a crimson color that gives a beautiful effect through the shell.

There is also an ivory plectrum of excellent workmanship. (Fig. 45) The design is composed of flowers, birds, mountains and two sacred animals called *kirin*. All are incised on a red colored ground. One of the sacred animals is stepping forward in a gallant way; and another, on the other side, is just perching lightly on a flower, like a bird with wings outstretched. It is said that the *kirin* has the body of a deer, the tail of an ox, and a single horn. Its alleged appearance was, according to a tradition, believed to be a happy portent of the advent of good government or of the birth of virtuous rulers, and the emblem of perfect good. Here, the animal for ornament, it is harmoniously surrounded with flowers and birds in a fine color scheme. Its excellent finish can hardly fail to evoke admiration even from those who know nothing of its symbolical meaning.

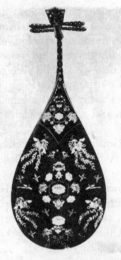
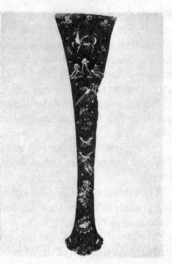

Fig. 44. Biwa Musical Instrument
Shōsō-in Collection

Fig. 45. Ivory Plectrum
Shōsō-in Collection

10. ARCHITECTURE

One full century passed after the Korean architecture had been for the first time introduced to Japan in the Suiko Period.

Now the first section of the Nara Period, that is, the later half of the seventh century, which is designated as the Hakuhō Era, was a transitional stage between the influence of the Chinese Six Dynasties and that of the T'ang Dynasty. In the Hakuhō Era, the Buddhist architecture was, like everything else in Japan, greatly influenced by T'ang ideas.

The plan of the monasteries in this period differed from that of the Suiko Period in having none of the buildings in the inner enclosure. A pair of stupas facing south stood outside the inner enclosure; the Kondō, or Golden Hall, interrupted the Northern cloister at the centre; and behind the Kondō, stood the Kōdō, or Lecture Hall, evidently conforming to the Chinese de-

mand for symmetry.

As for the technique, the cloud-form of the brackets which we saw in the Hōryū-ji architecture of the Suiko Period, has almost disappeared by this time, and the eaves are for the first time ceilinged like the interior.

The sole architectural monument remaining from the Hakuhō is the East Stupa of the Yakushi-ji monastery. (Fig. 46) The entire height of the stupa measures 125 feet. It is a three-storied one erected on a stone platform; but, as each story has what is known as a "skirting roof," the general appearance is that of a six-storied stupa. Each story is furnished with balustraded verandahs. The addition of the "skirting roof" and the balustraded verandahs breaks the monotony of the outline in a most original yet most charming way; the stupa has compound brackets, which form a link between the cloud-shaped brackets of Hōryū-ji architecture and the triple bracketing system of the succeeding period. The finial, which soars to heaven from the top of the roof, is most shapely and gives a captivating grace to the whole structure.

With the permanent establishment of the Imperial Court at Nara in 710, the Chinese architectural style of the T'ang Dynasty developed more rapidly and caused a high level of perfection in the court and Buddhist buildings. The plan of the monasteries became far grander and they were built on a larger scale. The temples were rectangular and raised on platforms of clay and stone. The floors were laid with tiles. The pillars still had entasis though much less than in the former age, and often showed the beauty of columns in a row. The simple bracketing gave place to elaborate and massive triple systems with heavy beams and eaves in proportion. The hipped roofs of the main buildings were ornamented at either end of the ridgepole by *shibi* or kites' tails, as a protection against fire. The exterior of buildings was coated with red oxide of iron; the interior painted in full color.

Of the palace architecture the only remaining example is the Lecture Hall or Kōdō in the Tōshōdai-ji monastery. (Fig. 47)

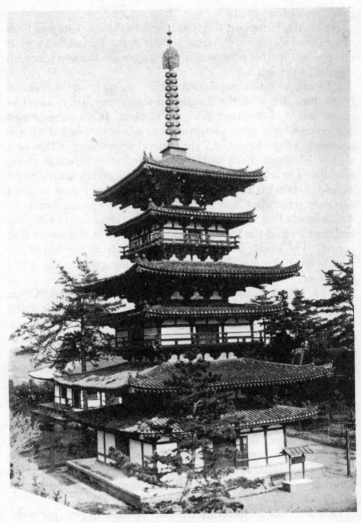

Fig. 46. Three-storied Stupa (N.T.)
Yakushi-ii, Yamato

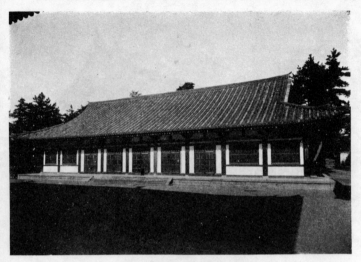

Fig. 47. Lecture Hall (N.T.)
Tōshōdai-ji, Yamato

It was originally the waiting hall belonging to the Imperial
Palace group, which was given to the monastery when it was
founded. It is the only relic bequeathed from the Nara Period that
reflects the palace architecture of the 8th century. It is a single-
story building, with a kind of gabled roof, *irimoya*, and though its
exteriors were more or less modified at the time of the Kamakura
repairing, the inside retains the former features unaltered.

The finest example of the Buddhist architecture of the eighth
century is the Kondō or the Golden Hall of the Tōshōdai-ji mon-
astery, near Nara. (Fig. 48) The hall stands on a stone platform
and has seven column intervals in the façade and four on the
sides. It is a one-story building surmounted by a hipped roof which
is tiled and both sides of the ridgepole are decorated with kites'
tails. The eight orders in the open space in front of the façade
make a long columnal row, magnificent and imposing like the
classical orders of Greek architecture. The columns are massive
and have a slight entasis; the bracket and details are boldly and

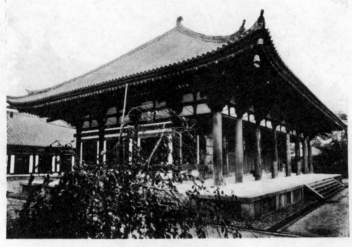

Fig. 48. Golden Hall (N.T.)
Tōshōdai-ji, Yamato

splendidly constructed. The exterior is painted principally with
red oxide of iron while the pillars of the inside of the sanctuary
are ornamented up to the ceiling with floral designs and with
pictures of Buddhas and Bodhisattvas, which have now almost
disappeared. On the whole, the hall is built beautifully and
nobly, and may be compared with any beautiful architecture in
the world.

Of the other important existing examples of the Buddhist
architecture of the eighth century, we have the Hokke-dō
chapei of Tōdai-ji, the Shōsō-in treasury, the Yumedono of the
Hōryū-ji, and the two stupas of the Taima-dera monastery.

As regards the dwelling houses of the people, no example ex-
ists today, but, in the reign of the Emperor Shōmu, officials hold-
ing court ranks above the fifth rank and also rich plebeians were
permitted to build red painted mansions roofed with tiles. From
this time on, tiled roofs seem to have been in general use. This
permission shows that the construction of dwelling houses made

remarkable development and that there were epoch-making changes. Together with other highly developed arts, the architectural appearance of the streets in the capital of Nara must have been magnificent.

CHAPTER V

THE ART OF ESOTERIC BUDDHISM

(The Heian Period 794–893)

1. GENERAL SURVEY

The Heian Period began with the removal of the capital from Nara to Heian (Kyoto) in 794 and lasted until about the end of the 9th century, when Japanese intercourse with China was interrupted by the civil wars that overthrew the T'ang Emperors.

In the eighth century the Imperial court and government were devoted to Buddhism and levied taxes for the purpose of encouraging it, bestowing large sums on the existent temples or building new ones. Consequently, not only did the financial condition of the state grow poor, but the distinction between government and religion became confused, and the arrogance of the priesthood was beyond description. At such a time, the Emperor Kwammu ascended the throne. The new Emperor was pre-eminently a great character; and, understanding the actual tendency of the age, spent all his energy in social and political reform. He removed the seat of government to Yamashiro and called the place Heian or "Peace and Ease." The greater convenience of the new site would have been a suitable reason for the removal, but the more direct reason was to escape from the shadow of the great monasteries of Nara. His founding of the new capital awakened the people to activity and brought about a complete social reform. It gave the people a new hope and new ideals.

As China had troubles in and out of her country in these days, and was in a disturbed condition, Japan did not draw much from her institutions; but in China famous writers, poets and priests arose in succession; literature, art, and religion developed to a high degree; and this progress, no doubt, had a great influence on the new development of Japan. Yet in these days, unlike that

of the preceding period, the adherence to the Chinese style was not pushed to the point of absolute imitation.

Almost all the priests who had been to China in these days were eminently talented and of penetrating minds. Among all these priests Saichō (Dengyo Daishi) and Kūkai (Kōbō Daishi) were the greatest.

The priest Kūkai brought back the first word of esotericism, and began to perform the secret rites of esoteric baptism in the year 812. Many of the eminent monks of the time joined in the movement.

The new capital, which had been laid out on Chinese lines, had a great monastery on each side of the main port, the eastern one (Tō-ji) of which was given over to Kōbō Daishi to form the headquarters of his esoteric teachings. Later he founded another great monastery on the summit of the sequestered Mount Kōya.

The site to the north of the city was given to Dengyō Daishi, the rival of Kōbō Daishi, who had started the Tendai sect, for his monastery of Enryaku-ji, in order that the capital might be protected from its ill-omened quarter by a sacred influence. This was enlarged by the priest Chishō Daishi and his successors, and became a great seat of learning.

The doctrines of these two sects accorded well with the belief of the day. As many distinguished priests administered them they exerted a good influence side by side with the government, and the Emperors and all the nobles, not to speak of the common people, came to believe in them.

In addition, Kūkai and Saichō completed their work of identifying Buddhistic with Shinto deities and made Buddhism and Shintoism common in many respects by identifying names and ceremonies. Thus Buddhism brought about a great change in the architecture of Shinto shrines.

Artistically, the later T'ang influence, which is noticeable in this period, differed from that of the eighth century; on the one hand, in having a stronger tinge of the Indian ideals brought by the esoteric sect, and on the other, in showing the effects of the Chinese nationalization of the early forms from India.

In this period a notable change was brought into the Buddhist art; first by the Shingon, and then by the Tendai sect.

Both sects needed a large number of new iconographic representations of Buddhist deities.

The priest Kūkai, the founder of esoteric Buddhism in Japan, brought home a complete set of sutras containing symbolic codes, which gave directions on how to make Buddhist images and prescribed symbolic services. He also put them into practice and attracted the hearts of the faithful.

The arts of painting and sculpture were taken as a regular course in the study of Buddhism, priests learning them with other subjects. Special encouragement was given them in the Shingon monasteries. Kūkai, Saichō, and many other eminent priests brought Buddhist paintings and images and many precious things from China; at the same time, it was customary then to paint portraits of great priests whom they adored and to hang them on the walls. The prosperity of Buddhist painting in this period was at its height when the Emperor Seiwa, about the middle of the ninth century, encouraged it still further by dividing a large number of paintings representing Buddhist figures among the Ministers of the Imperial Court, and distributing them in all parts of the country. As the Buddhist pictures that were painted by priests enlightened the people, the higher classes, in like manner, began to paint pictures at all possible times, thus painting became a great fashion among the aristocracy. By and by, the people who appreciated the beauty of Chinese pictures became desirous of imitating them, and some who were good calligraphers spent their spare time, as did the priests, in painting trees, birds, animals, landscapes, and human figures, and then used them for ornament in temples and monasteries by mounting them on sliding screens or folding screens. This love of painting led to the birth of a new school of non-religious pictures under an entirely different class of painters.

In short, this period of one hundred years was an age of great effort. The leading aims were to utilize Chinese civilization for the advancement of our culture and to prepare our national

character for the future; and because of this spirit the fine arts in this period were full of life and began to show much originality.

2. PAINTING

Painting in the Heian Period made a new development and began to show great genius for assimilating the Chinese style. Eminent priests, such as Kūkai, Saichō, Chisen, Jitsuei, Enchin, and Kokū, were all noted masters of Buddhist figures. Beside them, there appeared two great lay masters, Kudara Kawanari and Kose Kanaoka. These two masters and their followers painted secular subjects.

Kudara Kawanari attended the court and it is said that he painted portraits and scenery very realistically. However, none of his works is extant.

Kose Kanaoka was a great genius in painting and drew many kinds of things very realistically. The horses and the images of scholars which he painted in the palace at the Imperial command were very famous. His name is pre-eminent in the history of Japanese painting, and although many a painting is attributed to him there now exists not a single picture which is admitted to be from his brush.

The best representative examples of paintings that remain from this period are the portraits of the seven Shingon Patriarchs in the Tō-ji monastery, the portrait of the priest Gonzō in the Fumon-in, the picture of the Red Fudō in the Myō-ō-in, and the Yellow Fudō of the Mii-dera.

The five portraits of seven patriarchs of the Shingon sect, owned by the Tō-ji monastery, were brought back from China in the time of Kōbō Daishi; and they are said to have been painted by the famous Chinese painter Ri Shin (Li Chên). They are unique examples which influenced the Japanese portrait painting of this period. The outlines of the figures are drawn with the lines called *tessen* which literally means "steel cord." The lines are drawn with even power so that there will appear no undula-

Fig. 49. Fukū (N.T.)
Kyoto Onshi Museum of Art

tion. Such was representative of the lines used in this period. The portraits are now preserved in the Kyoto Onshi Museum of Art and one of them is reproduced in Fig. 49.

In the Myō-ō-in chapel on Mount Kōya is the famous Red Fudō. (Fig. 50) This is a unique example of Buddhist painting by an eminent priest-painter. It is after the Chinese style but expresses the Japanese mind. This picture of Fudō is attributed to the priest Enchin (Chishō Daishi). It is painted in colors on silk and measures about five feet. The Fudō is represented as sitting on a rock enveloped in flames and holding a sword entwined by a dragon. On his left stand two attendants. The flames of Fudō symbolize the wisdom which burns off all dross and wickedness that hinder the progress of the spirit. The reddened body is delineated with strong black lines drawn boldly like a rude steel cord; the red robes are painted with large flower designs, while the drapery-folds are shaded with gold pigment. Such a work as this is really the spiritual creation of an artistic genius inspired by a burning faith.

3. SCULPTURE

The statues of the Heian Period are lofty, sublime, and spirited. This is due to the fact that the priests of this period thoroughly understood the meaning of symbolism, and used the chisel themselves or ordered designs made to spiritualize material objects. But these statues are technically inferior to the Tempyō sculpture.

As to the medium of the sculpture, wood was largely used. The clay and dry-lacquer, which were very popular with the Tempyō sculptors, declined and died out.

At the beginning of this period, as we have said already, a number of priests who went to China brought back many Buddhist statues which gave a new esoteric meaning to our Buddhist sculpture. Although most of them are lost now, there remain five wooden figures of Godai Kokuzō or five different manifestations of the Bodhisattva called Kokuzō (Sky-Womb) in the Kwanchi-in of Tō-ji monastery in Kyoto. This set of figures was

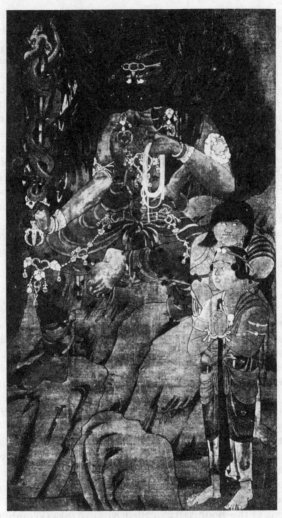

Fig. 50. Red Fudō (N.T.)
Myō-ō-in, Mt. Kōya

brought home from the Seiryō-ji monastery (Ch'ing-lung ssŭ) of China by the priest Ewun in the year 847. (Fig. 51) They are of Chinese workmanship, though quite Indian in spirit. The chiselling is comparatively primitive and is not so elegant as that in the stone carvings of the T'ang Dynasty now extant.

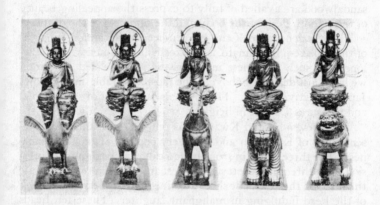

Fig. 51. Five Different Manifestations of Kokuzō Bodhisattva (N.T.)
Kwanchi-in, Kyoto

The wooden statues in the preceding periods were ornamented with colors over the whole surface. But in this period, for the first time, the sculptor began to use the natural color of wood to obtain a beautiful effect in the finish.

Such works developed in the later T'ang Dynasty and were introduced to Japan during the period of the later eighth and early ninth centuries, and had a new influence on the development of wooden sculpture. We may see a unique example of such works in the Nine-headed Kwannon (Fig. 52) preserved in the Kōfūzō of the Hōryū-ji monastery. It is only a little over one foot in height, but it is carved in sandalwood, the most precious material for sculpture. Although small, the statue has its own character-

istics, and will awaken our deep interest. The small heads of Buddhas shown at the side of the crown, and the decorations worked exquisitely around the figure, are all evidently according to the T'ang tradition. The statue well combines the charm of delicate craftsmanship with the deep spiritual power of Kwannon; special attention is invited to the way in which the niceties of sandalwood are availed of fully to express the appealing beauty of the smooth flesh of the body and the filminess of the drapery.

The wooden statue of the Eleven-headed Kwannon (Fig. 53) of the Hokke-ji in Yamato, is an excellent specimen which developed on such a Chinese model as the Nine-headed Kwannon we have just described above. The most admirable finish shows Japanese native genius. The image is carved out of sandalwood and measures 3.2 feet in height.

The Eleven-headed Kwannon is one of the manifold representations of Kwannon and was very popular among the Japanese. The three heads in front have a calm and benignant expression. The three on the left side suggest an angry expression, while the three on the right side show a canine tooth, the one at the back of the head indulging in malignant laughter. These ten heads are arranged about the central and larger head; and finally there is one on the top with the face of Buddha. The different expressions of the minor faces are intended to symbolize all the different human minds, good and bad, which this Kwannon vows to deliver. Now, in this example of Kwannon, such minor faces are arranged most cleverly as parts of his crown, and no discord will be noticed with the magnificent and dignified expression of the main face, which sums up all the different expressions manifested on the minor faces, for the deliverance of humanity. The form of the body is also excellent and is most harmonious with the noble beauty of the main face. It is slightly inclined and rests on the left leg; the free right arm, which is exceptionally long at the right side, gives a beautiful effect to the pose of the body. The folds of drapery are carved rather sharply and deeply, very unlike those graceful curves of the Tempyō sculpture. Such was, however, the characteristic technique of drapery-folds in the Heian Period.

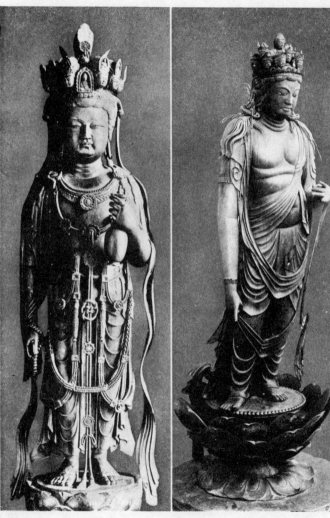

Fig. 52. Nine-headed Kwannon
(N.T.) *Hōryū-ji, Yamato*

Fig. 53. Eleven-headed Kwannon
(N.T.) *Hokke-ji, Yamato*

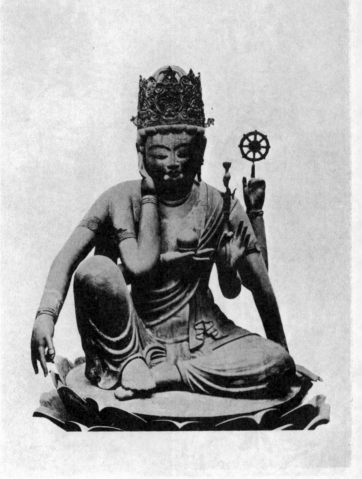

Fig. 54. Nyoirin Kwannon (N.T.)
Kwanshin-ji, Kawachi

Slight coloring is given only to the hair, eye-lids, and lips, and the rest is left uncolored to show the beautiful finish of plain wood. This statue of the Eleven-headed Kwannon is surely one of the most excellent works produced at the height of this period.

An example of a masterpiece statue in wood, representing Nyoirin-kwannon (Fig. 54), is preserved in the Kwanshin-ji monastery in Kawachi, Settsu province. It measures 3.5 feet in height, and is colored. He is sitting with the right knee uppermost and has six arms. The first right hand supports the cheek, the posture signifying meditation on the deliverance of humanity. The second hand holds the jewel which grants every wish. The third right hand holds a rosary, which is the emblem of power to deliver. The first left hand rests on a symbolic representation of a mountain, implying the salvation of ferocious spirits by the virtue of firmness. The second left hand has a lotus which purifies mankind of depravity. The third hand has a wheel which stands for the law of Buddha that governs the cosmos and enlightens all beings. The work is marvellously successful in rendering the mystic power of the Bodhisattva. It has gracefulness of form and expression, and in spite of the six arms does not give any feeling of grotesqueness. Such an effect can be attained only by a master hand.

Having seen enough of the excellent examples of the lovely and benignant figures of Kwannon, let us now turn our minds to examining some Buddhist figures which are more formidable in aspect. They were likewise intended to deliver humanity from its sin and wickedness. Among them Fudō or Achala was most popular.

One of the masterpieces, perhaps the best of all statues of Fudō which were produced in this period, is that of the Shōchi-in temple, now placed on view in the Reihō-kwan Museum on Mount Kōya. (Fig. 55) He is shown in a sitting posture, made of wood, and colored red which is now much effaced. This statue measures about 3 feet in height and has a formidable and somewhat ugly appearance. He holds a sword in his right hand and a rope in his left. He is regarded as a partial incarnation of the Dainichi Bud-

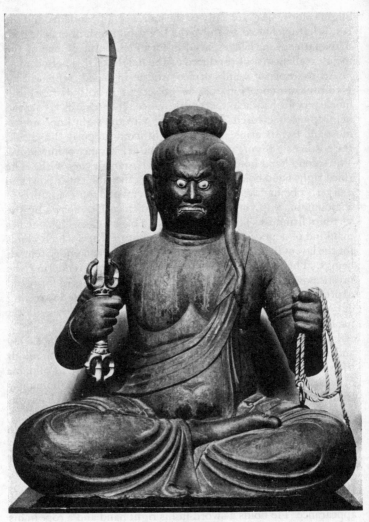

Fig. 55. Fudō (N.T.)
Reihō-kwan Museum, Mt. Kōya

dha or the Great Illuminator. According to the sutra, Fudō should be a fat person, and rather ugly and repelling in appearance, modelled after the youthful slaves of India. The reason why Fudō was obliged to assume so low a form of humanity is that he had taken his oath to deliver people as their servant. The sword in the right hand signifies that he has power to cut off the three most wicked passions of man, as well as to despatch all man's spiritual enemies. The rope indicates that he will bind and bring to the place of enlightenment all who are too prejudiced to hear the teaching of Buddha. In our figure of Fudō all such traditions are carved excellently. In most cases he is represented as sitting or standing on a rock among flames but here the flames seem to have been lost.

Before this period, stone was rarely used in making statues and almost no specimen exists today. But for the first time in this period rock-cut images developed, of which some important ex-amples still remain. In the Six Dynasties of China, there were cave temples. They were mostly grottos, each with a narrow entrance passage, signifying the direct influence of Indian cave temples like Ajanta. This custom, however, did not reach Japan because Japan had no rocky mount suitable for such a purpose. But in the T'ang Dynasty a new style came into fashion, in which Buddhist images were carved out on the open cliffs of living rock and sheltered by a wooden

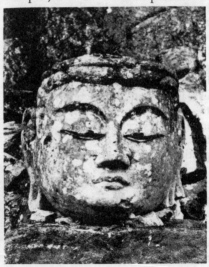

Fig. 56. Rock-cut Buddhist Image
Usuki, Bungo

construction. It was introduced into Japan and practised here and there in local districts where it was possible to do it. Examples of such rock-cut images are most numerous in the province of Bungo in Kyushu Island.

In Fig. 56 we have reproduced the head of a colossal figure of Buddha, which is one of many fine examples remaining still at Fukada, near the Usuki station of the same province. The workmanship is excellent and its countenance is gracious.

4. INDUSTRIAL ARTS

Very faw objects illustrative of the industrial arts of this period remain, and they are too insufficient to give a conprehensive idea of the general condition of the lesser arts produced in the age. These few examples are all Buddhist things.

Just as Buddhist temples have their own symbolism through which to explain their character to people, so Buddhist monks carry certain symbols, wear their own particular costumes, and officiate at services in order to impress the people with their existence and power. In the esoteric Buddhism of the Heian Period such symbols and behavior of priests were mystic and had deep meaning to the faithful.

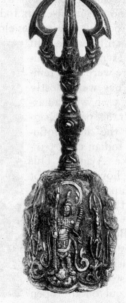

Fig. 57. Bell with Five Pointed Vajra (N.T.)
Iyadani-ji, Sanuki

In the Iyadani-ji temple of Kagawa prefecture is a unique example of a bell with a handle (Fig. 57) which is traditionally believed to have been brought back by the priest Kōbō Daishi (Kūkai) from China during the last days of the T'ang Dynasty. It is made of gilt-bronze; around its body are cast Deva Kings in relief and the handle is in the shape of a five pointed *vajra*. In officiating at a service, a high priest tinkled the bell with his hand to remind the people of his existence and to concentrate their minds on Buddha.

In the Tōdai-ji monastery of Nara is preserved a Buddhist wand called *nyo-i*. (Fig. 58) This is a rare example of minor art, produced in this period. It is supposed to have been used by the priest Shōbō when he was expounding Buddhist sutras towards the end of the ninth century. It is made of semi-translucent tortoise sehll, smoothly polished. It has silver appliqué of five lions on the head and a *vajra* on the handle. The wand is highly prized, not only for its tradition but also for its excellent workmanship. Also in the Daigo-ji, Kyoto, is preserved another specimen of Buddhist wand from the same age, which is made of gilt-bronze.

Fig. 58. Nyo-i (N.T.)
Tōdai-ji, Nara

The famous sutra-case (Fig. 59) of the Ninna-ji in Kyoto is a rare specimen that shows the excellent lacquer work of this period. This was originally made to keep thirty volumes of sutras of the Shingon sect brought from China by the priest Kūkai. The sutra-case is lacquered black and decorated with a gold and silver design. The design represents sacred flowers and birds in the *togidashi* gold lacquer. It consists of designs having gold and silver dust on the surface that has first been prepared with lacquer, then covered again with lacquer, and then finally polished. The technical dexterity reaches here a very high standard of elegance. While still retaining the force of the Nara style,

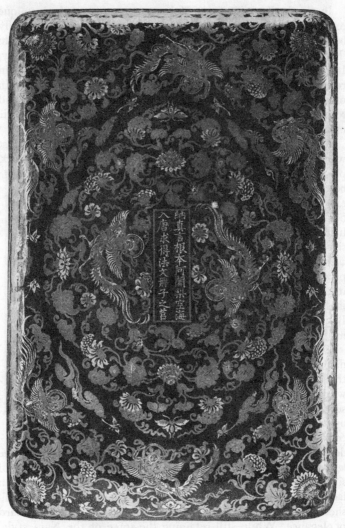

納真言根本阿闍梨空海
入唐求得法文冊子之筥

Fig. 59. Gold Lacquer Sutra-case (N.T.)
Ninna-ji, Kyoto

it already brings in a new style to be developed later in the Fuji-
wara Period.

5. ARCHITECTURE

The important and epoch-making events in the architectural
development of this period were the erection of a new court at
Kyoto on a gigantic scale and the remarkable changes in the styles
of Buddhist temples and Shinto shrines.

The new palace buildings in Kyoto were almost completed
in 805. Within the twelve gateways there were the Imperial
residence, the ceremonial hall, the banqueting hall, drill hall, and
the hall for the transaction of state affairs.

Of these buildings, the ceremonial hall had the most magnifi-
cent architecture. It consisted of the main building, called Dai-
goku-den, two pavilions called the Seiryū and the Byakko, the
terrace called Ryūbidan, twelve subordinate buildings, a gate, and
open corridors. They were uniformly painted red, roofed with
blue tiles, and paved. Most of them were surmounted with hipped
roofs and all the ridges were decorated with fish-shaped finials.
All the state ceremonies of greatest importance were held in this
hall. In short, all the court buildings were modelled on the T'ang
system, modified to satisfy the Japanese taste. The Imperial res-
idence consisted of seventeen buildings, including the Shishin-
den (ceremonial hall) and seven other minor buildings, enclosed
by a wall with twelve gateways. The buildings stood apart and
were connected with one another by open corridors. Such an
arrangement of buildings is a purely Chinese fashion; from it, the
type called *shinden-zukuri* seems to have taken its rise.

The original palace buildings are lost now, but the buildings
reproduced according to their ancient style have stood on the
same site from 1856. They are very fascinating for their noble
simplicity.

The Buddhist architecture, as we have said already, made a
great change in this period. The change was brought in by the
new sects, Tendai and Shingon. The esoteric minds of both sects

loved to come more closely into touch with nature and they preferred to build their monasteries on mountains rather than on level ground. The Tendai sect had its main monastery erected on the summit of Mount Hiei, while the Shingon sect erected its head monastery in the virgin forest of Mount Kōya. Thus, as the monasteries of the Tendai and Shingon sects were built on the summits of thickly wooded mountains, space did not allow of maintaining the rigid symmetry that had been a characteristic feature of the temples in the Nara Period. Therefore the marked difference from the former period consisted mostly in the arrangement of the buildings and in the interior decoration.

However, these original monastery buildings that once crowned the virgin soil of Mount Hiei and Mount Kōya have disappeared many years ago, and the present buildings were erected in a much later age. But we may still see there the lofty and noble nature which once enveloped the original monasteries.

The only two buildings remaining from the Heian Period are to be seen in the Muro-o-ji monastery in Yamato. They are the stupa and the Kondō, or Golden Hall.

The stupa is five-storied and rather small, measuring 2.4 metres square and 16 metres in height. (Fig. 60) Each side of the square is made up of three spans, and the pillars have entasis. The slight slope of each roof and the horizontal members of the balustrade at each story redeem the height and give a restful feeling. The spire capping the tower has a jar and canopy in place of the *suien* finial. Altogether, the proportions have an effect of lightness, unlike the strong and massive stupas of the Nara Period.

In esoteric Buddhism the stupa has an especially important meaning. It signifies all the laws of the universe. Its paramount importance is that in its external aspect it soars to heaven high above other buildings and gives to the beholder a feeling of uplift.

In Shinto architecture, for the first time in this period, there was a great change and a considerable Buddhist element was introduced into its construction.

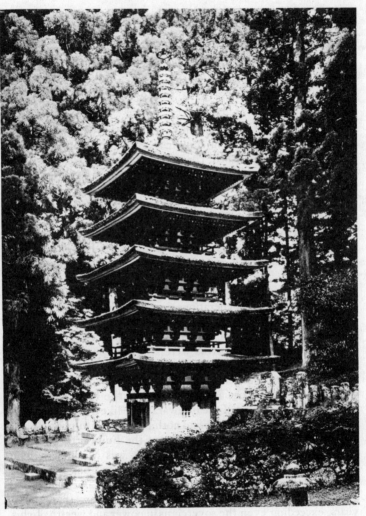

Fig. 60. Five-storied Stupa (N.T.)
Muro-o-ji, Yamato

CHAPTER VI

THE ART OF THE COURT LIFE

(The Fujiwara Period 894–1185)

1. GENERAL SURVEY

The Fujiwara Period, opening with the year 894 when intercourse with China was interrupted, and closing in 1185 when the Taira family perished, covers two hundred and ninety-two years. During this period the nationalizing spirit developed, and the continental culture imported in the former three centuries was for the first time fully assimilated to express the tastes and ideas of the Japanese.

In Kyoto the centralized government and aristocratic oligarchy became firmly established; and the head of the Fujiwara family came to play the most important rôle in the court and government.

Many Empresses and Princesses had come from the Fujiwara family through many generations since the time of their ancestor Kamatari, and some Emperors were dethroned in order to make way for the young sons of Imperial ladies. The Fujiwara were the regents while these Emperors were still too young to rule, and even when the Emperors reached manhood they still occupied the highest position in the court. Moreover, as most of the Emperors of this period were born and brought up in the Fujiwara family, some of the residences of the Fujiwara were like detached palaces of Emperors. The Emperors had nothing to do with politics, and were looked upon only as puppets of the Fujiwara. The most powerful member of the Fujiwara family was Michinaga, who had four of his daughters made Empresses, and one a princess; and, as his three grandsons by those daughters became Emperors, he held the political control in his hands for more than thirty years, exceeding even the sovereigns in power and wealth. In his later days he built a Buddhist temple called Hōjō-ji, which showed

his wealth and extravagance most clearly, and which brought about improvement in the artistic and industrial world.

The members of the Fujiwara family monopolized not only the highest positions but also the richest lands in all the country. They poured out their money unstintedly for architecture, and for landscape gardening; for feasts and festivals, luxurious dresses, dances and music, and such entertainments as poetical contests, concerts, games of football, and checkers.

In literature, there were produced many kinds of prose writings, such as stories, diaries, historical narratives, accounts of travel, and other miscellaneous works, together with poems. Many men and women displayed freely their genius and talent. Among the female writers, Murasaki Shikibu and Seishō Nagon were most famous, and their works have enjoyed the admiration of all ages. As these writers and poets were all people of high rank, their literary works were characterized by polished and fluent wording and refined and delicate thought. From them one can judge the inclination of contemporary arts and industries.

Environed by such circumstances, people of rank generally lacked spirit, and were mindful of etiquette and ceremonies; they all abhorred illness, misfortune, or death, and clung desperately to life and comfort. So, in religious feeling, the more mystical and philosophical doctrine of the Tendai and Shingon sects was overlooked, and superficial teachings and showy ceremonies swayed the minds of the people.

In such an atmosphere the faith in Amida took hold of those who were pious. The doctrine of Amida was expounded most forcibly by the priest, Genshin, 942–1017, better known by the name of Eshin Sōzu, who witnessed the heyday of the Fujiwara Period and felt strongly the people's need of deep religious inspiration.

It is said also that he inaugurated a ritual procession of priests through the valley of Mount Hiei. They were gorgeously attired, as if forming a pageant.

Mount Hiei stands between Kyoto and Lake Biwa. In the morning the boundless light of the sun comes to the city of Kyoto

from Mount Hiei; while on the other side of Hiei, Lake Biwa shows its extensive mirror framed all around by beautifully undulating ranges of misty hills and mountains. In the morning the light comes from the east over those ranges of hills, sending golden streams on the living waters of the lake. When the evening comes after the day's work is over, the sun sheds its magnificent light on the sacred summit of Hiei. In the time of our priest Eshin in the tenth century, it was just the same as it is now. He associated his doctrine of Amida with this exceptional landscape beauty and taught men to see and hear what Amida was saying to them through that wonderful beauty of landscape.

This same priest Eshin, a pious philosopher, not only taught men with words and pageant-like manifestations, but also depicted the glories of Amida in association with the landscape of Hiei and Lake Biwa, and represented him coming over the green hills to welcome the souls of the faithful. In this respect he made a new departure in Buddhist painting, liberating it from the rigid conventions of Shingon iconography and inspiring it with fresh vitality emanating from his own piety.

Priests were treated with the utmost care and respect, because they were considered to be the only persons that could keep off all evils. For this reason, many Buddhist temples and stupas were built, and Buddhist images and pictures were made in abundance by the Fujiwara family and the Imperial court. Thus Buddhism controlled the minds of Court nobles, and naturally one can easily see its influence on painting, architecture, sculpture, and all other arts.

Although the social life in Kyoto was splendid and flowery, the country could not go on in harmony without careful direction. Worse than this, disturbances broke out everywhere. But the Fujiwara, themselves despising all military arts, laid the task of quieting these uprisings on the shoulders of the military families, and left the incantations for warding off evils to be performed by the priests.

Such serious neglect on the part of the Fujiwara family began to cause its decline in the second half of the eleventh

century. Therefore, local barons and the provincial governors, being able to make their positions and holdings hereditary, came to be the new centres of power in various provinces.

When finally the test of arms came, it was found that the leaders of the military class were masters of the situation, the peace being kept only by the services of the two eminent families of Genji and Heike. While these two families were gradually rising in power, strife between them for supremacy became unavoidable, and after a long conflict, the Heike gained supremacy. When the Heike took the controlling power from the hands of the Fujiwara, they wanted to follow all the ways of life established by the Fujiwara and tried to imitate the rather heavy beauty of their arts; but notwithstanding this, one can discern some freshness in all the designs of this period. In paintings and decoration and other works representing the manners and customs of the people of the time, there was much more of interest and dramatic quality.

But the Heike had not the gift for ruling, and before long were displaced by the Genji who consolidated the feudal elements and created a Shogunate at Kamakura which gives its name to the succeeding period.

2. PAINTING

Painting was never before so prosperous as it became in this period. A remarkable new development was made in Buddhist painting under the influence of the Pure Land Doctrine propagated by the Priest Eshin Sōzu. He was one of the greatest of priest-painters; and a great number of paintings that represent the Buddha Amida and his Bodhisattvas coming down from heaven to welcome the faithful when they die are usually attributed to him, even those which were surely painted much later than his time.

The earliest example of the welcoming Amida, illustrative of the Pure Land Doctrine, is to be seen in a triptych, depicting Amida triad with an attendant, owned by the Hokke-ji. The painting is preserved in the Nara Imperial Household Museum.

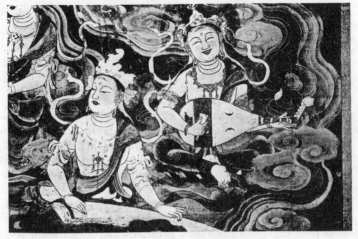

Fig. 61. Detail of Amida and Twenty-five Bodhisattvas
Reihō-kwan museum, Mt. Kōya

But a more complete expression of the same doctrine is visualized
by the painting representing Amida and Twenty-five Bodhisat-
tvas, which is preserved in the Reihō-kwan Museum on Mount
Kōya and is also attributed to the priest Eshin. The outlines of
all the sacred figures are built up entirely with fine delicate lines
drawn with wonderfully even power and colored red. The main
figure is gorgeously decorated with designs in fine cut gold work.
But in all the figures of Bodhisattvas we find much human ex-
pression in the faces and bodies, as well as in the designs and colors
of the costumes, which were influenced by the court life of the
day. The variety of colors and graceful forms of the sacred figures
mark the full glory of the feminine beauty characteristic of the
Fujiwara Period; and symbolizes the happiness, the spiritualized
joy, and the florescence of feminine "libido," all consecrated by
the absolute mercy of Amida. (Fig. 61) Such was the expected
vision of the next world which appealed to the hearts of the court
nobles of the day; and such Buddhist painting represents the at-
titude of the people towards a future life. (Color plt. 1)

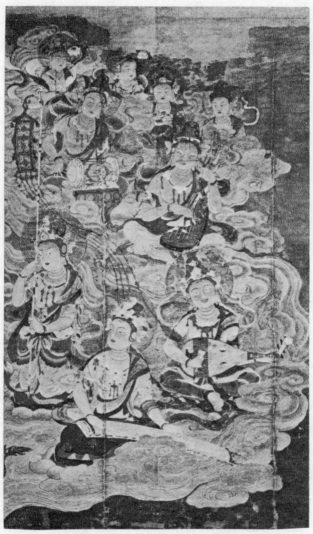

Color plt. 1. Detail of Amida and Twenty-five Bodhisattvas (N.T.)
Reihōkwan Museum, Mt. Kōya

In Fig. 62 we have reproduced the image of Kwannon painted on the wall of the Phoenix Hall of Kyoto. He is coming down, riding on the clouds, in front of Amida. His pose and expression are purely feminine. More than this, he is modelled after the ideal beauty of the age, and looks more humanistic than the angel in the Annunciation painted in the High Renaissance period of Europe.

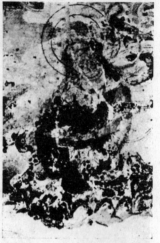

A similar type of painting was generally found in other Buddhist figures. The resurrection scene of Shaka-muni Buddha from a gold coffin owned by the Chōhō-ji monastery, now on view in the Kyoto Onshi Museum of Art (Frontispiece); the figure of Fugen of the Tokyo Imperial Household Museum; and the picture representing Nirvana in the Reihō-kwan Museum on Mount Kōya, are all representative examples of the Buddhist painting produced in the Fujiwara Period.

In the painting of purely lay-subjects, there also was a remarkable development. It was for the first time in this period that ro-

Fig. 62. Kwannon, a Detail of the Wall Painting of Phoenix Hall. *Kyoto*

mantic stories were beautifully illustrated with pictures representing some important scenes of the stories. But there are hardly any examples extant.

The picture scroll illustrating a famous novel called Genji Monogatari written by Murasaki Shikibu, the celebrated lady writer of the age, is a unique example of the kind. We do not know how many scrolls were originally painted to make a complete set of illustrations for the novel, but now only four scrolls remain, three of which are owned by Marquis Tokugawa in Owari, and one by Baron Masuda in Tokyo. The pictures are attributed to Fujiwara

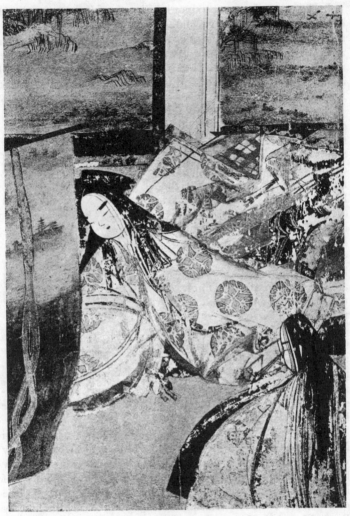

Fig. 63. Part of the Genji Monogatari Picture Scroll
Marquis Tokugawa's Collection, Nagoya

Takayoshi, but the authenticity of this claim has not been established. Anyhow the work is evidently by a master hand of the Kasuga School in the age. They are important pictures depicting the life of the nobility circle of the Fujiwara Period, and are representative of pictures developed entirely after the taste of Japanese nobles. Their significant characteristic is the beautiful contrast of rather heavy and gay coloring with the fine delicate lines of the human figures; the general effect is quiet and full of refined feminine beauty. The peculiar style of the court painters of this period may be studied in the delineation of faces of the Fujiwara nobility. An example is shown in Fig. 63. The eyes are drawn with two lines, and the nose with two broken lines. This peculiarity of style is called "*hikime-kagihana*", or drawn eyes and keynose. This mode of delineation induces a feeling of quietness and unaffected elegance; and, not only in the faces, but in the posture and in the natural background, there is something concordant with this feeling, which spreads itself all over the canvas. It is no other than the general emotional atmosphere of the late Fujiwara Period, and as these pictures depicted the life as it was actually lived, the feeling was thus reflected in them.

Other important examples, in which a similar style of painting can be seen, are found in illuminated manuscript copies of Buddhist scriptures dedicated to the Itsukushima Shrine by Tairano Kiyomori, which are preserved in the Kyoto Onshi Museum of Art, and also in the sutras written on fan-shaped paper, owned by the Shitennō-ji monastery of Osaka, and the similar sutras owned by the Tokyo Imperial Household Museum. (Fig. 64)

In this period there appeared some artists who made painting their specialty. Among them, Kose Hirotaka and Takuma Tamenari were most eminent.

Kose Hirotaka was the most prominent painter of the Kose School which sprang up in the previous period. He was so deeply interested in Buddhism that he became a priest, but regretting that such genius should be lost in retirement, the Emperor called him back and appointed him the chief painter to the court.

Takuma Tamenari is said to have founded the Takuma School,

Fig. 64. Sutra Written on Fan-shaped Paper with Painting
Tokyo Imperial Household Museum

and was appointed to the presidency of the Art Department in the Court. The Takuma School was noted for religious painting and to its founder is attributed the wall painting of Hō-ō-dō at Uji.

In the later years of the Fujiwara Period, there appeared other schools, Kasuga and Tosa—both native styles.

The Kasuga School was famous for its beauty of coloring and grace in the use of brush. This school saw its glory in the next period, but most of the names of the painters are unknown.

The Tosa School was founded by Fujiwara Motomitsu. Its masters showed the native style very gloriously, with a light and free movement of the brush and clever placing of color, quite different from the style of Chinese schools. This school drew most of its subjects from the lives of people and animals. Fujiwara Mitsunaga, the great painter of this period, belonged also to the Tosa School, but his life is little known.

3. SCULPTURE

The development of sculpture was not so prosperous as that of painting, but, as in other arts of the age, the Jōdo ideal had taken a fast hold of sculpture and the new spirit was expressed eminently in the statues of Amida and of his Bodhisattvas and angels.

The statues produced in the high time of the Fujiwara Period had stout bodies, round faces, narrow and long eyes and eyebrows, and dresses lying in smooth folds; and they showed delicacy and elegant taste in every way.

The medium of sculpture in this period was of wood only, and metals were used mostly for decorative art.

Until this period, wooden statues were usually carved out of one block of wood, but in this period the method of joinery structure was established. The head was modelled separately and inserted in part of the neck; the body was composed of three parts, the hands and arms also were carved separately and then fastened to the body.

In the ornamentation of figures, gold and various other colors were used profusely as in painting. But only the figure of Amida was lavished with gold on the face and body, and the most elaborate variety of colors was applied to the figures attending him. Gold was generally applied to the lacquered foundation while other colors were usually put on a gesso ground that had been applied to the plain surface of wood.

It is noticeable that professional sculptors for the first time appeared in this period, because the demand for Buddhist statues increased and priest-sculptors had almost disappeared.

Among professional sculptors, the foremost was Jōchō. When Fujiwara Michinaga built the Hōjō-ji temple, Jōchō set about the work with many of his assistants. He carved the main Buddhist figure, which was about thirty-two feet high, and a hundred other Buddhist images. For this merit he was conferred with the honorable title Hokkyō. This was the first case in which the title was given to a professional artist. Then he established a carving studio in Kyoto and taught his pupils. His son Kakujō

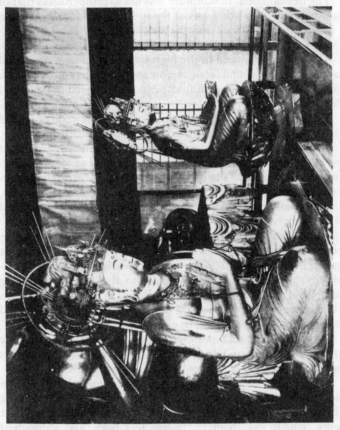

Fig. 65. Amida Triad
Sanzen-in, Kyoto

figure, which was about thirty-two feet high, and a hundred other Buddhist images. For this merit he was comforted with the honorable title Hokkyo. This was the first case in which the title was given to a professional artist. Then he established a carving studio in Kyoto and taught his pupils. His son Kakuryo

opened his carving studio at Shichijō and his pupil Chōsei at Sanjō, both in Kyoto, and continued the traditions of the school founded by Jōchō.

The large image of Amida enshrined at the Hō-ō-dō or Phoenix Hall of the Byōdō-in at Uji, near Kyoto, is said to be a representative work carved by Jōchō.

In the Sanzen-in temple in the northern suburb of Kyoto is a unique example of the Amida triad (Fig. 65) which developed in the later years of the Fujiwara Period. In this triad,

Fig. 66. Statue of Prince Shōtoku (N.T.)
Hōryū-ji, Yamato

attention is specially invited to the postures of the two attendant Bodhisattvas, Kwannon and Seishi. Their kneeling postures are entirely in Japanese style and express a very soft feeling.

In the Jōruri-ji temple between Kyoto and Nara is the most picturesque statue of Kichijō-ten, a deity of fortune represented as an incarnation of beauty. (Color plt. 2) She has a gem on the palm of her hand, which gives fortune to her adorants as she wishes to give. The chiselling is very fine and the costume is beautifully decorated in colors with typical designs of the Fujiwara Period. In its gay decorativeness are preserved the traditions of the Nara art as will be proved by comparing it with the painted figure of the same goddess (Fig. 28) in the Yakushi-ji. The fact makes it seem probable that the work was influenced by Nara sculpture of the eighth century. An excellent example of portrait sculp-

ture in the Fnjiwara Period will be found in the image repre-
senting the prince Shōtoku Taishi expounding the sutras with
marvellous wisdom at the age of seven, which is owned by the
Hōryū-ji monastery. (Fig. 66) He sits and holds a Chinese fan in
the left hand. His hair is dressed in the manner of the children
of the Fujiwara Period. The figure is full of life and dignity.
According to the inscription written on the interior of the statue,
it was carved by Enkwai in the fifth year of Chiryaku (1069)
and ornamented in colors by a painter called Hatano Chishin.

4. INDUSTRIAL ARTS

In this Period the Chinese ideas were finally assimilated; the
mind attained independence; and industrial arts made remarkable
progress, reaching the high watermark of originality and perfec-
tion in purely native designs, with an unprecedented flawlessness
in artistic taste. Yet it must not be overlooked that it was the
fruit of the preceding centuries of imitation. This can be clearly
proved when we compare what was created in the Fujiwara
Period with what was
borrowed from abroad in
the period preceding it.

Among other arts,
metal, lacquer, and inlaid
work made remarkable
progress. The progress
of metal work can be seen
in bronze mirrors and
metal fittings applied
to boxes and to archi-
tecture; the progress of
lacquer work may be ex-
amined in various u-
tensils and in the deco-
ration of architecture;

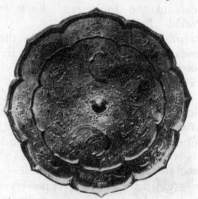

Fig. 67. Bronze Mirror (N.T.)
Kongōshō-ji, Ise

and examples of inlaid work can be seen in various lacquered

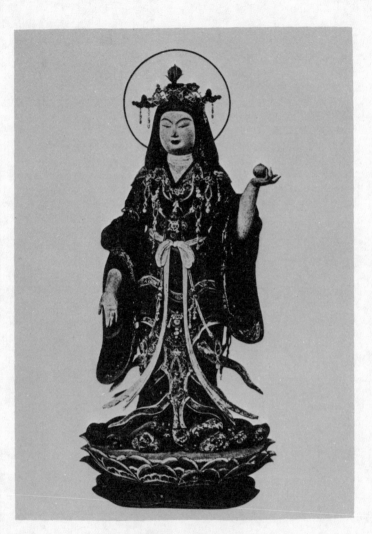

Color plt. 2. Kichijō-ten (N.T.)
Tokyo Imperial Household Museum

boxes and in the lacquered wood of architecture, as in the interior decoration of Hō-ō-dō at Uji and of the Konjiki-dō of Chūson-ji, which are described elsewhere.

Most of the bronze mirrors of this period were discovered in the scripture mounds built in the Fujiwara Period. When we compare them with Han and T'ang mirrors we find that they are much smaller and very handy. The designs on their backs are usually composed of birds and butterflies associated with grass and flowers. Although they are much simpler than those of the T'ang mirrors, they show that artistic spirit and native ability had reached a very high degree, as will be seen in our illustration in Fig. 67. Many examples of bronze mirrors of this period are collected in the Tokyo Imperial Household Museum. (See pp. 314—316)

Lacquer work in the Fujiwara Period was applied most widely to various articles that were used by the nobility. For example, tables, trays, toilet-boxes, clothes-horses, mirror-stands, mirror-boxes, ink-stone boxes and other kinds of utensils were beautifully decorated with designs made of gold lacquer, mother-of-pearl, or gilt-metals, on lacquered ground of plain black speckled with gold dust (*chiri-ji*) or entire gold lacquer ground (*ikake-ji*). The Karabitsu, or a kind of chest, of the Kongōbu-ji monastery is an excellent specimen of the gold lacquer work

Fig. 68 Karabitsu (N.T.)
Reihō-kwan Museum, Mt. Kōya

in the Fujiwara Period. The chest is placed on view in the

Reihō-kwan Museum at Mount Kōya. The design is composed of sweet flags and birds. The birds and the flowers are inlaid with mother-of-pearl, the white lustre of which beautifully harmonizes with the gold and black lacquer, showing a picturesque color scheme. The inside case is decorated with fine metal openwork and mother-of-pearl inlay on a lacquered ground. (Fig. 68)

5. ARCHITECTURE

The creative genius of Japanese architects, for the first time in this period, was expressed fully in the buildings of monasteries and residences of the nobility.

The most magnificent examples of monastery architecture of the Fujiwara Period, were the Hōjō-ji, founded by Fujiwara Michinaga in the first quarter of the eleventh century, and the Hosshō-ji, founded by the Emperor Shirakawa in 1071. Both, however, were lost not many years after their completion.

Although not so great as these two lost pieces of architecture there still remain some important buildings from which we can form our ideas about the Fujiwara architecture. The exterior of Fujiwara architecture is elegant but quite simple and plain, being at most covered with red lead paint, while the interior is lavished with delicate decorations.

In the sanctuary of a temple we generally find an altar surrounded by railings which are beautifully inlaid with mother-of-pearl. On this altar, under a canopy, stand Buddhist images which are richly decorated. Sometimes, the altar is inlaid with mother-of-pearl. The sanctuary has a coffered ceiling, while the aisle has a decorated open-timbered roof. The rafters and ribs are ornamented with floral designs of *hōsōge* flowers, and the interspaces of the rafters and ribs are decorated similarly. The wainscoting has upon it paintings or mural pictures. The columns mostly bear Buddhist images and arabesques, and the *nageshi* (horizontal boards over the lintels), *nuki* (horizontal braces of the pillars) and compound brackets are also beautifully painted.

Of the architecture remaining from this period the Hō-ō-dō,

or the Phoenix Hall, is most important and representative. Its history, construction, decoration, and garden all inform us of the ideal beauty of Fujiwara architecture in a tangible way. (See pp. 406—411)

The following Buddhist buildings are also important examples of Fujiwara architecture still remaining: The five-storied stupa of the Daigo-ji monastery near Kyoto; the main temple of the Hōkai-ji monastery, near Kyoto; the main temple of the San-zen-in monastery, near Kyoto; the main temple and the three-storied stupa of Jōruri-ji monastery, Kyoto prefecture; the main temple of the Fuki-ji monastery, Ōita prefecture; and the Konji-ki-dō of the Chūson-ji monastery at Chūson-ji, Iwate prefecture.

CHAPTER VII

REALISTIC ART UNDER NEW RELIGIOUS INSPIRATION

(*The Kamakura Period 1186–1333*)

1. GENERAL SURVEY

The last flickering glory of the Fujiwara civilization, which was upheld by the Taira family for some twenty years, was brought to an end by the crushing defeat it sustained in the battle of Dan-no-ura with the rival clan of Genji. Yoritomo, the chieftain of the Genji, inaugurated the Shogunate at Kamakura at the close of the twelfth century and a new era of feudal government was for the first time ushered in, to be followed by radical changes in manners and customs.

The new culture at Kamakura was full of martial spirit, quite different from the effeminate delicacy of the Fujiwara in the preceding period.

Naturally the art of the Kamakura Period assumed a very different aspect and national consciousness was expressed in it. However greatly Kyoto differed from Kamakura, it still retained something of its former splendor in art and literature.

Thus, in the Kamakura Period there were two cultural centres, one in Kamakura where everything was new and full of life, and the other in Kyoto where people were clinging to the old. This contrast of opposite ideas lasted through the whole course of the Kamakura Period and was mirrored in the art until the succeeding Muromachi Period when, in the fourteenth century, the Ashikaga Shogun established his government in Kyoto and the two currents were united.

There were three noticeable aspects in the Kamakura Period. One was the intercourse with the Sung Dynasty of China; the second, the introduction of Zen Buddhism and the newly formed

Buddhist sects, Shinshū, and Nichiren, and Jishū; and the third, the influence of the martial spirit and new religious ideas upon art.

The communication with the Chinese Sung Dynasty became active, especially after Taira-no Kiyomori opened the port of Hyōgo to foreign intercourse. Its effect was twofold, material and spiritual; that is, trade and an exchange of visits between priests of the two countries. Each served as a means of introducing Chinese art, which was at that time marked with elaborate splendor and delicate execution and greatly struck the fancy of the Japanese.

In religion, Zen, a new form of Buddhism, was introduced by Dōgen and Eisai. It gained ground slowly at first against the power of the established sects, the Tendai and Shingon, which held their traditional sway over the court at Kyoto. Consonant, however, with the growing individualism of the new age, the Zen sect was welcomed at Kamakura. Tokiyori and Tokimu-ne, both famous dictators of the Hōjō family, believed firmly in the Zen faith, and all the military aristocracy followed them. So it became an important social force.

From this time on, under the influence of Zen idealism, a new style of art, quite different from the older Buddhist arts, developed, and that influence was most conspicuous in the later Kamakura and Muromachi periods which followed.

On the other hand, within the country, religious reformers appeared and founded new sects against the old Buddhism to arouse national ideas and consciousness.

The most outstanding figures among the reformers were Hō-nen, Shinran, and Nichiren.

Hōnen, 1133–1212, democratized the Amida Buddhism and founded the Jōdo-shū, or Pure Land sect. Shinran, 1173–1263, who was the disciple of Hōnen, established the Jōdo-shin-shu sect and made Buddhism most popular. Nichiren, 1222–1282, a militant propagandist of prophetic ardor, founded the Hokke Buddhism, and likewise greatly democratized the Buddhist deliverance.

Throughout the new Buddhist teachings in the Kamakura

Period, the strong personalities and careers of these founders were a very important force in the religious movements of the time. Moreover, this force was an important feature of the Kamakura Period that naturally expressed itself as shown in Buddhist architecture, sculpture, and painting.

2. PAINTING

Naturally, the new spirit of the Kamakura Period expressed itself in paintings as well as in other branches of art. There were various styles, old and new; but each of them had new life.

The paintings of this period were mostly Buddhistic as in former periods, and those relating to the "Jōdo-kyō" or Pure Land doctrine, were most popular. The painters of such pictures generally followed the styles of the preceding age.

From the middle of the thirteenth century, the influence of the Sung and Yüan dynasties of China began to be felt remarkably. and was especially accelerated by the prosperity of the Zen sect. Such subjects as "Rakan" and the ten kings of Hell, were copied after Sung and Yüan prototypes.

But in these Buddhist paintings nothing peculiar to this period was produced except that they were concordant with the new spirit of the time.

The most conspicuous development in painting was attained, however, in the production of picture scrolls, or *emakimono*. They were purely Japanese in their development and were full of life in their vivid rendering of historical, legendary, and religious subjects, and the lives of venerable priests. The extant examples of such scrolls are so numerous that this period is called the age of picture scrolls.

On the other hand, the art of portraiture also made remarkable development. Warriors and high priests were favorite subjects of the imagination.

Such were the varieties of subjects painted by the artists of four different schools, namely, the Kose, Takuma, Kasuga and Tosa. However, it should be noticed that not all of these

schools had such a distinctive style as did those of later periods; but some of them involved nothing more than the difference of the families to which they belonged.

The specialty of the Kose School is seen in Buddhist pictures, but this school declined greatly during the period. Of the painters belonging to it may be mentioned Arihisa, Korehisa and Yukitada.

The Takuma School also is noted for Buddhist painting. It gradually lost its original characteristics, outshone as it was by the splendor of the Sung style. The noted painters of this school were Shōga, Seinin, Tameyuki, Eiga and Ryōson.

Eiga, who appeared in the later Kamakura Period, studied the Chinese painters Ri Ryūmin (Li Lung-mien) and Gan Ki (Yen Hui) of the Sung of China and paved the way for reviving the Chinese style in Japan.

The Tosa and Kasuga schools maintained respectively their own special native styles which are generally called Yamato-e in contrast to the Chinese styles. But the Tosa and Kasuga schools were ultimately blended. The Tosa School produced in rapid succession a number of celebrated artists who maintained faithfully the graceful style of the Fujiwara age and contributed much toward enhancing the characteristic merit of the Yamato-e School. Nobuzane, Keinin, Kunitaka, Yukinaga, Yoshimitsu, Mitsuaki, Hōgen En-i, Gōshin, and Yukimitsu are noted names in the Tosa School; while Nagataka, Takakane, Takasuke and Nagaaki, came to be recognized as of the Tosa School, though they started as representatives of the Kasuga.

Fujiwara Nobuzane, son of Takanobu, studied after Mitsunaga and was a distinguished portrait painter in the early Kamakura Period.

Keinin, or Keion as he is erroneously called, was probably a Shinto priest of the Sumiyoshi Shrine, Settsu; and he is also known as a painter of the Sumiyoshi School. He painted the illustration of the Kwako-genzai-ingwa-kyō or "Sutra on the Cause and Effect of the Past and Present" in the sixth year of Kenchō (1254). The sutra is now owned by Baron Masuda and Mr. Nezu of Tokyo. His style is marked by extraordinary vivacity

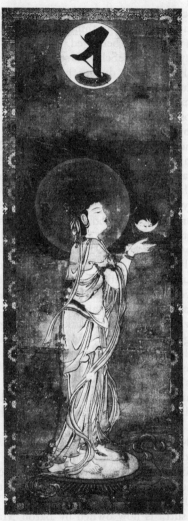

Fig. 69. One of Twelve Devas (Moon) (N.T.)
Tō-ji, Kyoto

and vigor.

Fujiwara Yoshimitsu lived in the later Kamakura Period and the picture scrolls illustrating the life of Saint Hōnen Shōnin are attributed to him.

Hōgen En-i was a master painter and is known as the painter of the picture depicting the life of Ippen Shōnin owned by the Kwankikō-ji, now on view in the Kyoto Onshi Museum of Art.

Fujiwara Nagataka succeeded in blending the Tosa and Kasuga schools. The famous scroll paintings in the Imperial Household collection illustrating the Mongol Invasion are attributed to him.

Takashina Takakane, flourishing about the beginning of the fourteenth century, was appointed chief painter to the Court. He was a keen observer of nature and life and his style is very vivid. He was one of the greatest artists of this age; and the cheerfulness of his coloring and the minuteness of his design can hardly be equalled by others. He is remembered as the painter of the celebrated masterpiece of the Kasuga Gongen Reikenki in the Imperial Household collection.

The paintings produced in the Kamakura Period may be classified conveniently into three different kinds: first, Buddhist paintings; secondly, portrait paintings; and lastly picture scrolls.

The Buddhist paintings most popular in the early Kamakura Period were the images of Amida and his attendant figures, all related to the Pure Land doctrine. One of the most representative examples of such paintings is owned by the Konkai-kōmyō-ji temple of Kyoto, and is now on view in the Kyoto Onshi Museum of Art.

The figures of Jūniten, or Twelve Devas (Fig. 69) preserved in the Tō-ji monastery of Kyoto are representative examples in which may be studied the new style of Buddhist paintings which the Takuma School developed under the influence of the Sung style of China. The figures are painted in colors on silk, which are mounted as six-fold screens in pair. They are in a standing posture which is a departure from the sitting attitude of the old school. The lines are vigorously accentuated by an undulating

touch of the brush, while the lines of the old school were drawn evenly with quiet power. The colors are gorgeous and full of contrasts. The air of tranquillity that prevailed in the preceding style was now transformed into one of movement. When this innovation was introduced, it not only became the model for all the succeeding Twelve Devas, but established a new school, to be known as Takuma. Another group of paintings representing Twelve Devas, which is also attributed to the same painter, is owned by the Jingo-ji monastery of Kyoto; and they are now on view in the Kyoto Onshi Museum of Art.

Jūniten, or Twelve Devas, represent Eight Directions, with Heaven, Earth, the Sun and the Moon all together symbolizing the universe; and the screens with their figures were used to visualize their guardianship in the time when the baptismal ceremony was held in monasteries.

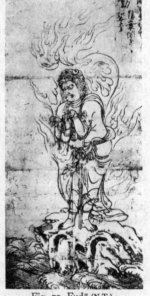

Fig. 70. Fudō (N.T.)
Daigo-ji

In the Daigo-ji monastery near Kyoto are preserved a great number of Buddhist paintings, produced in the later Fujiwara and early Kamakura periods by priest-painters, most of which are excellent works of Buddhist art. One of them is shown in Fig. 70.

The portrait paintings of the Kamakura Period were of great persons, contemporaneous as well as historical, because the people were specially interested in their personalities and were deeply inclined to dream of their individual power and social influence.

In the Ninna-ji of Kyoto there is preserved a famous picture of Prince Shōtoku Taishi, who was the central figure of the early days of Japanese Buddhism and who

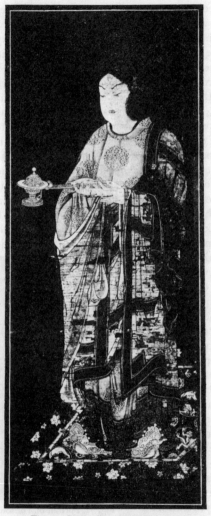

Fig. 71. Prince Shōtoku Taishi (N.T.)
Ninna-ji, Kyoto

has been an object of veneration ever since. Especially he was most widely worshipped in this Kamakura Period. There are many well-known portraits of him from babyhood to full growth, as is the case with most great men of the East and the West. The one under review is traditionally supposed to show him at the age of sixteen in the act of offering incense to Buddha with a prayer for the recovery of his sick father, the Emperor. (Fig. 71) Standing with grave wisdom in his young face, he wears a red ceremonial court robe with gold floral patterns and the colorful scarf of a high priest. Tradition ascribes this picture to Kanaoka, a painter of the ninth century; but this is obviously wrong. The portrait can not be earlier than the Kamakura Period. The picture is painted on silk and its draughtmanship is that of the Chinese Sung Dynasty which we have come to associate with the Kamakura Period in Japan. The color and the gold work of the shoes and the censer are raised. This is a peculiar technique developed in the Kamakura Period.

With the dawn of the Kamakura Period, under the influence of the martial spirit of the times, for the first time the warrior was portrayed; and though the workmanship was often conventional, the manner of portrayal was not yet stabilized.

The portrait of Yoritomo, the first Shogun of Kamakura, which is owned by the Jingo-ji of Kyoto, is an important example illustrative of the new movement in the history of portraiture in Japan. (Fig. 72)

Fig. 72. Portrait of Yoritomo (N.T.)
Kyoto Onshi Museum of Art

Another kind of portraiture much prized in this period was that of the Zen priests, because the Zen sect had high regard for individual personality and respected the portraits of its priests. One of the good examples is that of the priest Daitō Kokushi, owned by the Daitoku-ji monastery of Kyoto, which is described elsewhere. (pp. 384—5)

The picture scrolls or *emakimono* were produced to illustrate the lives of great religious leaders, miraculous attributes of Shinto deities and sacred Buddhist images, or the famous battles. They are usually voluminous, sometimes exceeding more than twenty scrolls.

In the Kitano Shrine of Kyoto are the famous picture scrolls called Kitano Tenjin Engi, composed of nine scrolls illustrating the life of Sugawara Michizane to whom the Kitano Shrine of Kyoto is dedicated.

In the Imperial Household collection is one of the most famous picture scrolls. It is called Kasuga Gongen Reikenki or the Miracle Records of the Kasuga Shrine. (Fig. 73) It was painted by Takashina Takakane, and is composed of twenty scrolls. It belonged originally to the Kasuga Shrine of Nara. It contains very realistic representations of palaces and street scenes and general customs and manners of men and women of the time. In deft execution and gorgeousness of coloring, as well as in variety of design, these pictures surpass all the picture scrolls of the kind and this scroll is one of the representative picture scrolls produced in the later Kamakura Period.

As to the picture scrolls illustrating famous battles, the Heiji Monogatari composed of three scrolls is the best and most famous example. One of the three is owned by the Museum of Fine Arts in Boston and the rest belong respectively to Baron Iwasaki and Count Matsudaira. The picture is painted in colors on paper and its painter is said to be Sumiyoshi Keinin, the master painter of the Tosa School. It is powerful in execution and vivid in the representation of the characters and horses. The composition and coloring are excellent and it is no doubt the most representative masterpiece of the Kamakura painting.

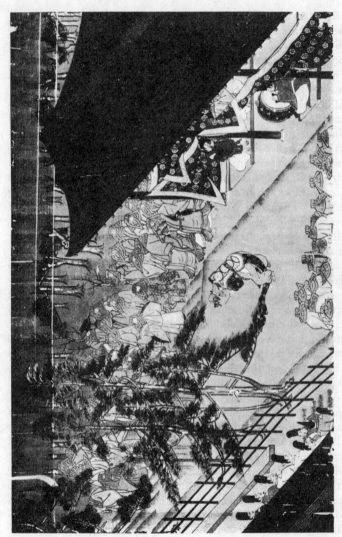

Fig. 73. Kasuga Gongen Reikenki
Imperial Household Collection

What we have seen above of the picture scrolls of the Kama-
kura Period, are all elaborate works with rich coloring. On the
other hand there are lighter ones in which the pictures are paint-
ed on paper in black and white with lighter mind. As a good
example of such picture scrolls, we may take up a set of four
picture scrolls painted with animal caricatures owned by the
Kōzan-ji monastery and now borrowed by the Tokyo Imperial
Household Museum.

Another specimen of a similar kind is owned by the Kōryū-ji
monastery in Kyoto. The scroll is called Noe Hōshi Ekotoba and
depicts the miraculous journey of the priest Noe to the nether
regions where he is said to have taught Buddhism to the King

Fig. 74. Noe Hōshi Ekotoba (N.T.)
Kōryū-ji, Kyoto

of Hell. (Fig. 74) Such a subject was much appreciated by the
people of the Kamakura Period, because they had much interest
in the talk of Hell. The priest Noe died in 1243 and the picture
is supposed to date from shortly after his death, probably from
the middle or late Kamakura Period. It is painted on paper,

mostly in black and white except for a very slight coloring. The words spoken by the characters are written too near them, thus harming the beautiful composition of the pictures. Such, however, added a new style to the later picture scrolls. Its well developed draughtmanship and the ease of delineation belong to the Yamato-e School of the Kamakura Period.

Besides those described above, the following picture scrolls are likewise important masterpieces of the Kamakura Period:

Illustrated History of the Kegon Sect of Buddhism or Kegon Engi. Attributed to Nobuzane. A national treasure. Kōzan-ji monastery. Colored on paper. Mounted as six makimono. Borrowed by the Kyoto Onshi Museum of Art.

Mongol Invasion Picture Scroll, by Nagataka and Nagaaki. Imperial Household collection. Colored on paper. Mounted as two makimono.

Pictorial Biography of Ippen Shōnin, by En-i. A national treasure. Kangikō-ji monastery. Colored on silk. Borrowed by the Kyoto Onshi Museum of Art.

Pictorial Biography of Hōnen Shōnin. A national treasure. Chion-in monastery. Colored on paper. Mounted as forty-eight makimono.

History of the Origin of Matsuzaki-tenjin. A national treasure. Matsuzaki-jinja. Colored on paper. Borrowed by the Tokyo Imperial Household Museum.

3. SCULPTURE

Kamakura sculpture made remarkable development materially under the new policy adopted toward Buddhist temples by Yoritomo, the first Shogun of Kamakura. Yoritomo began the reconstruction work of the great monasteries of Nara, such as Tōdai-ji, Kōfuku-ji and other monasteries with the opening of his Shogunate government at Kamakura. In connection with this, Buddhist figures were greatly in demand, and gave the sculptors great opportunity to display their genius.

However, what intrinsically made the Kamakura sculpture

was the martial spirit of the time which gave new direction to the Kamakura sculptors. The great master sculptors such as Unkei, Tankei, Jōkei and Kōben all benefited from this great opportunity given by Yoritomo.

The Kamakura sculpture was usually made of *hinoki* wood, carved in separate parts, and joined together to compose a whole figure, as in the Fujiwara sculpture.

The most conspicuous characteristic of Kamakura sculpture was the realistic activity of the mind and the chivalrous spirit of that age. Therefore, the Kamakura sculpture excelled in figures representing heroic movement. The touch of the chisel was free and powerful. More interest was felt in the flesh of man than in the graceful faces of godly quiet which we saw in the masterpieces of Fujiwara sculpture.

Such were the remarkable changes and the important characteristics of the Kamakura sculpture. Unkei was the best sculptor, representative of these new changes. But there was another famous sculptor called Kwaikei, Unkei's great contemporary and rival. Indeed both were great masters, representing two schools of Kamakura sculpture in wood. Before either appeared, however, there lived a sculptor called Kōkei who was the pioneer master of the Kamakura sculpture.

Kōkei was the father of the great sculptor, Unkei. Kōkei worked with his son and pupils at the Kōfuku-ji monastery during the time of its reparation and enlargement by the Fujiwara family in the Kamakura Period. To him was due the radical departure from the traditions which were still strong at the end of the Fujiwara Period and had hampered individuality for more than a century. He and his school laid stress on the accurate depiction of statuesque movement in place of the old repose which had become almost meaningless, and their work reflects half unconsciously the brush strokes of the painters which had lately become so full of vigor. The deep-cut and boldly outlined drapery and the use of rock crystals for the eyes appeared for the first time in this period.

In the Nan-en-dō of the Kōfuku-ji monastery at Nara, we can

find several examples produced by Kōkei who seriously studied the Tempyō sculpture at Nara where he could find its master-pieces more abundant than he could if he were living now. He initiated his own style concordant with the new spirit of the age. Among others, the figures of the Four Guardian Kings of the Nan-en-dō were the best in which the new spirit of the age was most cleverly expressed. Yet, compared with that of Unkei and Kwaikei, his work lacked the unity of all the important elements and failed to eliminate all the unnecessary elements.

Unkei, the son of Kōkei, was a great sculptor, as has already been said. He succeeded in expressing the new spirit of the age, to which his father could not do full justice. He had great skill in rendering activity and courage. Even when his subject was placid, he tried to catch the intrinsic movement with a vital touch of his chisel as Michael Angelo had done with his brush and chisel. The two Niō or Deva Kings standing at the gate of Tōdai-ji in Nara show Unkei's genius at his best. They are the largest statues of Niō in Japan, having a height of 26.9 ft. Their majestic countenances are well proportioned to their Herculean physiques; they are physically perfect and unequalled in the ex-pression of terrifying fierceness. Although these two statues are attributed to Unkei and Kwaikei, they most typically represent the type and technique of Unkei. (Fig. 75)

The figure of Seshin, one of the patriarchs of the Hosso sect, is another master work by Unkei. (Fig. 76) It is now on view in the Nara Imperial Household Museum, but was originally placed in the Hokuen-dō of the Kōfuku-ji monastery as a side-attendant to Miroku-Bosatsu with the figure of Muchaku. The figure was produced by Unkei in 1208, together with these two figures of Miroku and Muchaku. In this figure we see the in-dividual character of the priest wonderfully visualized by his genius. The bold, strong, yet rhythmic folds of drapery chiselled out of an innocent block of wood reveal a personality, grand not only in physique, but in spirit. Crystal is inserted in the eyes as an aid to the facial expression.

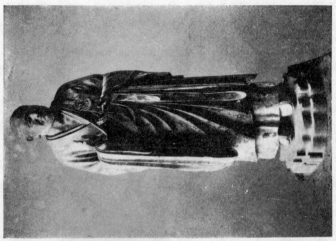

Fig. 76. Seshin, by Unkei (N.T.)
Nara Imperial Household Museum

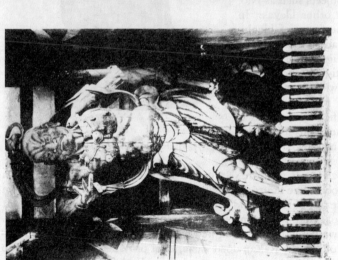

Fig. 75. Niō, by Unkei (N.T.)
Tōdai-ji, Nara

Jōkei, the son of Unkei, was also a great master; and he left us his signed statue of Yuima which is now on view in the Nara Imperial Household Museum.

The great contemporary of Unkei was Kwaikei, a pupil of Kōkei, as has already been said. He show-ed the new spirit in his beautification of the old forms. He was most skilful in representing peace-ful subjects, such as Buddhas or Bodhis-attvas, while Unkei showed his genius in rendering chivalrous subjects such as Niō, or other Devas. In the figure of Hachi-man Bodhisattva (Fig. 77) of the Tō-dai-ji monastery, Kwaikei left a type of pure beauty and refinement. This is the greatest work by him carved in the first year of Kennin

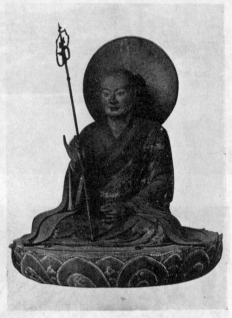

Fig. 77. Hachiman Bodhisattva, by Kwaikei (N.T.)
Tōdai-ji, Nara

(1201). It measures 87 centimetres in height and is colored on wood. The figure is preserved perfectly. Its form and expression are full of reality and there is nothing superhuman about it. It looks like an ordinary man with a calm and noble posture. Kwaikei left us other signed work, such as the statue of Shaka-muni in the Rakan-dō at Zeze, Ōmi province, the statue of Jizō in the Tōdai-ji monastery, and several others in local provinces.

At Kinomoto on the northeastern side of Lake Biwa is a

Buddhist temple called Jōshin-ji where is enshrined a figure of Jizō with two attendant figures. The temple became famous for this triad of Jizō, which are made of wood. This figure of Jizō measures about 160 centimetres in height and has magnificent form and yet a most merciful expression. (Fig. 78) Inside the figure is an inscription dated the third year of Ninji (1242). The attendant figures, called Gushōjin, were produced at the same time as the main figure. We have reproduced one of the two attendants. (Fig. 79) In this we see the superb touch of the chisel, simple and strenuous as if animated with a spirit that has keen insight into all the conduct of men. As a whole, the triune figures are masterpieces representing the Kwaikei style of wooden sculpture developed in the Kamakura Period.

Jizō, or "Compassionate Buddhist Helper," is one of the most popular Bodhisattvas of mercy, and is called Ksitigarbha in Sanscrit. He is described in a sutra as

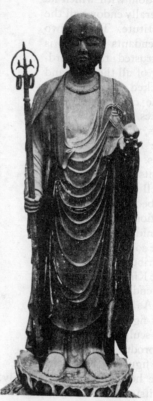

Fig. 78. Jizō (N.T.)
Jōshin-ji, Ōmi

a partial incarnation of the Buddha Amida; and he visits subterranean worlds where doomed spirits are suffering. He carries in his right hand a pilgrim's staff, to the top of which are attached jingling rings, which serve to arouse the spirits in agony to the presence of an all-embracing mercy. And in his left hand he

holds a jewel symbolizing the inexhaustible riches of bliss and wisdom with which he liberally endows all the destitute. To the two attendants of Jizō, is entrusted the recording of all the good and wicked acts of men. The one on the left, takes notes of good acts, while the other on the right records evil acts. They are attendants to the King of Hell who is also described as a partial incarnation of the Buddha Amida, representing the solemn phase of his attributes. Therefore the King of Hell is also attended by Gushōjin.

As an example of lay-figures of Kamakura sculpture, we have reproduced here a seated figure of Kiyomori,

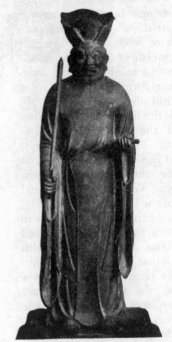

Fig. 79. Gushōjin (N.T.)
Jōshin-ji, Ōmi

the head of the Taira family. It is owned by the Rokuhara Mitsu-ji and is now on view in the Kyoto Onshi Museum of Art. (Fig. 80) The figure is made of wood and measures about 91 centimetres in height. It represents him in advanced age, wearing a sacerdotal costume, entirely engrossed in deep thinking over the sutra which he is holding with both hands. The expression of the face, the attitude of the hands, and the pose of the body all unite to bring out the individual vividness of his personality and show the excellent workmanship of the

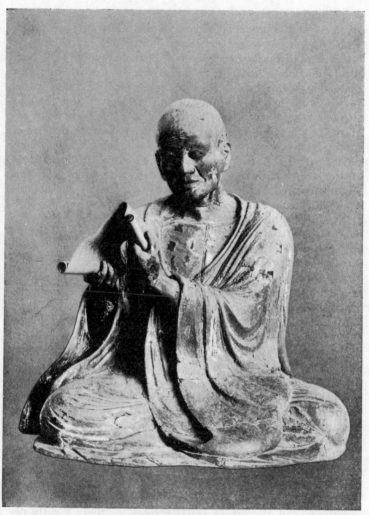

Fig. 80. Kiyomori (N.T.)
Kyoto Onshi Museum of Art

Kamakura sculpture.

There was a unique tendency in the Kamakura sculpture, which had never before developed in the history of Japanese sculpture. It was the production of the nude figures of the Buddhist and Shinto gods. However, those figures were not left nude, but were dressed up like living men. People of this period were inclined to think of gods as human and thought it more faithful to change the dresses of gods. A unique example of a nude figure representing Benzaiten, the goddess of music, is owned by the Tsurugaoka Hachiman-gū, the famous Shinto shrine at Kamakura. The figure is enrolled as a national treasure. It is made of wood and is coated with white gesso and slightly colored, showing the beauty of the flesh. She holds a musical instrument called Biwa in the left hand, and a plectrum in the right. On the foot is inscribed the following inscription:

"This is for the first time dedicated to the Goddess in the 3rd year of Bun-ei (1266) by Nakahara-Ason Mitsu-uji and enshrined in the hall of dance and music."

The greatest merit of Kamakura sculpture is achieved in the medium of wood. However, an exception will be found in the colossal bronze statue of Amida at Kamakura, which is now famous throughout the world. (See p. 322)

4. METAL WORK

In this period, Kamakura, the seat of the Shogunate government, became a new centre of minor arts as well as of other arts, although Kyoto still kept the honorable position of being another centre of art that clung to the old traditions.

The ideal of Zen Buddhism and the simplicity of taste began to be felt also in the expression of minor arts, and the greatest activity was shown in producing weapons which were most important in the lives of military men who rose to prominent positions; and the art of metal fittings for them greatly developed.

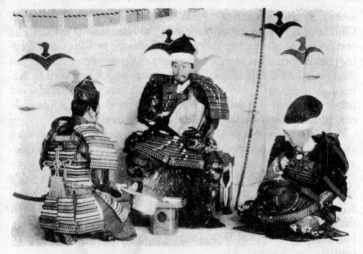

Fig. 81. General, wearing Grand Armor

The art of Japanese sword-making had made remarkable development already in the Archaic Period and many fine examples are found from the burial mounds as explained in the part dealing with archaic art.

In the Kamakura Period, a great impetus to sword-making was given by the Emperor Gotoba (1184–1198) who summoned the twelve famous smiths to Kyoto, each to work for him one month in the year. These swordsmiths are called by the name "Ban-kaji." Their blades were highly esteemed. In the reign of the Emperor Shijō (1232–1241), Mitsunaga and Nagamitsu appeared, and they are called the Osafune School. Then, in the reign of the Emperor Fushimi (1287–1297) Awataguchi Yoshimitsu and Rai Kunimitsu appeared in Kyoto and the work by Yoshimitsu was held in the highest esteem.

Japanese experts divide sword blades into two classes, the Old Swords (Ko-tō) and the New Swords (Shin-tō). The swords produced in all ages before the Keichō Era, which begins with the year 1596, are called "Old Swords," and those produced

since that time are called "New Swords"; and the best work of Old Swords was produced largely in the Kamakura Period. The tempering of blades, the process of doubling, welding and forging, developed most highly and a fine finish was obtained without flaws or specks, as if symbolising the pure and lofty spirit of Kamakura warriors. However, the decoration of scabbards and other furniture was quite simple, but highly elegant, while elaborated sword fittings developed with Shin-tō swords.

In the Atsuta-jingū is an excellent example of a Kamakura sword called Hyōgo Kusari-no-tachi, all complete with fittings and excellent decoration.

The armor-making also made remarkable progress. Among the armor-makers the most noted is Masuda Izumo-no-Kami Ki-no Munesuke who flourished in the latter half of the twelfth century in Kyoto. He was granted a new name, Myōchin, by the Emperor Konoe. Afterwards, he removed to Kamakura, where he produced many pieces of armor, and founded a long line of Myōchins, lasting more than ten generations.

Of the Japanese body armor the grand armor, called ō-yoroi, is the most elaborate and magnificent of all the armor ever produced in Japan. The finest was produced in the early Kamakura Period or a little earlier,

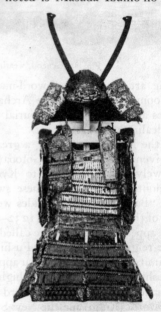

Fig. 82. Grand Armor (N.T.)
Nara Imperial Household Museum

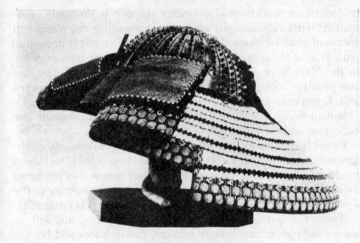

Fig. 83. Helmet (N.T.)
Ōyamatsumi-jinja, Ōmishima

that is, in the latter part of the twelfth century. The notable features of the grand armor are a curious winglike projection called *fukigaeshi* at each side of the helmet, a broad flat piece called *sode* at each shoulder, and a piece called *waidate*, which is laced separately to the body to protect the whole right side. It is very decorative, being lavished with gilded metal fittings, bright colorful lacing; and it is majestic in form. It looks magnificent when worn by a general, as will be seen in Fig. 81. Indeed, Japanese armor may be the most decorative body armor in the world.

From the Kamakura Period there remain several specimens of excellent grand armor. The red-laced grand armor of the Mitake Shrine in Tokyo prefecture is famous and is beautifully preserved although the original condition is more or less lost through two repairs. This is traditionally said to have been used by Hatakeyama Shigetada (1164–1205). In the Kasuga Shrine at Nara there are two sets of red-laced grand armor which are likewise very important examples and illustrate elaborate and high-

ly decorative workmanship. One of the two is profusely orna-
mented with exquisite gilt appliqué representing the blossomed
sprays of plum blossoms (Fig. 82); and the other suit is decorated
with that of the gorgeous peony flower. Both are now on view
in the Nara Imperial Household Museum. However, the best
and greatest collection of armor produced in the late Fujiwara
and Kamakura periods is exhibited in the treasury of the Ō-
yamatsumi-jinja at Ōmishima island. One of the helmets in the
collection is shown in Fig. 83.

Other body armors may be divided into three different kinds:
haramaki, *dōmaru* and *gusoku*. The first two kinds had been
produced already in the Heian Period, but *gusoku* was produced
mostly in the Yedo Period. They are all generally inferior to the
ō-yoroi or grand armor in quality, magnitude and workmanship.

The art of casting was also popular in this period and left us
some examples of cast bronze mirrors, flower vases and bronze
or iron lanterns, which are highly artistic. Of these, cast bronze
mirrors remain most numerous and highly artistic, expressing
the esthetic taste of the age. In a Shinto shrine called Nitta-
jinja, in the province of Satsuma, there is one of fine bronze
mirrors, and the design on its back is composed of peony and
two lively birds skimming along over the water under the
flower. (Fig. 84) In the Tokyo Imperial Household Museum is
another beautiful example, the design of which is composed of
birds and a plum tree in bloom. (Fig. 85) In the Hokke-ji
temple, Yamato, there is a pair of bronze vases with a relief
ornament of peonies. In the Kurama-dera temple, Kyoto, is an
excellent example of cast bronze lantern; and in the Kwanshin-ji
temple, Kawachi province, is another iron lantern of highly
artistic workmanship. (Fig. 86)

5. POTTERY

The pottery discovered in our prehistoric sites as well as in
protohistoric burial mounds was already quite artistic in form and
pattern. In the Shōsō-in treasury at Nara are preserved some ex-

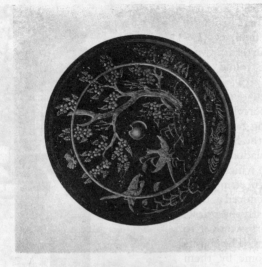

Fig. 85. Bronze Mirror (N.T.)
Tokyo Imperial Household Museum

Fig. 84. Bronze Mirror (N.T.)
Nitta-jinja, Satsuma

amples of the T'ang pottery of China. From the scripture mounds (*kyō-zuka*)built in the Fujiwara Period are found some specimens of incense boxes called *gōsu*, a kind of white porcelain ware, representing Sung art of China. In the Kamakura Period, celadon or *seiji* porcelain, which could not be produced in Japan, was introduced from China, mostly by priests who had crossed over to that country. The objects brought home by them were flower vases and tea-bowls called *temmoku*, literally meaning eyes of heaven. They were highly artistic. Some examples of them still remain and a lot of fragments are found at various sites

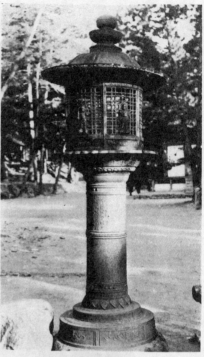

Fig. 86. Iron Lantern (N.T.)
Kwanshin-ji, Kawachi

of Kamakura, showing that the *seiji* porcelain was then quite popular. But as native industry, pottery did not on the whole make any remarkable progress when compared with the sister crafts. In China the pottery industry made noticeable progress after the T'ang, and culminated in the Sung Dynasty. Japanese aristocrats of the Fujiwara Period used mostly imported pottery, so the native wares consisted mainly of domestic utensils.

The pottery industry was first elevated to the dignity of art by Katō Shirozaemon Kagemasa of Owari, popularly called Tō-shirō. For this notable innovation, Japan is indebted to the

inspiration of China; for Tōshirō went over to China about the beginning of the thirteenth century, and after five years' study of ceramic works there, came back to the village of Seto, near Nagoya, where he constructed a kiln. His products consisted chiefly of tea-services and were enamelled with light brown and then mottled with black. The pieces produced by him are now called Ko-seto or "Old Seto." The second Tōshirō produced yellow glaze, with which he experimented on tea-utensils and incense burners. His work is called Ki-seto or "Yellow Seto." The third Tōshirō used the clay obtained from Mt. Kinkwa, in the province of Mino, and, following the glazing method of the first Tōshirō, manufactured numerous tea-pots and other wares. They are called Kinkwazan kiln. Finally appeared the fourth Tōshirō, early in the fourteenth century, who applied yellow glaze over light brown glazing, which is called *hafu-gama*, or the "gable kiln," as the scanty glaze applied left the ground exposed, producing an appearance like the gable (*hafu*) of a Japanese house.

In the Tokyo Imperial Household Museum there is a tea-caddy by Tōshirō the First, which bears the title of Kokonoe.

In the Fukagawa-jinja of Seto is the famous porcelain figure of a dog. (Fig. 87) It is traditionally said to

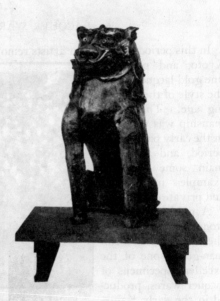

Fig. 87. Koma-inu, Pottery of a Dog (N.T.)
Fukagawa-jinja, Seto

have been made by Tōshirō the First, and measures about 45 centimetres in height. The whole surface is applied with glaze which has a glossy buff color. It is beautifully formed with a strong touch; and it is no doubt a masterwork of the Kamakura Period. The left front leg is, however, broken, and a wooden one has been substituted.

The city of Seto has been famous for its pottery work since the time of Tōshirō, and has produced various kinds of pottery such as Shino-yaki, Oribe-yaki and Ofuke-yaki. The city still holds its fame as one of the most renowned centres for the production of pottery, and has in fact given rise to the general name for porcelain, "Setomono," just as Chinese ware is universally known as "China" in English speaking countries.

6. LACQUER WARE

In this period gold lacquer artists removed to Kamakura from Kyoto, and produced fine gold lacquers after the style of the preceding age. The workmanship was exquisite in the early part of this period, and there remain some excellent examples in temples and private collections.

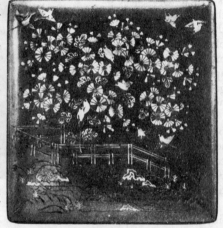

A gold lacquer inkstone box owned by the Tsurugaoka Hachiman-gū, is one of the excellent specimens of lacquer wares, produced ed in the early Kamakura Period, and is now

Fig. 88. Gold Lacquer Ink-stone Box (N.T.)
Kokuhō-kwan Museum, Kamakura

on view in the Kokuhō-kwan Museum at Kamakura. The en-

tire surface of the box cover is decorated with chrysanthemums in mother-of-pearl inlaid work on a gold ground, called *ikake-ji*. It is an early example of pictorial design that has a highly decorative quality. (Fig. 88)

A gold lacquer toilet box of Mishima-jinja at Mishima is also an excellent specimen of the Kamakura gold lacquer. The box with all its contents is ornamented with the same design, that is, with plum trees, running streams, reeds, and wild geese. The design itself is very picturesque. The gold dust used for the purpose is of no small amount, and the design is somewhat relief in effect, which later developed into the raised gold lacquer.

In the middle of the Kamakura Period a new lacquer carving called Kamakura-bori was invented under the influence of Chinese Sung lacquer. It had rather a rustic style combining a peculiar carving and lacquering. Rough designs were first carved in high relief and then lacquered; first with black, and next with red juice.

7. ARCHITECTURE

With the reopening of the intercourse between China and Japan, Japanese architecture received a new acceleration of vitality. At the beginning of the Kamakura Period there were three different styles of architecture; one was the native style called *wayō* transmitted from the preceding period; the second, the Hindu style called *tenjiku-yō*, which was introduced from China in connection with the restoration work of the Tōdai-ji monastery at Nara; and the third one was the Chinese style called *karayō* which was introduced with Zen Buddhism. In the early part of the period, the architecture in native style (*wayō*) was somewhat revived. Its construction and technique were bold and full of power, indicating a certain amount of genuine growth of real vitality. Meanwhile the Hindu style was mingled with the new native style and lost its independence in a short time. The third style, the new Chinese style called *karayō*, had a most important position, not only in the Kama-

kura Period but also in the succeeding development of Japanese architecture. At the beginning this style developed indepedently with the erection of many temples of the Zen sect. But later on, the new *karayō* style modified by certain elements of native style, had a remarkable development, and left behind it an enduring style which greatly prospered in the succeeding ages. The greater part of the Kamakura buildings extant from this period are of the hybrid style of architecture.

Besides the Buddhist architecture, we have only a few Shinto buildings from this period; but there remain no palace buildings, nor any private dwelling houses.

The buildings belonging to the old sects, the Tendai, the Shingon, and other older sects, were built in native style or combined styles; and those of the new sects such as Jōdo-shū, Shin-shū, or Nichiren-shū, which developed on the soil of Japan were built in native style or in combined types of two or three different styles.

Architecture in native style preserved its essentials in the earlier part of the Kamakura Period without being influenced by the new Chinese style. Some of the best examples of this are the Sanjusangen-dō of Kyoto and the stupa called Tahō-tō of Ishi-yama-dera in Ōmi.

The distinguishing characteristics of the *tenjiku-yō* architecture were the inserted bracket elbows (*sashi-hijiki*), the saucer-shaped base of the *daito*, a certain irregularity in the arrangement of the bracket groups, and the peculiar form of their ends. Among the existing examples of the *tenjiku-yō* architecture, Nandai-mon, the Great South Gate of the Daibutsu at Nara, is the most famous typical structure in this style. The next fine examples of the *tenjiku-yō* architecture are the main temple and the Amida-dō of the Jōdo-ji monastery in the province of Harima.

The *karayō* style of this period was derived from China under the Sung Dynasty and was adopted for the temples of the Zen sect. So it must not be confused with the early *karayō* of the Chinese Six Dynasties, which was introduced to Japan in the

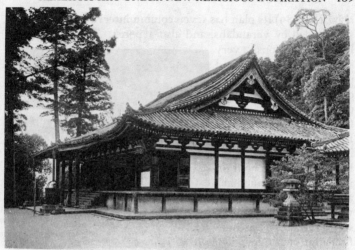

Fig. 89. The Main Temple (N.T.)
Kwanshin-ji, Kawachi

seventh century along with the first Buddhist propaganda. It differed from that in the shapes of the pillars, brackets, eaves, doors and windows, and in the arrangement of tiles on the floor. The interiors of the new style were either plain or colored with the utmost simplicity, carving in low relief being generally the only form of decoration. The Shari-den of the Engaku-ji monastery at Kamakura is the only good specimen of this style existing from the Kamakura Period.

The hybrid style between the native, Chinese, and Hindu style arose in about the middle of the fourteenth century and developed in the Muromachi Period following. The main hall of the Kwanshin-ji in Kawachi, the main hall of the Taima-dera in Yamato, and the drum house of the Tōshōdai-ji in Yamato are all good examples.

The main hall of the Kwanshin-ji is a noteworthy building of the latter part of the Kamakura Period, and may be considered the best representative of what we call the hybrid style or *set-*

chūyō. (Fig. 89) Its plan has seven column intervals on each side, surrounded by verandahs, and also a porch. The exceedingly

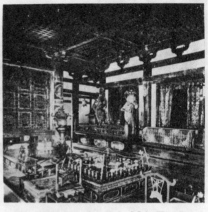

Fig. 90 The Interior of the Main Temple
Kwanshin-ji, Kawachi

low proportions, very slight inclination and gracefully curved lines of the roofs are all features faithfully copied from the types of the Fujiwawa Period. The interior is divided by a heavy lattice partition into an inner sanctuary and an outer hall for worship, and in the inner section there is a holy fire altar for invocation. (Fig. 90) To the right and left of this altar are wooden screens with Buddhist figures. After all, the various styles are most cleverly harmonized to get a general effect of dignity and strength.

As regards the arrangement of the monastic buildings, the Zen sect of Buddhism had the most complicated plan on a large scale. They were erected on a rectangular ground, facing the south; and the main buildings stood on a straight line which ran from south to north at the middle of the ground. At the south extreme stood a general gate called Sō-mon, which was meant for the general public to pass under. Next come a rectangular pond with a stone bridge over it. Across the pond stood a two-storied gate called Sam-mon. Next came the Buddha Hall called Butsu-den. Behind the Buddha Hall stood the Preaching Hall called Hatto; and then finally came residential quarters consisting of buildings called Hōjō and Kuri. All these main buildings looked solemn and magnificent ranged along the central straight line. On the east and the west side of the main line stood a belfry, a sutra depository, a bath-house, the toilet house (Tōsu) and Zen-dō

where the monks sat and meditated.

In Kyoto and Kamakura were erected five great monasteries of the Zen sect with a complete arrangement of buildings; but none of them remain as originally built. However, the Myō-shin-ji and Daitoku-ji monasteries of Kyoto have a plan similar to that described above, through which we may infer the general plan of the great Zen monasteries of the Kamakura Period.

The arrangement of monastic buildings of the other Buddhist sects such as Jōdo-shū, Shin-shū and Nichiren-shū, is quite different from that of the Zen sect of Buddhism and much simpler and freer. The Shin-shū sect which was most purely Japanese, had two main buildings, the Founder's Hall (Soshi-dō) and the Amida Hall (Amida-dō) side by side in front, and the living houses of the priest at the rear. The Jōdo and the Nichiren monasteries had nearly the same plans. Among these monastic buildings, the Founder's Hall was the largest. This fact should not be overlooked, as all the religious activities were focussed upon the personality of the founder, and the faithful congregated at his hall. Such were the most striking characteristics of the Buddhist activities seen in the monastic buildings of the sects newly developed in the Kamakura Period.

CHAPTER VIII

IDEALISTIC ART UNDER ZEN INSPIRATION

(*The Muromachi Period 1334-1573*)

1. GENERAL SURVEY

The Muromachi Period nearly corresponds to the Renaissance in Europe. It began nominally with the establishment of the Ashikaga Shogunate in Kyoto in 1338 and ended when the last Shogun Yoshiaki was expelled by Oda Nobunaga in 1573: thus it covered about 230 years.

The last of the Hōjō dictators, Hōjō Takatoki, had committed suicide at Kamakura in the year 1333, and with the downfall of the Hōjō, the Shogunate of Kamakura broke down, and the real power of the state was restored to Kyoto in the name of the Emperor Godaigo. The court nobles now thought that they could conduct themselves as the true masters of Japan, but their expectation was a dream: after only three years the Imperial power was again lost. But, as the warriors who had assisted them in the restoration of their former power could not get the lion's share of the booty, one of them, Ashikaga Takauji, supported by a multitude of such dissatisfied soldiery, made himself the real master of the situation and was appointed Shogun.

At the same time the Imperial Family was divided into two, and a civil war raged all over the provinces for fifty-six years, until the two parties were reconciled in the year 1392. In this way the whole of the Empire came under the hegemony of one military regime, and for about two centuries, the family of the Ashikaga continued at the head of the new Shogunate government at Kyoto.

Thus, the greatest advantage in the removal of the Shogunate government from Kamakura to Kyoto was the achievement of political concentration of the Empire, by making it coincide with the centre of civilization.

The third Shogun, Yoshimitsu, succeeded in bringing about the re-union of the dual lines of the Imperial Family. Peace and order were restored and prosperity followed. But having nothing to check his arbitrary wishes, he gave himself up to extravagance and sensuous indulgence. He built or repaired large monasteries and edifices, such as the Tō-ji, Enryaku-ji, Kōfuku-ji and Shōko-ku-ji. He also built his gorgeous residence, known by the name of "Palace of Flowers," and established there his Shogunate government. He erected a villa at Kitayama, which surpassed all others in splendor and costliness. His time was indeed the most flourishing in the Muromachi Period. Kyoto not only recovered its former prosperity, but even surpassed the preceding ages in architectural gardening and became the headquarters of the industrial arts.

The succeeding Shoguns followed his example and did not care to improve their ways even when peace was disturbed by civil trouble. As a whole, the welfare of the people was not seriously considered by the Shoguns of Ashikaga, but art developed because of their luxury and taste.

Among the Ashikaga Shoguns, the eighth Shogun, Yoshimasa, was known as the patron of art. He was absorbed in esthetic pursuits even in the midst of war and financial stress. He built the elegant villa of Gin-kaku-ji (Silver Pavilion). He collected old pictures and ceramics regardless of cost and labor. He developed the tea-ceremony which had originated in the Zen sect of Buddhism to a refined form of social entertainment in which were included the arts of incense burning and flower arrangement. The prevalence of such refined amusements led to a marked progress in art.

There remains a unique catalogue of art objects collected by Yoshimasa mostly from China. The catalogue is called Kundai-kwan Sayuchōki and was compiled by his attendant connoisseur called Nō-ami. In the catalogue are a commentary on tea-caddies and tea-bowls and brief descriptions of how to show pictures, how to judge the genuineness of objects, and how to arrange tea things on shelves. In the following generations, this catalogue

was as highly esteemed as scripture among art connoisseurs and tea masters.

Almost all the Shoguns of the Muromachi Period were closely associated with Zen priests and their lives were tinged with the doctrine of Zen. Of all the sects then existing, none attained a higher prosperity or exerted more influence upon art than the Zen sect, and that was chiefly because its doctrines were in accordance with the current frame of mind of the people.

Zen, meaning meditation in supreme repose, had been introduced into China by Bodhi Dharma from India in 620 and in China it became amalgamated with the tranquil temper of Taoist quietism and absorbed the poetic genius of the Chinese. Zen is an intuitive method of spiritual training, the aim of which consists in attaining a lofty transcendence over worldly care. Zen aims at giving an intuitive assurance of having discovered in the innermost recess of one's own soul an ultimate reality which transcends all individual differences and temporary mutations.

In the investigation of the artistic development of this period, it will be noticed that the most remarkable change was made in the development of painting. The master painters of this age were mostly votaries of the Zen doctrine and therefore directed their attention toward producing works redolent of chastity and profound abstraction. In industrial art, which followed the lead of painting, the foremost art of the period, a similar simplicity is noticeable. But on the other hand, it should be remembered that there was also gorgeous architecture such as that of the Golden Pavilion.

As a whole the art of the Muromachi Period bears an entirely different aspect from that of the preceding period. It was from the time of the Shogun Yoshimasa that because of its increased secular appeal religious art began to get a hold on the lives of individuals.

2. PAINTING

In this Muromachi Period, the most remarkable development was made in the painting. It is distinguished by two features, one being the use of ink instead of color, and the other rigour and sincerity, deeply tinged with subjective idealism.

This newly developed style of painting is known by the name of *suiboku-gwa* which means literally water and black ink painting. The spiritual source of this development was in the inspiration of the Zen doctrine of Buddhism and its technique was greatly influenced by the paintings in black and white, produced by Chinese masters of the Sung and Yüan dynasties, which were imported in the previous period as well as in this period.

The artists who studied this style of painting were mostly Zen priests, or those interested in the doctrine of Zen. Some of them crossed over to China in pursuance of their study.

The paintings produced by them were characterized by purity, simplicity and directness, the elaborate coloring and the delicate curves of the Fujiwara and Kamakura periods being discarded for simple ink sketches.

The subjects that attracted their interest were mostly figure compositions closely associated with nature. The Buddhist disciples called Rakan were generally represented in a group against a background of mountain scenery. Shaka-muni, the founder of Buddhism, was pictured in a quiet mountain scene or coming out of the mountain where he had practiced his long meditation to attain perfect enlightenment. Kanzan, a hermit sage, was generally represented as holding a blank roll partially unrolled, symbolizing the book of nature. Jittoku, another hermit sage, was always represented with Kanzan, holding a broom—the broom of insight—with which to brush away the dust of worry and trouble. Thus the priest-painters were keenly interested in figures set against the background of nature.

In addition to such subjects, they were also extremely fond of landscape paintings, and of birds and flowers, separated from human figures. According to the ideal of Zen artists, beauty or

the true life of things is always hidden within rather than expressed outwardly. Realizing the limited power of any elaborate depiction in revealing the infinite life and power of nature, they tried not to display everything that may be seen, but rather to suggest the secret of infinity.

Therefore the work by great masters of this school was not the depiction of nature, but the expression of their emotion about it. To them there seemed to be neither high nor low, neither noble nor refined. In a single flower or a spray of bamboo, they tried to see the eternal life that permeates through man and nature alike; and they strove to catch it with simple, bold strokes of the brush and with little color.

Among others, the works by Ri Ryū-min (Li Lung-mien) and by the Emperor Kisō (Hui ts'ung), of the North Sung Dynasty; those by Baen (Ma Yüan), Ka Kei (Hsia Kuei), Ryō Kai (Liang K'ai) and Mokkei (Mu-ch'i) of South Sung; and those by Chō Su-gō (Chao Tzu-ang) and Sen Shunkyo (Chien Shun-chü) of Yüan Dynasty, were popular with them.

To improve their respective works, these Chinese masters were studied by such Japanese painters as Minchō, Josetsu, Shūbun, Sesshū, Sōtan, Jasoku, Motonobu and the three brothers of "Ami."

An excellent example of the Chinese pictures which might have been studied by some of these Japanese painters is preserved in the Nanzen-ji monastery. This picture is an ink painting produced in the Southern Sung Dynasty of China. It represents two figures, a Zen philosopher Yakusan (Yao-shan) and a celebrated statesman Rikō (Li Ao) having a discussion on the philosophy of Zen. (Fig. 91) The philosopher is seated on a bamboo chair behind a massive stone table on which is placed a vase with a spray of plum tree, and his bony hand is raised to emphasize his opinion. In front of the table stands the statesman in an attitude of respectful consideration. The composition and line movement express wonderfully the directness and simplicity of the Zen idea.

A rare example by Mokkei (Mu-ch'i) is owned by the Daitoku-

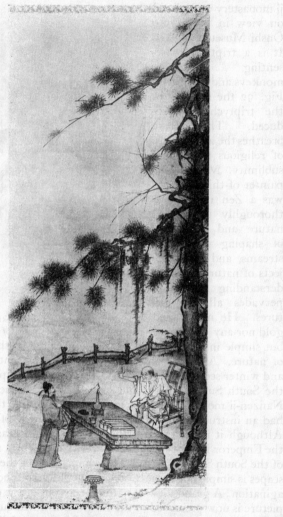

Fig. 91. Yakusan and Rikō (N.T.)
Nanzen-ji, Kyoto

ji monastery and placed on view in the Kyoto Onshi Museum of Art. It is a triptych representing Kwannon, monkeys and a stork. In Fig. 92 the monkey of the triptych is reproduced. The picture breathes the atmosphere of religious repose and sublimity. Mokkei, the painter of this triptych, was a Zen monk who thoroughly understood nature and her ways of shaping mountains, streams, and other objects of nature. His understanding of nature pervades all his pictures. He never used gold nor any rich color,

Fig. 92. Monkeys, by Mokkei (N.T.)
Kyoto Onshi Museum of Art

but simple ink, which was highly suggestive of the inner life of nature. A pair of landscape paintings representing autumn and winter scenery, attributed to the Chinese Emperor Kisō of the South Sung Dynasty and owned by the Konchi-in of the Nanzen-ji monastery, is also an excellent example that likewise had an instructive influence on Japanese painting of this period. Although it is not certain whether the picture was painted by the Emperor Kisō or not, it was surely painted by a master-hand of the South Sung Dynasty. The composition of these two landscapes is simple but broadly suggestive, leaving much to the imagination. A grand view of nature peeps out of the canvas. The picture is now preserved in the Kyoto Onshi Museum of Art.

Pictures representing Gama and Tekkai, two of Chinese Eight

Immortals in the Taoist legend, painted by the Chinese master Gan Ki (Yen Hui) whose works had much influence on Japanese painting of this period, are owned by the Chion-ji monastery of Kyoto and are now preserved in the Kyoto Onshi Museum of Art. One of the pictures, representing Tekkai, is reproduced in Fig. 93. It is painted in harmonious combination of lines and colors. As he was a follower of Zen philosophy, he was always ready to take up his artistic brushes for the sake of Zen temples. When Zen Buddhism was introduced into this country his masterpieces came along with it, and this was no doubt one of them.

It was from such pictures as these that the Japanese painters of the

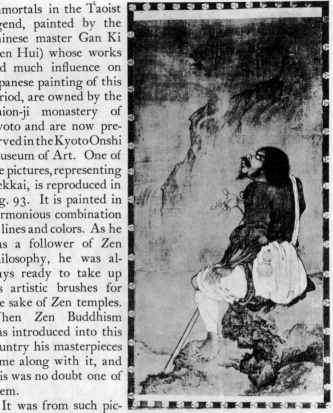

Fig. 93. Tekkai, by Gan Ki (N.T.)
Chion-ji monastery, Kyoto

Muromachi Period learned an expression in ink that has never been rivalled.

A Japanese priest-painter called Minchō, 1352–1431, was one of the most noted followers of the style of Gan Ki whose works we have just described. Minchō lived in the Tōfuku-ji monastery of Kyoto and officiated there. His lines are remark-

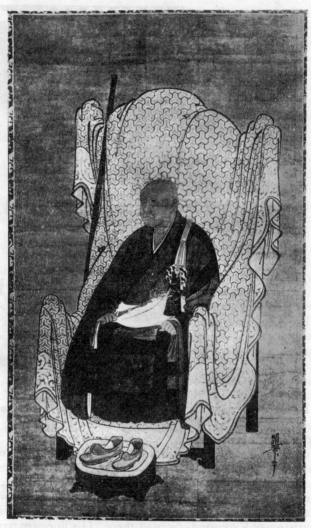

Fig. 94. Shōichi Kokushi, by Minchō (N.T.)
Tōfuku-ji monastery, Kyoto

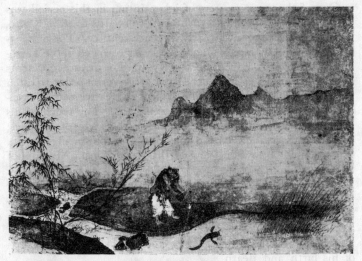

Fig. 95. Man Watching a Catfish, by Josetsu (N.T.)
Kyoto Onshi Museum of Art

able for a technical peculiarity, an alternate heavy and light line in the same stroke, which gives his drawing much character. He was very famous for his Buddhist and Taoist figures, all of which were painted on large canvasses and distinguished for vigorous strokes. He drew inspiration not only from Gan Ki but also from the Chinese Ri Ryū-min (Li Lung-mien) of the Sung Dynasty. Truly he was a great Buddhist painter who kept the religious spirit.

Most of his masterpieces are still preserved in the Tōfuku-ji monastery and the best of his works will be seen in the portrait of Shōichi Kokushi which is also one of the treasures of the monastery. (Fig. 94) It is slightly colored on paper. The aged priest with austere wrinkled features sits on a high chair over which a large cloth of green and white pattern has been thrown. The tip of his long staff resting on the chair makes a simple note of red in the picture.

One of the great masters of ink painting in this period was Josetsu. He was born in Kyushu but afterwards lived in Kyoto, and was flourishing in the early fifteenth century. The only existent painting by him, a unique work, is preserved in the Taizō-an of the Myōshin-ji monastery of Kyoto. The picture represents a man watching a catfish at the bank of a river in order to catch it with a gourd in hand. The subject is treated with a fascinating power which comes from Zen ideas. The touch of his brush evidently shows the influence of the style of Mokkei; it is very soft and yet the man looks so powerful in will. (Fig. 95) It is now on view in the Kyoto Onshi Museum of Art.

Shūbun, a pupil of Josetsu, is said to have been even greater than his master. He was born in the province of Ōmi and after-

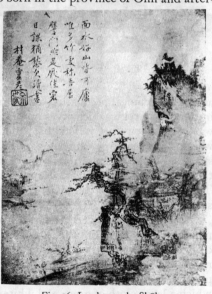

wards lived in Kyoto as a priest of the Shōkoku-ji monastery. The dates of his birth and death are uncertain but he flourished in the first half of the fifteenth century. There are a number of paintings which are attributed to him, but it is most regrettable that there is nothing authorized as his real work. However, it is known that in the year 1430, he colored the figure of Daruma, the founder of the Zen sect, which is owned by the Daruma-ji, a temple of

Fig. 96. Landscape, by Shūbun
Tokyo Imperial Household Museum

Nara. This figure is now enrolled as a national treasure.

There are also several famous landscape paintings attributed to him by connoisseurs. One is in the collection of Mr. Hara of Yokohama, another in the collection of Marq. Hachisuka in Tokyo, and the other in the Tokyo Imperial Household Museum, which we reproduce in Fig. 96. This example is in black and white. In it we see the purity and sublimity of nature, excellently expressed in the forms of rocks and trees, by his master hand in black and white.

After Shūbun, there appeared such masters as Sesshū, Jasoku, Sōtan, Nō-ami, Gei-ami, Sō-ami, Shokei, Masanobu, Motonobu, and Mitsunobu.

Among these masters, Sesshū, 1420–1506, was one of the greatest landscape painters Japan ever produced. His real name was Tōyō. He early turned priest and was initiated first at Shōkoku-ji in Kyoto and afterwards lived at the Kenchō-ji monastery at Kamakura. He at first studied the style of Josetsu and Shūbun, but in time he began to display marked originality. In the yaer 1467 he went over to China in the hope of finding there some masters of the Chinese landscape painting under whom he might study. But, finding that he had more to teach than to learn, he travelled far and wide over the land with nature as his only teacher. His great originality was acknowledged in China and elicited immense admiration from both the Chinese Emperor and the people. The Emperor himself commissioned him to paint the three Japanese views of Mt. Fuji, the Japanese port of Miho, and the Seigen-ji temple near Shizuoka.

On his return to Japan after two years in China, he established himself in a cottage at Yamaguchi under the name of Unkoku-an and did much to spread the Chinese manner of landscape painting.

Sesshū developed his originality mostly from nature, thus causing a great stir in the artistic world of Japan at that time. His greatness lies in his power of grasping the essentials of what he was representing, and of rejecting the unnecessary. His brush touch is free and extremely sensitive in portraying with ink of deep and light tones the landscapes created in his own mind.

His lines and gradation of ink are magnificent and sublime.

There still remain a number of his masterpieces in Japan. Among them, a landscape painting in the Tokyo Imperial Household Museum, the two landscapes, winter and summer scenes (Fig. 97), in the Manshu-in temple at Kyoto, and the long landscape scroll in the collection of Prince Mōri, are very famous and representative.

Sesshū had many followers. His style was later called the Unkoku School. Among the painters who studied it, Shūgetsu and Sesson are most famous.

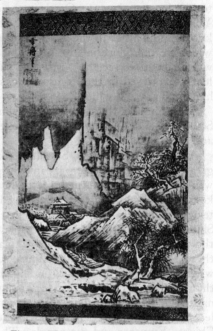

Fig. 97. Winter Landscape, by Sesshū (N.T.)
Kyoto Onshi Museum of Art

Jasoku, —1483, studied painting under Shūbun and painted landscapes, human figures, flowers and birds. His brush work is rather rough and does not resemble that of his teacher. The vigor of his stroke and compact composition are almost unequalled. He was born in the province of Echizen in the house of a samurai and flourished as a painter during a period of about thirty years (1452–1483). He was much interested in the doctrine of Zen Buddhism, which he learned from the famous priest Ikkyū. This is the reason why he decorated the interior of the Shinju-an temple founded by Ikkyū, with landscape paintings in black and white, which are good examples of his work.

He also excelled in portrait paintings, an example of which will be seen in the triptych of three patriarchs of the Zen sect, Daruma, Rinzai, and Tokusan, preserved in the Yōtoku-in of the Daitaku-ji monastery of Kyoto. The figures are delineated minutely. As to the drapery, the bold lines and the shadings along them are made skilfully to give the desired effects. Daruma occupies the centre; to the left, sits Rinzai, with one hand tightly clenched (Fig. 98); and to the right, Tokusan, with his famous stick. The deep serenity and mental purity reached by Zen spiritual training are represented in their faces and postures by slight coloring, simple technique, and bold expression.

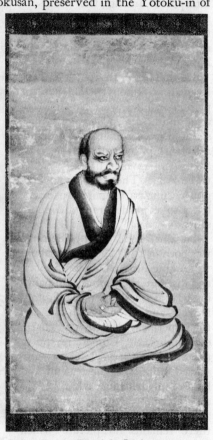

Fig. 98. Rinzai, by Jasoku (N.T.)
Yōtoku-in, Kyoto

Oguri Sōtan, —1481, also a pupil of Shūbun, is said to have developed great originality. He flourished from about 1462 and died in the year 1481. He served the Ashikaga Shogun to whom he used to present a painted fan every New Year's Day. The Honchō Gwashi says: "He was particularly skilful in painting lands-

capes. As to details of his work, the varying views of mist or clouds interposed among the woods in spring, evince a spontaneous taste for natural beauty." But there remains no authentic painting by him.

In the fifteenth century, there lived also a famous trio of landscape painters. They were Nō-ami, Gei-ami, and Sō-ami, who were father, son and grandson in this order of relationship, and collectively called "San-Ami" which literally meant three Ami. They all served Shogun Yoshimasa, not only as painters, but also as gardeners and connoisseurs.

Nō-ami, properly called Shin-nō, was born in 1397 and died in about 1476. He studied under Shūbun and distinguished himself in painting landscapes, human figures, flowers and birds, which are said to be permeated with the charm of Mokkei, the Chinese master of the Sung Dynasty. He was also versed in poetry, the tea-cult and landscape gardening, while he was a great connoisseur of calligraphy and old Chinese paintings. But there remains no picture which can be proved to be his real work.

Gei-ami, 1431–1485, son of Nō-ami, was properly called Shin-gei.

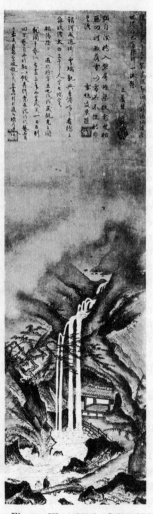

Fig. 99. Waterfall, by Gei-ami
Mr. Nezu's Collection

His painting was unlike his father's and also different from that of his son Sō-ami. He showed originality which was further developed by his pupil, Kei Shoki. His masterpiece (Fig. 99) painted when he was fifty years old, remains. It represents a priest passing over a bridge near a waterfall, and is said to be the best representative work by him.

Sō-ami, son of Shin-gei, properly called Shin-sō, flourished in the time of the Shogun Yoshimasa in the later fifteenth century. He was a valet to the Shogun and was noted for his draughtmanship, especially in landscapes, human figures, birds and flowers, either in black and white or in light color. His style of painting very much resembled that of his grandfather, Nō-ami. He was a many-sided man, and was distinguished equally in poetry, the tea-cult, incense-testing contest and landscape gardening. Especially he was a great expert in the methods of art appreciation. Landscape paintings in ink on paper, mounted in twenty kakemono which are owned by the Daisen-in temple, are famous works by him.

Keishoki, called also Shokei or Hinraku-sai, flourished in the later fifteenth century. He displayed precocious talent in painting, being especially noted for his Buddhist and Taoist figures, after which his landscapes and secular figures come next in excellence. He studied painting from Gei-ami. But it seems that he drew inspiration from the works by Mokkei and Shūbun.

During the later Muromachi Period, there developed a new style of painting, which is called the Kanō School. Three great landscape painters, Josetsu, Shūbun, and Sesshū, whom we have described, had all studied seriously the style of Chinese painting of the Sung and Yüan dynasties, which Sesshū had been foremost in Japanizing. Yet, after all, they were priest-painters, to whom painting was rather a hobby. But now the Kanō masters, Masanobu, and his son Motonobu specialized in painting. They made remarkable progress by adapting the native style of the Tosa School to their own which they had acquired through the Chinese masters and their Japanese followers, finally establishing the Kanō School, which became the most important school of

painting in the following two periods, that is, Momoyama and
Yedo.

Kanō Masanobu, 1454–1550, called Shirojirō, afterwards Ōi-
nosuke, was born in the village of Kanō, Izu, from which his
family name was derived. He studied painting early under Shū-
bun and Sōtan, and served the Shogun Yoshimasa with his art.
He originated the Kanō style. His son Motonobu was the most
celebrated master painter in the later Muromachi Period. (Fig.
100)

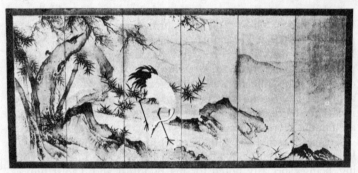

Fig. 100. Landscape, by Masanobu
Kyoto Onshi Museum of Art

Kanō Motonobu, 1476–1559, son of Kanō Masanobu, was
noted from his early days for his artistic talent, which won high
favor from the Shogun who appointed him as his valet. He
was made a court painter also and honoured with the title "Hō-
gen"; he is popularly called Ko-Hōgen, or Elder-Hōgen. He
did his best in bringing the Japanese and Chinese styles into
perfect harmony, and established the canon of the Kanō School
that had been founded by his father, Masanobu. The reason why
Motonobu grew to be the father of the Kanō School was mainly
his Japanizing ability.

He married Chiyo, daughter of Tosa Mitsunobu, the distin-
guished master painter of the Tosa School. This matrimonial al-
liance with a representative of the Japanese style of painting

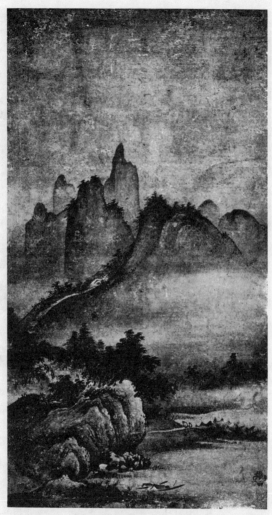

Fig. 101. Chinese Landscape, by Motonobu
Nara Imperial Household Museum

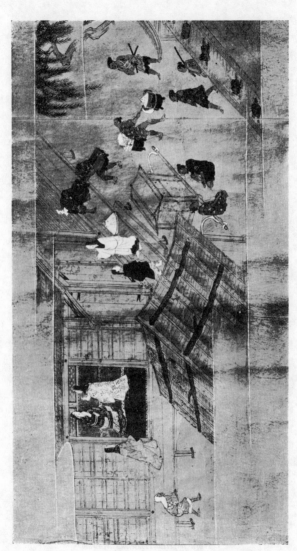

Fig. 102. Kiyomizu-dera Engi, by Tosa Mitsunobu
Tokyo Imperial Household Museum

did much toward developing the Kanō style. In 1508 he sent a series of his pictures to China. They soon gained him so much respect that not a few Chinese artists of the time wrote him to come over and teach them. With Sesshū he was one of the two most outstanding painters in the Muromachi Period. However, when we compare his painting with that of Sesshū there is a great difference between them. Motonobu showed his masterly finish in landscapes in monochromes as well as in light colors; and his paintings are distinguished by the mellow tones of his strokes and fine delineation, appealing much to the taste of the Japanese. Sesshū, on the other hand, had mastered thoroughly the ink painting of Sung and Yüan, and showed originality. But Motonobu did more for the Japanization of the Sung and Yüan style, and left us a number of his masterpieces. His greatest and most representative works are the pictures painted on the sliding screens in the rooms of the Reiun-in of the Myōshin-ji monastery at Kyoto. The pictures are now peeled off and mounted as forty-nine kakemono. Some are in monochromes, others lightly colored, according to the subjects. The Chinese pictures doubtless served the artist as models for landscapes, flowers, and birds, but in composition as well as in expression, there are traces of Japanization. Indeed, in these pictures every characteristic of his painting is well represented. Some of them are preserved in the Kyoto Onshi Museum of Art and in the Tokyo Imperial Household Museum. (See pp. 302—4)

The following are also famous works by Motonobu:

The Eight Scenes of the Shōshō River in China. A national treasure. Tōkai-an temple, Kyoto prefecture. Mounted in four kakemono. Ink painting on paper. Now preserved in the Nara Imperial Household Museum. (Fig. 101)

Flowers and Birds. A national treasure. Daisen-in temple, Kyoto. Mounted in eight kakemono. Colored on paper. Now preserved in the Kyoto Onshi Museum of Art.

Shaka Triad. A national treasure. Zenrin-ji temple, Kyoto. Mounted in a kakemono. Slightly colored on paper.

The Japanese native style of painting represented by the Tosa

School declined very much in this period. But Tosa Mitsunobu, the contemporary of Sesshū and Motonobu, flourished in the beginning of the sixteenth century. It was remarkable that he raised the fame of the time-honored Yamato-e painting, which was almost dying away in the age when the new school of *sumi-e*, the black and white painting, was so popular. He enhanced his fame by his elaborate and delicate painting in rich colors. One of his best works is the illustrated history of the Kiyomizu-dera temple, which is composed of three scrolls owned by the Tokyo Imperial Household Museum. (Fig. 102)

3. SCULPTURE

The Buddhist sculpture of the Muromachi Period declined pitifully because the Buddhist sects, which had needed many Buddhist figures, did not prosper as before. But noticeable progress was made in portrait sculpture because of the popularity of Zen Buddhism among the leading class of people. The Zen Buddhism, which had little need of Buddhist figures, taught the importance of the individual mind. This attitude of Zen Buddhism naturally valued the greatness of the individual personality and also resulted in the adoration of portrait figures of high priests or great personages. Therefore the greater works of sculpture in this period are found among portrait sculpture.

It should be noticed that for the first time in this period the Noh drama became one of the refined amusements among the feudal barons and aristocratic class. For this the carving of Noh masks became a special work and in this field new progress was attained.

As the medium of sculpture, wood was used almost entirely, and metal work was extremely rare.

As a whole, the sculpture of this period made progress only in portrait sculpture and Noh masks. And all other kinds of sculpture declined. But a few Buddhist sects which needed Buddhist figures still existed and wanted some figures to be worshipped. They showed a certain style and technique, which were peculiar

to this period.

The Buddhist sculpture, which was made principally of wood, lost the greatness and fluency of the Kamakura style, but tried to imitate the delicacy and flowery effect of the Fujiwara sculpture. But it fell into a feeble delicacy, decorated with rather heavy coloring. It was generally covered with golden foils; designs on robes were gold lacquered or wrought in cut gold. Nevertheless, it was far inferior to that delicate and highly refined work of the Fujiwara Period.

In the Tokyo Imperial Household Museum is a figure of Kwannon, the Buddhist god of mercy. This is one of the finest examples produced in the early part of this period, that is, about the fourteenth century. It is a very decorative statue. (Fig. 188)

Among the leading sculptors of this period there were two schools, namely the Middle Buddhist workshop and the West Buddhist workshop, both in Kyoto. The former was represented by the descendants of Jōchō. Inshin, Injō and Inshō were conspicuous among the sculptors of this school. The latter school was represented by those who were followers of the style of Unkei. Kōrin,

Fig. 103. The Priest Butsugai (N.T.)
Fusai-ji, near Tokyo

Kōshū, and Kōsei were known as master hands.

The portrait sculpture made its development only in wood, and it was decorated with slightly colored designs on plastered or lacquered ground. The eyes inserted were generally quartz, having an intuitive glitter. It was also very realistic in individual form and character.

The portrait sculpture in this period represents usually the figures of founders of Zen temples, because of the prosperity of Zen Buddhism, and they are enshrined in founders' halls of the monastery. Besides high priests, the donors or patrons of Zen Buddhism are sometimes figured and enshrined in the temples to which they are intimately related. The figure of Shogun Yoshimitsu in the Golden Pavilion and that of Shogun Yoshimasa in the Silver Pavilion are both famous examples.

In the Fusai-ji temple, not far from the Tachikawa Station, about thirty kilometres west from Tokyo, is a figure of the priest Butsugai (Fig. 103), the first abbot of the temple. The temple was founded by the feudal baron of the district in the fourth year of Bunwa (1355), and belonged to the Rinzai sect of Zen Buddhism. The figure is made of wood, and sits cross-legged on a

Fig. 104. Priest Daiō Kokushi (N.T.)
Myōkō-ji, Ishinomiya

chair, holding a staff in the right hand. The sacred robe hangs down over the knees, flanked by long sleeves. To represent the wrinkles of the aged priest the flesh is deeply scooped off, making sharp edge lines on the cheeks. This technique has a unique effect in presenting the old man's physiognomy by a remarkable contrast of light and shade. A similar technique is used in showing the folds of the robe. All the surface of the figure is now black, but originally the robe was decorated with patterns on the lacquered ground. In the interior side is an inscription stating that the figure was made in the third year of Ōan (1370). It was only nine years after his death, which happened in his seventy-eighth year. As a whole, the statue seems to represent the character and actual physiognomy of this aged priest, and is a highly representative work produced in the early years of this period.

Another remarkable example (Fig. 104) of the portrait figure representing a high priest of the Zen sect remains in the founder's hall of the Myōkō-ji monastery near Ichinomiya city, Gifu. The figure represents Daiō Kokushi, a high priest of Zen Buddhism in the Kamakura Period. It is made of wood and sits cross-legged on a stool. Both hands are placed on the knee, and the right hand holds a staff. The massive head upon the well built body with glittering eyes of quartz, represents realistically the dignity and force of a Zen priest in magnificent form. There is a trace of colored design applied to the lacquered ground.

Confucianism in Japan has a longer history than Buddhism and has done much for the moral development in the political and social life of the people. During the feudal period, that is, from the Kamakura to the end of the Yedo Period, parallel with the Zen Buddhism, it had many followers among the military class of people. In different districts there were schools for Confucianism under the patronage of feudal barons.

In Ashikaga, a historical town, 120 kilometres north from Tokyo, was a school of Confucianism; there still remains an old temple dedicated to Confucius, and originally attached to the school. In this holy edifice is enshrined a unique wooden statue

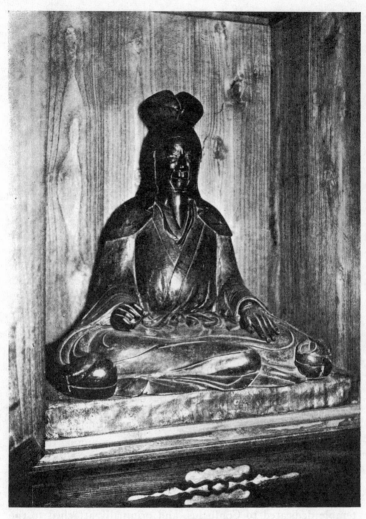

Fig. 105. Statue of Confucius
Seidō, Ashikaga

of Confucius. (Fig. 105) The figure is dated the third year of Tem-mon (1534). It represents Confucius, in his advanced age, with a long beard, as he sits quietly. The character and dignity of the sage is well expressed in the contemplative pose. The surface is now quite plain, but it was originally decorated with a design, and a trace of golden foil remains on part of the collar. This is the best and the oldest specimen of the figure of Confucius in wood.

4. METAL WORK

The industrial arts of the Muromachi Period developed along with the feudal pros-perity, and the metal work made remarkable progress because of the practical need of arms and armor for use in the wars so often fought in the capital and elsewhere throughout this period. Ex-cellent suits of armor were made for Shoguns and other military aristocrats, and many were dedicated to shrines and temples, with prayers for their donor's victory and prosperi-ty. Therefore, examples of armor of this period remain mostly in Buddhist and Shin-to shrines.

In the department of arms and armor of the Metro-politan Museum of Art, New York, there is a good collec-tion of Japanese armor in

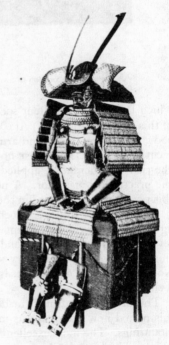

Fig. 106. Grand Armor
Metropolitan Museum of Art, New York

Fig. 107. Decoration of Sword Mounting, by Gotō Yūjō
Tokyo Imperial Household Museum

which there is an excellent specimen of *ō-yoroi*, or grand armor of this period. (Fig. 106) It consists of helmet and defences for body, shoulders, thighs and armpits, dating from the late fourteenth century. The most notable feature of the suit lies in the rich ornamentation applied to it without tresspassing upon the practicality of armor. A new technique that developed in this period will be noticed in the lacquered metal fittings.

Among armor-smiths, Myōchin Muneyasu was the greatest figure. His descendants kept up the fame of the family for several centuries following, and Nobuie, the seventeenth Myōchin, displayed extraordinary skill in tempering iron. Sōtome Nobuyasu, a pupil of Nobuie, is famous as the founder of a new style of helmet.

The art of swordsmith made remarkable development. In this period new progress was made in the decoration of sword mountings. The most excellent sword mountings in metal were produced by Gotō Yūjō who was the founder of the Gotō School which flourished for four centuries. Yūjō was born in Mino

Fig. 108. Ashiya Kettle
Tokyo Imperial Household Museum

province and is said to have died there in 1512 at the age of
seventy. He worked chiefly on the designs supplied by Kanō
Motonobu and was granted the honorable title "Hō-in" by the
Emperor. He carved figures of dragons and lions, men and other
subjects in high relief. His works are full of vigor and life-like
movement, and are characterized by dignity and exquisite work-
manship. Several examples by him are shown in Fig. 107.

His son Gotō Sōjō and his grandson Jōshin were also good
carvers in this period but these first three masters of the Gotō
School did not engrave their signatures on their works; and their
genuineness was certificated by the artists of the Gotō School.

The art of hilt-guard or *tsuba* had an epoch-making develop-
ment in ornamentation, and formed a special art industry in
which the Umetada family became most celebrated. The design
was carved in relief and was very picturesque.

Umetada Shigeyoshi, who was employed by the Shogun Yo-
shimitsu, produced excellent hilt-guards. Kaneie (the first) who

lived at Fushimi, near Kyoto, and flourished in the early part of this period, began to make picturesque designs in relief for iron hilt-guards. His designs were landscapes, and figures of men, plants, and animals, all displaying exquisite chiselling. Myōchin Nobuie also, whose specialty was armor, produced masterpieces in hilt-guards of iron.

In the art of cast iron kettles used in the tea-ceremony, the work made at Ashiya in the province of Chikuzen, was esteemed highly by virtuosi. The kettles made at Ashiya have smooth surfaces, and the designs, by such master painters as Sesshū and Tosa Mitsunobu, were sometimes wrought out by Ashiya artisans. An example of Ashiya kettles is reproduced in Fig. 108. It has a design composed of plum and paulownia trees, said to have been drawn by Mitsunobu. Also at Temmyō in the province of Shimotsuke, good work in iron kettles was produced. Their surface is rough and mostly of no design. But they were likewise appreciated by the tea masters.

5. LACQUER WARE

In this period the art of lacquer work also made a new and notable development in raised gold lacquer and *nashi-ji* or gold pear-skin-like ground. The most famous artists of this period were Igarashi Shinsai and Kō-ami Michinaga. They produced excellent and elaborate wares.

Kō-ami Michinaga, who was personal attendant of the Shogun Yoshimasa, was famous for both raised gold lacquer and work in the *togidashi* style. In the *togidashi* style a design made of gold lacquer is applied to the lacquered ground and covered by thin transparent lacquer; then the gold lacquer design is polished out on the even surface. The designs wrought by him are said to have been supplied by Kanō Motonobu, Nō-ami, Sō-ami and other painters. In carrying out the picturesque designs supplied by such master painters of his time, he used skillfully the raised and flat *togidashi* gold lacquer. In reproducing rocks the raised lacquer was most suitable.

Fig. 109. Gold Lacquer Desk, by Igarashi Shinsai
Imperial Household Collection

Igarashi Shinsai was another noted gold lacquer artist, also patronized by the Shogun Yoshimasa. There is an excellent example of his work in the Imperial household collection. It is composed of *bun-dai* or writing desk (Fig. 109) and *suzuribako*, or ink-stone box. (Fig. 110) The work has a popular romantic design called Tsutano Hosomichi, or Ivy Lane, taken from a famous story entitled Ise Monogatari. For this design the work is given the title "Tsutano Hosomichi." This is an excellent representative work of raised gold lacquer, highly developed in this period.

In the collection of Baron Masuda is another exclleent example (Fig. 111), also highly representative of the gold lacquer of this period. It is a high square box for keeping incense, and measures about 20 centimetres in height. The construction is extremely tender in execution, and unexpectedly light in weight. The decoration consists of the moon, autumnal grasses, rocks, birds, calligraphic elements, and various kinds of insects; all of which are combined and applied most delicately to the outside and inside. The raised and *togidashi* style gold lacquer is executed excellently.

Fig. 110. Gold Lacquer Ink-stone Box, by Igarashi Shinsai
Imperial Household Collection

Fig. 111. Gold Lacquer Box
Baron Masuda's Collection

6. POTTERY

In the earlier part of this period, *temmoku* tea-bowls, such as *yōhen*, *yuteki*, and *kenzan*, and vases and incense burners of *seiji* porcelain, were imported from China and highly appreciated by Cha-jin, or adepts in tea-cult. At the same time the great popularity of the tea-cult encouraged the potters in various parts of the country to produce wares that were suited to the refinement of the ceremony; and in different places new kilns were established. Shino, Jō-ō-Shigaraki, Imbe, and Karatsu wares were all well known potteries of this period produced for the patrons and masters of the tea-cult. The only real porcelain work was Imari.

In the latter part of the period, Spanish and Portuguese merchants brought their native pottery wares as well as Cochin, Luzon, and Annam wares. They were much appreciated by tea-masters and had a certain influence on the art of Japanese ceramics.

Shino-yaki ware was made first during the Bummei Era (1469–1486) by order of a Chajin named Shino Sōshin, serving the Shogun Yoshimasa, who directed a Seto potter of Owari, to make him tea-utensils. The ware itself was of rough quality, and it was glazed with a very thick white enamel, crackled and usually painted with rude floral design. However, a special beauty was found in its glaze and design.

Jō-ō-Shigaraki ware was made during the Eishō Era (1504–1520) at Shigaraki in the province of Ōmi. They produced mainly water pots, tea-jars and flower vases that were much appreciated by the famous tea master called Jō-ō. The ware thus produced was called Jō-ō-Shigaraki. It is very hard and heavy, and glazed with an enamel of a deep yellowish red. The better kind is again covered in parts by pouring, with a transparent light blue glaze on it.

Imbe-yaki ware has the factories which have always been situated in the neighbourhood of the town of Imbe in the province of Bizen. This province has a long history in the pottery

industry of Japan. However, work with artistic merit began in this period. The ware is made of peculiarly hard and extremely dense clay of a reddish brown color which was modelled into tea-utensils, such as bottles or small vases.

Karatsu-yaki ware, the factory of which is situated at the foot of a hill near Karatsu in the province of Hizen, has a long history. In this period, encouraged by the popularity of the tea-ceremony, in which Korean pottery was highly appreciated by tea drinkers, they began to produce an imitation of the Korean work, which is now called Oku-Kōrai, meaning "Old Korean."

7. BUDDHIST ARCHITECTURE

Generally speaking, the architecture of the Muromachi Period (1335–1569) follows the styles developed in the Kamakura Period immediately preceding. But there was a fuller development in the monastery buildings of the Zen sect which was most popular among the leading class of people. The architectural style of the Zen monastery was chiefly Chinese. It was called *karayō* and was introduced in the Kamakura Period. We explained when we studied the Zen architecture of the Kamakura Period the complete arrangement of buildings in the Zen monastery.

There remains no original example of the complete arrangement of a Zen monastery built in this period. But we have some representative buildings that once formed important parts of Zen monasteries.

In the Tōfuku-ji, a head monastery of the Rinzai branch of the Zen sect in Kyoto, there remain the Sammon-gate, the meditation hall, or Zendō, and the toilet or Tōsu, which were erected in this period.

At Bessho, a famous hot spring resort in Shinano province, stands an octagonal four-storied stupa of Anraku-ji monastery. (Fig. 112) This stupa was erected in the early fourteenth century, and is a unique example having an octagonal roof and beautiful appearance. The complicated system of brackets and

radiated rafters sustaining the eaves all represent the Chinese technique. In the interior of the first story is a dais on which is enshrined the figure of Buddha Dainichi.

Near a small town called Toyo-oka, about 35 kilometres northeast from Nagoya, is a famous place celebrated for landscape scenery, known for many years by the name Kokeisan. In the fourteenth century, Musō Kokushi, a famous priest of the Zen sect, founded here a Buddhist monastery called Eihō-ji.

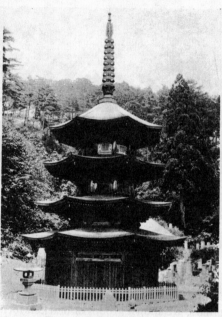

Fig. 112. Octagonal Stupa (N.T.)
Anraku-ji, Nagano

The main temple, Kwannon-dō, founded by him in the year 1314, still exists in a state of good preservation, showing the Chinese style of architecture which had developed in the Kamakura Period.

However, what we are here particularly concerned with is another building of this monastery, which was erected to enshrine the figure of the priest Musō Kokushi, the founder of this monastery, soon after his death in 1352. (Fig. 113) Therefore the building is called the Founder's Hall, or the Kaisan-dō. It consists of a main temple and a hall of worship, joined together by a corridor. The hall of worship or Raidō in front is much larger than the main temple. It is one-storied building of three spans. The roof is thatched with the bark of *hinoki* and has a beautiful slope in

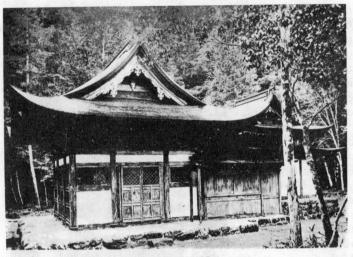

Fig. 113. Founder's Hall (N.T.)
Eihō-ji, Toyo-oka

front and at the rear. Under the eaves, immediately over the
pillars, are shown groups of brackets forming a magnificent kind
of cornice. The rafters are arranged in radii like the bones of a
fan. These are all characteristic features of the Chinese style of
architecture. The ground floor of the interior of the hall is tiled
and spacious for receiving adorants of the main temple. The
main temple stands on a higher ground. It is of one span, and the
construction of brackets is much simpler than that of the hall of
worship. In the innermost place, the holy of holies, is enshrined
a figure of the founder. In a niche at either entrance of the temple
are kept the tablets made sacred to all the deceased chief abbots
of this monastery. So this temple has in its essential nature the
significance of a mausoleum building. The most noticeable feature
of this architecture lies in the fact that the sanctuary and the main
temple are connected by a corridor. This style of architecture was
the prototype of the *gongen-zukuri* which developed later in the
Shinto architecture of the Momoyama and Yedo periods.

About 15 kilometres north from Takayama in the province of Hida stands the Ankoku-ji monastery. It was one of the provincial monasteries erected by Takauji, the first Ashikaga Shogun, who desired to have, under Imperial sanction, a provincial monastery in each province. The original buildings of this monastery no longer exist, but there remains an old building erected in 1408, in which are contained a complete set of Buddhist scriptures. It is a two-storied building of three spans built in the Chinese style. (Fig. 114) The roof is thatched with shingles and

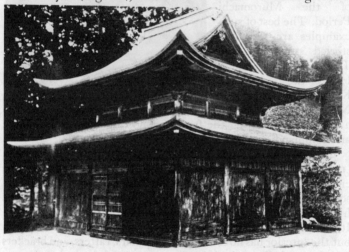

Fig. 114. Scripture Depository (N.T.)
Ankoku-ji, Hida

has a beautiful shape, each corner being curved skyward. In the middle of the interior is set a revolving depository (*rinzō*) for the scriptures, contrived so as to revolve on an axis. The *rinzō* depository is also a rare example made in the same period as the building. In the construction of this architecture, the carving applied to the block called *tabasami*, which is inserted over the bracket system to sustain the rafter, is to be noted. The carving is simple but has several varieties. Some have a carving of cloud-

form and others, floral design (Fig. 115), and the carving in the cornice is highly decorative.

Besides the Chinese style of architecture, the revival of the ancient style of Nara architecture was noticeable in the Buddhist temples of the Muromachi Period. The best of such examples are the five-storied stupa and the Tō-kondō or Golden Hall of the East of the Kōfuku-ji monastery at Nara, both standing on

Fig. 115. Tabasami
Ankoku-ji, Hida

a low hill confronting the famous pond called Sarusawa-no-ike and commanding a beautiful site.

The five-storied stupa (Fig. 116) was rebuilt in the Ōei Era (1393–1427), in accordance with the plan of the original stupa erected in the Nara Period. The first story measures 28.93 feet square, and about 170 feet high, including the finial. It is the highest Buddhist tower, next only to that of the Tō-ji of Kyoto. It has no verandah at the first story. The outside is painted red but the interior has no coloring. The pillars, rafters, and brackets are all stoutly formed, giving an appearance of grandeur in construction and beautiful balance.

The Golden Hall of the East was built at the same time with the stupa. It also has the particular styles of the Nara architecture. The roof has four hips, and in front, under the deep eaves, are shown eight columns without walls, making a magnificent columnal façade. The interior has no floor. Although in details there is the technique of the Muromachi Period, we see in both buildings a revival of the architecture of the Nara Period, giving important examples in the history of Japanese architecture.

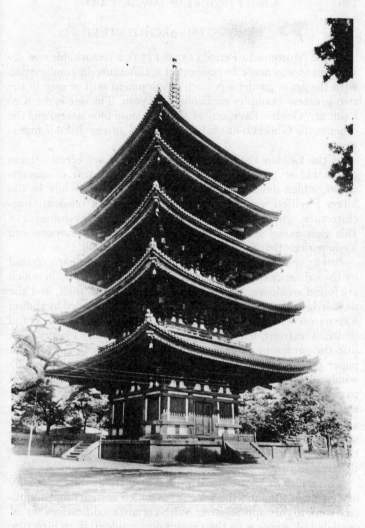

Fig. 116. Five-storied Stupa (N.T.)
Kōfuku-ji, Nara

8. RESIDENTIAL ARCHITECTURE

In the Muromachi Period (1334–1573), a remarkable new development was made in residential architecture in combination with the art of gardening. Such development will be seen in the two greatest examples remaining in Kyoto. The one is the Kinkaku or "Golden Pavilion" of the Rokuon-ji monastery, and the other is the Ginkaku or "Silver Pavilion" of the Jishō-ji monastery.

In the Golden Pavilion and its garden we see certain traces of the old style of residence, known by the name of *shinden-zukuri*, which developed in the Fujiwara Period, while in the Silver Pavilion we find an entirely new style of residential architecture, which is called *shoin-zukuri* The full development of this *shoin-zukuri* architecture was made in the Momoyama and Yedo periods that followed the Muromachi Period.

Briefly speaking, the *shoin-zukuri* architecture is characterized by the existence of a low elevated room, or *jōdan-no-ma*, in which are found an alcove, or *toko-no-ma*, an ornamental shelf, and the desk ledge called *shoin-gamae*. The rooms are divided by sliding screens on which are generally painted pictures in black and white. The front, left, and right sides of the rooms usually open into the garden by sliding screens pasted over with transparent paper on the upper half, and panelled on the lower half, or by windows, all allowing the light to be diffused into the rooms and to reveal the beautiful sight of the gardens when the screens are slid back. In the alcove is hung a picture, in front of which is set an incense burner and a flower vase. The building as a whole seems to have been carefully planned to form an integral part of the garden rather than to have the garden an integral part of the architecture.

This style of architecture is much influenced by the philosophy of Zen Buddhism and the tea-cult, in which rusticity and simplicity were highly appreciated. With certain modifications its essentials still survive in the present-day residential architecture of pure Japanese style.

9. THE ART OF GARDENING

Although gardens were built very early in the history of Japan, there remains no complete example older than the Muromachi Period.

According to a record in the Nihon-shoki or the Chronicles of Japan, the house of Sogano Umako, the Premier in the reign of the Emperor Suiko (592–628), had a small pond dug in the courtyard, in the middle of which was a little island. This garden might be taken as an example of the earliest type of Japanese gardens.

In the Nara Period wild trees and flowers, such as cherry trees, plum trees, azaleas, iris, and other grasses were transplanted to gardens for the appreciation of their natural beauty. In the Manyōshū and the Kwaifūsō, collections of poems composed in the Nara Period, we find some poems referring to the natural beauty of such gardens in the Nara Period.

Such gardens as these seem to have continued to be laid out in much later ages. There are many illustrations of them in picture scrolls painted in the Kamakura Period to illustrate the life of the people. In Fig. 117, we have reproduced an example from a picture scroll called Matsuzaki Tenjin Engi, painted in the year 1311. A room opens on a fine rustic garden, to which water is drawn through a wooden gutter, making a stream running along small hills where ducks play at the margin of the water.

On the other hand, however, in the Fujiwara Period a definite style of garden was crystallized. This was called *shinden-shiki* garden, because it developed in connection with the dwelling houses of the Fujiwara nobles, which were called *shinden-zukuri*, or "bed-chamber" style of architecture.

In the *shinden-zukuri* garden there is a large pond laid out in front of the main building, facing the sunny south where plants thrive best with plenty of light and warmth. An island was built in the middle of the pond; a highly curved bridge was spanned from the north side of the island, and a flat bridge from the opposite side. The island was spacious enough to have a tempo-

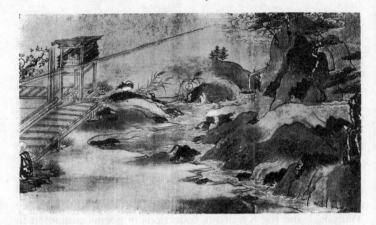

Fig. 117. Ancient Garden Illustrated in the Matsuzaki Tenjin Engi (N.T.)

rary pavilion where music and dance might be performed in the case of a grand fête. On the southere shore of the pond was an artificial hill. At each side of the pond stood a pavilion, facing the pond, one called *izumi-dono* and the other *tsuri-dono;* both were connected by a corridor with a larger building erected on either side of the main hall. Between the intervals of various buildings ran a narrow stream, forming here and there a pretty landscape scene with flowers and tiny plants transplanted from mountains or plains, and finally reaching to the pond.

In a book called Sakutei-ki compiled in the Kamakura Period and no remarkable change seems to have been introduced.

In a book called *Sakutei-ki* compiled in the Kamakura Period is described the general principle of the Japanese gardens built before the Muromachi Period. The book deals principally with ponds, waterfalls, water led into gardens, rocks, trees and islands.

As to ponds, the book gives important instructions. Ponds should be shallow and ducks be allowed to swim on the water, for the sake of ease and comfort to the host. The water should be led in from the east and let go out from the west so that all impurities may be carried off.

As to rock work in connection with ponds or streams, it is explained how to imitate an ocean, a large river, a mountain stream or marshy land. Indeed, the liveliest imagination is used in telling rock faddists how to imitate various phases of nature.

As to the shape of islands, ten different types are mentioned. Among others, are a hill island, a field island, a wood island, a cloud-form island, a "fog-shaped" island, and a delta-shaped island. A short description is given of how to construct all these different styles. For example, to get a hill island, an undulating hill is to be built up in the midst of a pond, on which evergreen trees are to be densely planted; a sandy beach is to be made in front, and then rocks are to be erected on the beach as well as at the skirt of the hill. In order to have beautiful waterfalls in great variety, a number of interesting instructions are given of the shape of the rocks to be used in their construction. It is said that if a waterfall be made facing the moon, the silver light of the moon may be reflected over the falling water on a moonlight night. As to the virtue of trees, the book teaches that the trees were believed to be a mystic ladder leading to heaven. When Buddha taught his peoples, he sat under a tree. When gods descended from heaven they took their way through trees. Therefore the planting should be considered carefully in regard to the human dwelling. With such opinions, instructions are given regarding different kinds of trees and their locations in gardens.

After all, in the gardens constructed before the Muromachi Period, appreciation of the value of the natural beauty, consisting mainly of ponds, hills, rocks, trees, and waters, was stressed most.

At the beginning of the Muromachi Period, the Ashikaga Shoguns and their generals lived in Kyoto and longed after the flowery life of court nobles of the Fujiwara Period. Therefore, their residential buildings and gardens had much resemblance to those of the *shinden-zukuri* style of architecture and the *shinden-shiki* style of garden, both prospering in the Fujiwara Period.

The most famous of the kind were the palatial buildings erect-

ed by the Ashikaga Shogun Yoshimitsu at Muromachi in Kyoto, which was called Hana-no-gosho, or Palace of Flowers, and his villa at Kitayama in a suburb of Kyoto. The villa, with its Golden Pavilion, still remains.

However, the taste and characteristics peculiar to the residential architecture of the Muromachi Period, began to express themselves when the eighth Shogun, Ashikaga Yoshimasa, built his retiring residence at Higashi-yama.

The art of gardening of this period owes much to the direction of Zen priests, such as Musō or Sō-ami. Under such circumstances it was greatly influenced by the doctrine of Zen Buddhism. In the garden of the Silver Pavilion of Kyoto, we find an epoch-making change that had never developed before. It is very different from that of the *shinden-shiki* style of garden. In the garden of *shinden-shiki* style decorated boats floated on the pond. However, the garden of this style is planned for one to appreciate its natural beauty by walking quietly around in the garden. Therefore this style of garden is called *kaiyū-shiki* garden, which means literally "stroll garden."

There are two other famous examples of a similar type of garden laid out in the Muromachi Period; one is at the Tenryu-ji monastery, and the other in the Saihō-ji monastery, both in the suburbs of Kyoto.

There was another style of garden, called *hira-sansui* or *kare-sansui;* the former means literally a level garden; and the latter, a landscape garden with dry stream-basin. Both have a similar style. This style of garden became much smaller and more symbolic and similar in taste to the contemporary landscape paintings in black and white. In the Ryūan-ji temple and also in the Daisen-in temple, we can find the most representative gardens of this style, both remaining in good preservation from the Muromachi Period.

We shall now describe some important examples of gardens laid out in the Muromachi Period.

The Tenryū-ji garden (Fig. 118) is laid out at the Tenryū-ji monastery in a suburb of Kyoto, a short walk from the terminus

Fig. 118. Tenryū-ji Garden
Arashiyama, Kyoto

of the Arashiyama tram line. This monastery was erected for the Emperor Godaigo by Ashikaga Takauji, the first Shogun of the Ashikaga family. The buildings and the garden were constructed under the directorship of the first abbot, Musō Kokushi, who was an able expert in the art of gardening. The original buildings were lost many years ago, and now only the garden remains. It is in almost its original condition, and is one of the best examples of the "stroll garden." This garden is a little older than the Ginkaku-ji garden. It is formed at the foot of a hill beautifully groved. A pond lies at the skirt of the hill, and a stone bridge is spanned across to a miniature island. A number of rocks with fantastic shapes are arranged at the edge of the pond and there are a few in the water. A waterfall flows down from the hill. Although a path leads round the edge of the pond, the garden is mainly intended to be appreciated from the interior of the abbot's dwelling.

The Saihō-ji garden (Fig. 119) is situated on the southern

Fig. 119. Saihō-ji Garden
Arashiyama, Kyoto

skirt of Mount Arashiyama in a suburb of Kyoto, and can be reached easily by a tram car from Kyoto. The Saihō-ji monastery has a long history, but the garden was laid out at the beginning of the Muromachi Period, when the priest Musō Kokushi re-erected the buildings of this monastery. The garden is also a rare example of the stroll garden built at the beginning of the Muromachi Period. The heart of the garden is made by the pond called Ōgon-chi, or Golden pond, which is dug in a level space at the foot of a hill. In the pond have been made two or three little wooded islands, to which extend bridges covered with earth. At the edges of the pond and also in the water as usual, there are rocks. Surrounding it evergreen trees have been planted, and the path goes round under the trees along the pond. The poetic atmosphere of a wild wood and the quiet feeling of still water are effected most harmoniously by the ingenious art of the gardener. At present the most characteristic feature of the garden is the moss all over the ground under the

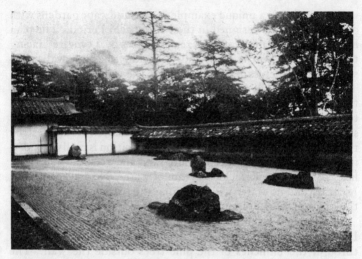

Fig. 120. Ryūan-ji Garden
Ryūan-ji, Kyoto

trees throughout the garden. The soft verdure of the delicate moss, which is said to have more than twenty varieties, makes different patterns wrought only by nature. Because of this, the monastery gets the name Koke-dera, meaning "the Temple of Moss." At a side of the pond stands a tiny tea house, which was re-erected at the beginning of the seventeenth century, about two centuries and a half after the original one, which was made with the garden itself.

The Ryūan-ji garden (Fig. 120) is in the Ryūan-ji temple situated at the southwest side of a historical hill called Kinu-gasa-yama, a short distance from the Ryūan-ji stop of the Arashi-yama tram car line from Kyoto. This temple, belonging to the Zen sect, was founded by a general called Hosokawa Katsumoto, who served the Shogun Yoshimasa during the Bummei Era (1469–1486). The founder lived here in his later years, and the garden was made for his parlour. But now, of the original, only the garden of the Ryūan-ji vicarage remains.

The garden is a unique example of the landscape gardens with dry stream-basins designed in the Muromachi Period. The plan has an oblong shape of small size, 31 metres by 15 metres, facing the south, and on the front and west side it has low walls measuring only 2 metres in height. Outside the walls is a pine grove. The whole ground of the garden is flat and white-sanded. On the sanded ground are fifteen rocks, laid in fives, threes, and twos, grouped at five places. The arrangement of rocks is very skilful, and any change from the original location would destroy the beautiful harmony. Their space composition is really wonderful. There is nothing except white sand and rocks, which seem like rock islets in a spacious stream of water. No tree, no flower, no grass, and no water will be seen in the garden. This is one of the greatest works of imagination in the art of gardening.

However, with this alone the garden would not be complete. It is designed to give a distant landscape view beyond the wall through the branches of the pine trees outside the wall. The pine trees were much smaller in the time when the garden was originally made and a fuller sight of distant landscape scenery was obtainable from the interior. The important meaning of this garden lies in enjoying an extensive natural scenery as a background of the simplest level garden. And this style of garden had much influence on the art of gardening in later ages.

The Daisen-in garden (Fig. 121) is in the precincts of the Daitoku-ji monastery, in the north-west suburb of Kyoto. This is a unique example of rock gardening built in the later Muromachi Period. It is laid out in a small plot of land along the verandahs of the vicarage of the Daisen-in, which is also a unique kind of architecture erected in the same period. This is also called *kare sansui*, or landscape garden with dry stream-basin, but its construction is entirely different from that of the Ryūan-ji vicarage that we have just described. Here the building up of rock work is very complicated, so as to imitate a waterfall and mountain brook in the arrangement of a number of differently shaped rocks. The garden is right-angled along the east and north sides of the vicarage, and is screened with earthen walls

Fig. 121. Daisen-in Garden
Daitoku-ji, Kyoto

from the outside. There is an imitation waterfall at the north-east with upright rocks cleverly combined and shaded with camellia trees; a suggestion of water running out from here to the left and right along the lines of both verandahs is given by white sand spread on the basin. Here and there is a slab bridge. A mountain and a cliff are also skilfully represented with fantastic shapes and cleavages. Every kind of skill and care is exhausted to bring out the feeling of the great beauty of nature in the placing of different kinds of rocks, as if a master painter were depicting a great landscape with black ink on paper. Nowhere else will there be found such an achievement of imaginative rock gardening.

CHAPTER IX

A RENAISSANCE OF ART

(The Momoyama Period 1574–1614)

1. GENERAL SURVEY

The period of Momoyama, or Peach Hill, was the shortest in Japanese history. It was a period of about forty years from the late sixteenth to the early seventeenth century, corresponding to the later High Renaissance in Europe. However, the art of this period extended its influence and played an important rôle in the development of Japanese culture.

The century preceding this period was the darkest age in the history of Japan. Prolonged civil wars were fought between the partisans of the rival pretenders to the seat of the Shogun, and the whole country was in a state of anarchy.

Japan had then to emerge from its chaotic condition and secure political unification. The first man who took up this task was Oda Nobunaga. He was a daring captain who broke away from the past and made himself the harbinger of the new age. However, Nobunaga, in the tenth year of Tenshō, 1582, met untimely death at the hands of a traitor, and left his work unfinished. He was swiftly revenged by his lieutenant Toyotomi Hideyoshi. After that Hideyoshi became the most prominent figure in Japan and in ten years achieved the unification of the nation.

After Hideyoshi had restored peace, he repaired the palace buildings and restored the ruins of the capital of Kyoto. At the same time he began to erect the castle of Osaka, the Jurakudai mansion at Kyoto, and the castle of Fushimi. Meanwhile he sent his army to Korea with the ambition of subjugating Korea, China, and all the Orient. He encouraged poetry, drama, tea-ceremony, and other arts. The great tea-ceremony function held by him at Kitano, the Emperor's visit to his Jurakudai mansion with a full retinue, and his flower-viewing picnic at Daigo,

astounded the whole country by their mighty splendor. Moreover, the expedition into Korea and the intercourse with Portuguese and Spaniards, contained in themselves the evidence of his spirit of enterprise.

The art of the Momoyama Period was indeed created by the taste and lofty imagination of Hideyoshi. His desired impression of unity and grandeur, as well as his joy in conquering obstacles, were expressed in the fine buildings erected at his orders in Osaka, Fushimi, and Kyoto. Everything was of a colossal style, with large proportions and majestic regularity which produced an imposing effect.

The art developed under this atmosphere created by Hideyoshi was characterized by a grand scale, by a magnificence of form, and brightness of colors. Its grandeur was manifested most eloquently in both architectural and decorative arts, by the best artists of his age. The sculpture developed as architectural ornamentation. Painting made remarkable development as interior decoration of buildings, and as grand pictures in rich colors which were usually painted on wall and sliding screens at the partitions of rooms. Fine examples of such architecture and paintings may still be found in some temples in Kyoto and its vicinity.

Meanwhile, the minor arts also made notable development in textile fabrics and in gold lacquer. They are conspicuous for brightness of colors and originality of designs.

On the other hand, there was quite a different phase of art, which made a remarkable contrast with the heavy and ornate form and color. It was an art developed by the influence of the tea-ceremony which was popular among the people of the military class. For the tea-ceremony they had a small and simple building called Sukiya, or Chashitsu. In such architecture the studied simplicity and rusticity were highly appreciated, and the tea-utensils were also of archaic simplicity.

Such was the most notable variety in appreciation of art developed in this period.

However, the Buddhist and portrait sculpture degenerated still more than in the preceding period and almost no example

remains today to be treated separately. Therefore it will be more convenient to describe this ornamental sculpture together with architecture.

2. PAINTING

It is noticeable that a new esthetic attitude, never before attained, was developed in this period. Those who needed magnificent paintings were such military generals as Nobunaga, Hideyoshi, and other minor chiefs. Their attitude toward art was quite different from that taken by court nobles of the Fujiwara Period, and also from that of the military men of the Kamakura and Muromachi periods. They were not so much interested in Buddhist art as in that of the former periods, and were much more interested in magnifying themselves. To display the greatness acquired by their power, through the architectural beauty and decorative painting in which they found satisfaction, they built large castles and magnificent mansions. Therefore Momoyama painting made remarkable development in the field of architectural painting.

The architectural painting was applied mostly to walls and sliding screens at the partitions of rooms. Popular subjects painted on them were pine, cherry, plum and willow trees of lofty forms; and flowers and birds in rich colors on gold leaf. Chinese historical or legendary characters also were popular among them, but Japanese characters were rather rare.

There was also another kind of painting in black and white, on walls and sliding screens in contrast with the ornate and rich colored pictures, giving a variety to esthetic appreciation.

Large folded screens painted in opaque pigments of rich colors on gold leaf were also in vogue as indispensab.e furniture in magnificent rooms of imposing mansions.

There were three important schools of painting in this period, the Kanō, Unkoku, and Hasegawa. The older schools, the Kasuga and Tosa, still remained, but were in the last stage of decadence, and their work was limited to religious paintings.

On the other hand, the Kanō School stood above all the others in prosperity and produced many artists of ability. Among these, Eitoku and Sanraku were the masters who represented the age most notably. They painted gorgeous decorative pictures on walls and sliding screens.

Eitoku, 1543–1590, was the eldest son of Shōei. Early in childhood he studied painting under his grandfather, Motonobu, and came to excel his father, Shōei, in the art. At first he was in the service of Oda Nobunaga, and afterwards of Toyotomi Hideyoshi.

The characteristic features of Eitoku's art were the strength of his brush stroke and his extremely vigorous manner of showing bold crevices in rocks and mountains. His forte was indeed in big work, his style being full of life and animation, with the dazzling brilliancy of colors expressing the heroic spirit of the times. At the request of Hideyoshi he painted the golden walls of the castle of Osaka and the Juraku-dai mansion at Kyoto. He also adorned most of the other principal castles and residences that arose one after another. Thus he had no time to attend to a smaller and more delicate style. Among his works there are pine trees and plum trees sometimes ten or twenty feet in height, and men life-size or even larger. Therefore his paintings are in a way rather rough and it is easy to believe the story that he employed a monstrous brush made of straw. His work well represents the characteristic features of the painting of this period.

One excellent example (Fig. 122) of his work is in the Imperial Household collection. It is a pair of screens, on which lions are painted on gold leaf. It measures 8 feet in height and 16 feet in length. The lions are fabulous in form but royal in aspect. The broad and gigantic composition and bright coloring well represent Eitoku. In a corner is an inscription which reads "Kanō Eitoku Hōin-hitsu," meaning "Painted by Kanō Eitoku Hōin."

In the Jukō-in of the Daitoku-ji monastery remain excellent pictures painted on sliding screens, which are attributed to Eitoku. One of the pictures is composed mainly of a large pine tree, a crane and rocks, all painted in black ink on a ground slightly

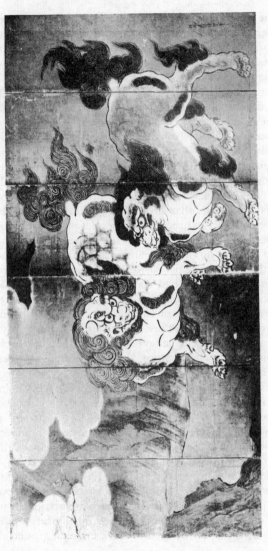

Fig. 122. Lions, by Eitoku
Imperial Household Collection

colored with gold. The living strength of the pine tree and the immovable power of living rocks, painted with a powerful touch of the brush, balance magnificently with the crane and flower under the tree. This massive composition well represents Eitoku and the orthodox style of the Kanō School.

There is another unique example of his work in the Hiun-kaku hall, which was erected by Hideyoshi in his Juraku-dai mansion, and later removed to the Nishi-Hongwan-ji monastery where it still remains.

The following are also famous paintings attributed to Eitoku:

Folding screen painted with the story of Genji. Pair. Imperial Household collection.

Folding screen with flowers. Imperial Household collection.

Folding screen with *hinoki* tree. Tokyo Imperial Household Museum.

Folding screen with a hawk on a pine tree. The Tokyo Fine Art school.

Sanraku, 1559–1635, was made a personal attendant of Hideyoshi, who recognized his rare ability in painting, and placed him under Kanō Eitoku to study. Afterwards, Hideyoshi caused him to enter into paternal relations with Eitoku and take the family name of Kanō. The young pupil mastered the spirit of the Kanō School, and in landscape, human figures and flowers, his works resemble those of Eitoku. Sanraku excelled in painting gorgeous pictures that adorned walls and sliding screens. His art reached its climax in expressing the heyday of the powerful Hideyoshi. After the downfall of the House of Hideyoshi, Sanraku retired to a temple, but was soon allowed by Ieyasu, the first Shogun of the Yedo Period, to return to Kyoto. It was at the time of his retirement that he assumed the name of Sanraku (Mountain Enjoyment).

One of the best of his works is in the Tokyo Imperial Household Museum. It is a pair of screens, with Chinese figures painted on it. On one of the pair is painted the Chinese Taoist legend of Chō Ryō (Chang Liang), and on the other Kokei Sanshō, or The Three Laughers in the Tiger Valley.

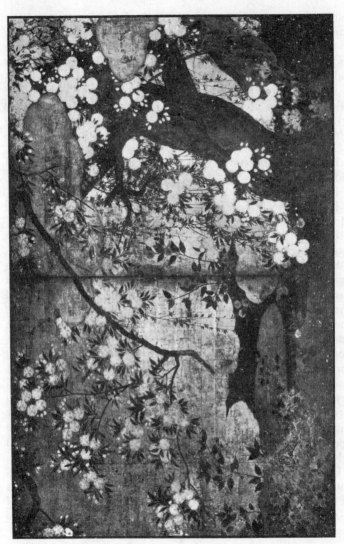

Fig. 123. Cherry Tree in Full Bloom, by Sanraku (N.T.)
Chijaku-in, Kyoto

Sanraku was also a great painter of flowers. There is a magnificent picture attributed to him, representing a cherry tree in full bloom, painted on the wall of a building of the Chijaku-in monastery of Kyoto. (Fig. 123) It is said traditionally that this wall painting was originally in the Momoyama castle erected in 1593 by Toyotomi Hideyoshi. The picture painted on paper is pasted on the entire wall, measuring 5.6 metres in length and 1.7 metres in height. The artist endeavoured to depict "spring joy of flowers," shining through gorgeous clouds of gold. The larger branches of a cherry tree spread out from a gigantic trunk to the right and left over the gold ground. The drooping branches of willow with their fresh green leaves make a charming color contrast to the magnificent cherry blossoms, symbolizing a quick growth of life. In the foreground blue water flows quietly from a near by pond; dandelions, pansies and water lilies blossom in profusion; floating clouds form the background. This was intended to represent an everlasting Paradise on earth, and to make the occupants of the room feel as if they were in the garden of Extreme Happiness. It is, indeed, one of the most representative examples of the highly decorative pictures of the Momoyama Period.

Another excellent example of Sanraku's work, representing trees, flowers and tigers, will be seen in the interior decoration of the Tenkyū-in chapel of the Myōshin-ji monastery of Kyoto. The subject is painted on panels and on sliding screens which divide the interior into three rooms. In the middle room are painted bamboo bushes and a group of tigers, which were the favorite subjects of the Momoyama painters for symbolizing the feeling of power. And in one of the two side-rooms are painted morning glories, lilies, chrysanthemums and other flowers, making the room feel like flowery spring. In the other side-room are represented an old plum tree in bloom and an old willow with drooping branches. These make a broad composition on a long extensive gold leaf field of eight sliding screens. Between the trees is a huge immovable rock covered with partially melted snow, on the right and left of which the willow and the plum tree

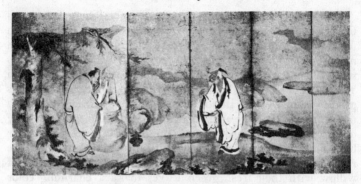

Fig. 124. Three Tasters of Vinegar, by Yūshō (N.T.)
Kyoto Onshi Museum of Art

extend their stout trunks outward. A few tiny birds flying from
the top branches of the plum tree seem to tell of the coming of
spring by their thin cries and swift flight into the golden sky. On
one branch of the willow, under the drooping branches green with
shoots of new hope, perch two white herons in meditation. These
pictures of Tenkyū-in chapel are enrolled as national treasures.

Another famous painter of the Momoyama Period was Yūshō
(1533–1615). He first studied under Kanō Eitoku, but later de-
veloped a liking for the style of Liang K'ai of the Sung Dynasty
of China, and finally founded a school of his own, called the Kai-
hoku School. He was almost as famous in landscape, human
figures, flowers and animals as were Eitoku and Sanraku. He
liked to paint human figures with as few brush strokes as possible.

In the Myōshin-ji monastery at Kyoto are five pairs of folding
screens, enrolled as national treasures, all of which have Chinese
figures painted by him. Except for one pair, on which is painted a
floral picture, the subjects painted on them are taken from Chinese
legends and stories.

On a pair of these screens is painted the picture of Three Tas-
ters of Vinegar, and the two hermit sages, Kanzan and Jittoku.
In Fig. 124 is reproduced the picture of Three Tasters of Vinegar.
They represent a Confucianist, a Taoist and a Buddhist priest.

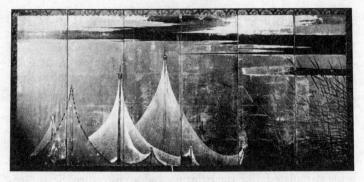

Fig. 125. Fishing Net, by Yūshō
Imperial Household Collection

They taste the same vinegar, but each experiences a different taste from the others. Although the taste is different, its source is in the same vinegar. With this the picture symbolizes that the ultimate source of Taoism, Confucianism, and Buddhism is the same, despite what they preach being different. In the depiction of these sacred figures the painter used only a few brush strokes. His figures are called "bag-like pictures" or *fukuro-e*, because their garments have a few folds like bags, as will be seen in this picture. Such is one of the characteristic features of Yūshō's portraiture. This pair of screens is preserved in the Kyoto Onshi Museum of Art.

In the Zenko-an chapel in the Kennin-ji monastery of Kyoto there is another example of his best work. It consists of pines painted on sliding screens in black ink on gold leaf. The broad power of the brush and the magnificent shape of pines on the gold background have a wonderful decorative effect for a small room. This is also a national treasure.

In the Imperial Household collection there is another unique pair of screens on which are painted nets hung up to dry. The first impression we get in facing this picture is the novelty of design. The artist found an art motive in fishing nets hung out to dry and patches of green-leafed rushes. He has succeeded in

embodying the poetry of simplicity and quietness. (Fig. 125)

Beside these three great masters of the Kanō style, two other eminent masters lived in this period. They were Unkoku Tōgan and Hasegawa Tōhaku. Both mastered the style of Sesshū, the great master in the preceding period. Tōgan became the founder of the Unkoku School, and the latter founded the Hasegawa School.

3. METAL WORK

The industrial arts of the Momoyama Period made a new start, being stimulated, like the painting and architecture, by the triumphant and flowery feeling of those upstarts who took advantage of the age of conflict and dissension and carved out their positions by their own powers. Under such an atmosphere, the composition of design was naturally free and broad and extraordinarily vivid in display. As gold and other bright hues appealed most to their taste, the color scheme applied to industrial arts had an advancing rhythm of the warmest nature. We find the best examples in gilded metal fittings, gold lacquer, and polychromatic decorations applied to architecture.

But on the other hand there was a contrary taste which was inculcated by the tea-ceremony. In the tea things we find a studied simplicity and archaic treatment of nature.

Now, the metal work of this period made remarkable progress in the art of decorative metal fittings, arms and armor, in sword furniture, and in iron kettles used in the tea-ceremony.

Excellent examples of decorative metal fittings applied to architecture will be seen in the buildings of the Sambō-in in the Daigo-ji monastery near Kyoto, in the Kara-mon gate of the Hōkoku-jinja Shrine in Kyoto, in the Mausoleum (Otamaya) of the Kōdai-ji monastery in Kyoto, in the main hall of the Kangaku-in in the Onjō-ji monastery at Ōmi, in the Chikubu-shima Shrine on the Chikubu-shima Island in Lake Biwa, and in the Zuigan-ji monastery of Matsushima in Sendai.

In such buildings we see fine gilded metal fittings with floral

designs that are applied profusely to both their interior and exterior. For example, they are applied to the ceilings, horizontal members, the upper and lower ends of capitals, and rafter-ends, or to the pediments. They give emphasis to the color scheme of the architecture and express the gorgeous feeling of the age.

In Fig. 126 we have reproduced a fine example of gilded bronze fitting used at the capital of the Chikubu-shima Shrine. The outline of the floral scroll is of *repoussé* work and the details are produced by hair-line engraving.

In the art of making sword blades, there was a famous swordsmith, called Minju, in Kyoto under the patronage of Hideyoshi. He was also an able artisan in making *tsuba* and metal carving. His pupils, Ichijō Kunihiro and Hashimoto Tadayoshi, were also famous swordsmiths.

In the art of making sword furniture, there lived Gotō Kōjō, the

Fig. 126. Capital Ornament
Chikubu-shima Shrine

fourth of the Gotō family and Takujō, the son of Kōjō, who died in the eighth year of Kwan-ei (1631) at the age of eighty-two. Their work was excellent and assumed a bold aspect.

In armor-work, Muneie and Munenobu of the Myōchin family and Saotome Ieharu were noted artisans.

Fig. 127. Phoenix and Paulownia in Gold Lacquer (N.T.)
Chikubu-shima Shrine

4. LACQUER WARE

The art of lacquer ware made special development in a new direction as decorative art. It was free and original in composition as well as in the use of gold lacquer that expressed the gorgeous and flowery taste of the times.

In the Chikubu-shima Shrine at Chikubu-shima Island in Lake Biwa, there remains a unique example of gold lacquer applied to the constructive members of the interior of the building. The design is composed of chrysanthemums with streaming water, long-tailed birds perching on branches, phoenixes with paulownia trees, shells or sea-grass. They are very picturesque and in beautiful harmony with the carvings and paintings of the walls and friezes. The gold lacquer is executed in *hiramakie* technique in which the design is flat on a lacquered ground. The inside of the floral design is sprinkled over with gold dust on a lacquered *nashi-ji* or pear-skin-like gold ground and some other designs made of thin gold-plate are imbedded on the ground. Such was the new technique of gold lacquer work developed in this period. This is an example of the most representative gold lacquer work applied to interior decoration. In Fig. 127 we have reproduced a phoenix flying over the paulownia tree, produced by this technical process of gold lacquer. This is applied to the horizontal timber in the inner sanctuary of the shrine. The motif of this design is of Chinese origin. It is said that the phoenix never rests on any tree

Fig. 128. Gold Lacquer Dinner Tray (N.T.)
Kyoto Onshi Museum of Art

Fig. 129. Detail of Fig. 128

but the paulownia and that it feeds on the fruit of the bamboo; it is supposed to appear only in times of peace and prosperity.

Another most important and representative example of gold lacquer of this period will be seen in the large group of gold lacquered utensils owned by the Kōdai-ji monastery of Kyoto. They are placed on view in the Kyoto Onshi Museum of Art.

In Figs. 128 and 129 is reproduced one of the dinner trays which is the finest of them. The whole ground is lavished with thick gold-filing, and a lake-side scene is shown in gold lacquer over which are scattered paulownia crests. The gold color is emphasized here and there by cut-gold applied to rocks and leaves. Tiny silver nail-heads attached to the leaves sparkle like diamonds of dew. The gorgeous feeling of the Momoyama Period is thus expressed skilfully by the gold lavished on every part of the tray in harmony with its exuberant life.

As to the gold lacquer artists of this period, Kōetsu, Sei-ami, and Kō-ami Chōan were most famous.

5. CERAMIC ART

In this period ceramic art made particular development under the influence of Hideyoshi's partiality for the tea-ceremony and for antique objects, and also under the encouragement of such virtuosi as Sen-no Rikyū, Hosokawa Yūsai and others who displayed a similar taste.

Chō-yū, popularly known by the name Chōjirō, began to produce Rikyū wares at Kyoto with the clay found in the premises of the Juraku palace erected by Hideyoshi. They were of such excellent quality that Hideyoshi gave him a seal bearing the character "Raku" to be impressed on them. Hence his wares got the name of Raku-yaki. Tea-bowls produced by him were highly appreciated by the adepts of the tea-cult because their soft texture was agreeable to the lips and kept the tea warm longer than did hard stone wares. Since his time, Raku-yaki ware has always been appreciated by the adepts of the tea-cult. In Fig. 130 we have reproduced a tea-bowl by Chōjirō. It has a broad form and a warm

Fig. 130. Raku-yaki Tea-Bowl, by Chōjirō
Tokyo Imperial Household Museum

reddish glaze. It measures 7.3 centimetres in height and 10.6 centimetres in diameter. This is on view in the Tokyo Imperial Household Museum.

On the other hand, the Korean potters brought to Japan by those Daimyos who returned in triumph from the Korean expedition in the Bunroku Era(1592–1595), contributed much to the development of ceramic art in Japan, especially in the districts of Kyushu.

The Imari-yaki ware of Arita was much improved by a Korean potter Ri San-pei; the towns, Chōsa in Satsuma, Takatori in Chikuzen, Yatsushiro in Higo, and Hagi in Nagato were all new centres of porcelain industry, originated mainly by those potters brought to Japan from Korea.

6. ARCHITECTURE

The gorgeous spirit of the Momoyama Period was expressed

most eloquently in architectural construction and ornamentation. For the first time in this period Japanese architecture underwent a great change. Until now the history of Japanese architecture had been mostly religious; but at this time lay-buildings in large numbers came to outshine the temple buildings.

The most notable innovation appeared in castle architecture. Older castles had been simply in the shape of ramparts and stockades, but the introduction of fire-arms demanded a thorough improvement in their construction. Deep moats, generally two or three, one within the other, were now dug round the castle, while inside the moats, high stone walls were erected with *tamon* (gateways provided for the passage through the stone wall) and several storied towers were built at the corners. The gates had massive wooden doors provided with strong latches. Inside the gate there was a square court, and still further within it stood an inner gate reached by a bridge. Inside the castle proper, were built stately and magnificent palaces of *shoin-zukuri* architecture. Then a high central tower rose above all the buildings to add to the grandeur and to serve also as a vantage point for commanding a bird's-eye view of the surrounding country.

The first great castle of this kind was erected at Azuchi by Nobunaga at the southern shore of Lake Biwa in Ōmi in the year 1576. The place is a wonderful landscape looking over the extensive water of the lake. However it was destroyed in 1582 and today nothing remains except some of its stone walls and foundation stones. But there are reliable descriptions of the castle, recorded by a priest called Nanke, who actually saw the castle shortly after its completion. The Christian missionaries under the patronage of Nobunaga also reported its grandeur to their homes. According to such reliable records, the principal tower of the castle was seven-storied. Each room was wonderfully decorated with magnificent pictures and carvings in gold and other rich colors, never before seen in the architecture of castles. The attached palace-buildings were decorated with gorgeous designs, likewise in gold and rich colors.

The castle of Osaka, erected by Hideyoshi, was built on a much

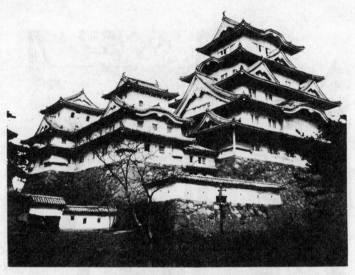

Fig. 131. Castle of Himeji (N.T.) (*Gov. Rys. Photo.*)

greater scale than that of Azuchi, and displayed fully his kingly greatness. This castle was, however, destroyed with the downfall of his son Hideyori, leaving only the extensive site and gigantic rocks of the foundation on which we see the new castle recently restored.

The castle of Fushimi near Kyoto, also erected by Hideyoshi in his later years, was likewise magnificent and included a number of various buildings. It survived the defeat of the Toyotomi family and its ownership passed into the hands of the Tokugawa Shogun. But in the time of the third Shogun of Tokugawa, it was destroyed and some of the dwelling quarters were transferred to different places where most of them remain, and show some of their original glory and splendor.

The castle of Himeji is the only existing specimen of a donjon erected by Hideyoshi in the Momoyama Period. (Fig. 131) The

Fig. 132. Jōdan-no-ma (N.T.)
Nishi-Hongwan-ji, Kyoto

castle of Nagoya is the finest among the existent feudal castles in Japan. In it we see the specimens of a magnificent donjon and annexed palace-buildings, but they were built early in the following Yedo Period.

Parallel with the remarkable development of the castle architecture, residential buildings also made remarkable development. The most gorgeous dwelling houses were built in the precincts of castles, as residential quarters of the lords. The architectural style of these residential buildings was called *shoin-zukuri* which had already begun to develop in the preceding period. The highest development of the *shoin-zukuri* architecture was, however, reached in the residential buildings erected by Hideyoshi in the castle of Fushimi. Some fine examples of those buildings still remain in the Nishi-Hongwan-ji monastery where they were transferred from the castle of Fushimi in the year 1632. The Momoyama Period was really the golden age of the *shoin-zukuri* architecture. The *shoin-zukuri* buildings of this period became much more gorgeous and decorative than were those in the preceding period, although the general plan was the same. The most important room in the *shoin-zukuri* architecture is the elevated room, called *jōdan-no-ma*, which is used by the lord for guests or for the reception of his subjects.

In Fig. 132 we have one of the finest examples of the *jōdan-no-ma* that remains in the Nishi-Hongwan-ji monastery of Kyoto. As will be seen in the reproduction, the walls, sliding screens, and the ceiling are painted with various pictures in colors on the golden ground. Among them the most important and attractive painting is that on the wall of the largest recess, called *toko-no-ma;* and next, are the pictures painted on the four heavy sliding screens called *chōdai-kazari* which have heavy lacquered frames decorated with beautiful gilded metal fittings. Besides these, the cupboard called *chigai-dana* fixed in the smaller recess at the side of the greater recess, and the desk ledge called *shoin-gamae* by the window not shown in our reproduction, are also indispensable constructions in the *shoin-zukuri* architecture. The ceiling is also gorgeous. In our reproduction it will be seen that it is coved and

has compartments. The inside of each coffer is painted with flowers on gold leaf and the frames also are decorated with gilded metal fittings. The sliding screens called *fusuma* at the partitions of the rooms are all painted with pictures. This is also an essential interior decoration of the *shoin-zukuri* architecture. The frieze-like spaces of the wall, between the cornice and lintels are filled in with wooden panels with perforated carving, which is called *ramma*. The perforated carvings of the *ramma* were also painted elaborately in rich colors. In Fig. 133 we have selected a fine example of panel frieze in the same building of the Nishi-Hon-

Fig. 133. Panel Frieze (N.T.)
Nishi-Hongwan-ji, Kyoto

gwan-ji monastery. It is a beautiful carving in open work, representing squirrels among grapes.

After all, the highest kind of *shoin-zukuri* architecture should have the elevated room in which are an alcove (*toko-no-ma*), a cupboard (*chigai-dana*), a desk ledge (*shoin-gamae*), painted sliding screens (*fusuma*), the panel frieze (*ramma*), and four heavy panelled sliding screens (*chōdai-kazari*).

Except for the *chōdai-kazari* all the others are essential interior decorations of the guest room of *shoin-zukuri* architecture, even of a meagre kind.

The floor of the *shoin-zukuri* architecture is quite simple. It is only laid with straw mats, called *tatami*. The broad open gallery

called *hiro-en* or *irigawa* which opens to the garden is another characteristic feature of the *shoin-zukuri* architecture as will be seen in Fig. 134. It is very spacious. It makes a happy combination with the garden and gives a feeling of space.

Fig. 134. Open Gallery of the Shoin-zukuri

The gateways attached to the *shoin-zukuri* architecture also displayed magnificent decorations.

There still remain in Kyoto three gorgeous and magnificent gates, which had once expressed the pride of Hideyoshi or of his generals at the castle of Fushimi. One stands as the gate of the Hōkoku Shrine which was erected to the soul of Hideyoshi. Another gate stands at the entrance of the Nijō castle which was built by Ieyasu, the first Tokugawa Shogun, the rival and successor to Hideyoshi. The third one remains at the Nishi-Hongwan-ji monastery in Kyoto. They are all calld "Kara-mon" gates, but the most elaborate and magnificent is that which stands at the Nishi-Hongwan-ji monastery. (Fig. 135) It has three pillars or uprights at both ends, a circular one at the

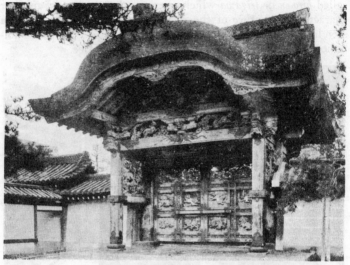

Fig. 135. Kara-mon Gate (N.T.)
Nishi-Hongwan-ji, Kyoto

middle and two square ones at the outer side, linked together by horizontal members. These six pillars support the splendidly shaped roof covered with the bark of *hinoki* wood. The front and back eaves are gabled in the Chinese fashion called *kara-hafu*. The shape resembles the upper jaw of a lion and has a heavy and oppressive look. But the gables of the right and left sides are shaped in Japanese fashion called *chidori-hafu* which has a triangular form with a pointed top as if soaring to heaven, and are quite in contrast to the oppressive style of the Chinese gables. The pillars, doors, beams, and ribs are all thoroughly coated with black lacquer on which brilliant metal fittings are profusely set with gorgeous effect. Over the lintel a large carved peacock stretches its splendid plumage decorated with bright colors and gold leaves. On the beams of both sides are large tigers with bamboos carved and colored. The beam-ends are carved in the forms of lions and peonies. On the transverse panels

in open work are represented the heroes of Chinese legends. (Fig. 136) And on the door panels are conventional lions in various forms. As a whole all the subjects of design are taken from the Chinese classics, but in them are expressed the gorgeous spirit of the times and the Japanese originality in composition.

In contrast with such imposing buildings as the castle and *shoin-zukuri* architecture, there developed an extremely simple kind of architecture. It was the tea-ceremony house called *chashitsu* (tea room) or *sukiya* (a house of the imperfect). Its development was in-

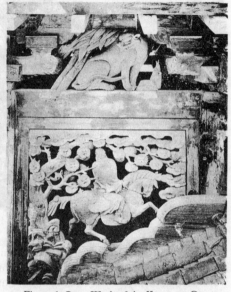

Fig. 136. Open Work of the Kara-mon Gate
Nishi-Hongwan-ji, Kyoto

fluenced entirely by the tea-ceremony. The tea room was already initiated in the preceding period by the Shogun Yoshimasa. It was the famous tea room of four and a half mats, which still remains in the Tōgū-dō erected in the garden of the Jishō-ji monastery in Kyoto.

It is, however, nothing more than the room where tea was served in a simple *shoin-zukuri* building. But in this period, Rikyū, the celebrated master of tea-ceremony appeared and tea-ceremony house architecture made an independent development under his directions. One of the most conspicuous changes was that the four and a half mats space of the original tea room began to be lessened until it finally reached as small a space as one mat and a

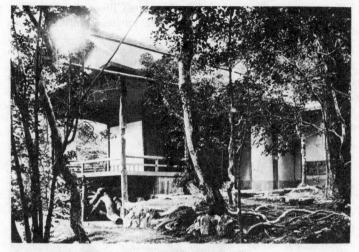

Fig. 137. Shōnan-tei Tea-ceremony House (N.T.)
Saihō-ji, near Kyoto

half. The material used was also very humble and crude and the construction was quite simple. For example, pillars with bark were used and rafters were made of boughs or bamboo; the walls were made of rough earth, and the entrance was so small that the guests had to creep in. The window is also the simplest. The ceiling was generally made of reed or bamboo. The roof was usually thatched with straw. The garden attached to the tea room was also left as natural as possible. The essential idea of Rikyū was that the things which happened to be at hand should be used ingeniously in some way or other so that a highly tasteful result might be secured.

It is highly interesting to note that there were two contradictory aspects in the architecture of this period; that is, the magnificent castle and gorgeous *shoin-zukuri* architecture on one hand; and on the other the simple and archaic architecture of the tea room house. Such contradiction would be the outcome of the human desire for change and variety. The tea room archi-

tecture has continued to the present day, passing through the entire length of the Yedo Period; but in many examples of the later tea room architecture, the principle of the tea-ceremony established by Rikyū has often lost its true meaning.

There still remain three important examples of the tea-ceremony house from this period. One is the Myōki-an of Yamasaki, Kyoto prefecture; the second is the tea-ceremony house in the precinct of the Shinto shrine called Minase-gū near Yamasaki; and the third one is the Shōnan-tei at the Saihō-ji monastery, Kyoto. They are all enrolled as national treasures.

In Fig. 137 we have reproduced a general view of the Shōnan-tei, a tea-ceremony house built in the Keichō Era (1596–1614). The house has a high floored open verandah in front. Its structure is quite a rare example. The ceiling is made of hardened earth. The design of the inside is very simple but beautifully done, as will be seen in Fig. 138. The light is so well diffused into the room through the windows that it gives a feeling of brightness when one enters the room.

Of the Buddhist architecture of the Momoyama Period the entrance porch and the main hall of Zuigan-ji monastery at Matsushima and the Kondō or Golden Hall of Tō-ji monastery in Kyoto will perhaps be the most noteworthy examples among those which still remain.

Of the Shinto architecture, a new style called *gongen-zukuri* first came into existence in this period. The building of Ōsaki Hachiman Shrine at Sendai is the oldest example of the *gongen-zukuri* architecture. It was erected by Date Masamune, the Lord of Sendai in the twelfth year of Keichō (1607), and displays gorgeous features characteristic of the Momoyama Period. It has a main hall and an oratory, connected by a stone-floored chamber. The ground plan is complicated and the roofs of various sizes form what is called *yatsumune-zukuri* or eight-ridged construction, presenting a beatiful variety. The roofs are thatched with shingles of *hinoki* bark. The lower half of the constructural members of this building, namely the panels, pillars and floors, are all black lacquer and glitter with glossiness. With the black lacquered sur-

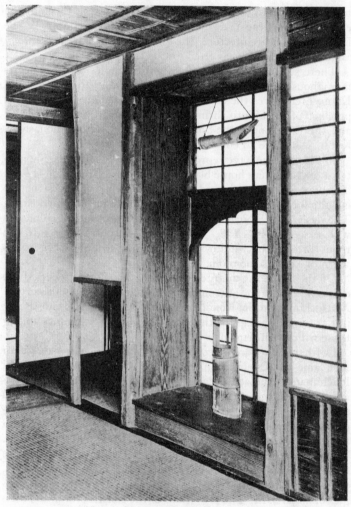

Fig. 138. Interior of Shōnan-tei Tea-ceremony House (N.T.)
Saihō-ji, near Kyoto

face, gilded metal fittings are used profusely. The upper part, namely the various horizontal members, groups of brackets, *kaeru-mata*, or frogleg supporters, are decorated beautifully with polychromatic designs and carvings. The exterior as well as interior color harmony are most wonderful. It is an interesting feature of this architecture that its interior decoration expresses a feature of Shinto and Buddhism. The carving of Buddhist angels on the friezes carries out this idea most conspicuously, as will be noticed in Fig. 139.

Fig. 139. Interior of Ōsaki Hachiman (N.T.) *Sendai* (*Photo. taken by the author*)

CHAPTER X

PLEBEIAN ART

(The Yedo Period 1615–1866)

1. GENERAL SURVEY

The Yedo Period lasted from 1615 to 1866, covering about two centuries and a half. It was the most peaceful period of national seclusion in Japanese history, during which time literature and arts first made remarkable progress among the masses. Before this, the culture of each period had been almost entirely monopolized by a specific class, such as court nobles, military aristocrats, or Buddhist priests, and commoners scarcely benefited from the culture developed among these privileged classes. However, in this period, plebeians could think for themselves and do as they liked. In the course of these peaceful years they accumulated wealth, while the military men, who now had to live only upon a definite emolument given by the government of the Shogun or feudal lords, gradually became so poor that they could not enjoy comforts and amusements.

In 1603, Ieyasu became Shogun and established his Shogunate in Yedo. But on the other hand, Hideyori, the son of Hideyoshi, still held the castle of Osaka against the Tokugawa Shogunate, until he was totally crushed by the force of Ieyasu in the year 1615. After this, Yedo became the most important social, and political centre. As all the feudal lords had to reside periodically in Yedo, they built mansions, thus attracting merchants and artisans to the city.

It immediately became great and prosperous, so that scholars and artists also followed and ultimately made it a centre for literature and fine arts, which gave birth to what we now call the plebeian culture.

The first Shogun, Ieyasu, instructed his successors not to use military power for governing the people, though they might use

it to bring the country under their sway. This precept was observed strictly in his generation. During the beginning of the Yedo Period, that is about the first half of the seventeenth century, a warlike spirit still pervaded society. A valiant touch was naturally shown in the painting of the day, and a grand style, the heritage of the preceding Momoyama Period, was' shown in the architecture.

In these early years of Yedo, mausoleum architecture took the place of the castle-building that had marked the preceding period, because big castles menacing the peace of neighbours was strictly prohibited. Among the famous mausoleums are Tōshō-gū Shrine at Kunōzan, Suruga province; Daitoku-in at Shiba, Tokyo; and Nikko Shrine in Shimozuke province. Of these, Nikko Shrine is the finest.

The Genroku Era (1688–1704) was most significant in the development of the plebeian arts. A hundred years previously the warlike spirit still prevailed and social life was not yet well harmonized. But during the Genroku Era, effeminacy and luxury crept into every tissue of the social organization. It was indeed in the Genroku Era that such popular literature as "haikai" and popular drama made a great advance and opened a new world of popular literature. The pompous and flowery manner of life was shown in gay robes of rich colors and bold designs. There were many artists who tried to make a mark in this new world.

Painting made unprecedented development. A number of master painters appeared in different branches of painting and established new schools.

Sculpture, generally speaking, declined except for small things such as masks, *netsuke*, and so forth.

Industrial fine art made striking progress in Yedo, the seat of the Shogun, Kyoto, and many local districts under the patronage of feudal lords. Pottery, gold lacquer, and textile industries made the most remarkable progress in every direction.

2. PAINTING

In the world of painting, the painters of the Kanō School held the highest position all through the entire period of Yedo; but they were all bureaucratic painters clinging strictly to their traditional styles. Among them, Tannyū was the greatest. Other master painters were Naonobu, Yasunobu, Morikage and Tsunenobu.

The Tosa and Sumiyoshi schools kept up their time-honored traditions in the classical style of painting. The masters of both schools were court painters in Kyoto. However, the painters of the Sumiyoshi School came down to Yedo later and worked for the Shogunate government with the painters of the Kanō School.

In the middle of the Yedo Period, the Chinese painting of the Southern School, or Nangwa, was introduced by I Fu-chiu and other Chinese painters, through Nagasaki, the trading port at Kyushu. This style, originally formed and loved by literary men of China, had a fertile soil for a remarkable development among Japanese scholars because the Shogunate government very much encouraged the study of Chinese classics as an administrative policy. Its great masters were Taiga, Buson, and Kwazan.

However, the most characteristic features of the plebeian art of the Yedo Period will be seen in the school of decorative painting created by three geniuses, Kōetsu, Sōtatsu, and Kōrin, in the early seventeenth century; and in the Ukiyo-e, or genre painting which developed remarkably in the Genroku Era (1638 –1704); and in the Maruyama and Shijō schools, the masters of which took great pains to copy nature faithfully in depicting landscapes, flowers, and birds.

It is also notable that in the later Yedo Period European painting was introduced through the port of Nagasaki. Hiraga Gen-nai and Shiba Kōkan studied Dutch painting and left us some interesting Western pictures. Such painters as Bunchō, Hiroshige, and Kwazan were also more or less influenced by Dutch painting.

THE KANŌ SCHOOL

The Tokugawa Shogun gave special patronage to the painters of the Kanō School. The spiritual inspiration of the Kanō painters was in Confucianism, the doctrine of which became a leading idea of the administration of the Shogunate government.

In the period of Yedo, society was divided distinctly into different classes according to professions. The highly honored military class had to know the Chinese classics. The painters of the Kanō School who worked for them naturally made these classics the source of their inspiration.

To meet the needs and desire of the military class, the members of the Kanō School usually painted Chinese subjects. For example, the portrait of Confucius, the Seven Wise Men in the Bamboo Grove, or the Four Esthetic Accomplishments—writing, painting, psaltery, and checker board, were favorite subjects. As animal subjects they often painted Chinese sacred animals, such as Dragons, Tigers, Lions or *Kirin*. The dragon was one of the divine beasts depicted as a four-footed reptile. It was believed that in the spring it ascended to the skies and that in autumn it buried itself in depths of water. It was usually painted in various ways in association with clouds. The tiger was a beast of many mythical attributes. He was believed to be the greatest of four-footed creatures, representing the masculine principle of nature, and was usually painted with bamboo. The lion was popular for its magnificent form and was usually painted with peonies. The *kirin* was a pair of supernatural Chinese creatures, the alleged appearance of which was regarded as a happy portent of the advent of good government or of the birth of virtuous rulers.

Of birds, the favorites were cranes and the phoenix. The crane was believed to live more than one thousand years. It is said that its plumage is white because it loves cleanliness, and that its cry reaches heaven. With its powerful wings it flies high over the clouds. It is the king of the birds and the friend of hermit saints. The phoenix is a mythical bird. In ancient legends it is narrated that it made its appearance as a presage of the

advent of virtuous rulers. In pictorial representations it is usually delineated as a cross between the peacock and the pheasant, with the addition of many gorgeous colors; and it is usually painted with the paulownia because it never perches on any other trees.

Of the trees, Kanō masters were fond of painting the pine and plum trees and bamboo. These three were traditionally combined as triune friends and were believed to be lucky and happy symbols of the New Year.

In landscape painting, eight famous Chinese views of Hsiao and Hsiang (Shōshō-hakkei) were favorite subjects. As other more bureaucratic subjects, virtuous Chinese kings and loyal subjects were selected from the famous Chinese illustrated book called Teikan Zusetsu (Ti-chien t'u-shuo).

The most suitable style of painting for such subjects as are mentioned above were worked out ably by three eminent Kanō masters, Tannyū, Naonobu, and Yasunobu in the seventeenth century. They were three brothers, but Tannyū was the greatest and his name was very popular. Each opened an academy. The Academy of Yasunobu was called Nakabashi Kanō, because Yasunobu lived in the street called Nakabashi; the Academy of Tannyū was called Kajibashi Kanō, taking the name of the street where he lived; and the Academy of Naonobu was called Kobi-kichō Kanō.

Kanō Tannyū, 1602–1674, the eldest son of Takanobu, was initiated by Kanō Kō-i into the secret of the family style of Kanō. He was highly interested in the various styles of painting and mastered almost every branch of them. He acquired different styles according to the subjects he had to paint. For example, when he intended to paint court ladies he used a touch of the Tosa School. When he painted landscapes, the touch of his brush was more like that of the Unkoku style. And when he painted Chinese figures, his own family style was conspicuous. Finally he effected a radical modification in the accepted canon, and gave a new life of great elegance and delicacy to the old Kanō style. His success won him the honor of being the last one of the three greatest Kanō masters, the other two having been Motonobu in the

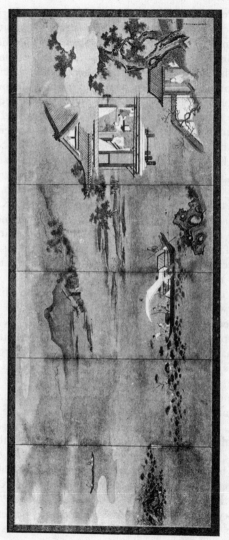

Fig. 140. Landscape Painting, by Tannyū

Tokyo Imperial Household museum

Muromachi Period and Eitoku in the Momoyama Period. He left us many masterpieces that amply illustrate his greatness.

One of his masterly works is a picture representing the history of Nikko Shrine. It shows his power in the manipulation of the Tosa style. The picture is painted on paper in colors and mounted in five makimono, which are owned by the shrine and enrolled as a national treasure. The lions and *kirin* painted on the panels of the sanctuary of the Nikko Shrine, as well as the tigers in a bamboo grove, painted on the sliding screens at the partitions of the rooms of the Ko-hōjō building of the Nanzen-ji monastery of Kyoto, are also famous works by him. In Fig. 140 is reproduced one of his landscape paintings, which is in the possessions of the Tokyo Imperial Household Museum.

Kanō Sansetsu, 1589–1651, was an adopted son of Kanō Sanraku. He made a new departure in the technical method of painting. He usually painted in black and white, quite unlike Sanraku, his father-in-law, who had excelled in the use of rich colors. He became the founder of the Kyoto branch of the Kanō School in the Yedo Period.

Kanō Kō-i, d. 1625, studied at the studio of Kanō Mitsunobu, but was afterwards converted to the style of Sesshū and the Chinese master Mokkei. In the vigor of his strokes, as is shown in his landscape and human figures, he stands somewhat distinct from many masters of the Kanō School. He took charge of the training of Tannyū and his two brothers, Naonobu and Yasunobu.

Kanō Naonobu, 1607–1650, also called Jiteki-sai, brother of Tannyū, painted rather rough pictures of landscape, human figures, birds, and flowers, unlike those of his brother Tannyū who had highly elaborated the details. His style resembled that of the Chinese master, Mokkei. He was patronized by the third Shogun, who bestowed on him a residence in Kobikichō, Yedo; hence he is generally known as the founder of the Kobikichō branch of the Kanō Academy.

In the Tokyo Imperial Household Museum is preserved one of his master works, which represents Eight Famous Chinese

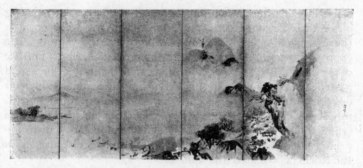

Fig. 141. Landscape Painting, by Naonobu
Tokyo Imperial Household Museum

Views of the Hsiao and Hsiang rivers. (Fig. 141) This was painted in his prime and shows the broad and powerful touch of his brush in black and white.

Kanō Yasunobu, 1613–1685, followed more faithfully the traditional canon of the family style, but his brush falls somewhat below that of his two brothers, Tannyū and Naonobu. He painted the figures of Chinese saints on the walls of the Imperial Court. He founded the Nakabashi Academy of the Kanō School.

Kanō Tsunenobu, 1636–1713, first studied under his father Naonobu, and after the latter's death, under his uncle, Tannyū. He was a master painter of the Kanō School, whose best works may stand comparison with those of the great Tannyū.

Kusumi Morikage flourished in the late seventeenth century. He entered the atelier of Tannyū and mastered the Kanō style. But he studied also the styles of Sesshū, of old Tosa, and some Chinese masters, and finally evolved methods different from those of Kanō. In his late years he served the lord of Kaga and had some influence on the designs of Ko-kutani porcelain wares.

DECORATIVE PAINTING

In the early Yedo Period there lived two great masters, Kō-etsu and Sōtatsu, who did much for the development of Japanese

taste and laid a foundation for progress in the decorative painting of the Yedo Period. Kōetsu was a genius who was well versed in the arts of pottery, gold lacquer, calligraphy and painting. He expressed a purely Japanese taste in form and color. On the other hand, Sōtatsu excelled in decorative painting which had a particular beauty of coloring. After him, appeared Kōrin, who developed further the style of decorative painting inaugurated by Sōtatsu. He worked for rich merchants in the Genroku Era (1688–1703), and founded the Kōrin School. Hōitsu, who appeared in the later Yedo Period, was the only great master of the Kōrin School after the founder.

Sōtatsu, 1576–1643, was born in the province of Noto and died at Kanazawa. His family name was Nonomura, and his personal name, I-etsu; but he was popularly called Tawaraya Sōtatsu. He had several other pseudonyms beside Sōtatsu; they were I-nen Taisei-ken and Ryūsei-ken. He first studied the Kanō style of painting in Kyoto, and then the old style of the Tosa School. His works may be divided into three periods. In the first period they showed some influence of the Kanō School. In the second period, he combined the Kanō style with that of the Tosa. But in his last period he discarded the Kanō style entirely, and used the Tosa style in an original way. His creative ability was recognized in his third period. The composition of his pictures is rather simple, but full of originality. Usually his lines are drawn in light black ink and their beautiful curves give a soft and calm feeling to his pictures. He always avoided the harsh and straight lines which the Kanō masters had been quite fond of using. The most characteristic feature of his painting was its unique color scheme. This brought him great fame. He understood thoroughly the value and intensity of color. He did not use many different colors, but showed marvellous ability in contrasting various colors with black ink. He mixed black ink with gold or with other colors while the black ink was still wet. Its effect is quiet and sublime and very much decorative. His great merit is evident in several of his masterpieces that still remain.

His masterpiece is owned by the Imperial Household. It is a

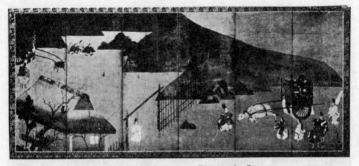

Fig. 142. Genji Monogatari Picture, by Sōtatsu
Baron Iwasaki's Collection

pair of folding screens of eight leaves. The ground is of gold leaf, on which is pasted paper cut into the shapes of outspread fans and painted with different subjects, such as armored soldiers, court nobles, flowers, and landscapes. The color scheme is wonderful. The brightest tone of the gold ground is beautifully harmonized with the variety of colors used for the pictures, and his colors are full of wet freshness. (Color plt. 3)

The following pictures are also his master works:

Folding screens overlaid with fan-shaped papers on which different kinds of pictures are painted in rich colors. A national treasure. Pair. The Sambō-in, Kyoto.

Folding screens painted with the Genji Monogatari pictures of "Sekiya" and "Miotsukushi." (Fig. 142) Pair. Baron Iwasaki's collection.

Kōrin, 1653–1716, was an eccentric genius among Japanese artists. His family name was Ogata but he had several pseudonyms, Hōshuku, Jakumei, and others. At first he studied under Kanō Yasunobu and Sumiyoshi Gukei. But he was most deeply indebted to Kōetsu and Sōtatsu, and created a style of his own that is amazingly original in design. He applied gold and silver paste to get the most effective result in decorative painting. When he painted in ink he often obtained a pleasing effect by mixing gold paste with wet ink. He painted figures, landscapes,

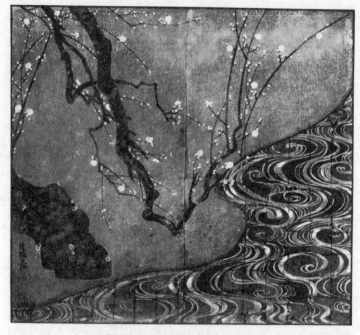

Fig. 143. Plum Tree, by Kōrin (N.T.)
Count Tsugaru's Collection, Tokyo

flowers, and birds with bold sweeps of the brush. He did them all with equal facility but he was most fond of painting flowers. He was the most famous painter of decorative pictures in the Genroku Era (1688–1703), the golden age of luxury for the commoners in the Yedo Period.

Kōrin left us quite a number of his masterpieces. One of them is a pair of folding screens, owned by Count Tsugaru of Tokyo. (Fig. 143) On each screen is painted a large plum tree with a broad stream of water on a ground of gold leaf. The large trunks of these plum trees are painted in black and green with a wet freshness of color; both blooming, one white and the other red,

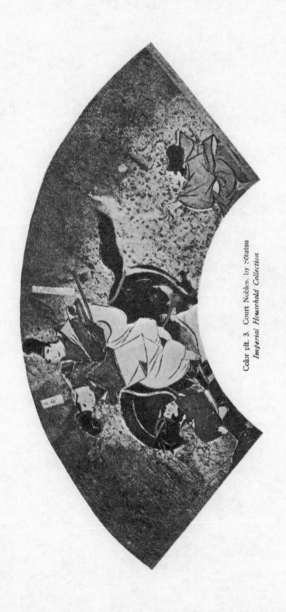

Color plt. 3. Court Nobles. by Sōtatsu

Imperial Household Collection

Fig. 144. Azalea by a Brook, by Kōrin (N.T.)
Baron Ino Dan's Collection, Tokyo

with all the vitality of early spring. The broad streams are painted in silver. The composition is spacious. The form and color scheme are magnificent. Its decorative value is great.

The following are also his famous works which still remain:

Folding screen with a figure of Taikō-bō. Colored on paper. A national treasure. Tsunekichi Kobayashi's collection.

Azalea by a Brook. Colored on paper. A national treasure. Baron Ino Dan's collection. (Fig. 144)

Ise Monogatari Picture. Colored on silk. Tokyo Imperial Household Museum.

Folding screen with iris flowers. Colored on a ground of gold leaf. A national treasure. Owned by Mr. Kaichiro Nezu, Tokyo.

Hōitsu, 1759–1828, whose family name was Sakai. He studied the styles of Kanō, Tosa, and Maruyama schools. Later on, however, the works by Kōrin appealed to his fancy and he mastered his style. Among representative examples of his work are two picture scrolls painted with flowers and birds of four seasons in

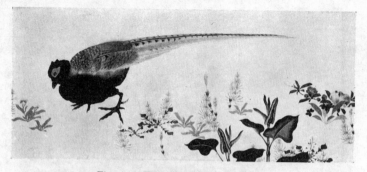

Fig. 145. Flowers and Birds, by Hōitsu
Tokyo Imperial Household Museum

rich colors on silk. The scrolls are owned by the Tokyo Imperial
Household Museum. The excellent touch of his brush and his
variety of rich colors are the characteristic features which make
him a master of decorative painting in the Kōrin style. (Fig.
145)

UKIYO-E PRINT AND PAINTING

Ukiyo-e, the genre picture, initiated by Matahei and his
followers in the early Yedo Period, became the most popular
plebeian art. It includes two kinds of pictures, one of which is
painted by hand, and the other printed from blocks.

The subjects painted by the Ukiyo-e painters were full of
variety. However, the favorite subjects were the famous beauties
of Yoshiwara or love scenes. The next favorite subject was the
actors, because the theatre was then the most popular amusement
and provided active subjects for the Ukiyo-e painters. But they
did not paint them realistically. In painting beauty each painter
had his own ideal. Sharaku, for example, was all the time paint-
ing his own type of beauty under multitudinous disguises. Like-
wise, Utamaro painted his own particular type of beauty.

Ukiyo-e painters were also sometimes interested in making
travesties on sacred figures. For example, they painted Fugen,

the Bodhisattva of All Pervading Wisdom, on the back of an elephant in a sitting posture, holding a love letter, instead of holding a Buddhist scripture. Daruma, the founder of Zen Buddhism, was often represented as being soothed by a beauty with a love letter.

The development of Ukiyo-e may be divided into four periods, as follows:

The first period, from the Keichō to the Meireki Era (1596–1657). This was just a preliminary period of the Ukiyo-e picture.

The second period, from the Kwambun to the Gembun Era (1661–1740). In this

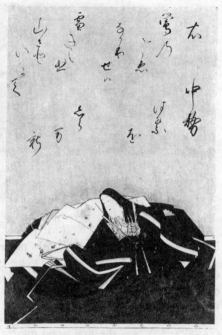

Fig. 146. One of Thirty-six Poets (N.T.)
By Matahei
Tōshō-gū Shrine, Kawagoe City

period the Ukiyo-e, painted in colors, was prosperous.

The third period, from the Kwampō to the Tempō Era (1741–1843). In this period the Ukiyo-e, printed in colors, was prosperous.

The fourth period, from the Kōkwa to the Meiji Era (1846–1912). This was the period in which color prints declined.

In the first period, the best known painter of the early Ukiyo-e picture was Iwasa Matahei, who belonged to the Tosa School. One of the most authentic paintings by him is preserved in the oratory of the Tōshō-gū, in the city of Kawagoe, near Tokyo.

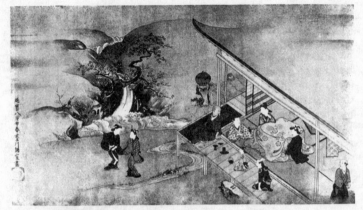

Fig. 147. Ukiyo-e Painting, by Hishikawa Moronobu
Tokyo Imperial Household Museum

It represents the famous thirty-six poets. (Fig. 146)

In the second period (1661–1740), a remarkable development was made in Ukiyo-e painted by hand (*nikuhitsu Ukiyo-e*). However, on the other hand, Ukiyo-e print (*Ukiyo-e hangwa*) began to develop.

Hishikawa Moronobu, who appeared in the Genroku Era (1688–1703), was the first great master who contributed to the development of both colored paintings and primitive prints of Ukiyo-e. He learned all the best features in Ukiyo-e paintings that had developed before him and established his own style, which is known by his family name Hishikawa. He was especially fond of painting professional beauties, scenes of flower-viewing parties, and customs and manners in general.

In the Tokyo Imperial Household Museum is a picture scroll which contains a number of his works painted at different times in colors on silk. Therefore the pictures are excellent examples for the study of his paintings. (Fig. 147) Another masterpiece by him is a picture scroll representing customs and manners in Yedo, which is owned by Baron Masuda in Tokyo.

It was he who enhanced the beauty of prints to a very high

standard of art. His work became the foundation of the later development of Japanese color prints. He first made the so-called single sheet print, or *ichimai-e*, in black and white. On this kind of prints he did not leave any signature. Therefore, it is not certain which ones were by him and which by his followers. He for the first time produced picture books which appealed much to the masses and had a great run among the common people. He embellished such prints in black and white with dull red color by hand. They were called *tan-e*. He did not at all intend to copy the real colors, giving but a mere touch of reddish color. After *tan-e*, there developed what is called *urushi-e*, a style in which part of a picture is painted with black lacquer or black ink mixed with glue and the rest colored with warm hues, so as to make a harmonious contrast with the black.

In this period there was also a remarkable development in the pictures of signboards of theatres. The pioneer in this field of Ukiyo-e painting was Torii Kiyonobu, who became the founder of the Torii School. He flourished in the Genroku Era (1688–1703). Most of his works that remain today are *tan-e* or *urushi-e*.

In the early eighteenth century, there developed a school called Kwaigetsudō the artists of which usually painted by hand the professional beauties of Yoshiwara. The founder of this school was called Kwaigetsudō Andō and his followers prefixed Kwaigetsudō Matsuryū above their names, which means the followers of the Kwaigetsudō School. They usually painted a woman alone, but sometimes added a smaller woman beside a large one. (Fig. 148) They seldom produced works in print.

Miyakawa Chōshun, 1682–1752, another famous painter, did not produce prints, but excelled in beautiful color painting. His followers also, except for Katsukawa Shunshō, did not produce color prints.

In Kyoto there appeared an able Ukiyo-e painter called Nishikawa Sukenobu who flourished in the first half of the eighteenth century. He excelled both in color painting and prints. But his prints were used only in picture books.

In the third period (1741–1843), a remarkable development was made in what is called crimson prints, or *beni-e;* and then further development was achieved in what is called *nishiki-e;* or brocade-picture.

But before describing these two kinds of color prints and their artists we shall pause here to see the unique processes by which Japanese color prints are made, so that our readers may understand why they deserve so much fame throughout the world.

First of all, it must be understood that the color print is not a reproduction of a picture in colors. It is entirely different from a colored reproduction. Any reproduction of a famous painting is necessarily inferior to the original; and no one will

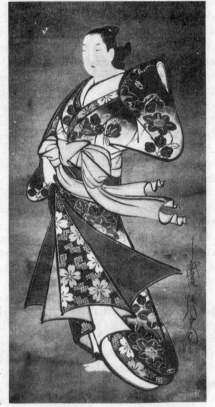

Fig. 148. Lady, by Kwaigetsudō Andō
Tokyo Imperial Household Museum

take it for the original. But in the Ukiyo-e print, the case is entirely different. There is no independent colored picture to be reproduced by printing. The Japanese color print is produced by the co-operation of three different artists; that is, the painter, the engraver, and the printer. The painter first draws a picture in black and white, this being known as the *shita-e* or "founda-

tion picture." Then the engraver transfers this foundation picture to the block. What colors are to be applied to what portions of the picture are noted by the painter in letters. Then the printer actually applies the colors to the blocks, so as to get the desired effects.

The lines in color prints are very different from those drawn by painters with brushes. The lines traced on the blocks express the skill of the engraver, and assume quite a different beauty from that of brush painting. The painter of the original lines must consider what kinds of lines will get the best effect when they are transferred to the block by his engraver. Therefore, the characteristics of the lines of the color prints depend mostly upon the engraver. But the final finish is achieved by the printer. The printers transfer the lines to the paper by pressing them with a kind of pad called *baren*. The pressing of the colors gives them a certain fine lustre which can never be obtained by hand coloring.

It will now be clearly understood that in making up a color print three artists—the painter, the engraver, and the printer—must co-operate closely from the beginning to the end. When the three co-operate well, the best kind of Ukiyo-e print will be produced; and it deserves higher appreciation than does the painting. This is the reason why Japanese color prints are so highly prized.

As has been said, in the period from Enkyō (1744–1747) to Hōreki (1751–1763) the first step of progress was made in what is called *beni-e* color print. *Beni-e* literally means crimson picture. The principal color of the *beni-e* print is a soft vegetable pink. The pink is generally used in contrast with green, yellow, and some other colors. But the colors are not graded so as to get beautiful tints and shades as they are in the brocade picture which developed later.

The size of *beni-e* was generally small, measuring one foot in height and half a foot in breadth. Okumura Masanobu and Ishikawa Toyonobu were outstanding painters who produced a number of fine *beni-e* prints.

Okumura Masanobu, 1690–1768, is said to have been the pupil of Torii Kiyonobu. He studied the Hishikawa style and founded his own style. He was a painter and publisher of color prints.

Ishikawa Toyonobu, 1711–1785, studied Ukiyo-e in the studio of Nishimura Shigenaga. He was fond of painting men and women of a quiet type. He made many efforts for the advancement of color prints and left excellent pictures printed in two or three colors.

After *beni-e*, a much finer color print, called *nishiki-e* or "brocade picture," developed. As the name brocade picture denotes, a number of different complimentary hues and tints were used skilfully so as to give a complicated, yet very harmonious color scheme as a whole.

The most meritorious pioneer in the development of brocade picture prints was Suzuki Harunobu. His style was studied further by Isoda Koryūsai and Ippitsusai Bunchō. On the other hand, Kitano Shigemasa and Utagawa Toyoharu were all able masters and established their own styles. They flourished during the Meiwa and An-ei eras (1764–1780).

The following Tem-mei and Kwansei eras (1781–1800) are known as the golden age of the brocade print. In this golden age appeared such able masters as Katsukawa Shunshō, Tōshūsai Sharaku, Torii Kiyonaga, Kubo Shumman, Kitakawa Utamaro and Hosoda Eishi. The favorite subjects painted by these masters were usually beauties or actors.

The most outstanding and representative master painters among them were Harunobu, Shunshō, Kiyonaga, and Utamaro.

Suzuki Harunobu, 1718–1770, usually painted beautiful women of tea houses and daughters of merchants; but rarely actors of Kabuki theatres. He did not try to paint real faces of individuals. He acquired great fame for his special type of beauty. Even between his different figures there was almost no distinction. And even when he painted two young lovers, the young man and woman had nearly the same type of face. His figures are highly idealistic and look like fairies who have just

come out from the land of dreams. He tried to express their
mental attitudes. He excelled in the depiction of dresses. His
design, his colors, and delicate line movements are all intended
to represent the inner hearts of the figures. (Color plt. 4)
Harunobu generally tried to give architectural as well as lands-
cape background, and in this he was quite successful.

In contrast with beauties painted by Harunobu, the beauties
by Kiyonaga, 1753–1815, are more realistic. Kiyonaga's lines
are more powerful than those by Harunobu. His clothes envel-
op real women, not dreamy nor ephemeral ones like Haru-
nobu's. While Harunobu is much more spiritual and more or
less celestial, Kiyonaga's beauties are much more terrestial and
sensuous in form and colors.

Another famous master was Katsukawa Shunshō(1726–1792).
He painted famous beauties and portraits of actors. Of his pupils,
Shunkō and Shun-ei were prominent.

Kitagawa Utamaro, 1754–1806, first studied the Kanō style
and then entered the studio of Toriyama Sekien, devoted much
attention to the style of Torii Kiyonaga, and became a master
painter of his day. He specialized in painting the busts of beau-
ties. He was usually so engrossed in painting the beauties them-
selves that he did not pay much attention to the background.
(Fig. 149)

From the Bunkwa and Bunsei eras (1804–1829) the art of
engraving progressed even more, but the pictures drawn for
making prints rather declined. However, the subjects painted by
the Ukiyo-e painters extended to much broader fields. Lands-
capes, flowers and birds, the contemporary customs and manners
became favorite subjects. Noted painters who flourished in this
period were Katsushika Hokusai, Utagawa Toyokuni, Utagawa
Kunisada, Utagawa Kuniyoshi and Andō Hiroshige.

Katsushika Hokusai, 1760–1849, studied first at the atelier
of Katsukawa Shunshō. Then he studied the styles of the Kanō
and Tosa schools. Moreover, he paid attention to the Chinese
painting of the Ming Dynasty. By Shiba Kōkan, he was initi-
ated into the painting of the West. He was attracted by many

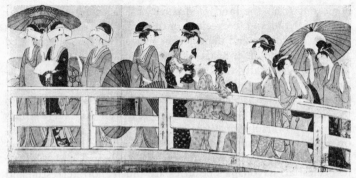

Fig. 149. Ladies on the Ryōgoku Bridge, by Utamaro
Tokyo Imperial Household Museum

other styles also and often changed his style. Whenever he changed his style he used a new pen name. The fact that he changed it more than twenty times shows how hard he worked. His painting was distinguished by free and bold strokes and fertile designs. The subjects he painted were full of variety, human affairs of daily life, historical events, natural scenery, flowers, and birds. He had very astonishing ability in seizing the essential points of things, which he exaggerated, as will be seen in his picture of Mount Fuji, the crest of which seems to be pulled high up to heaven. (Fig. 150) His genius was expressed most remarkably in this field. His prints representing thirty-six different views of Mount Fuji are the best examples of his ability in landscape painting He once painted Japanese customs and manners for a Dutch captain in two scrolls, and obtained much admiration. After this, his pictures were so highly esteemed in Holland that hundreds of them were sent there every year.

Andō Hiroshige, 1797–1858, studied in the studio of Utagawa Toyohiro. He excelled in the delineation of noted scenes, among which are the famous Fifty-three Posting-stations on the highways of the Tōkaido.

Large collections of color prints are to be found in the United States, in the Museum of Fine Arts in Boston, in the Metro-

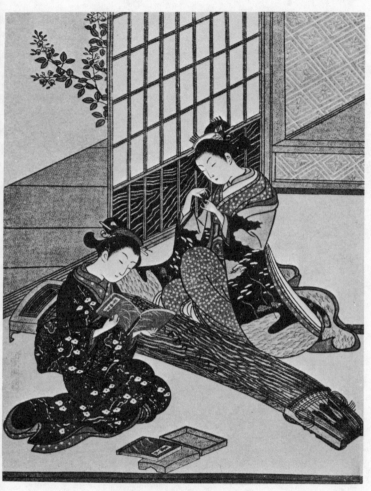

Color Plt. 4. Lady, by Harunobu
Mr. Shigekichi Mihara's Collection

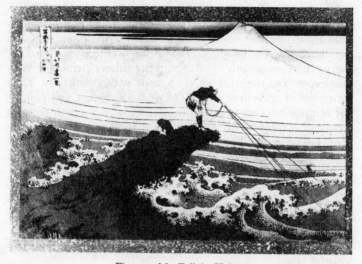

Fig. 150. Mt. Fuji, by Hokusai
Tokyo Imperial Household Museum

politan Museum of Art, New York, and in the Art Institute of
Chicago; in London, in the British Museum, and in the Victoria
and Albert Museum. The superb collection of Mr. Shigekichi
Mihara in Tokyo is said to be the best in Japan. But it is not
open to the public. Some fine examples are to be seen in the
Tokyo Imperial Household Museum.

THE NANGWA SCHOOL

The Nangwa, or Southern School, originated in China and
made the greatest development in the Ming and Ch'ing Dynasty.
But it was introduced to Japan by I Fu-chiu in the Kyōho Era
(1716–1735) and had much influence on the literary style of
painting which began to develop among the scholars of Con-
fucianism, who formed their own social community between
the military class and the plebeians of the Yedo Period.

The Nangwa School is therefore called Bunjin-gwa or Literati painting. In the technique of the Bunjin-gwa painting, the chiaroscuro of ink was essential. Deep and light colors, wet and dry touches of the brush, played an important rôle in making the pictures successful. The Nangwa painters painted mostly landscapes. But they did not try to copy nature faithfully. They were fond of travelling to see the works of nature and painted the impressions they received from it. Therefore their pictures were highly subjective. Above their pictures they usually wrote poems in Chinese. Thus Nangwa painting generally goes with calligraphic writing. However, its most essential feature is the expression of poetic thought through form and colors.

Therefore the trend of their pictures is transcendental, much unlike that of the Ukiyo-e, or genre painting, and the Maruyama and the Shijō schools which are attractive for the beauty of realistic expression.

After all, the Nangwa painting is rather scholarly and full of Chinese taste.

Gion Nankai, 1677–1751, a genius in literary work, studied the Chinese School and originated in Japan the style of the Nangwa School before a Chinese master of the Southern School, I Fu-chiu, came to Japan.

Sakaki Hyakusen, 1698–1753, also called Hō-hyakusen, lived in Kyoto and shared with Nankai the honor of the pioneer masters of the Nangwa School.

Taiga, 1723–1776, sometimes called Taiga-dō or Ike-Taiga, was a great master of the Nangwa painting. From childhood he excelled in painting and in writing. Usually he painted in light black with slight color, but sometimes he used a small quantity of gold with the black ink. His conception was lofty and full of poetic imagination. In the Mampuku-ji in Kyoto and in the Henjōkwō-in of Mount Kōya, are preserved a number of his master works which are enrolled as national treasures. In the Tokyo Imperial Household Museum is one of his master works, which represents a famous view of Lake Seiko (Hsi-hu) in China. (Fig. 151)

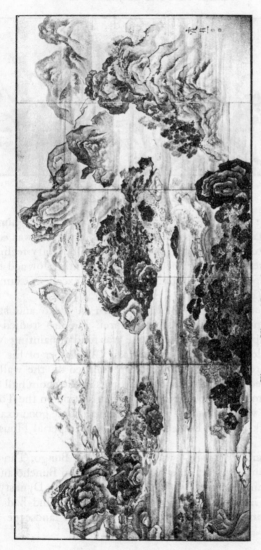

Fig. 151. View of Lake Seiko in China, by Taiga
Tokyo Imperial Household Museum

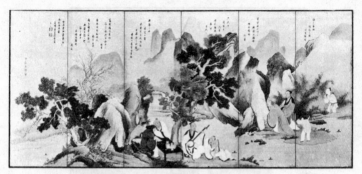

Fig. 152. Chinese Landscape, by Buson
Tokyo Imperial Household Museum

Buson, 1716–1783, sometimes called Yosa Buson, Shunsei or Yahantei, an eminent master of Haikai epigram, was equally great in literati painting. His works are full of lofty feeling. A folding screen with a Chinese landscape painting, owned by the Tokyo Imperial Household Museum, is an excellent example of his work. (Fig, 152)

Tani Bunchō, 1764–1841, was born in Yedo and studied painting in the atelier of Katō Bunrei. He also studied other schools, Japanese and Chinese. He was fond of painting Mount Fuji, and left us many masterworks. A number of his landscape pictures in black and white are painted on the walls and sliding screens at the partitions of rooms in the Shoin hall of the Honkō-ji monastery, near the Washizu station on the Tōkaido line at the western side of Lake Hamana. Some good examples of his work are also owned by the Tokyo Imperial Household Museum.

Chikuden, 1777–1835, was born at Oka in Bungo. Tanomura was his family name. He studied under Tani Bunchō and also studied Chinese painting of the Ming and Ch'ing Dynasty. On the other hand he was a scholar and a poet and had many accomplishments; but he was most gifted in landscape painting.

Kwazan, 1793–1841, was born in Yedo. His family name was Watanabe. He was a man of strong filial piety and great ambition and was a pioneer student of Dutch. He studied painting under Bunchō, Sō Shizan, and Kaneko Kinryō. He loved to paint landscapes, but excelled also in figures, flowers, and birds. His paintings are marked with vigorous strokes and daring designs. He left a large number of his works.

Urakami Shunkin, 1779–1846, Yamamoto Bai-itsu, 1783–1856, Okada Hanko, 1782–1846, Tsubaki Chinzan, 1801–1854, and Nukina Kaioku, 1778–1863, were all master painters of the Nangwa School.

THE MARUYAMA AND THE SHIJŌ SCHOOLS

It was a notable aspect in the Yedo Period that the different kinds of art were brought down within the reach and understanding of the common people. Now in the world of painting the Maruyama and the Shijō schools attracted the interest of the people in general with the realistic beauty of nature, parallel with the Ukiyo-e painting which approached the people with pictures dealing with the daily affairs of human life.

Before Maruyama Ōkyo established the Ōkyo School, and Goshun, his Shijō School, an impulse for the new style of realism was given by Chin Nampin (Shên Nan-p'in), a Chinese painter of the realistic school, who arrived at Nagasaki in the year 1731 and stayed two years.

Ōkyo, 1738–1795, the founder of the Maruyama School, was a son of a farmer in Tamba province. He first studied painting under Ishida Yūtei in Kyoto. At the same time he paid attention to the style of the Chinese masters, Sen Shunkyo (Ch'ien Shun-chü) and Kyū Ei (Ch'ou Ying). When he reached his thirtieth year he changed his method of study and became an ardent lover of nature. He exhausted his energy in the study of people and flowers and birds from life, and finally succeeded in becoming a great master of realism, the founder of the Maruyama School. His pictures highly express the national spirit. They

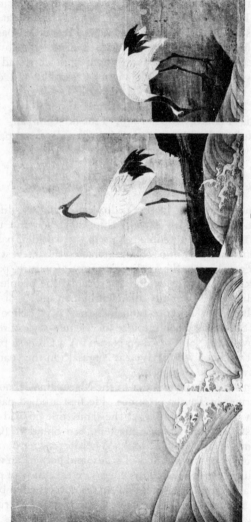

Fig. 153. Waves and Cranes, by Ōkyo (N.T.)
Tokyo Imperial Household Museum

are unlike those by Chin Nampin, which are naturally exotic. His forte was in the large scheme of composition as will be seen in the "Waves and Cranes" painted by him originally on sliding screens in the year seventeen hundred and eighty eight. (Fig. 153) The picture is owned by the Kongō-ji temple, near Kyoto; and now preserved in the Tokyo Imperial Household Museum.

He left a large number of excellent works, among which the following are famous, and they are all national treasures:

Waves. Slightly colored on paper. Mounted as kakemono in 28 pieces. Owned by the Kongō-ji temple, now borrowed by the Tokyo Imperial Household Museum.

Peony and Peacock. Richly colored on silk. Mounted as kakemono. Owned by the Emman-in, Ōtsu city.

Pictures illustrating Good Fortune and Misfortune. Colored on paper. Mounted as 3 scrolls. Owned by the Emman-in, Ōtsu city.

Landscapes, Seven Wise men in the Bamboo Grove; and Tigers and Cranes, painted in black and white on the ninety large paper surfaces of the walls and sliding screens in the rooms of the Sho-in. The Kotohira-gū Shrine, Sanuki province. In Fig. 154 is shown part of the bamboo grove by him.

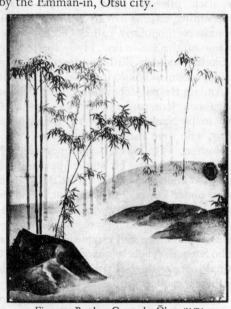

Fig. 154. Bamboo Grove, by Ōkyo (N.T.)
Kotohira-gū, Sanuki (Bijutsu-kenkyū-jo photo.)

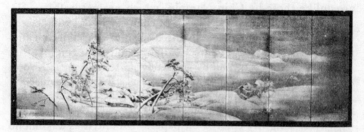

Fig. 155. Snow Landscape, by Goshun
Tokyo Imperial Household Museum

Landscapes, Peacocks, and Chinese Saints, painted in colors or black ink on twenty-eight paper surfaces of the walls and sliding screens in the rooms of the Sho-in. The Daijō-ji monastery (popularly called Ōkyo temple), near the Kasumi station on the San-in line, Hyōgo prefecture.

Sketch Books of Birds and Insects. Colored on paper. Mounted as 3 albums. Tokyo Imperial Household Museum.

Among the painters who studied in the studio of Ōkyo were Nagasawa Rosetsu, 1755–1799, Komai Genki, 1747–1797, Watanabe Nangaku, 1767–1813, and Minagawa Kien, 1734–1807, who were also master painters.

Goshun, 1752–1811, sometimes called Matsumura Gekkei, was born in Kyoto. He studied painting under Ōnishi Suigetsu and then under Buson. After the death of Buson, he wanted to study under Ōkyo. However, Ōkyo modestly declined his request because his ability was already beyond further instruction. But they became the best of friends. Goshun was also a master painter of realism and established his own style, which is called Shijō School. When compared with that of Ōkyo, his picture is tinted more with the national spirit, and has a literary touch. Goshun was always at his best in landscape pieces. In Fig. 155 is reproduced an example of his landscape painting, which is in the Tokyo Imperial Household Museum. His choice, as a rule, was a small canvas, and a theme that lent itself to simple treatment. He rarely attempted anything on a large scale. His

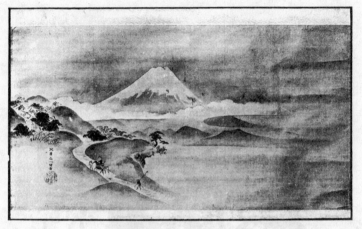

Fgi. 156. Mt. Fuji, by Itchō
Tokyo Imperial Household Museum

masterpiece, representing peasant scenes in rural places painted
on a sliding screen in the Nishi-Hongwan-ji monastery of Kyoto,
may be taken as a good example of his larger canvasses.

Keibun, 1779–1843, and Toyohiko, 1773–1845, were noted
painters among the disciples of Goshun.

MISCELLANEOUS MASTERS

Hanabusa Itchō, 1652–1724, was born in Osaka. He first
studied in the atelier of Kanō Yasunobu in Yedo. But he was too
able a man to follow the mere formalism of the Kanō School and
established his own style. He is noted for his independent con-
ception of design and the free and bold movement of his brush.
His paintings are humorous and touched with poetic expression,
as will be seen in the example shown in Fig. 156, which is own-
ed by the Tokyo Imperial Household Museum.

Ganku, 1750–1838, the founder of the Kishi School, was born
at Kanazawa in Kaga. In his later years he came up to Kyoto.

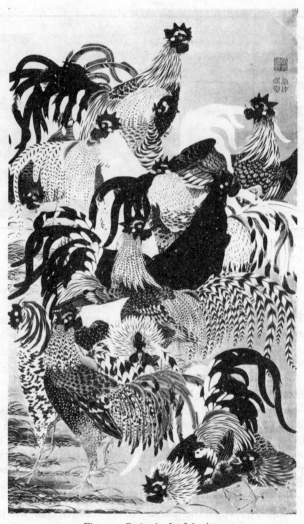

Fig. 157. Cocks, by Itō Jakuchū
Imperial Household Collection

He first studied the style of Chin Nampin and became a painter of the realistic school. He was clever in painting animals, and his tiger is especially famous. In the Tokyo Imperial Household Museum is a pair of screens with a tiger and waves painted by him in black and white on paper.

Itō Jakuchū, 1716–1800, was born in Kyoto. He first studied the Kanō style and then imitated the old works of the

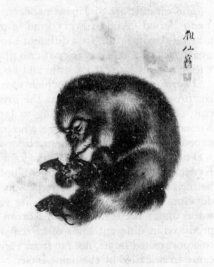

Fig. 158. Monkey, by Sosen
Tokyo Imperial Household Museum

Yüan and Ming schools of China. On the other hand he was influenced by the works of Kōrin, but founded his own style. He was especially fond of painting cocks which he studied very seriously from life. His cocks are therefore highly realistic and masterly. In the Imperial Household collection are preserved famous examples of his cocks, which are mounted in kakemono in thirty pieces. (Fig. 157)

Mori Sosen, 1747–1821, lived in Osaka. He first studied the Kanō style. But afterward his style became very similar to that of Maruyama and Shijō schools. He was particularly fond of painting monkeys and succeeded in painting them with very realistic effect. (Fig. 158)

3. POTTERY

The ceramic art of Japan made remarkable progress in the Yedo Period. Almost every kind of pottery was produced. It may be classified into four different kinds according to its hardness: *doki*, or earthen ware with no glaze, *tōki*, or earthen ware with glaze, *sekki*, or stone ware and *jiki*, or porcelain ware.

There were two factors which were at work to bring about the progress; one of which was the great popularity of the tea-cult, and the other the bringing to Japan of a large number of Korean potters by those generals who participated in the Korean expedition waged by Toyotomi Hideyoshi.

Those Koreans discovered fine kaolin in different districts in Kyushu, and instructed Japanese potters to make new and better kinds of pottery. In the province of Hizen a remarkable development was made in producing various kinds of porcelain wares under the instruction of Korean potters, and these wares produced in different kilns of Hizen were transported for sale to a port called Imari, not far from Arita. For this reason they came to be called by the name Imari.

Distinct from so-called Imari wares there were produced two famous kinds of porcelain, Kaki-e-mon and Iro-nabeshima wares from the kilns established at Arita and Nabeshima.

Arita and Imari are still famous places for fine polychrome porcelain wares.

In the southernmost part of Kyushu, Satsuma faience was produced, also under the instruction of Korean potters. They are all fine polychrome wares, and still they produce a similar kind of faience.

On the other hand, progress was made in producing monochrome wares such as celadon, white porcelain and *some-tsuke* wares mostly under the influence of the tea-ceremony, in which simple colors were appreciated. In the province of Hizen, Hirado was the most famous for its white porcelain.

Now the beautiful color of pottery is produced mainly by glaze. But the raw materials which are used for modelling the

shape of pottery are also closely related to the beauty of glaze.
The simplest glaze will be made by ashes and red clay which
includes iron. Various colored glazes can be developed by differ-
ent quantities of iron included in the plain glaze and by the
nature of the flames in the kiln. Iron gives a red color as its
essential nature when heated by an oxidizing flame and blue
when heated by a reducing flame. But the small quantity of iron
in the plain glaze will become yellow when burned by weak heat.
The mixtures for getting various colors are composed of ground
glass, white lead, quartz, and different kinds of metals: for ex-
ample, copper for green, cobalt for blue, mangan for purple, and
antimony for yellow and so forth. The fine colored glaze which
has translucent lustre by vitrification is really a gem to the hu-
man eyes.

The Greek vases are famous for their simple beauty of form.
But of color, I think, the finest examples will be found in Japa-
nese porcelain produced in the Yedo Period. Especially the Iro-
nabeshima, Kaki-e-mon and Ko-kutani are full of variety in
light and dark, bright and dull tints and shades with elegance
of color scheme.

Famous kilns in the Yedo Period developed mostly in Kyoto,
Hizen, Satsuma and Kaga. In Kyoto such kilns as Ninsei, Awa-
ta, and Kiyomizu were famous.

In northeastern Japan, Kutani in Kaga province was a centre
of the famous porcelain wares called Ko-kutani; and Kutani still
keeps its fame for polychrome porcelain wares.

NINSEI

Ninsei, 1596–1660, was one of the great ceramists. However,
the dates of his birth and death are not certain. According to
some reliable traditions, he was born in the year 1596 at Nono-
mura in Tamba province. He was calleb Nonomura Seibei. He
died in the year 1660.

It seems that he learned the art of handling the potter's wheel
from Kyūemon of Awata in Kyoto; and for the art of coloring

he owed something to Chawanya Kōemon, who brought Arita polychrome porcelain to Kyoto from Hizen in Kyushu.

It is said that he opened his kilns in about fifteen different places. However, the most famous ones were those opened near the Ninna-ji monastery in Kyoto and at the residence of the lord of Marugame in Shikoku Island. He was flourishing in the middle of the seventeenth century.

Before him Japanese ceramic art was more or less an imitation of Chinese or Korean styles. But he elevated the esthetic standard of ceramic art and expressed highly Japanese taste.

Let us note here the most interesting features of his works. In the first place his skilful handling of the wheel is very superb in finish. In the second place, his ground glaze has a soft and quiet shade and fine minute crackles. In the third place, greater than these two features, is his design painted on the ground glaze. He painted flowery and bright pictures on such wares as water holders, or tea-jars, which were considered ornaments as well as practical utensils. On the other hand, he used subdued colors for tea bowls because he wished to keep a harmonious combination with the green colored tea. In both cases, his design is reposeful and peaceful in composition and color scheme, and never disturbs a quiet mind. More than anything else he succeeded in the clever arrangement of gold and silver colors. In his brighter designs he used much gold to represent clouds. But there was nothing vulgar in his design. It is like the golden cloud in the morning sky. He often gave gold outlines to colored flowers and they looked beautiful like the golden light from heaven. His works are usually marked with his seals.

In the Tokyo Imperial Household Museum is a tea-jar produced by Ninsei at the kiln he established at the residence of the Lord of Marugame, Shikoku. It is one of the best of his works. (Fig. 159) The jar measures o. 300 m. and is decorated with a plum tree in full bloom, overshadowed with golden clouds. Its graceful shape and the color of the crimson blossoms, the golden clouds, and slightly bluish white ground create a superb feeling. Another excellent example is owned by Mr. Matasaku Shiobara,

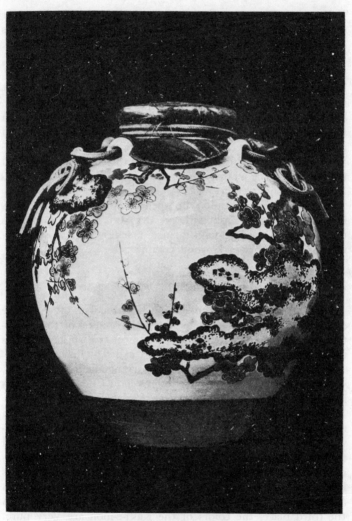

Fig. 159. Tea-jar, by Ninsei
Tokyo Imperial Household Museum

Tokyo. It is a jar measuring 0.460 m. in height. The diameter of the lid is 0.216 m. The design is composed of four phoenixes and flowers in beautiful colors of red, green, gold, and silver. This is really a rare and unique example of the works by Ninsei, and is enrolled as a national treasure. In the collection of Mr. Kinya Nagao at Kamakura is also a famous jar made by him. It in decorated with wisteria flowers painted in green, dull red, light purple, and silver on the superb white ground glaze which has fine crackles. The reddish flowers are outlined with gold and the silvery flowers which now have turned black are outlined with red. The form is sublime and the colors are quiet and fascinating on the white ground. (Color plt. 5) This is also enrolled as a national treasure.

Ninsei had many pupils who opened kilns at different places in Kyoto and the neighbourhood and came to be respected as the founder of the Kyō-yaki faience, marking a great step forward in the history of Japanese ceramic art.

KAKI-E-MON WARE

Kaki-e-mon is the name of a famous potter who invented the enamelled porcelain in Japan about the middle of the seventeenth century at Arita in Hizen province. His works as well as those which were made in his style are called by his name.

Its color scheme is made by a skilful arrangement of red, green, yellow, and purple. Some of its designs show Chinese and Dutch influences, but others are quite after the Japanese taste.

There are three characteristic features in the Kaki-e-mon. In the first place its milky white glaze is fine and glossy, and somewhat opaque, but not quite translucent. Thus, it gives a restful feeling to the eyes. In the second place, the design of Kaki-e-mon is very picturesque. In its space composition a large area is left white, and in no Kaki-e-mon wares will there be found such a dense arrangement of patterns as there are in Imari wares. In the third place, the colors of the Kaki-e-mon are very pure. Red, yellow, green, and purple are superb and delightful to the

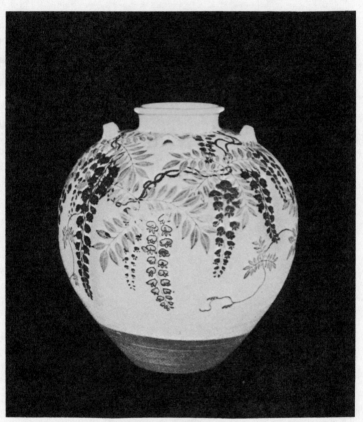

Color plt. 5. Tea-jar, by Ninsei (N.T.)
Mr. Kinya Nagao's Collection

eyes in contrast with the milky white glaze.

Some fine examples of Kaki-e-mon will be found in the collection of Mr. Matasaku Shiobara, Tokyo. A large vessel with a beautiful design composed of birds and flowers is among them. (Color plt. 6) This vessel and several other Kaki-e-mon in his collection are registered by the government as important art objects.

IRO-NABESHIMA WARE

The Iro-nabeshima is the finest of Nabeshima wares turned out in limited quantities from the Ōkōchi kilns of Hizen; and its beauty may be compared with that of Kaki-e-mon. The best of Iro-nabeshima will be seen in the work of round plates. The curve is so delicate as to escape notice, but it gives a fine soft feeling as a whole. The ground glaze is extremely smooth and glossy and seems to have a slightly bluish shade. The design of Iro-nabeshima is quite unlike that of Kaki-e-mon. Although the design of Kaki-e-mon is like a picture, it sometimes lacks fitness for the dish it has to decorate. On the other hand, the design of Iro-nabeshima harmonizes well with the delicate curve of the plate for which it is intended. The design of Iro-nabeshima is natural and realistic, and beautifully adapted to its color scheme. The sketch design is first painted in cobalt blue before the glaze is applied. Then the glaze is applied and the dish is fired, after which the design is carefully painted in such primary colors as red, green, and yellow. These colors cannot stand the same high heat as cobalt blue. Therefore, they are applied separately over the glaze to develop the colors in a weaker heat after the glaze is burned in sufficient heat. Therefore the design is painted very thinly so that it looks as if it were painted on the same plane. All these primary colors harmonize with the bluish shade of the ground glaze, and aid in giving a reposeful and quiet atmosphere to the table at which they are used.

A large plate owned by Mr. Matasaku Shiobara is a fine ex-

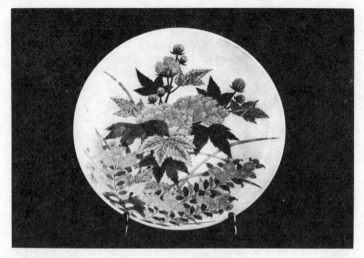

Fig. 160. Iro-nabeshima (N.T.)
Mr. Shiobara's Collection,

ample of Iro-nabeshima; and it is registered as a national treasure. (Fig. 160) Its height measures 0.079 m. and diameter, 0.317 m. The inside of the plate is decorated with a large rosemallow (*fuyō*) surrounded by chrysanthemums. Its melodious red, blue, green, and yellow, show their purity of color on the beautiful ground glaze, which looks like a clear sky. The flowers belonging to earth are here almost lifted up to heaven by the skill of the artist and the firing in the kiln.

SATSUMA WARE

Satsuma ware owes its origin to Shimazu Yoshihiro, the lord of the Satsuma clan, who brought home a number of Korean potters when he returned from the Korean invasion. Hence it dates from the close of the sixteenth century. These Korean potters opened kilns under the direction of Yoshihiro.

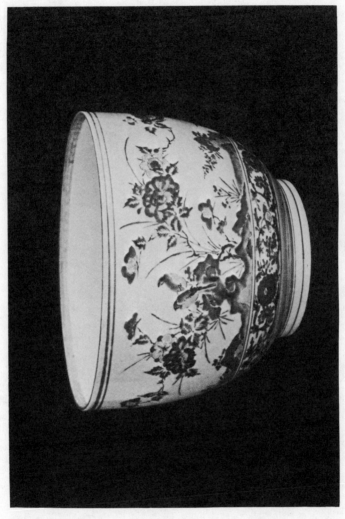

Color plt. 6. Vessel, by Kaki-ye-mon

Mr. Matasaku Shiobara's Collection

In the Kwansei Era, 1789–1800, the Satsuma ware began to be decorated with polychromatic design by the order of Shimazu Narinobu, the lord of the country. It was highly appreciated, and called Nishiki-de or "Brocade-like."

In producing Nishiki-de ware, three processes of firing in kiln are necessary. The first process is *suyaki*, in which the ware is fired in the kiln before it receives the glaze. In the second process the ware receives the glaze, being again put into the kiln, where it is fired for about forty-eight hours. In the third process, the ware is painted and gilded and then is finally heated in the kiln slowly and gradually to develop various colors.

There are several other varieties in Sa-

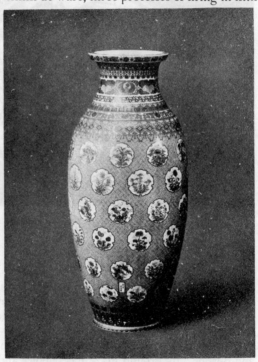

Fig. 161. Satsuma Ware
Tokyo Imperial Household Museum

tsuma wares, such as the Bekkō-satsuma, having a tortoise-shell-like glaze, the Mishima-satsuma, and the Sunkoroku-satsuma. But the Satsuma faience known to foreign collectors are fine crackled cream-colored wares and elaborately decorated. Some

examples of Satsuma ware will be found in the Tokyo Imperial Household Museum. (Fig. 161)

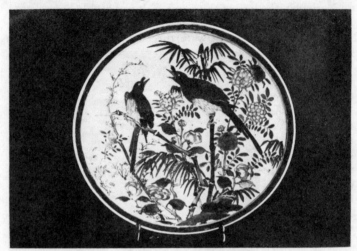

Fig. 162. Ko-kutani
Mr. Shiobara's Collection

KO-KUTANI WARE

Ko-kutani is a kind of Kutani porcelain ware. It was made from kaolin found in a place called Kutani-mura, in the province of Kaga. Its origin dates from about the middle of the seventeenth century when a factory was founded by Gotō Saijirō.

The body of Ko-kutani is greyish white and is rather crude and opaque. Its ground glaze has bubbles and is not so fine as that of Kaki-e-mon and Iro-nabeshima.

Ko-kutani is decorated with flowers, birds, landscapes, figures and diaper designs, in green, red, yellow, and purple colors; and it is generally marked with the name "Kutani." The designs for Ko-kutani are said to have been drawn by Kusumi Morikage, a painter of the Kanō School. Ko-kutani has much masculine

beauty in form and colors. Its beauty may be compared to that of an English lady, while that of Kaki-e-mon and Iro-nabe-shima, to the beauty of Paris.

Among Mr. Shiobara's collection are fine examples of Ko-ku-tani. There are two large plates. One is painted with two *haha-chō* birds perching on bamboo (Fig. 162); and the other is painted with two birds on a branch of a peach tree. Both are registered by the government as important art objects.

4. GOLD LACQUER WARE

During the Yedo Period (1615–1866) the art of gold lacquer attained the zenith of perfection and elaboration; and highly artistic gold wares were produced in Kyoto and Yedo, the seat of the Shogunate. In local districts Kanazawa in Kaga was the most famous place for the production of artistic gold wares.

However, although the artistic merit of the designs was inferior to that of the preceding periods, the work by Honnami Kōetsu, 1568–1637, was quite exceptional. He was a genius in gold lacquer, in painting as well as in calligraphy, and used tin, lead, or mother-of-pearl in making up his design on the ground of gold lacquer. In the Tokyo Imperial Household Museum there is an ink-stone box attributed to him, the design of which is composed of a floating bridge and a poem inlaid with lead and silver plates on a gold ground to illustrate an old famous osng. (Fig. 163)

During his time and in succeeding ages there lived some master makers of gold lacquer. They were Kō-ami Nagashige, 1599–1651, Koma Kyū-i, d. 1663, and Yamamoto Shunshō, 1610–1682. In the collection of Marquis Tokugawa of Nagoya is a famous set of raised gold lacquer wares called Hatsune-no-tana or the "Shelf of a Nightingale's New Year Song," which was produced by Kō-ami Nagashige and brought by a daughter of the third Shogun Iyemitsu when she married the lord of Owari. It is an excellent example of the raised gold lacquer wares with most elaborate designs, which were produced in the early Yedo

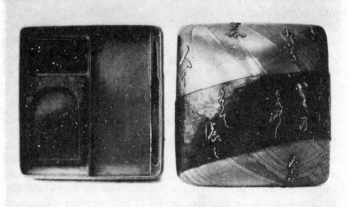

Fig. 103. Gold Lacquer Ink-stone Box, by Kōetsu
Tokyo Imperial Household Museum

Period. In the Tokyo Imperial Household Museum is pre-
served a raised gold lacquer box with a similar design produced
by him. (Fig. 164)

In the late seventeenth century Kajikawa Kyūjirō was one of
the master makers of gold lacquered *inrō*. *Inrō* is a kind of medi-
cine box. It is usually decorated with gold lacquer or mother-of-
pearl inlay. Men wore them at their waists as a rather showy
decoration.

In Kaga there was a famous gold lacquer artist called Igarashi
Dōho who served the lord of Kaga and produced fine works of
gold lacquer.

In the Genroku Era (1688–1703), Japan became more peace-
ful than ever, and the work of gold lacquer made remarkable
progress in technical elaboration and details. The gorgeous glow
of the gold lacquer ware was really a symbol of the luxurious
life of the Genroku Era.

In Kyoto, Ogata Kō-rin, 1658–1716, was the most famous maker of gold lacquer; and in Yedo, Yamada Jōkasai, who flourished in the late seventeenth century, Ogawa Haritsu, 1663 –1747, Koma Kyūhaku, –1732, and Tatsuki Chōbei, who flourished in the second half of the seventeenth century, were all noted workers in gold lacquer. Their works were highly ad-mired, and later they were called "Jōken-in gold lacquer." Jōken-in

Fig. 164. Raised Gold Lacquer Box,
by Kō-ami Nagashige
Tokyo Imperial Household Museum

was the posthumous name of the fifth Shogun Tsunayoshi who reigned in their time. Indeed the zenith of technical perfection and elaboration of gold lacquer was reached by them and was never surpassed by other gold lacquer artists who came after them.

Kōrin in Kyoto represented the Kōetsu style of gold lacquer and became very famous for the artistic quality of his designs which far surpassed the work of his contemporaries.

In the Tokyo Imperial Household Museum is an excellent example of his work. It is a box with a design composed of iris and Yatsuhashi bridge on a black lacquer ground. The iris is re-presented in gold lacquer and mother-of-pearl; and the bridge is made of lead plates. The iris pond is the motif of this design. The general tone is quiet and highly decorative with its glow of colors. (Fig. 165) Ogawa Haritsu also studied the style of Kō-etsu and became skilled in the work of inlay with tin, lead, pottery, and mother-of-pearl. But his work was not so fine as

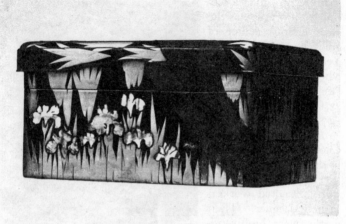

Fig. 165. Gold Lacquer Box, by Kōrin
Tokyo Imperial Household Museum

that of Kōrin.

The following artists were also master workers in gold lacquer in the Yedo Period:

Shiomi Seisei, 1646–1719; Iizuka Tōyō who flourished in about the middle of the eighteenth century; Koma Koryū who flourished in the later eighteenth century; Koma Kansai, 1766–1835; Hara Yōyūsai, 1772–1845; and Nakayama Komin, 1808–1870.

It would be helpful in the appreciation of gold lacquer work to know the important technical processes necessary in the manufacture of artistic kinds of gold lacquer.

First of all, the crude lacquer is obtained by making horizontal incisions on selected lacquer trees. The sap is then put into a large bowl and stirred with a spoon to evaporate any water. The lacquer is transparent and very sticky, the lacquer being blackened by mixing it with lampblack, and reddened by mixing it with vermilion.

The body of lacquered wares is usually made of wood which

is well dried. The joints are cut slightly hollow and filled up with a stuff called *kokuso*, a mixture of cut hemp and glue, to prevent any deformation from the joint parts; and then the whole surface is coated with pure lacquer, called *seshime*, entirely separated from water, to prevent any water or moisture creeping into the wood in later technical processes. After this, a coating of lacquer mixed with wheat flour is given and then a linen cloth is laid over it, taking the utmost care to stretch it perfectly smooth. The whole surface is coated several more times with other layers of lacquer; namely *jinoko*, a mixture of baked earth and lacquer, and then with a mixture of powdered whetstone and raw lacquer. These coats are given in order to get a smooth ground surface. After this, the black lacquer is applied and the surface is polished repeatedly with charcoal in order to get a glossy black finish of ground work.

The gold lacquer design can now be applied to the ground surface. There are three different methods by which gold lacquer design is produced; that is, *hira-maki-e* or flat gold lacquer, *togi-dashi-maki-e* or polished out gold lacquer, and *taka-maki-e* or raised gold lacquer.

In producing a flat gold lacquer design, the design required is drawn on paper and transferred by tracing its lines with lacquer on the article; then gold dust is sprinkled over the design so that the sticky lacquer will take the gold dust. After this, thin transparent lacquer is applied over the design. The article is dried in an air-tight damp box because lacquer dries only in damp air. Then the surface of the design is polished with charcoal.

In producing a *togidashi-maki-e* design, the design required is made in the same manner as that of *hira-maki-e* but a slightly coarser gold dust is used. After the gold dust is sprinkled over the lacquer with which the design is painted, the whole surface of the article receives a coat of black or transparent lacquer. After the lacquer coating is dried in an air-tight damp box, the surface is ground down with charcoal until the design shows out on the fine smooth ground.

In the processes of producing a raised gold lacquer design, some

parts of the design are raised with *sabi*, which is composed of powdered whetstone and raw lacquer. And then gold dust is applied several times with lacquer to the raised design. When the final coat of lacquer is dried, the design is polished.

The ground space, which has no pattern, is left black or sprinkled with different kinds of gold dust. According to the quality of gold dust sprinkled on the ground, there are three different kinds of golden ground, that is, the *nashi-ji*, *hirame-ji* and *kindami-ji*. The *nashi-ji* is sprinkled with fine dust gold and the dense grains make it look somewhat like a yellow pear-skin; the *hirame-ji* is made of coarse gold filings which are usually sprinkled rather sparsely over the black ground; and the *kindami-ji* is made of fine gold dust by sprinkling it so thick that its finish looks like gold plate.

5. TEXTILE INDUSTRY

The textile industry made remarkable development in the seventh and the eighth centuries and left us a number of excellent examples which we have described elsewhere. (pp. 54–60)

After the capital was removed from Nara to Kyoto at the close of the eighth century, it developed still more because of the needs of the court nobles. However, there remain almost no examples to show its actual conditions and prosperity. What we may know of the textile industry of those ages are the pictures of court nobles or Buddhist statues on which are painted dresses of the times. Through these pictures and statues we may understand the kind of pattern that prevailed among court nobles of the Fujiwara Period. The most characteristic pattern was a diaper design, of which there were two distinct types. One is the ground design figured by weaving, in which the same design is closely repeated. The other is the upper design, figured by weaving in threads of different colors over the ground diaper design. These designs are usually round patterns consisting of flowers, birds, or butterflies. Since this time, these classical designs have been used in ceremonial dresses of all ages. There

remain a number of fine examples of such fabrics from the Yedo Period in the collections of the Imperial Household and in some families of former feudal lords.

The next remarkable development in the history of the textile industry took place in the sixteenth century. At this time Japan was again much indebted to Chinese influence. Chinese experts came to Japan and started instruction in weaving at Sakai, a city not far from Osaka. In addition, Chinese trading ships brought fine examples of the Chinese weaving art to Japan. Meanwhile the Nishijin artisans of Kyoto learned advanced Chinese methods of weaving from Sakai artisans and made Kyoto the most important centre of high-grade weaving in Japan. Moreover, Dutch, Spanish, and Portuguese merchants brought European textiles, such as figured satins, velvets, and Gobelins, giving for the first time an important Western influence to Japanese textile industry.

Under these foreign influences, the textile industry in the Yedo Period made remarkable progress.

The most gorgeous textile fabrics, used in the Noh drama, were produced mostly in Yedo and Kyoto. There were four different kinds of fabrics worn by the actors who played in the Noh drama: *kara-ori*, *atsu-ita*, *nui-haku* and *suri-haku*. *Kara-ori* is a kind of rich brocade; *atsu-ita* is a kind of silk fabric; *nui-haku*, a fabric having a design in embroidery as well as in gold-leaf; and *suri-haku*, a fabric with a pattern of gold leaf only. The bright colors and intricate patterns of these Noh costumes were appreciated especially by the nobility and by military leaders in times of peace. Such taste for richly costumed drama had been first introduced by Toyotomi Hideyoshi in the Momoyama Period, late in the sixteenth century. His gorgeous taste was beautifully expressed by the flowery costumes of the quiet and pantomimic Noh actors. This taste was followed in the Yedo Period, although not so vividly as in his own time. The particularly interesting feature of the Noh costume is the variety of warm hues, such as gold, red, and yellow, which appear in the slow rhythm, punctuated by symbolic gestures of the Noh actors.

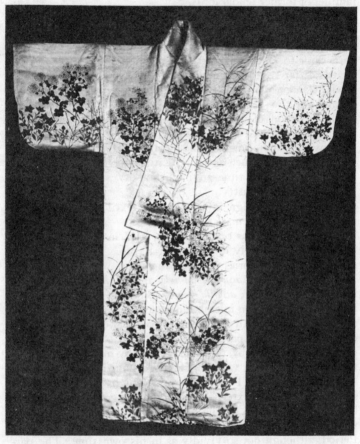

Fig. 166. Kosode Garment with Painted Pattern, by Kōrin
Tokyo Imperial Household Museum

In the Tokyo Imperial Household Museum are some fine examples of Noh costumes; but more examples will be found in private collections in Tokyo and other cities. In our color plate 7, we have reproduced an excellent specimen of *kara-ori* owned by Mr. Kikusaburo Fukui, Tokyo.

Next, various kinds of silk stuff, needed by rich plebeians, also were remarkably improved. The silk fabrics used most for making *kimono* and *obi* or sashes, were satin or *shusu*, figured damask or *donsu*, crepe or *chirimen*, *rinzu* and *yūzen*. To such silk stuffs, gorgeous patterns were applied by dyeing, embroidery, or weaving out in the loom. But a special design was sometimes painted by an artist himself. A unique example of such stuff is in the Tokyo Imperial Household Museum. It is a *kosode* garment worn by the lady of a rich merchant in the Genroku Era. It is made of white silk twill and painted with different kinds of autumnal grasses in colors by the famous painter, Ogata Kōrin. (Fig. 166) It well symbolizes the luxurious life of the plebeians in the Genroku Era (1688–1703).

In the Museum of Fine Arts in Boston are a number of Japanese ladies' clothes of the Yedo Period. Also some fine examples are in the Metropolitan Museum of Art, New York.

6. ARCHITECTURE

As a whole the architecture of the Yedo Period was a continuation of what had developed in the Momoyama Period; but it gradually declined. The architectural features of the Yedo Period were elaboration in technical details, too rich in colors, and too many carvings with no constructional significance. They presented what may be called a rococo style of Japanese architecture.

However, the early Yedo Period, that is, the major part of the seventeenth century, was not so bad, since mausoleum architecture made a notable development. Nevertheless the mausoleums were wonderful only in the decoration— prodigal, exquisite in details, and ornate in colors—as will be

Fig. 167. Interior of Zuihōden Mausoleum
Sendai

seen in Fig. 167 which reproduces the interior of the Zuihō-
den, the mausoleum of the lord of Sendai, erected in the year
1637.

The following are the important remains of this kind of mau-
soleum architecture in the Yedo Period:

The Tōshō-gū Shrine on Kunō-zan in Suruga built in the year
1617.

The Daitoku-in, the mausoleum of the second Shogun Hide-
tada, in Shiba Park, Tokyo, erected in the year 1635.

The Tōshō-gū at Nikko, the mausoleum of the first Shogun
Ieyasu, built in the year 1636.

The Daiyū-in, the mausoleum of the third Shogun Iemitsu,
at Nikko, erected in the year 1653.

Of the Buddhist architecture a number of large temples were
reconstructed and the following are worth while visiting:

The preaching Hall (1656) and the Hall of Buddha (1583) in

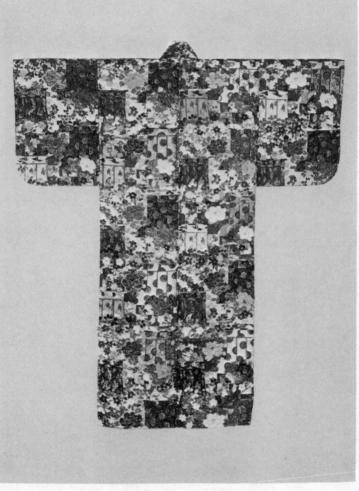

Color plt. 7. Kara-ori Noh Costume
Mr. Kikusaburo Fukui's Collection

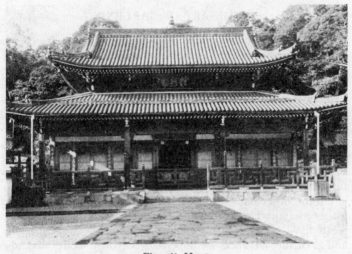

Fig. 168. Hattō
Mampuku-ji, Uji

the Myōshin-ji monastery, Kyoto.

The Main Hall (1642) and the Lecture hall of the Enryaku-ji monastery on Mt. Hiei.

The Daibutsu-den Hall(1708)of the Tōdai-ji monastery, Nara.

These buildings are all reconstruction architecture of the old temples. However, a new style of Buddhist architecture was introduced from China, coming with the introduction of the Ōbaku branch of the Zen sect of Buddhism. It was the architecture of Chinese style of the Ming Dynasty, and its best example remains in the Mampuku-ji monastery at Uji, near Kyoto. It is almost entirely Chinese in style and principle and no Japanese taste or feeling is expressed as will be noticed in the Lecture Hall (Hattō) reproduced in Fig. 168.

7. THE ART OF GARDENING

The garden is an important part of our habitation; it gives us rest and comfort and has an influence upon our life.

From the remote past, people, in the east and the west, and in the north and the south, have been seeking an everlasting land of happiness in places of distance and height or in heaven, in connection with the celestial abodes of gods. The Christians found Paradise for the blessed souls of the deceased. Taoists discovered the Mount P'êng-lai shan (Hōrai-san), a land of eternal spring. Buddha Amida has created for the faithful the Land of Extreme Happiness in heaven, where there is the garden filled with perfumed lotus flowers and bright with the golden rays of the sun.

On the other hand we have been also trying to create such a place on earth. The shrines and temples of gods and Buddhas on earth have their gardens, which are created by human hands, and as culture advances we hope that our own abodes may also become nearer to those of the gods and Buddha in heaven. The history of gardens shows this attitude of man in seeking for a beautiful garden for his habitation.

In the study of the gardens of the Yedo Period we also find this trend of human desire.

The gardens in the Yedo Period may be divided into three kinds, that is, tea-garden, or *cha-niwa*, flat-garden or *hira-niwa*, and stroll landscape garden or *kwaiyū-shiki-teien*.

The tea-garden is but a garden-path leading to a tea room from the gate; hence it is inseparably related to the tea room, and naturally it is very small and narrow. But the aim of tea-garden is to get an atmosphere of natural scenery with studied rusticity and simplicity. Such atmosphere is described by the word *wabi*. In other words the tea-garden should be so designed as to convey a feeling of loneliness and an appearance of extensive natural scenery in a given small plot of land, before one enters the tea room, which is likewise very small. For such a purpose evergreens are usually planted in the tea-garden, and flowers are not welcomed. Grass under the trees is also important in

Fig. 169. Stepping Stones of a Tea-garden
Mr. Nishida, Kanazawa

giving this feeling; and moss on the ground is especially appreci-
ated because of the soft and quiet feeling it gives to the garden.

In laying out a tea-garden the arrangement of stepping stones,
or *tobi-ishi*, is most important, not only for the beauty of the gar-
den but also for practical use. In Fig. 169 we have reproduced
some of the stepping stones in the garden of Mr. Giichiro Nishi-
da in Kanazawa, which was originally laid out by a *samurai* who
served Maeda, the Lord of Kaga, in the seventeenth century.
The stones, all of different shapes, are skilfully arranged; and
velvet-like moss, which covers the ground and creeps up over
the stones, gives the feeling of *wabi*.

The next important accessory in the tea-gargen is *tsukubai*.
The *tsukubai* located near the tea room, consists of *chōzu-bachi*,
or stone basin holding water for washing the hands, and several
stones arranged at the side of the basin. The stone lantern is
also indispensable in the tea-garden, and in Fig. 170 is shown a

Fig. 170. Tsukubai of a Tea-garden
Seison-kaku, Kanazawa

Fig. 171. Flat Garden
Nanzen-ji, Kyoto

fine example of *tsukubai* with a stone lantern behind. These are in the garden of Seison-kaku, the villa of Marquis Maeda, in Kanazawa.

The flat garden, or *hira-niwa*, is laid out for *shoin* type of building and is to be appreciated from the interior of a room. Fine examples will be seen in the gardens of the Hōjō at the Daitoku-ji and Nanzen-ji. (Fig. 171)

The stroll landscape garden is the largest and most elaborate of Japanese gardens, and its highest development was reached in the Yedo Period. They were mostly laid out for the residences of feudal lords.

In the stroll landscape garden the principal area is occupied by a large pond; and the pond has an island which often is called Hōrai-jima, meaning an Elysian Isle. The pond including an island has a long history in the Japanese garden. The oldest garden known to us had it, and it was surely related to the Taoistic conception of the everlasting island of spring time. The Buddhist

temple of the Amida doctrine had a garden in which there were a pond and an island, symbolizing the Land of Extreme Happiness of the Pure Land doctrine.

Furthermore the garden-path of the stroll landscape garden is usually laid out through undulating hills made along the pond. These are the essential features of the large landscape gardens in the Yedo Period. In laying out such gardens, different kinds of rocks were collected from distant places, and rare trees were transplanted from various localities. In the structure of a gate different woods were gathered. Different famous views were copied, and imitations of famous Chinese landscapes were highly appreciated by those feudal lords who were interested in Chinese landscape literature. Such were also characteristic features of the stroll gardens in the Yedo Period.

The idea of tea-ceremony was closely related to the development of stroll landscape garden.

Kobori Enshū, the greatest master of tea-ceremony, was the most eminent gardener of the stroll landscape garden in the early Yedo Period. In his garden many a different natural view was copied at different points in relation to the tea-ceremony houses, so that people might enjoy the changing views of the garden while they were proceeding to the tea-ceremony houses through the garden-path.

His style of garden, of which that of the Katsura Imperial villa is the masterpiece, became the model of the stroll garden in the Yedo Period.

In Tokyo there remain two famous gardens laid out for the residences of feudal lords. One of them is called Rikugi-en and the other Kōraku-en.

The Rikugi-en garden is located at Fujimae-cho, Hongo, Tokyo. The garden was originally laid out in the Genroku Era (1688–1703) as the villa of Yanagisawa Yoshiyasu, the feudal lord of Kawagoe, but it is now owned by Baron Iwasaki as his villa.

The Rikugi-en, covering about 23 acres, is the best example of residential gardens of feudal lords in Yedo(Tokyo). A special

Fig. 172. Rikugi-en Garden
Baron Iwasaki's Villa, Fujimae, Tokyo

feature of the garden is the extensive beautiful pond, the sur-
roundings of which are embellished with rocks, shrubs, and thick
groves of different trees. They are beautifully combined in mak-
ing a picturesque landscape garden. (Fig. 172)

When we enter the garden, we are captivated by the beauty
of an extensive foreground of lawn where two aged imposing
pine trees, supported by props, spread their majestic branches to
all directions.

The garden is so designed that we may make a round trip
around the pond over the hills, enjoying the changing views of
the garden from every spot as we proceed. On our way, there
are fanciful arbors and tea-ceremony houses, nestled among the
trees. We come cross a small but the highest hill in the garden.
From the hill we may have a fine extensive view of the garden.
We feel almost secluded from the world, as if we are far away
from the city. As we descend the hill, we are on the other side
of the pond. In autumn hundreds of wild ducks come and so-
journ in the pond. Among the thick woods, pheasants have their
nests all the year round. Proceeding further along the pond, we
come to a bridge spanned to an Elysian Isle called Hōrai-jima.
On the isle grow aged pine trees, the symbol of everlasting life,
and rare rocks are brought from different districts famous for
gardening rocks. The isle is indeed, the heart of the garden.

The Kōraku-en, another representative example of the stroll
landscape garden of the Yedo Period, is in the compound of the
Tokyo Arsenal in Koishikawa, Tokyo. It was originally laid
out by a gardener called Tokudaiji Sahei under the directorship
of Yorifusa and Mitsukuni, lords of the Mito clan, in the middle
of the seventeenth century.

The garden is characterized by Chinese features in its design
and construction. When we enter the garden through the kara-
mon gate, we go up a wooded slope intended to reproduce a
lonely mountain path of Mt. Kiso. Descending the slope we
come to the broader view of a large pond. (Fig. 173) In the pond
is an Elysian Isle called Hōrai-jima. On the southern beach of
the isle is a massive rock which gives a special attraction to the

Fig. 173. Kōraku-en Garden
Tokyo

Isle. Then, passing over the Tatsuta river along a grove of maples, we reach a rustic arbor with a statue of Saigyō, the famous Japanese priest-poet. Proceeding onward, we come to a broader view and reach the "Moon-crossing Bridge." Around here we may enjoy the miniature views of Arashiyama of Kyoto, and that of a famous Chinese lake called Seiko. From here we go up miniature hills which represent Chinese and Japanese scenes; and passing through a red colored "Heavenward Bridge," reach the "Hall for Acquiring Virtue and Benevolence" in which are enshrined two wooden statues representing Chinese saints. Proceeding further we enjoy other different views, and shall finish our circuit of the garden in about one hour.

Besides those two gardens there remain about seven large stroll gardens from the Yedo Period. They were all laid out by feudal lords of the places and are now converted to public gardens. They are mentioned below:

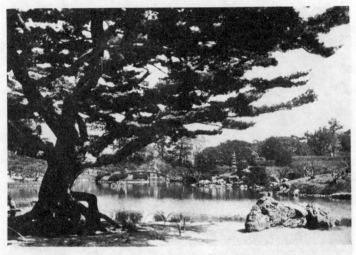

Fig. 174. Ritsurin Park
Takamatsu, Shikoku (Gov. Rys. Photo.)

Kairaku-en garden (Tokiwa-kōen), in the city of Mito, Ibara-ki prefecture. Originally laid out by Tokugawa Nariaki, the lord of Mito in the Tempō Era (1830–1843).

Kenroku-en garden is in the city of Kanazawa, Ishikawa prefecture. Laid out by the lord of Kaga in the early nineteenth century.

Gengū-en garden in Hikone, Shiga prefecture. Originally laid out as the residential garden of the lord of Hikone.

Kōraku-en garden in the city of Okayama. Originally laid out as the residential garden of the lord of Okayama in the later seventeenth century.

Sen-tei, or Shukukei-en garden in the city of Hiroshima. Originally laid out in the early seventeenth century as the residential garden of Asano Chōsei, the lord of Aki.

Ritsurin Park in the city of Takamatsu, Shikoku Island. Originally laid out as the residential garden of Matsudaira Yorishige, the lord of Takamatsu in the middle of the seventeenth

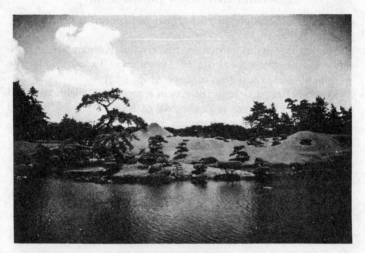

Fig. 175. Suizen-ji Garden
Kumamoto (Gov. Rys. Photo.)

Fig. 176. Iso-no-bettei Garden
Pyince Shimazu's Villa, Kagoshima (Gov. Rys. Photo.)

century. Occupies about 76 hectare and beautifully preserved. (Fig. 174)

Suizen-ji (Jōju-en) garden in the city of Kumamoto. Originally laid out as the villa of Hosokawa Tadatoshi, in the middle of the seventeenth century. (Fig. 175)

lso-no-bettei garden, in the city of Kagoshima. Originally laid out for the villa erected at the bay of Kagoshima by Shimazu Mitsuhisa, the lord of Satsuma in the seventeenth century. (Fig. 176)

CHAPTER XI

THE ART OF THE NEW AGE

(*The Meiji-Taishō Era 1867-1926*)

The Meiji-Taishō Era covered about sixty years, from 1867 to 1926. In 1867, the Imperial sovereignty was restored from the hands of the last Shogun of the Tokugawa, and a remarkable change in thought and institutions set in, and continued with sweeping power for a period of about twenty years. The people became inclined to take in everything new from the West, and to ignore their native culture. Their ignorantly destructive attitude toward old things and institutions went to an extreme.

The new era was inaugurated with the removal of the Imperial residence from Kyoto to Yedo in 1868, and the city of Yedo changed its name to Tokyo, which means the eastern capital. In July 1869, the feudal rights of the Daimyos over their territories and people were abolished. The Gregorian calendar was adopted. The military service, which had been the exclusive calling of the Samurai class became extended to people of all classes, and the French military system was adopted. European dress was introduced and school boys wore Western uniforms. English readers were translated and taught in the schools. The telegraph and the steam engine were introduced. In this way, and at this moment, Japan was most eager to clothe herself in new garbs and to discard her old garments as useless encumbrances.

The new movement was forcibly felt also in the world of art. Public buildings were erected in the Western style. The architecture of the Renaissance, of Gothic or Romanesque style, was adopted for universities, museums, and office buildings. Some Japanese painters learned oil painting from Charles Wirgman, a correspondent of the London Illustrated News. Among his pupils were Takahashi Yūichi and Goseda Hōryū. Meanwhile, in the

College of Engineering, Western painting was taught by an Italian instructor, Antonio Fontanesi; and sculpture, by Ragsa.

However, from about the twentieth year of Meiji (1887), a reactionary attitude began to struggle against this blind westernization, and Japan woke up to see that she should not lose what remained from her own past. This reaction was greatly accelerated by Ernest Fenollosa, a graduate of Harvard University, who was appointed a professor of philosophy at the Tokyo Imperial University in the eleventh year of Meiji (1878). He began to study Japanese art merely for pleasure, but as he pursued it deeper and deeper, he became quite astonished at its greatness, and becoming a great admirer of Japanese art, he made it known to the world. He thought that the civilization of a country should be based upon the history of her past, but that Japan was going astray by blindly adopting foreign styles and discarding her own supreme art, which she had acquired over a very long period of time. Such an attitude was a danger to her own existence. In co-operation with him, Mr. Kakuzo Okakura endeavored to propagate this conviction and had a considerable influence upon the new tendency toward nationalism.

This movement resulted in the establishment of a government art school at Ueno, Tokyo, in the twenty-first year of Meiji. It was inaugurated in the following year, 1888. Two professors of Japanese painting were appointed. They were Kanō Hōgai, 1828–1888, and Hashimoto Gahō, 1835–1908, both of whom belonged to the Kanō School. Kawabata Gyokushō, 1842–1913, of the Maruyama School, was also appointed at the same time.

Among these three professors, Kanō Hōgai and Hashimoto Gahō were greatly influenced by Professor Fenollosa and Mr. Okakura, and acted as forerunners in a national art movement. This activity was in favor of a new school of objective idealism. However, they found some value in the principles of Western painting and made use of them in their new work.

Hōgai's idealistic theory may be seen in his last and most famous work, Hibo Kwannon, or Kwannon as the Merciful All

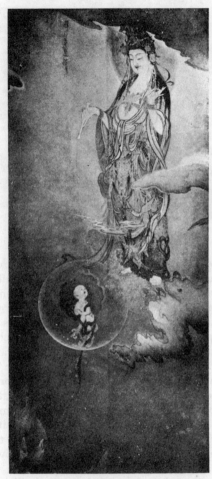

Fig. 177. Hibo Kwannon, by Kanō Hōgai
Tokyo Fine Art School

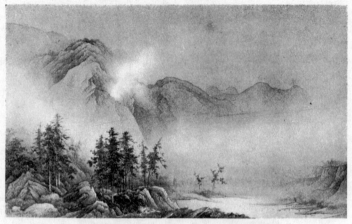

Fig. 178. Autumn Landscape, by Gahō
Tokyo Imperial Household Museum

Mother, owned by the Tokyo Fine Art School at Ueno, Tokyo. (Fig. 177) The Kwannon stands with a highly dignified pose, in resplendent clouds. In her left hand she holds a tiny branch of willow, a symbol of meekness. From the delicate flask in her right hand falls a drop of water, the water of wisdom, which forms a transparent globe containing a baby. The child is looking up with its tiny and lovely hands clasped in grateful adoration. Okakura has compared this painting with the "Creation" by Michael Angelo, in the Vatican at Rome, as expressing with equally wonderful merit the highest beauty of creative power. Unquestionably it occupies the highest position in modern Japanese painting as an example of idealistic painting with a distinctive high spiritual quality. He died in 1888 before the opening of the art school. His theory and style were followed and developed by Gahō.

Gahō left us a number of masterpieces. In the Tokyo Imperial Household Museum is the "Autumn Landscape" painted by him in ink and slightly colored on silk. (Fig. 178)

Among the pupils of Gahō were such able masters as Yoko-

yama Taikan, Shimomura Kanzan, Kawai Gyokudō, and Hishida Shunsō.

This new movement, the keynote of which may be called "Life True to Self," left the art school. Mr. Okakura resigned with the important professors of the school, Hashimoto Gahō, Yokoyama Taikan, Shimomura Kanzan, Terasaki Kōgyō, and Hishida Shunsō. They organized the Nihon Bijutsu-in at Yanaka, Tokyo, under the leadership of Okakura.

On the other hand, a Committee for the Investigation of Historic and Art Treasures in Buddhist temples and Shinto shrines was organized in the Imperial Household Department in 1889, acting on the original suggestion made by Professor Fenollosa. Later, in 1897, this work resulted in the establishment of a system of protection by law of national treasures and historical buildings.

After the Russo-Japanese War, when the peace of the country was restored to its normal condition, a general interest in art revived, and a competitive attitude in different groups of artists became distinctly noticeable. Such a trend was accelerated by the exhibition of Japanese and Western paintings held by the Department of Education in 1907 at Ueno. It attracted the keen interest of the general public and was crowded every day with a great number of visitors. The esthetic appreciation of the people was much encouraged. An art exhibition committee for Japanese painting was formed with the following representative painters of the times:

Hashimoto Gahō, Kawabata Gyokushō, Araki Kampō, Terasaki Kōgyō, Shimomura Kanzan, Kikuchi Hōbun, Takenouchi Seihō, Noguchi Shōhin, Imao Keinen, Kawai Gyokudō, Yokoyama Taikan, Yamamoto Shunkyo, Matsumoto Fūko, Kobori Tomoto.

Besides these painters, there were added some eminent critics. From the next year, the exhibition was held every autumn until 1919, when the task was transferred to the Imperial Fine Arts Academy (Teikoku Bijutsu-in), organized in the same year.

This annual government exhibition gave an important op-

portunity to place on view some representative paintings of all the different schools of the day under the same roof.

Generally speaking, throughout the Meiji-Taishō Era, the new and the old, that is, Westernization and Nationalism, were always at work in the field of painting as well as in the general civilization of new Japan. The new and old elements, such as Idealism, Naturalism, Classicism, and Esthetic Formalism were apparent in the works of the painters of different schools. Under such an atmosphere some painters became distinguished for their own imagination and subjectivity, based upon what they had acquired from different schools of the past.

In the early years of the government art exhibitions, Yokoyama Taikan, Shimomura Kanzan, Kawai Gyokudō, and Terasaki Kōgyō, became most prominent in Tokyo. In Kyoto, Takenouchi Seihō, and Yamamoto Shunkyo were distinguished leaders.

Taikan, who is still keeping up his high fame, was at first instructed by masters of the classical Kanō School, notably by Hōgai and Gahō. His eclectic researches into diverse schools, both Oriental and Occidental, have resulted in his present style, marked by fire and vigor, for which he is probably indebted to his early training in the Kanō School. His Yamaji, or Mountain Path, exhibited in the Fifth Government Art Exhibition attracted the keen interest of the public. Another well-known master of the Inten School was Kōgyō. His works likewise appealed to the public. His technical skill even surpassed that of Taikan. His landscape painting, entitled Keishidai, placed on exhibit in the Third Government Art Exhibiton, was one of the best paintings in the Meiji Era. It was an idealistic portrayal of nature. He mastered the Chinese and Japanese classical touch and added to them a new decorative form. He crossed to China several times, and in his later years Chinese landscapes were his favorite subjects. Such a painting as Summer Day in China, Morning on the Yang-tse-kiang, and Chinese Landscape were placed on view in the Fourth and Fifth Government Art Exhibitions at Ueno.

Seihō, who lives in Kyoto, came from the pure Shijō School.

Some criticize him as lacking ability to touch the deeper chords of passion, but his work excels in naturalism and esthetic formalism. As a master of pictorial bon mots he has almost no equal. His work entitled Are Yūdachi-ni (Dancing girl), placed on view in the Third Government Art Exhibition, has the rare charm of Kyoto.

Gyokudō and Shunkyo were both eminent painters; the former still keeps his high position in Tokyo, and the latter recently died in Kyoto. They were likewise much interested in design and made beautiful patterns which appealed to the public taste. Gyokudō placed his works, called Sui-en or Morning Smoke, and, Sai-u or Fine Rain in a Bamboo Grove, in the Fourth and Fifth Government Exhibitions. Shunkyo exhibited his masterpiece entitled Shiobara-no Oku, or Bosom of Shiobara, in the Third Government Art Exhibition.

Besides those described above, the following have been master painters in the Meiji-Taishō Era: Hishida Shunsō, Odake Chikuha, Komuro Suiun, Araki Jippo, Kaburagi Kiyokata, Yūki Somei, Hirafuku Hyakusui, and Kikkawa Reikwa in Tokyo; and Konoshima Ōkoku, Kamimura Shōen, Kikuchi Keigetsu, Miyakoji Kakō, and Tsuchida Bakusen in Kyoto. In the Old Yamato-e School we had two well known masters: Matsumoto Fūko in Kyoto, and Kobori Tomoto in Tokyo. They painted mostly classical subjects. Among the painters who clung to the Bunjingwa, or Literati School (Nangwa), Masuzu Shunnan, Yamaoka Beikwa, Takashima Hokkai, and Tomioka Tessai were well known masters. In genre painting we have had such masters as Mizuno Toshikata, Kaburagi Kiyokata, Ikeda Terukata, and his wife Shōen.

Sculpture in wood, which declined after the Kamakura Period, was probably at its worst in the beginning of the Meiji Era, when everything old and native was ignored.

However, when the movement of nationalism revived, the study of wood sculpture revived also and in 1889 was included in the curriculum of the Tokyo Fine Art School at Ueno. On the other hand, in 1898, a Department of Western

Sculpture was created. At the same time, Taketarō Shinkai returned from Germany where he had studied Western sculpture. Under such circumstances, Japanese sculpture developed gradually under the influence of the West.

The eminent sculptors in wood at the beginning were Takeuchi Kyūichi and Takamura Kōun, who were Buddhist sculptors. Among the pupils of Kōun, Yonehara Unkai and Yamasaki Chōun were most famous. After the opening of the Government Art Exhibition such master sculptors as Shirai, Hirakushi, Kitamura, Asakura, and Fujii appeared.

At this time plaster-modelling and casting by Western methods were introduced. Meanwhile the custom of erecting statues for commemoration became quite popular. Early examples will be seen in the statue of Ōmura at Kudan, in that of Kusunoki Masashige at Kyūjō-mae, and in that of Saigō at Ueno park. They are all cast in bronze on a large scale.

Throughout the period of Meiji and Taishō we recognize that there were three noticeable movements, working everywhere in the field of fine arts as in the other fields of culture: the introduction of the Western style, the revival of nationalism, and the harmonizing of the new and the old. At the beginning, the people were radical in looking abroad, but they soon came back to their own senses, and strove to create their own art out of the native and foreign. Yet they were still in a transitional stage, only hoping for success in the future.

CHAPTER XII

CONTEMPORARY ART

It is one of the hardest tasks to make any complete judgement of contemporary art, because it is so closely related to the changing life of the people. If one watches the kaleidoscope of life as it flows along the Ginza, or in the Mitsukoshi and other large department stores, one will find girls with bobbed hair, clothed in flowery Japanese dresses, or in smart American spring dresses. The people are attracted by things European as well as by things Japanese. A similar diversity in life will be noticed in the dwelling houses of the middle and upper classes. They have parlors in Western fashion, decorated in Western style, and other rooms furnished and decorated in Japanese style. But hosts receiving guests generally wear Japanese dresses. Their figures of course do not set beautifully in parlors of Western style. Thus the actual status of life is composed of different elements of East and West, which, in practice, are not yet quite harmonized.

Such is the background of the contemporary art of Japan. Its influence on visual arts is conspicuous. The contemporary painting in Japanese native style is so complicated that its worth can not be judged by the standards of schools like Tosa, Kanō, Maruyama, and others of olden times. It is quite rare that any painter clings solely to one particular school of the past. Many painters study different native schools as well as Western styles and there is no definite technique. They should express their own ideas of the things they see, giving them their own interpretations by new technical skill. But we find that their subjects are often too remote from the present life. They repeat classical subjects without giving any new interpretations. Such seems to be an outstanding defect in the contemporary painting in Japanese style.

Such a tendency will be found in the exhibitions held yearly by two organizations: Teikoku Bijutsu-in or the Imperial Fine

Arts Academy, and Nihon Bijutsu-in, or the Institute of Japanese Fine Art. The former is called Teiten; and the latter, Inten. The Teiten is the government organization and occupies the highest seat of art in Japan, as does the Royal Academy of Arts in England, while the Inten is a private organization founded by Okakura Kakuzo, the members of which cling to the style of the so-called Inten School.

The Imperial Fine Arts Academy has for its object the promotion and development of national art. Its members consist of Japanese artists with distinguished careers, who are appointed for life. The most important of its activities is the holding of an annual art exhibition in autumn. The exhibition is divided into four sections: Japanese style painting, Western style painting, sculpture, and applied arts. The works sent in for the exhibition are selected by a standing committee composed of several members of the Academy and of those appointed from artists of established fame by the Academy for exhibition. There are two ways of recognizing the superior merit by making Special Selection (Toku-sen) or by conferring an Academic Prize (In-shō).

About half the members of the Academy, in charge of Japanese painting, are selected from masters living in Tokyo and the rest are taken from among those in Kyoto. The Tokyo members have to supervise their pupils living in Tokyo, while those of Kyoto are the sponsors for younger painters living in that city.

Kawai Gyokudō, Araki Jippo, Komuro Suiun, Yūki Somei, Kaburagi Kiyokata, Matsuoka Eikyū and Yokoyama Taikan represent Tokyo, and Takenouchi Seihō, Kikuchi Keigetsu, Nishiyama Suishō and Kawamura Manshū represent Kyoto. The style of the members of the Kyoto section developed according to the style of the Shijō or Maruyama School, while that of those living in Tokyo is generally more complicated. Komuro Suiun, the leader of the Nangwa School, Kaburagi Kiyokata, the leading painter of the Ukiyo-e style, and Matsuoka Eikyū, the leader of the new Yamato-e style are exceptions.

Besides the members of the Imperial Fine Arts Academy, we have painters of established fame, in Tokyo and Kyoto, whose works are generally seen in the exhibitions of the Academy. In Tokyo live such masters as Shimada Bokusen, Yamaguchi Hōshun, Tsutaya Ryūkō, Yazawa Gengetsu, and Hiroshima Kwōho; and in Kyoto live such masters as Tsuchida Bakusen, Dōmoto Inshō, Hashimoto Kwansetsu, and Konoshima Ōkoku.

The painters of the Nihon Bijutsu-in, or the Institute of Japanese Art, represent the new style of national painting, and occupy the camp opposite the exhibitions of the Imperial Fine Arts Academy. Yokoyama Taikan now presides over the Institute, under the influence of the ideal and the spirit of Okakura, the founder of the Institute. Among the members of the Institute, Arai Kampō, Kobayashi Kokei, Kimura Buzan, Yasuda Yukihiko, Maeda Seison, and Tomita Keisen are well-known masters.

Besides these two great art organizations, there are the Seiryū-sha and the Nangwa-in. The Seiryū-sha was founded by Kawabata Ryūshi, and the Nangwa-in, or Institute of Nangwa Painting, is presided over by Komuro Suiun. Both hold a yearly spring exhibition at Ueno.

Contemporary painting in Western style is making remarkable progress. Exhibitions are held yearly in spring and autumn by various art organizations, besides those held by the Imperial Fine Arts Academy. The most noteworthy are the Nikwa-kwai, the Shunyō-kwai, the Kōfū-kwai, and the Kokugwa-kwai.

The Nikwa-kwai was originally organized by a number of artists who were dissatisfied with the attitude taken by the committee for the government exhibition. The members of the Nikwa-kwai are very radical and progressive, accelerating the new development against the bureaucratic and academic style of the members of the Imperial Fine Arts Academy and their associates.

But now, both new and old styles are studied carefully and critically by the artists of all the different art organizations, including those of the Imperial Academy. The Impressionist, Cubist, Expressionist, Realist, and other schools are studied as

sources from which they may create their own individual styles with esthetic freedom. So it will be recognized that every exhibition is yearly making progress toward the same goal.

In the exhibition held by the Imperial Fine Arts Academy are sometimes seen works by old masters, such as Fujishima Takeji, Minami Kunzō, and Wada Sanzō. But the tendency of the Imperial Academy exhibition is represented by younger masters, such as Aoyama Kumaji, Kanayama Heizō, Tanabe Itaru, Makino Torao, Kumaoka Yoshihiko, Katada Tokurō, Ōta Saburō, and Takama Sōshichi. They are as a whole moderate and reasonable, and never eccentric.

In the Nikwa-kwai exhibition we see works by such eminent painters as Ishii Hakutei, Yamashita Shintarō, Arishima Ikuma, Sakamoto Hanjirō, Tsuda Seifū and Yasui Sōtarō. They are much influenced by Impressionism or Post-impressionism. Ishii Hakutei, the founder of the Nikwa-kwai, shows much Japanese taste in his Naturalism. The work by Yasui Sōtarō, who has studied Cezanne, is especially remarkable and he plays a very important rôle in the exhibition. But the new tendency of the exhibition is now represented by Kojima Zenzaburō, Hayashi Shigeyoshi, Koga Shunkō, and Tōgō Seiji.

In the Shunyō-kwai we have such master painters as Yamamoto Kanae, Kosugi Hōan, Morita Tsunetomo, Hasegawa Noboru, Kurata Hakuyō, Adachi Gen-ichirō, Kimura Shōhachi, Nakagawa Kazumasa, Okamoto Ippei, Hayashi Shizue, and Koyama Keizō.

In minor arts, pottery, lacquer wares, textile fabrics, and metal works are making remarkable progress in a new direction. Two government exhibitions are held yearly to encourage development of minor arts. One is included in the annual exhibition of the Imperial Fine Arts Academy held in autumn. However, the exhibits in this exhibition are mostly too imaginative in form and decoration for practical use. Another exhibition, held in spring under the auspices of the Department of Commerce and Industry, seems to have more popular appeal than that held by the Imperial Fine Arts Academy.

The most artistic works made of metal by contemporary artists are vessels or flower vases in bronze. Tokyo and Kyoto are the principal centres of such productions. Cloisonné wares enjoy a world-wide reputation for their exquisite workmanship and extremely fine quality. Nagoya, Kyoto and Tokyo are the three great centres of the enamellers' art.

Contemporary textile fabrics have made remarkable progress in designs, dyeing, and weaving. The most artistic are Nishi-jin, Yūzen and embroidery, and the best of these are produced in Kyoto. The Nishi-jin, the weaving quarter of Kyoto, is generally known, and has held the highest position in the silk industry in Japan for hundreds of years. In recent years, under the influence of European methods, panels, screens, table cloths, and wall tapestries of excellent workmanship have come to be made, besides many kinds of damask, gold brocade, figured crêpe, striped satin, and so forth. Yūzen is a comprehensive name given to all these dyed delicate silk fabrics on which various designs are executed by a particular process, which has always been a specialty of Kyoto dyers.

In the decorative art of Japan pottery is probably most attractive in its color and form. Kyoto is celebrated for the manufacture of the art-faience, which, under the names of Kiyomizu-yaki and Awata-yaki, has won the golden opinion of connoisseurs of ceramic art both in Japan and abroad. Arita in Kyushu is famous for Kaki-e-mon, Iro-nabeshima, and Arita wares. Kanazawa of Kaga is famous for Kutani ware. At present the manufacture of Kutani ware is not on so large a scale as it used to be. It is worthy of note, however, that wares of such a quality as is fit to meet the general demand are now manufactured in greater quantities than are the orthodox Kutani wares.

It is a deeply deplorable thing for Japanese who are proud of their fine art that they have no museum where contemporary art can be seen. It can be seen only at exhibitions held in the spring and autumn in Tokyo and Kyoto; or from time to time in small galleries in large department stores in Tokyo, Kyoto, and Osaka.

PART II

GUIDE TO TEMPLES AND MUSEUMS

CHAPTER I

TOKYO

1. TOKYO IMPERIAL HOUSEHOLD MUSEUM, UENO PARK

The Museum was first opened in 1882. The collections are divided into three departments: Historical Department, Fine Arts Department and Industrial Arts Department. The collections of each department are sub-divided into various kinds. However, the following collections are most important for students of Japanese art:

The collection of protohistoric relics—arms and armor, horse trappings, bronze mirrors, and personal ornaments—beads mainly of stone and glass, and rings and fillets of metal.

The collection of textiles from the eighth century, formerly belonging to the Hōryū-ji monastery in Yamato.

The collection of arms and armor of the historic period.

The collection of costumes of the Yedo Period.

The collection of sculpture.

The collection of ceramic art.

The collection of gold lacquer wares.

The museum has also loan collections besides their own.

We describe here some of the important exhibits.

PAINTING

The Bodhisattva of All-Pervading Wisdom, or Fugen Bodhisattva. (Fig. 179) Mounted as kakemono. Colored on silk. Fujiwara Period. Fugen was one of the popular Bodhisattvas worshipped at this time and this painting is one of the finest examples now existent. The Bodhisattva is seated on a lotus blossom, which is placed on the back of a white elephant, the symbol of sagacity and prudence. The posture and the

worshipping attitude of the clasped hands are suggestive of sublimity, and at the same time the whole is typified by the ideal feminine beauty as conceived by the people of those days. The most delicate cinnabar lines outline the white flesh. The eyes are opened narrowly; yet clearly cast downward. The lines of the nose are so extremely fine that it almost escapes notice. On the other hand the lips are touched with deep red by the pious brush of the painter. As a whole the expression is extremely calm and of womanly quietude, symbolizing celestial and spiritualized joy, yet touching the spring florescence on earth. The coloring of the dress is very elaborate and the gold color and many other pigments that

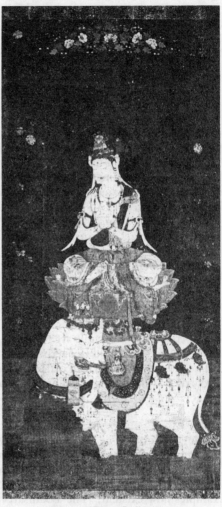

Fig. 179. Fugen Bodhisattva
Tokyo Imperial Household Museum

have been used reflect the most refined taste of the nobles of the day when this work was produced.

Figure of Shaka, or Shaka-zō. (Fig. 180) Jingo-ji monastery. Mounted as kakemomo. Colored on silk. Fujiwara Period. This is one of the most representative Buddhist paintings developed under the purely Japanese ideas of the Fujiwara Period. The face expresses womanly loving-kindness and the robe is highly decorated with a fine diaper design in rich colors and cut gold.

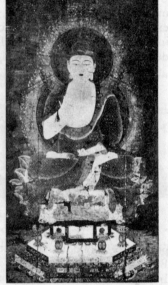

Fig. 180. Figure of Shaka
Tokyo Imperial Household Museum

Yellow figure of Fudō, or Ki-Fudō. A national treasure. Manju-in temple. Mounted as kakemono. Colored on silk. Late Fujiwara Period. In form and lines the power of Fudō is skilfully made visual.

Lotus Flower. A national treasure. Hompō-ji temple. Mounted as kakemono in pair. Colored on silk. Sung Dynasty.

Landscape. A national treasure. Kōtō-in temple. Mounted as kakemono in pair. Ink painting on silk. Late Sung Dynasty. A unique example of Chinese landscape painting.

Animal Caricatures. Kōzan-ji monastery. Mounted as scroll in four pieces. Painted in black and white on paper. Kamakura Period. This painting was long attributed to the priest Toba Sōjō, but without foundation. At the end of the picture is an inscription bearing the name Takemura and the date 1253. This may be the name of a former owner. The scrolls contain various sketches of the doings of Buddhist priests in Nara and Mount Hiei, humorously represented by lower animals, the stag stand-

ing for the priests of Kōfuku-ji and Kasuga, and the monkey for those on Mount Hiei. They are highly prized for their artistic merit, though the painter is unknown. No doubt they were executed by a master hand who had studied the Yamato-e style in the early Kamakura Period (1186–1333). In the part reproduced in Fig. 181 is seen a big frog, sitting on an altar, in the

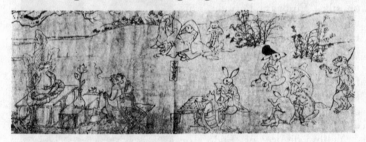

Fig. 181. Animal Caricatures (N.T.)
Tokyo Imperial Household Museum

posture of a Buddha. In front sits a large monkey, wearing a Buddhist costume vehemently saying something to the Buddha. In the background sit foxes, horses, monkeys, and other animals, in various postures and with different expressions. The lines depicting them are simple but strenuous, and full of life and movement, evoking some emotional interest when we trace the long series of caricatures.

The History of the Origin of Matsuzaki Tenjin, or Matsuzaki Tenjin Engi. (Fig. 182) Matsuzaki-jinja. Mounted as makimono in six pieces. Colored on paper. Late Kamakura Period. The picture is an excellent example of the beautifully colored picture scrolls developed in the Kamakura Period. At the end of the last scroll there is an inscription dated 1311 A.D.

Pictures of Arrogant Monks of Different Monasteries, or Tengu-zōshi. Mounted as makimono in two pieces. Colored on paper. Kamakura Period. Yamato-e style in the Kamakura Period is well represented in the long series of pictures.

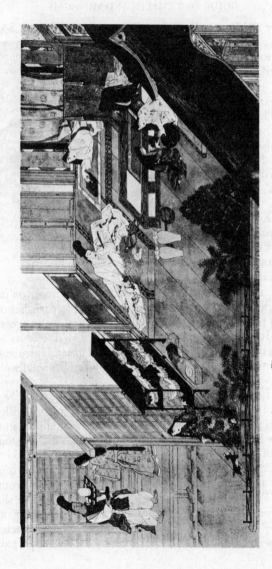

Fig. 182. Matsuzaki Tenjin Engi (N.T.)
Tokyo Imperial Household Museum

Picture of Hungry Devils, or Gaki-zōshi. (Fig. 183) Sōgen-ji Temple. Mounted as makimono. Slightly colored on paper. Early Kamakura Period. An appalling view of hell is presented vividly. The painting is attributed to Tosa Mitsunaga, but its origin is quite uncertain.

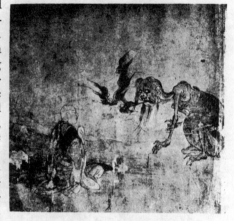

Fig. 183. Picture of Hungry Devils
Tokyo Imperial Household Museum

Peony. A national treasure. Kōtō-in temple. Mounted as kakemono. Colored on silk. Yüan Dynasty.

Landscape, by Sesshū. (Fig. 184) Mounted as kakemono. Ink painting on paper. Muromachi Period. In this work we see how a few strokes of the ink brush by his sensitive hand skilfully suggest rocks, trees, and a beach. It is an idealistic expression of his character as a Zen priest. Sesshū, 1420–1506, was one of the great Japanese landscape painters, and the founder of the Unkoko School. (See page 153)

Priest Eka Cutting His Arm, or Eka-dampi Zu, by Sesshū. A national treasure. Sainen-ji. Mounted as kakemono. Slightly colored on paper. 15th century. The picture was painted in 1495 when Sesshū was seventy-seven years old. This is a unique example of his work.

Landscape, by Motonobu, 1471–1559. Reiun-in temple. Mounted as kakemono. Slightly colored on paper. Muromachi Period. The pictures were originally painted on the sliding screens (fusuma) in the rooms of the Reiun-in temple of the Myōshin-ji monastery at Kyoto. But they have been peeled off the panels and mounted as 49 kakemono. A landscape painted

on three kakemono is now preserved in the museum. (Fig. 185) The picture represents mountains overlooking an extensive lake from three sides, with a wide opening in front under the lofty sky. It is painted with slight color on a large scale. On the kakemono of the left side is a place secluded by gigantic rocks, where a group of Chinese saints are playing music. The seclusion of such a rocky plot in the mountain is made thoughtfully for the saints, according to Taoistic idea. The rocks are delineated with a powerful touch of the brush. In the middle kakemono is painted an extensive lake with mountains in the background and beyond the lake is seen a line of ducks flying down peacefully. The lofty sky and mirror-like water are executed beautifully with a soft and sweet touch of the brush. In the kakemono at the right side there are a large misty hill and part of the lake, on the beach of which an old man is angling for fish. The main interest of this picture is in its chiaroscuro, the mellow tone of the strokes, and the harmonious composition of rocks, water, hills and sky. On the whole, the vast and restful feeling of nature as portrayed by this masterpiece of Motonobu is most attractive.

Fig. 184. Landscape, by Sesshū
Tokyo Imperial Household Museum

Illustrated History of Kiyomizu-dera Temple or Kiyomizu-dera Engi, by Tosa Mitsunobu. Mounted as makimono in three

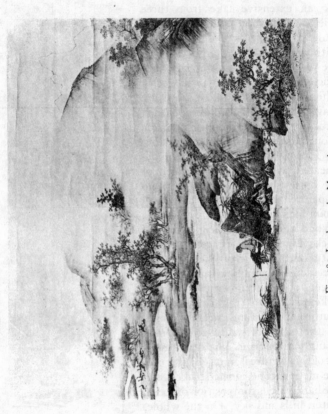

Fig. 185. Landscape, by Motonobu (N.T.)
Tokyo Imperial Household Museum

pieces. Muromachi Period. The picture was painted in the Ei-shō Era (1504–1520) when the painter was about eighty years old. (See page 162 and Fig. 102)

Chō Ryō and Three Laughers in the Tiger Valley, or Chō Ryō and Kokei Sanshō, by Kanō Sanraku. Mounted as byobu in pair. Colored on paper. Momoyama Period. This is one of the best works of Sanraku. On one of the pair is painted a Chinese Taoist legend of Chō Ryō (Chang Liang) and on the other, Kokei Sanshō, or The Three Laughers in the Tiger Valley. According to the legend, Chō Ryō, one day in his early life, encountered a poor and aged man, one of whose sandals had dropped off. Chō Ryō picked up the sandal and restored it to him. As a reward for this service the old man bade him come and see him five days later at an appointed place. The old man postponed the promised revelation three times, because each time Chō Ryō failed to arrive respectfully at an earlier hour than his strange acquaintance. However, the old man, satisfied at length, drew from his robe a volume of military tactics which he bestowed upon him with the words, "He who studies this book shall become a king's preceptor!" He added that in thirteen years' time Chō Ryō would meet him once more in the shape of a yellow stone (Kōseki) at Ku-chêng. This story is most dramatically and splendidly rendered on a gold screen. Chō Ryō is receiving the scroll from the old man who stands by the side of a horse, under a large pine tree. At the side of the pine tree a plum tree is in bloom, and beside a massive rock at the left a cluster of peonies is in full flower. The scene is altogether joyful. Its design and colors are bright and harmonious. On the other half of the pair is painted Kokei Sanshō or the Three Laughers in the Tiger Valley. (Color plt. 8) One of the three laughers is a priest of the Zen sect, who has come out of his temple to bid farewell to his two friends, one of whom is a Confucianist and the other a Taoist. The Buddhist priest had never crossed the Tiger Valley, in the vicinity of his temple, when he went to see his guests off. But this day, while talking on the way about his own philosophy, he became so deeply engrossed that he forgot to stop before reaching the valley, and so crossed

it. A tiger roared as a warning against his transgression of his usual practice, but the trio merely laughed at the roar and parted. This story symbolizes the unity of the three doctrines: Buddhism, Confucianism, and Taoism. This unity was prevalent in the Sung Dynasty. The artist has rendered this beautiful episode very successfully with wonderful space composition and a beautiful color scheme of gold, green, and blue, as is noticed in our color reproduction.

Pictures illustrating the Meaning of the Poems on the Twelve Months, or Jūnikagetsukai Emaki, by Tosa Mitsuoki. Mounted as two makimono. Colored on silk. 17th century.

Picture painted on fan-shape paper, by Sōtatsu. A national treasure. Sambō-in. Mounted as byobu in pair. Colored on gold ground. 17th century. One of the excellent examples in which Sōtatsu's color scheme and touch of the brush can be studied, although there is no sign nor seal by him.

Illustration of Part of the Ise Monogatari Romance, by Ogata Kōrin. Mounted as kakemono. Colored on silk. 17th century. One of the representative works by Kōrin.

Flowers and Birds of All Seasons, by Sakai Hōitsu. Mounted as makimono in two pieces. Colored on silk. Late 18th century. One of the excellent works by Hōitsu which are most beautifully colored.

Spring View of Lake Seiko in China, or Seiko Shunkei, by Ike Taiga. Mounted as byobu. Slightly colored on paper. 18th century. This is one of the representative masterpieces by Taiga, the great master of the Nangwa School. (Fig. 151)

Dragon and Cloud, by Ōkyo. (Fig. 186) Kwanchi-in temple. Mounted as a pair of byobu. Ink painting on paper. 18th century. Painted when Ōkyo was forty-one years old. Two furious dragons are painted on a large scale. Gold dust is mixed skilfully with ink, which gives a highly mystic power to the fabulous creatures.

Waves, by Ōkyo. Kongō-ji temple. A national treasure. Mounted as twenty-eight kakemono. Slightly colored on paper. 18th century. The picture was originally painted on the sliding

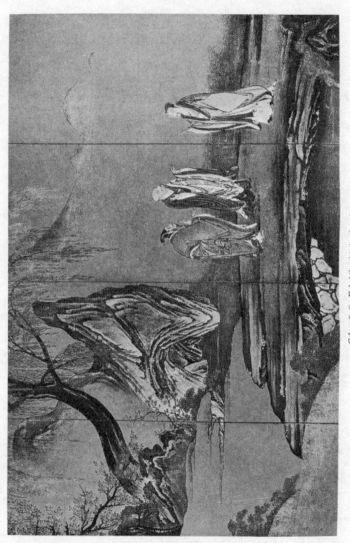

Color plt. 8. Kokei Sansho, by Sanraku.
Tokyo Imperial Household Museum

Fig. 186. Dragon and Cloud, by Okyo
Tokyo Imperial Household Museum

screens of the Kongō-ji temple. This is one of the grand master-pieces by Ōkyo. Six kakemono are borrowed by the Museum.

SCULPTURE

Kwannon. (Fig. 18) Gilt bronze. Suiko Period. The figure measures about 25 centimetres in height. The body of the sta-tuette is flat and thin, and the ends of the robe are extended to the right and left in the form of fins, serrated like those of the famous figure of Kwannon of the Yumedono of Hōryū-ji monas-tery. This is an example of the most archaic style of the Suiko sculpture cast in bronze in the seventh century and is known as the style of Tori. There is an inscription on the pedestal of this figure stating that two sons of Kasano-kōri-no-kimi Tako-no-omi who died in 591 A.D., made this image in order to pray that their father's life in the other world would be happy.

Kwannon. (Fig. 187) Gilt-bronze. Suiko Period. This, being rounder and less stiff, is much more graceful than that of the Tori style. The figure measures 33 centimetres in height and weighs 5.25 kilograms. In front of the head dress is a small figure of Amida. The right arm is bent, but the hand is missing from the point where it was attached by means of a tenon and

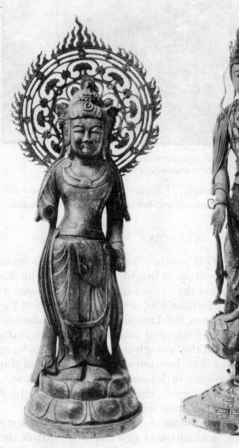

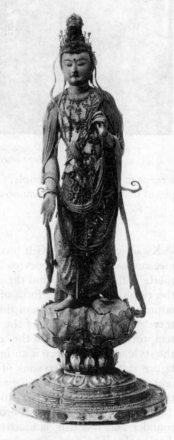

Fig. 187. Kwannon
Tokyo Imperial Household Museum

Fig. 188. Kwannon
Tokyo Imperial Household Museum

Fig. 189. Tea Bowl, by Third Dō-nyū
Tokyo Imperial Household Museum

a nail which pierced through the tenon from the outside of the arm. The posture shows considerable realistic development, but the feet still retain the conventional forms, the toes being roughly represented by engraved lines.

Kwannon. (Fig. 188) Wood. The early Muromachi Period. The statue has a calm expression and delicate pose. The figure is painted all over with colored lacquer except for the face on which gold leaf is overlaid. On the robe are elaborate patterns in cut gold. It is also decorated with a beautiful necklace made of gems of five different colors. The eyes and the prominence on the forehead are inlaid with quartz. Quartz is inlaid also in the lips, to give an appearance of moistness. This was a new technique initiated in Buddhist figures of the early Muromachi Period.

CERAMIC ART

Tea-jar, by Ninsei. Faience. 17th century. This is one of the

most representative works by Ninsei. The jar has an excellent
form and is beautifully decorated with a plum tree in blossom.
Gold and other colors are applied profusely. (See page 251 and
Fig. 159)

Tea Bowl. (Fig. 189) Red *raku* ware, by the Third Dō-nyū,
1574–1652. Yedo Period. He is popularly known by the name
Nonkō. The form of the bowl is magnificent. The inside and
outside are reddish and covered with vitrificated glaze except
for the lower part which is left white. The white part assumes a
view of snow moun-
tains under breaking
daylight. Thus the
bowl was named Sep-
pō, or Snow Peak, by
a tea master.

Hand - warmer.
(Fig. 190) Glazed
earthenware. By
Nin-ami Dōhachi,
1783–1855. Design
of a badger in a priest
robe. Excellent work-
manship in details
and glaze. Height
365 m.m.

Tea Pot. (Fig.
191) Earthenware.
By Mokubei, 1767–
1833. Late Yedo
Period. The form
of the pot is highly
delicate and is
decorated with a
bird in relief. It is
colored with yellow,

Fig. 190. Hand-warmer, by Dōhachi
Tokyo Imperial Household Museum

purple, and green glaze on an unglazed ground.

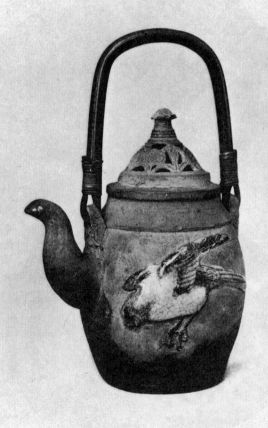

Fig. 191. Tea Pot, by Mokubei
Tokyo Imperial Household Museum

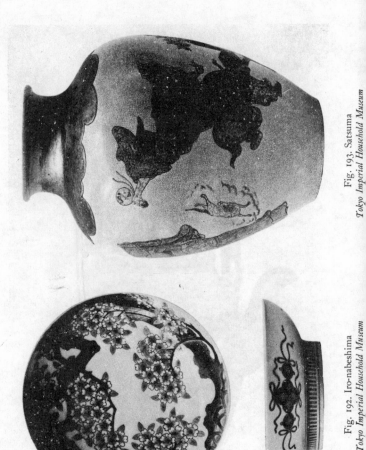

Fig. 193. Satsuma
Tokyo Imperial Household Museum

Fig. 192. Iro-nabeshima
Tokyo Imperial Household Museum

Plate. (Fig. 192) Iro-nabeshima porcelain. Early Yedo Period. The inside is most beautifully decorated with a cherry tree in full bloom in red, green, and yellow colors. Across the rim 203 mm. Height 58 mm.

Jar. (Fig. 193) Satsuma ware of Nawashiro kiln. Yedo Period. The pot is intended mainly for decorative purposes and is painted with figures in brown, blue, green, and red colors on a fine crackled ground. The mouth and shoulder are covered with gold plate. Dated 1765. Height 460 mm.

San-tsai-pot. (Fig. 194) Glazed earthenware. T'ang Dynasty. This is a fine example of T'ang pottery decorated with three different colored glazes—white, green, and yellowish brown. The beautiful form of its body and the powerful dragon-shape handles are also typical of the T'ang wares. Height 465 mm. This is one of a splendid large collection of Chinese pottery and porcelain given to the Museum by Mr. Tamisuke Yokokawa.

Fig. 194. San-tsai-pot
Tokyo Imperial Household Museum

LACQUER WARE

Tray for Censer. (Fig. 195) Red laminated lacquer, called *tsui-*

shu. Ming Dynasty (1368–1643). Peony blossoms are carved in relief, diameter 19.1 cm. and height 2 cm.

Chest. (Fig. 196) Lacquer. Heian Period. This is one of the fine examples of mother-of-pearl inlay on black lacquered ground. The design is composed of a phoenix transformed into beautiful round patterns, showing an elegant contrast of black and white.

Chest of Drawers. (Fig. 197) Gold lacquer. Momoyama Period. The chest is intended for incense. The outside is decorated beautifully with a design of autumnal grass in gold lacquer on a black lacquered ground in the style of *Kōdai-ji maki-e.* Width 250 mm.; depth 192 mm.

Hand Box, by Kō-ami Nagashige. (Fig. 164) Gold lacquer. 17th century. This is a fine example of the perfect workmanship in gold lacquer that developed in the early Yedo Period. It belonged formerly to the famous cabinet called Hatsune-no-tana which is owned by Marquis Tokugawa in Owari.

METAL WORK

Mirror. (Fig. 198) Bronze. Fujiwara Period. The mirror measures about 11 centimetres in diameter. Our illustration shows the back with its delicate floral design of the Fujiwara Period (894–1185). This kind of mirror is found mostly in the *Kyōzuka,* or Scripture-mound, and the museum has a large collection. The making of Scripture-

Fig. 195. Tray for Censer
Tokyo Imperial Household Museum

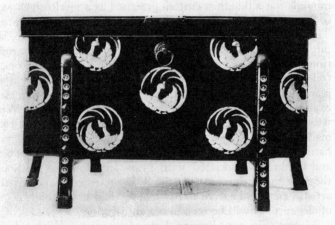

Fig. 196. Chest
Tokyo Imperial Household Museum

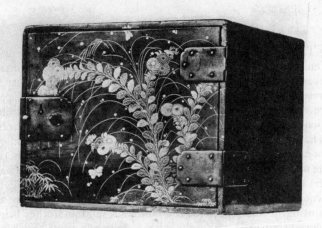

Fig. 197. Chest of Drawers
Tokyo Imperial Household Museum

mounds was a Buddhist custom practised as a meritorious work of faith from the tenth century down to the fourteenth century. The Hokkekyō, the most important Buddhist scripture, was put into a cylindrical case made of bronze, terra-cotta, or sometimes of stone, and was often buried with daggers, mirrors, or toilet things on some famous mountain or in some other noted place, with a prayer to Buddha. This is one of the numerous examples collected in the museum from many localities. When we compare them with Han or T'ang mirrors and copies of them made in Japan, Fujiwara mirrors are much smaller and very handy. The designs on their backs are composed mostly of birds and butterflies associated with grass and flowers. Although they are much simpler than the T'ang mirrors, they show that artistic spirit and native ability had reached a very high degree of elegance, as will be seen in our illustration.

Mirror. (Fig. 199) Bronze. Late 16th century. With a design of a paulownia and bamboo on the back. Dated 1588. Diameter 221 mm.

2. THE TŌSHŌ-GŪ SHRINE, UENO PARK

This shrine stands in Ueno Park. It was founded by the priest Tenkai in the Kwan-ei Era (1624–1643) to enshrine Tokugawa Ieyasu, the founder of the Tokugawa Shogunate, but the present buildings were rebuilt in 1651. The principal parts are the main shrine, hall for prayers, stone-floored chamber, open-work fence, and middle gate, and they are all enrolled as national treasures. The structure of this shrine is called *gongen-zukuri*. One of the conspicuous features of this style is that the main shrine is connected by the *ai-no-ma* (stone-floored chamber) to the hall for prayer. Inside and outside, black and red lacquer is used everywhere. There are decorative sculpture and painting in many parts of the buildings, gold and other bright colors being used profusely with a gorgeous effect. Such was characteristic of the early Yedo Period. The roofs are covered with copper plates.

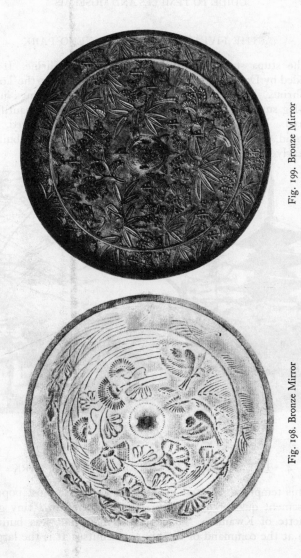

Fig. 199. Bronze Mirror

Fig. 198. Bronze Mirror

Tokyo Imperial Household Museum

3. THE FIVE-STORIED STUPA, UENO PARK

The stupa stands in front of the Tōshō-gū Shrine. It was founded by Doi Toshikatsu in 1639 and dedicated to the Tōshō-gū Shrine. The exterior is red, and the animal carvings in the frog-leg supports between the bracket systems are beautifully colored. The whole structure is restful, well balanced, and splendid, showing the best characteristics of the stupas built in the early Yedo Period. (Fig. 200)

Fig. 200. Five-storied Stupa (N.T.)
Ueno Park, Tokyo

4. THE SENSŌ-JI MONASTERY, ASAKUSA PARK

This temple is situated in Asakusa Park, the most popular amusement quarter in Tokyo. It is dedicated to a tiny gold statuette of Kwannon. The present main hall was built in 1649 at the command of the Shogun Iemitsu. It is the largest

piece of Buddhist architecture in Tokyo, magnificent in construction and vigorous in execution of details. The exterior is red, but the interior is gorgeous with colorful decoration.

A five-storied stupa stands on the right as one enters the temple gate called Niō-mon. This also was built in 1649 at the order of Iemitsu. It is a stupa of three spans, measuring 32.50 metres in height, and has a red exterior. It is regarded as a good example of the magnificent architecture of the early Yedo Period.

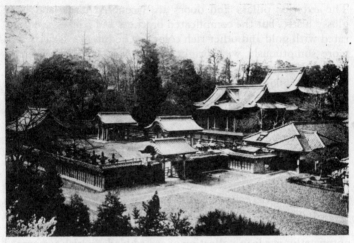

Fig. 201. Mausoleum of Second Shogun (N.T.)
Shiba Park, Tokyo

5. ZŌJŌ-JI MONASTERY, SHIBA PARK

The Zōjō-ji is situated in Shiba Park and is one of the greatest Buddhist monasteries in Tokyo. It was founded by the Tokugawa Shogunate at the end of the seventeenth century as a family temple of the Tokugawas. The remains of six Tokugawa Shoguns are entombed here and three separate shrines are erected for them. They are all gorgeous architecture of the

Yedo Period. But the finest of them is the one dedicated to the soul of the second Shogun, Hidetada, in 1632. It is called Dai-toku-in Mausoleum. Its general arrangement consists of an outer gateway, a gate bearing a tablet inscribed with the Emperor's handwriting, a fountain-pavilion, a belfry, an inner gateway, portico, oratory, a stone-floored chamber and a main hall. (Fig. 201) The architectural style is a combination of Shinto and Buddhist types, but it is recognized as a representative example of the mausoleum architecture developed in the early Yedo Period. The exterior pillars and doors are lacquered black and have glossy lustre, but the complicated brackets and friezes are decorated with gold and other rich colors. The interior is decorated more sumptuously with bright colors, gold being used everywhere. His tomb is exceptionally elaborate. It is covered with a fine octagonal building. Inside the building is enshrined a *hō-tō* or stupa which contains the remains. Decorated with gold lacquer design and encrusted with jewels, it is unparalleled in beauty and artistic elaboration.

6. THE YŪSHŪ-KWAN MUSEUM, KUDAN

The museum is situated in the precincts of the Yasukuni Shrine at Kudan. It was founded in 1881, and contains Japanese arms and armor of every period. The collection amounts to about ten thousand exhibits, arranged in chronological order. The most noteworthy is a loan collection of sword blades which are owned by Shinto shrines of many districts and enlisted as national treasures.

CHAPTER II

KAMAKURA

1. ENGAKU-JI MONASTERY, KAMAKURA

This monastery was founded by Hōjō Tokimune in 1282.
The first abbot was Bukkō Zenshi, a learned Chinese priest, who
was invited here by the founder. The Engaku-ji has been one of
the greatest monasteries of the Zen sect in Kamakura.

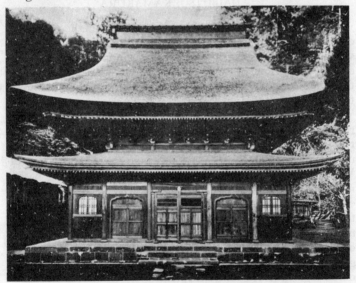

Fig. 202. Shari-den (N.T.)
Engaku-ji, Kamakura

The Shari-den was built in 1282. Here, the relic of the
Buddha's tooth, brought over from China, is enshrined. (Fig.
202) The hall is five spans square, of double-story construction.
It has a heavily thatched *irimoya* roof, the eaves of which are

supported by a double row of ribs spreading out like the sticks of a fan. Its complicated bracket system on the upper story, the rafters in radiating formation, the admirably constructed ceiling, the dais (*shumi-dan*) decorated with a repetition of peculiarly shaped mouldings, and the peculiar form of railing, doors, and curve-topped windows, are the chief features of this building, which are characteristic of Zen monasteries of the *karayō* style. This is the only building that remains in Kamakura from the Kamakura Period.

2. DAIBUTSU, KAMAKURA

This is a colossal bronze statue of Amida cast in the thirteenth century. (Fig. 203) According to the records, the monk Jōkō started to gather subscriptions for it in the year 1238, and the casting was begun in 1252 by the master founder Tanji Hisatomo. The original designer of the model is, however, not known to us.

The Buddha is seated on a lotus throne, without an aureole, resting upon a stone platform. The figure measures about 11 metres in height, and weighs 93,750 kilograms; the length of face measuring 2.3 metres, and the width from ear to ear, 5.4 metres. When completed, the statue was inclosed in a building with a massive roof supported by 63 immense wooden columns. However, this structure was twice destroyed by two tidal waves, the first in 1369 and the second in 1494. Since then, the house has never been restored and the image stands weather beaten, roofed only by the sky. It was not cast in a single shell, but made up gradually by means of sheets of bronze cast separately and soldered together. The joints are plainly visible today.

The statue may not be as magnificent as the best of Tempyō sculpture of the eighth century, but it is surely a great masterpiece, which reflects the realistic tendency of the time, and it has an air of peace and profound intimacy symbolizing the infinite love of the Amida Buddha. The patina is beautiful greenish black.

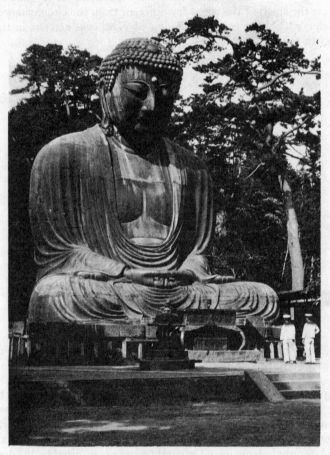

Fig. 203. Daibutsu (N.T.)
Kamakura

While the great Buddha at Nara was built by Imperial order heavily taxing the national exchequer, the one at Kamakura was planned by an obscure Buddhist monk supported by the people at large, who thus evinced their faith and sympathy. This reflects the spirit of the age, very different from the circumstances under which the colossal Buddha of Nara was erected in the eighth century.

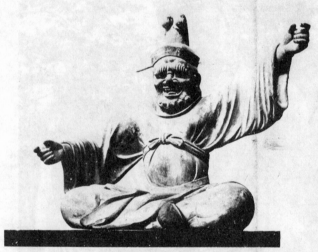

Fig. 204. Gushō-jin (N.T.)
Kokuhō-kwan Museum, Kamakura

Mr. Pier, an art-critic of the West, who visited Kamakura to see this colossal figure of Amida, admired it in the following words: "More than any other artistic treasure of its kind in Japan, the statue of Amida needs to be seen, and seen often, to be fully appreciated. No Western pen can do justice to the consummate beauty of its pose and expression; for it is no exaggeration to say that this matchless figure combines within itself all the essential elements of Oriental beauty, as inspired by the doctrines of esoteric Buddhism."

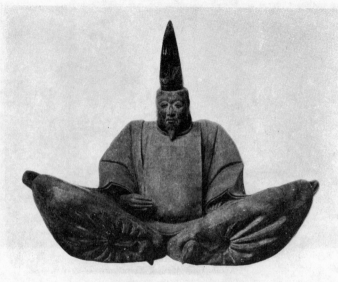

Fig. 205. Figure of Uesugi Shigefusa (N.T.)
Kokuhō-kwan Museum, Kamakura

3. THE KOKUHŌ-KWAN MUSEUM, KAMAKURA

The museum is situated in the compound of the Tsurugaoka
Hachiman Shrine. The first aim of the museum is to preserve
and exhibit different kinds of objects owned by Shinto and Bud-
dhist temples and private collectors in Kanagawa prefecture to
show the culture, arts, and civilization of the Kamakura Period.
But owing to the difficulty of borrowing enough exhibits to il-
lustrate the art of the Kamakura Period, objects of other periods
also are placed on view. There are about thirty good examples
of sculpture of different ages including about twenty national
treasures; about fifty exhibits of painting, including twenty na-
tional treasures, mostly produced in the Kamakura and Muro-
machi periods; and of minor arts there are about ten national

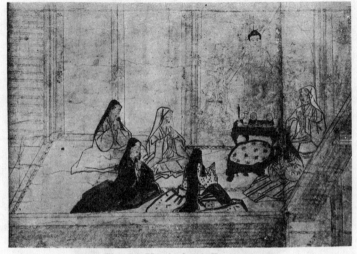

Fig. 206. Hōyaki Amida Engi (N.T.)
Kokuhō-kwan Museum, Kamakura

treasures. They are mostly related to Buddhist art.

Gushō-jin. (Fig. 204) A national treasure, Ennō-ji temple. Gushō-jin is one of the attendants to the King of Hell. The figure is very realistic in form and expression and is a representative masterpiece of the Kamakura sculpture in wood.

Figure of Uesugi Shigefusa. (Fig. 205) Meigetsu-in temple. The figure measures 68 centimetres in height, and is one of the best examples of portrait sculpture produced in the late thirteenth century. The costume he wears is called *kari-ginu*, the ceremonial dress of military nobles in the Kamakura Period.

Illustrated History of the Figure of Hōyaki Amida, or Hōyaki Amida Engi. (Fig. 206) Kōsoku-ji temple. Mounted as two kakemono. Colored on paper. The Kamakura Period. The picture illustrates the miraculous attributes of the figure of Amida enshrined in the Kōsoku-ji temple, and it is one of the best representative picture scrolls produced in the Kamakura Period. Its style of painting belongs to the Tosa School.

CHAPTER III

NIKKO, SENDAI, AND HIRAIZUMI

1. THE TŌSHŌ-GŪ SHRINE, NIKKO

The Tōshō-gū at Nikko is the mausoleum built for Ieyasu, the founder of the Tokugawa Shognate. The first mausoleum was erected by the Second Shogun Hidetada in 1617. But the present one was rebuilt by the Third Shogun Iemitsu. He began rebuilding it in November of the eleventh year of Kwan-ei (1624) and completed it in April of the thirteenth year of the same era. It took only one year and a half; but for lavish decoration and dazzling ornamentation it is universally admitted to be the foremost edifice in Japan. In the plans and the architecture of the shrine three important facts will be noticed. In the first place, it is laid out most cleverly on a narrow hill side, the buildings being arranged very irregularly but harmoniously in relation to one another and to their environment. Second, the vast and evergreen trees, much older than the buildings, are preserved in their original places, to make them a harmonious background for the elaborate ornamentation of the buildings. Third, every effort is made to have the most elaborate and gorgeous ornamentation for all the buildings.

Five-storied stupa, a national treasure, stands on the left as one enters the main entrance. It was re-erected in the year 1817, and measures 32 metres in height. The exterior is red but the doors are lacquered black and all the brackets and carvings between them are lavished with different colors.

Three storehouses, national treasures, stand on the right as one enters the Niō-mon gate. They are built in composite form, a harmonious combination of the storehouse style (*azekura*) and the ordinary palace style. The exterior is lacquered red except for doors which are black lacquered, and the bracket systems, the carvings of frog-leg supporters, and

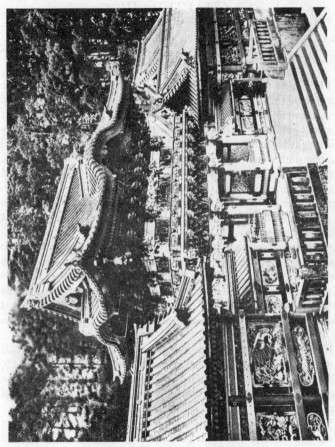

Fig. 207. Yōmei-mon (N.T.)
Tōshō-gū Shrine, Nikko

gable ends are decorated with various bright colors. On the left is the sacred stable. This is the only building constructed of plain wood. At the end of the pavement that passes between the stores and the stable is the Fountain Pavilion, which is decorated with elaborately colored carvings and gilded metal fittings. Although very small in scale, its roof is supported by twelve monolithic columns. Turning to the right at this point and passing through the bronze Torii, we come to the Rinzō (revolving library) which faces one of the storehouses. The interior of the library is furnished with revolving bookcases which contain the *tripitaka* or all the collections of Buddhist scriptures.

Coming up a flight of stone steps, we see the Bell Tower and the Drum Tower. Behind the latter stands a magnificent temple called Honji-dō dedicated to Yakushi Buddha whom Ieyasu worshipped in his life time as his tutelary Buddha.

The Yōmei-mon gate (Fig. 207), a national treasure, approached by passing upward between the two towers of the bell and the drum. This is the most elaborate and the most famous architecture of all the buildings of the shrine. It is a two-storied gateway with three column intervals, the roofs of the upper story having curved gables (Kara-hafu) on four sides. Everywhere the technical details are most elaborate, and there is prodigal use of polychromatic decoration. The whole surface of this small structure is covered with intricate carving and resplendent with colors; every inch presents what we call the Rococo style of Japanese architecture. The cornice is most complicated. All the brackets are lacquered black but the chamfered parts are gold lacquered. Between the groups of brackets are inserted statuettes of Chinese sages and wisemen. The ornamentation of this architecture is, however, so skilfully harmonized with the surrounding landscape that there is no vulgarity of over-elaboration. The galleries extending from the gate are filled with wonderful polychromatic carvings of phoenixes, peacocks and other birds of gorgeous plumage. (Fig. 208)

As we pass through the Yōmei-mon gate, there is a storehouse for the sacred portable shrines on the left; and on the right is the

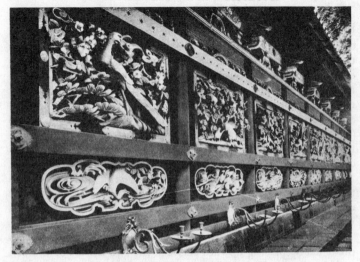

Fig. 208. Carving of Gallery (N.T.)
Tōshō-gū Shrine, Nikko

stage for sacred dance (Kagura-den). Next, we come to the innermost gate, called Kara-mon, which is also elaborately overlaid with many colored carvings.

The main shrine (Honden), the stone-floored chamber (Ishi-no-ma), and the hall for worship (Haiden) are inside the Kara-mon gate. The hall for worship measures nine spans by four and is surrounded by a gallery. Inside is one spacious room flanked by two chambers, the right to be used by the Shogun (Fig. 209) and the left by the Lord Abbot of the shrine. Both of these chambers are decorated with elaborate carving on the panels, friezes, and ceiling. Back of the hall is the stone-floored chamber which leads to the main shrine. The interior of the main shrine is divided into three apartments, outer, inner, and innermost sanctuary where is the sacred shrine most sumptuously ornamented, in which Ieyasu is enshrined.

This style of construction in which the main shrine is connected with the hall for worship by the middle hall, is called

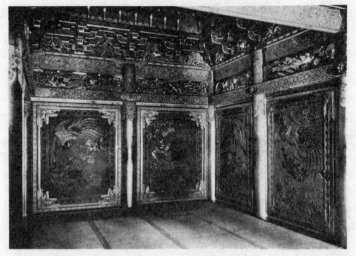

Fig. 209. Shogun's Chamber (N.T.)
Tōshō-gū Shrine, Nikko

gongen-zukuri in the history of Shinto architecture; and this shrine is a good specimen. There are about 220 Tōshō-gū shrines distributed among all the districts of Japan. Ieyasu is enshrined in all of them and their architectural style is always the same as that of this shrine.

2. THE ZUIGAN-JI, MATSUSHIMA

The Zuigan-ji, a Zen monastery, was re-erected by the order of Date Masamune, Lord of Sendai, in 1609 at Matsushima, one of the "Three Scenic Beauties of Japan." The temple has the middle gate (Chū-mon), the Onari-mon gate, the main hall (Hon-dō), the residential building (Kuri), and the galleries (Kwairō). They are all national treasures. Among all of them the main hall is the greatest piece of architecture in the *shoin-zukuri* style. It is a single-story construction with an *irimoya* roof which is covered with tiles. The interior is divided into different rooms;

but the central room, called the Peacock Room, is the finest. The sculpture on the door-panels and friezes is vigorous and decorated in rich colors; and all the sliding screens (*fusuma*) are painted with gorgeous pictures. As a whole, one finds here some good examples of architectural sculpture and painting of the Momoyama Period.

3. KWANRAN-TEI, MATSUSHIMA

The Kwanran-tei was a villa of the Lord of Sendai, situated at the beach of Matsushima Bay overlooking a beautiful view of the sea. It is said that the villa was originally one of the buildings in the castle of Fushimi, near Kyoto, which had been given to Date Masamune by Toyotomi Hideyoshi and later transferred here. Anyhow, it is a good example of residential architecture of the *shoin-zukuri*. The walls and sliding screens are all covered with gorgeous paintings in the Momoyama style, which are attributed to Sanraku.

4. CHŪSON-JI MONASTERY, HIRAIZUMI

The Chūson-ji monastery is situated on a hill of Hiraizumi, overlooking a vast landscape field through which the Kitakamigawa river flows quietly. The temple may be reached by train in twelve hours from Tokyo.

It was founded by Fujiwara Kiyohira in the early twelfth century and was enlarged by his successors, Motohira and Hidehira. In the time of its prosperity, there were about forty temples and a hundred residential buildings for priests. However, at present only two buildings, the Konjiki-dō and the Kyō-zō remain to tell of its past glory.

Kiyohira and his two generations reigned with supreme power over eastern Japan. Their headquarters was Hiraizumi. To it, they were eager to transplant the aristocratic life of the court nobles in Kyoto. Archaeologists may trace its grandeur in the various sites of the temples and residential build-

ings erected by them, as well as in the two extant examples, the Konjiki-dō and Kyō-zō.

The Konjiki-dō was constructed in 1124 by order of Fujiwara Kiyohira who wished it to be his own mortuary. His remains are actually buried under the dais of the hall. It is a small one-storied edifice 18 ft. square, but the whole building stands as a sample of gorgeous extravagance achieved by all the technical skill and artistic imagination that were available at the time. The architecture was too fine and delicate to be exposed directly to the vicissitudes of weather for many years. Therefore it is

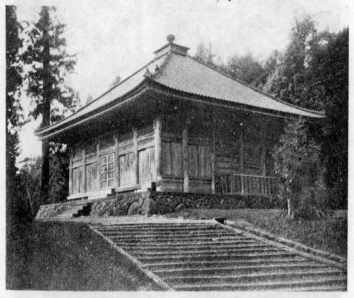

Fig. 210. Outer Building of Konjiki-dō (N.T.)
Chūson-ji, Hiraizumi

protected under an outer building built in the Kamakura Period (Fig. 210) and from that time it has not been possible to see the exterior appearance properly.

However, the interior decoration is marvellously well pre-

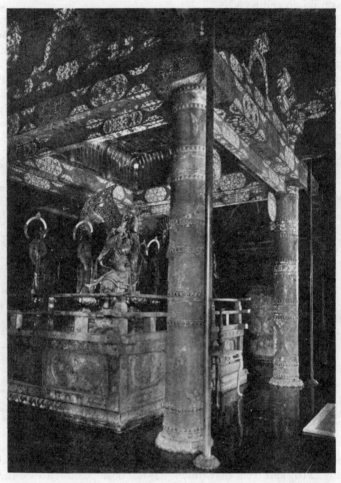

Fig. 211. Interior of Konjiki-dō (N.T.)
Chūson-ji, Hiraizumi

served. (Fig. 211) The dais, on which is enthroned the image of Amida with his attendant figures, is extremely beautiful and the most important example of its kind in which the best of the Fujiwara decorative art can be seen today. The ceiling above the dais, specially constructed and coffered to dignify the place, is supported by four columns. On each column are represented twelve Buddhist figures, called Jūnikō-butsu, in gold lacquer. These twelve Buddhas symbolize twelve manifestations of the attributes of Amida's boundless Light of Mercy. The interstices of the Buddhist figures are filled with a diaper design called *shippō* which was one of the characteristic designs of the Fujiwara Period. The upper and lower parts of the figures are encircled with ornamental bands inlaid with the *hōsōge* design in mother-of-pearl. The *hōsōge* design is composed of floral arabesque, the most popular design in the Fujiwara Period. The columns, brackets, tie-beams, and other horizontal members are decorated profusely with this design made of mother-of-pearl on lacquered ground and have beautiful color harmony. The panels at each side of the dais are decorated with peacocks in gilt *repoussé*, in the tails of which are inserted colorful gems. The railings are veneered with some foreign wood on which are inlaid decorative flowers in mother-of-pearl. From the beams which connect the four columns, are suspended ornamental hangings made of gilt-bronze. There are Two Buddhist sacred birds, called *Karyō-binga*, in the *hōsōge* design in open work. This is also representative metal work of the Fujiwara Period. The whole interior decoration of this chapel represents most colorfully the best of the later Fujiwara decorative art, raised from the terrestial art of the age to religious sacredness.

The Kyō-zō. This is the sacred library erected by the order of Kiyohira in 1108. It was originally a two-storied building, but it lost its upper story by fire in 1339. Along the walls are wooden shelves on which are arranged two hundred and sixty black lacquered sutra-cases. These cases contain two kinds of Buddhist sutras; one copied with gold and silver pigment and another with only gold pigment, altogether numbering 620

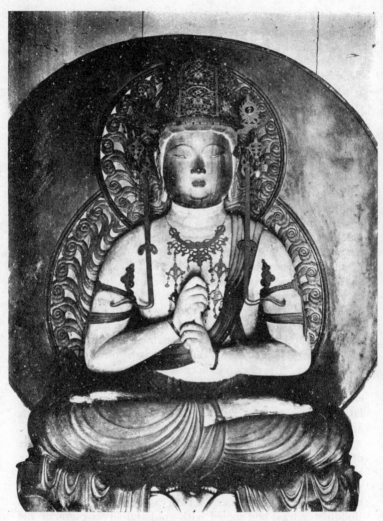

Fig. 212. Ichiji Kinrin (N.T.)
Chūson-ji, Hiraizumi

scrolls. The pictures inside the covers of these sutras are also painted with gold and silver pigment. They are all excellent examples bequeathed by the late Fujiwara Period. In the middle of the room there is an octagonal dais (*shumi-dan*) which is decorated with mother-of-pearl inlay and gilded metal fittings. On the dais is enthroned Monju Bosatsu or Manjusri. In front of the dais are several pieces of lacquered furniture which are of the same age and value as the building itself.

Benzaiten-dō temple. In this temple are placed on view ten pictures of "Saishō-wo-kyō-jikkai-hōtō-mandara." In the middle of each picture is the shape of a stupa, which is formed by an arrangement of all the ideographs of the Saishō-wo-kyō sutra. And around the stupa are colored pictures illustrating the meaning of the sutra. The pictures are rare examples of the late Fujiwara Period.

The Sacred Treasury (Hōmotsu-kwan) stands near the Konjiki-dō. The treasury contains a number of fine examples of art objects produced in the late Fujiwara Period. The following are a few of the important ones:

Ichiji Kinrin. Wood. This is the colored wooden image of Ichiji Kinrin in a sitting posture. (Fig. 212) The figure of Ichiji Kinrin is one of the manifestations of Dainichi Buddha or the Great Illuminator. It was worshipped for protection against calamities and evil spirits or for getting childen, in the Fujiwara Period. The figure typifies the ideal form of elegance as conceived by late Fujiwara Period, even attempting to appeal to our sense of reality; but it lacks spiritual vigor. In technique it is curious, for though the manner is quite that of sculpture in the round, the back is flat against the halo and the body is only about three quarters of the natural thickness. In this figure, we see crystal eyes for the first time.

The figure of Dainichi-nyorai. A national treasure. Wood. The statue is sitting cross-legged, measuring about 76 centimetres in height. This is an excellent example of the sculpture produced in the late Fujiwara Period.

Tengai or canopy. A national treasure. Wood. This was

originally suspended over the main Buddhist figure of the Konjiki-dō. It has a design of lotus flower in the middle and *hōsōge* arabesque around the lotus in delicate relief and open work. This was also produced in the late Fujiwara Period.

Gilt-bronze banner. A national treasure. This is an excellent example of metal work of the late Fujiwara Period. It represents Buddhist sacred birds and *hōsōge* arabesque in delicate open work.

CHAPTER IV

NAGOYA CASTLE

In the eleventh year of Keichō (1606) Ieyasu, the first Shogun of the Tokugawa family, made his son Yoshinao the Lord of Owari, and built for him a forceful and magnificent castle, which we are about to describe. Since the erection of the castle, the city of Nagoya has developed remarkably and is at present the third largest city in Japan.

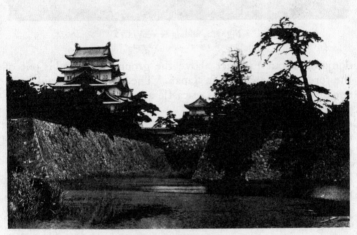

Fig. 213. Nagoya Castle (N.T.)
Gov. Rys. Photo.

The castle (Fig. 213) was completed in 1610, its erection being shared, by the Shōgun's command, among twenty-two great daimyos. It is noted for its five-storied donjon, built under the direct supervision of the great warrior, Katō Kiyomasa, who was also known as an eminent castle architect. The height of the

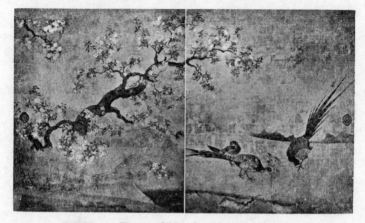

Fig. 214. Sliding Screens (N.T.)
Nagoya Castle, Nagoya

donjon is about 144 feet above the ground level and is one of the foremost old castles in Japan. The structure is said to be one of the finest examples of castle architecture Japan has ever produced.

The castle was the residence of the Lord of Owari for about two centuries and a half from its erection till the Meiji restoration in 1867. The original residential buildings of the lord, which were also erected in the early seventeenth century with the donjon, still remain in the inner enclosure. There are several large buildings connected by galleries, the rooms of which are gorgeously decorated with splendid pictures on the walls and sliding screens used as the partitions of rooms. The style of pictures belongs to the Kanō School of the late Momoyama Period. They are really unique examples of the gorgeous residences of powerful daimyos in the early Yedo Period; and are worthy of careful study. Among them, the most noteworthy rooms are the Genkan, Omote-shoin, and Taimen-jo.

The Genkan consists of two rooms which are also called "Tiger-rooms." The wall of the toko-no-ma, or alcove, and all the

Fig. 215. Interior of Taimen-jo
Nagoya Castle, Nagoya

faces of the sliding screens are painted with about ninety tigers roaming about in bamboo groves and flowers, in rich colors on a ground of gold leaf. The powerful appearance of the tiger was a popular subject selected for interior decoration in the Momoyama and early Yedo periods; and it was appropriate in the entrance rooms of such an imposing mansion as this.

The Omote-shoin. This building is connected with the Genkan by a gallery and divided into four rooms: the elevated room, first, second, and third rooms. On the wall of the alcove of the elevated room is painted a large pine tree, together with a plum tree, in rich colors on gold leaf. But the finest and the most representative picture is that painted on the sliding screens of the first room of this building. A large cherry tree in full bloom is painted at the bank of a stream which runs between rocks where plants and flowers blossom in profusion. The picture remains in good condition. (Fig. 214)

The Taimen-jo. This building is divided into two rooms, the walls and sliding screens of which are painted with the customs and manners of Kyoto and Osaka in colors on a ground on which gold is dusted. (Fig. 215) They are not, however, so splendid in colors as those in the other rooms just described. But they are important examples of the genre painting of the early Yedo Period, which were produced by the Kanō School as the interior decoration of residential buildings.

CHAPTER V

KYOTO AND VICINITY

1. THE KYOTO ONSHI MUSEUM OF ART

The museum was originally established by the Imperial Household and opened to the public in 1897. But in 1924 it was given to the city.

The exhibits consist largely of things borrowed from the Buddhist temples, many of which are enrolled as national treasures. They are divided into three departments—history, fine art, and industrial arts.

The most important exhibits of the museum are painting and sculpture.

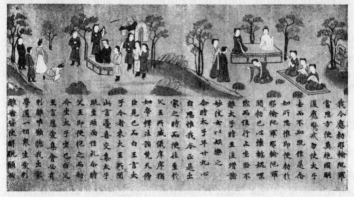

Fig. 216. Sutra on the Cause and Effect of the Past and Present (N.T.)
Kyoto Onshi Museum of Art

PAINTING

Sutra on the Cause and Effect of the Past and Present or the Kwako-genzai-ingwa-kyō. Jōbon-rendai-ji monastery.

Mounted as makimono. Colored on paper. The text of the sutra is written on the lower half, and on the upper half are delineated pictures illustrative of the meaning of the sutra. (Fig. 216) The picture and the text were produced in the Tempyō Era (729–748). Although the picture was painted in the eigth century, it is in the oldest style of painting, that is, the Six Dynasties style, which was handed down from the Suiko Period. The figures, dresses, and other objects depicted on the scroll illustrate some of the customs of Northern China that prevailed in the sixth century.

Portrait of Seven Patriarchs of the Shingon Sect. Tō-ji monastery. Mounted as seven kakemono. Colored on silk. T'ang Dynasty. Each picture measures about 2.5 metres by 2 metres. They are slightly colored. On the top and bottom of each image are Buddhist mottoes in Sanscrit or in Chinese. Two of the pictures are attributed to the brush of Kōbō Daishi, while the other five were brought from China during the T'ang Dynasty. These five patriarchs are said to have been painted by the T'ang artist, Ri Shin (Li Chên), who was one of the noted artists of the time. The pictures are by no means elaborate. They are rather sketches, but the strokes display great power and full maturity, the images presenting a solemn and dignified appearance well befitting their saintly character. Our reproduction (Fig. 49) shows the portrait of Fukū by the Chinese artist. He is represented as seated with his hands clasped, wearing a black scarf. His quiet air of introspection is highly impressive. Such a style of T'ang portrait has served as model to many a later Japanese artist.

Shaka-muni Buddha Rising from the Golden Coffin or Shaka-kinkwan-shutsugen Zu. Chōhō-ji monastery. The picture is painted in colors on silk about 1.7 metres in height and 2.42 metres in breadth.(Fig.217,Frontispiece)Shaka-muni Buddha is rising from a golden coffin and turning towards his mother, the princess Maya, who has come down from heaven. Other saintly figures surround the central image, together with angels and demons, and all are struck with joy and wonder, with reverence and worship. The impression is cheerful and opposed to death, quite unlike the

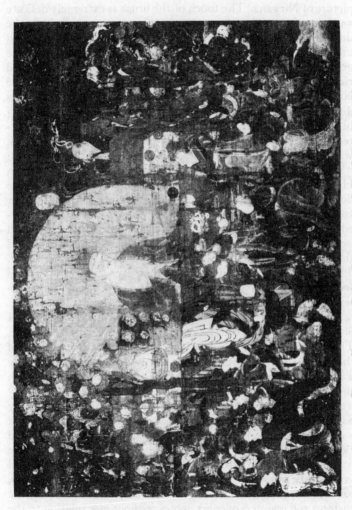

Fig. 217. Shaka-muni Buddha Rising from the Golden Coffin (N.T.)
Kyoto Onshi Museum of Art

picture of Nirvana. The touch of the brush is extremely delicate
and sensitive. The elaborate cut-gold design applied to the
dresses of all the figures is characteristic of the Fujiwara Period
and the technical process is excellent. The lines drawn over the
gold and other colored ground are also full of life. The gold and
rich colors applied to the main figure wonderfully reveal the
boundless light of eternity in inexpressible beauty and religious
dignity. This is indeed a unique masterpiece of religious painting
in the Fujiwara Period. The first mention we have of the resur-
rection of Shaka-muni Buddha is in the Mahâmâyâ sutra which
was translated into Chinese in the sixth century. There it says:
"When the Buddha died, his mother Maya, who was already in
Heaven called Tosotsuten and bitterly deploring his death, came
down upon the earth and wailed sorely before the coffin of her
sacred son. At this moment the coffin opened and Buddha appear-
ed alive, with one thousand halos gleaming from his head. And
he calmly informed his mother that all laws are imperishable, and
that he had left behind him all the law necessary for posterity.
Then he asked her not to sorrow for him, even though he entered
within the veil of Nirvana." This mention in the sutra is doubt-
less the origin of the resurrection scene in this beautiful painting.

Buddhist sutras dedicated by the Heike family. Itsukushima
Shrine. Mounted as thirty-three makimono. Colored on paper.
The sutras are composed of the Hokkekyō or the Lotus of
the True Law and other minor sutras, which were copied by
Tairano Kiyomori and thirty-two members of his family with
the utmost devotion to the god of the Itsukushima Shrine. They
were dedicated in 1166 with a separate roll of prayer written by
Kiyomori. On opening each of the scrolls one is at once struck
with the marvellous perfection of its decorative art, illumined
even more richly than any mediaeval breviary. The colors are
full of variety, and there are gold and silver filings on a beautiful
ground. Between the verses there are painted various pictures,
some illustrating the meaning of the text, others showing the
customs and manners of court nobles without any relation to the
text. The frontispiece of each scroll is colored most beautifully

Fig. 218. Buddhist Sutra Dedicated by the Heike Family (N.T)
Kyoto Onshi Museum of Art

and wisely lavished with silver and gold all over the ground.
(Fig. 218) Some are fine gold or silver dust and gold or silver
threads, but here and there the color is emphasized by large cut
leaves of gold and silver; yet there is nothing vulgar or unrefin-
ed. The coloring of the entire length of the text is also beautifully
arranged in innumerable shades, notes and hues, yet each has a
distinctive office and attractiveness. The style of the picture
belongs to the Yamato-e School. The delineation of faces is of
the peculiar style called "*hikime-kagihana*" or drawn-eyes and
key-nose. The eyes are drawn with one line and the nose with
two broken lines. These lines are very delicate and expressive
of the quiet feeling and unaffected elegance of court nobles. All
these beautiful scrolls are kept in a case made of copper and
beautifully decorated with an appliqué composed of a *gorintō*
stupa, dragons and clouds, all in silver or gold gilt. This is also a
unique example of the industrial arts of the Fujiwara Period.

Portrait of Minamoto Yoritomo. Jingo-ji monastery. Mount-

Fig. 219. Pictorial Biography of Ippen Shōnin (N.T.)
Kyoto Onshi Museum of Art

ed as kakemono. Colored on silk. Early Kamakura Period. The picture is attributed to Takanobu, the famous portrait painter almost contemporary with Yoritomo whom he painted; and it is an important example illustrative of the new movement in the history of portraiture in Japan. (See Fig. 72) The face is delineated with fine lines and yet the manly and forcible character of Yoritomo, as the leader of warriors, shines out of every line, in remarkable contrast to those effeminate and sentimental court nobles of the Fujiwara Period. His dress is entirely that of court nobles, colored black, but stiffened with the strong starch which was a particular style of Kamakura costumes. This type of dress accords with the chivalrous expression of his face and fits well with the spirit of the age.

Pictorial Biography of Ippen Shōnin or Ippen Shōnin Eden, by En-i. (Fig. 219) Kwangikō-ji monastery. Mounted as twelve makimono. Colored on silk. Late Kamakura Period. Ippen, 1239–89, was the famous monk who was the founder of a sect called "Time Doctrine" or Jishū. He spent all his religious life in itineration, propagating the practice of repeating Buddha's name to gain welfare in future life. The priest naturally travelled far and wide all over the country. The picture scrolls illus-

trate his missionary journey. The painter depicts faithfully the actual incidents, customs, and manners, with all the surroundings. Each shifting scene has its own attractiveness and a new interest. The touch of brush is fluent and the color harmony is excellent. The style of painting belongs mainly to the Yamato-e School. However, the Chinese style, newly introduced from China, is used skilfully in the landscapes. The pictures of the seventh scroll are copied, the original of which is separately owned by Mr. Tomitarō Hara of Yokohama. The end of the last scroll is inscribed as follows: "The texts are by Shōkai and the pictures by Hōgen En-i, in the first year of Shōan (1299)." According to this inscription, we understand that the pictures were painted by En-i, and the text by Shōkai, a disciple of Ippen, in 1299, that is, only ten years after the death of Ippen. Although these are the only data from which we know about the painter, his name is immortalized in the history of Japanese painting by this master work.

Pictorial Biography of Hōnen Shōnin or Hōnen Shōnin Eden. (Fig. 220) Chion-in monastery. Mounted as forty-eight makimono. Colored on paper. Late Kamakura Period. Hōnen Shōnin, 1133–1212, was the eminent priest who propagated Amida-Buddhism and founded the Jōdo sect. The paintings depict all the important events in the life of the prelate, beginning with his birth and ending with his death, together with customs and manners in towns and countries where he visited, and also with natural surroundings. In landscape we find the Yamato-e style skilfully mingled with that of the Chinese style of the Sung Dynasty. The pictures are attributed to Tosa Yoshimitsu, but it was natural that many painters took part in their completion.

The Amida Triad rising over the Mountain and the picture of Paradise and Hell, or Yamagoshi-no Mida and Jigoku Gokuraku Zu. Konkai-kōmyō-ji monastery. Colored on silk. The Kamakura Period. It is composed of three screens: the central one, three panelled; and the two side screens, two panelled, each measuring 105 centimetres in height. On the middle screen is represented the Amida Triad rising over the mountains. (Fig.

Fig. 220. Pictorial Biography of Hōnen Shōnin (N.T.)
Kyoto Onshi Museum of Art

221) On the two side screens are painted separately the terrestrial world, hell, and the Paradise of Amida, making a complete picture when both are joined. (Fig. 222) The picture of the Amida Triad is traditionally said to have been the vision which appeared to the priest Eshin Sōzu, 924–1017, who transferred it to silk. The design and coloring are generally Fujiwara, but when we examine them carefully, the

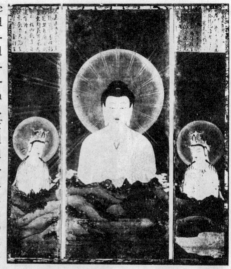

Fig. 221. Amida Triad rising over
Mountain (N.T.)
Kyoto Onshi Museum of Art

production certainly belongs to the early Kamakura Period and was therefore not painted by Eshin Sōzu. The picture symbolizes the height of religious consciousness reached by Japanese followers of the Pure Land doctrine or the Jōdo-kyō. The three figures are profusely decorated with gold; and even the smaller patterns on their dresses are rendered in cut-gold much more richly than in the Fujiwara Period. It is indeed the climax of beatitude, manifested by gold in the iconographic representation of the Amida Triad, and developed in the time when the Pure Land faith was much democratized. To the fingers gathered in front of the chest of Amida are attached real silk threads of five different colors, which can be recognized in our reproduction. They were originally long enough to be caught by the faithful while on his death-bed, so that he might be firmly conscious of his deliverance by Amida at the very moment of his passing. The

Fig. 222. Paradise, Hell and Terrestrial World (N.T.)

Kyoto Onshi Museum of Art

threads were used for such an actual purpose. According to the contemporary records, such was a custom practised in the Kamakura Period, and such figures of Amida were carried round to the death-beds of the faithful to assure them of their reception to the Land of Highest Happiness of Amida.

Pictures of Five Hundred Arhats, or Gohyaku Rakan Zu, by Minchō. Tōfuku-ji monastery. Mounted as forty-five kakemono. Colored on silk. Early Muromachi Period. Ten Arhats being painted on each kakemono, the complete set consisted originally of fifty pieces of kakemono. It is said that Rakan, or Arhats, have super-natural powers, conquering all passions, and that they receive successive promotions to Buddhaship. Therefore they deserve worship. Minchō spent several years of devoted zeal in painting them all. All the figures are painted on a natural background with delicate lines and beautiful coloring. The posture of each expresses its individual personality. The style in these pictures is no doubt based on that of Sung painting of China. But they are representative Chinese paintings developed in Japan in the Muromachi Period. (Fig. 223)

Landscape Representing Summer and Winter, by Sesshū. (Fig. 97) Manju-in temple. Mounted as two kakemono. Black and white on paper. Muromachi Period. Both pictures represent rocky mountains with a solitary temple in the valley. In one of the pictures he successfully reproduced the refreshing coolness of summer, and in the other, the shivering loneliness of winter. Sesshū was no doubt an ardent student of nature, but the pictures must have been the creations of his own imagination to reveal such infinite life and loftiness of nature. And his imagination is carried out with a bold and direct touch of brush. We find in these pictures the purity, simplicity and directness which are characteristic of Sesshū's work in ink sketches. They deserve a high admiration.

The Picture of Wind and Thunder Deities, or Fūjin Raijin Zu, by Sōtatsu. A national treasure. Kennin-ji. Mounted as two byobu. Early Yedo Period. The thunder-deity has two horns; the body is red or white and is represented as nude. On his back he

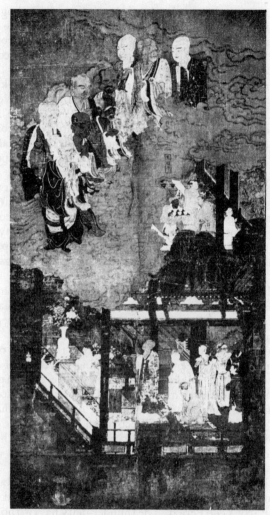

Fig. 223. Rakan, by Minchō (N.T.)
Kyoto Onshi Museum of Art

carries a large ring attached to a number of drums, and a plectrum in one hand, riding on black clouds. The wind deity is blue and one horned. He carries a wind-bag, and is riding on white clouds. They belonged originally to the Buddhist pantheon, but after being separated from Buddhism they became a favorite subject in painting. Now, Sōtatsu painted the two deities on gold leaf with soft yet bold black ink combining black and gold and other colors in a most admirable way.

<center>SCULPTURE</center>

Head of Buddha. (Fig. 224) Tōshōdai-ji monastery. Thick layer of dried lacquer over wood and overlaid with gold leaf. Tempyō Era. The piece is much broken; but for this reason the technical processes by which lacquer is applied may be conveniently studied.

Twenty - Eight Attendants of Kwannon (Nijū Hachibushū). Myōhō-in monastery. Colored on wood. Kamakura Period. These figures were originally made as the attendants of Senju Kwannon of the Sanjusangen-dō and all remain in

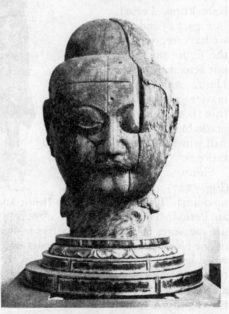

Fig. 224. Head of Buddha (N.T.)
Kyoto Onshi Museum of Art

good condition. Eight of them are placed on view in the museum. Each of them shows a different posture and expression in accordance with his capacity as an attendant to Kwannon. They are all full of realistic movement. Their dresses are decorated with fine cut-gold and colored designs. They are no doubt master works produced in the early Kamakura Period. In Figs. 225 and 226 we have reproduced the figure of a hermit attendant called Hasu, which is a master work. Its thin body and remarkable expression will win high admiration.

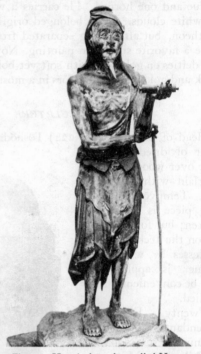

Fig. 225. Hermit Attendant called Hasu (N.T.)
Kyoto Onshi Museum of Art

Shinto Deity. (Fig. 227) Matsuno-o-jinja. The Heian Period. The figure measures about 90 centimetres in height and is carved out of one block of wood except for part of the knee, where other wood has been added to make its form. It is worth noticing that the costume of the figure represents that of the day and that although the figure looks like the head of a family it still has the dignity of deity. Such is the ideal of Shintoism from the remote past, and in this lies the greatness of this figure.

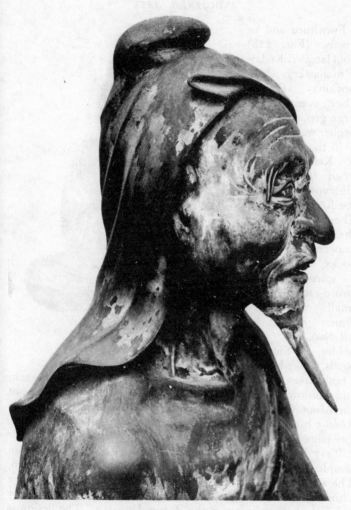

Fig. 226. Detail of the Fig. 225.

INDUSTRIAL ARTS

Furniture and u-
tensils. (Fig. 228)
Gold lacquer. Kōdai-
ji monastery. Mo-
moyama Period.
They constitute a
large group of gold
lacquer ware produc-
ed in the tenth year
of Keichō (1605)
when the wife of
Hideyoshi erected
the Kōdai-ji temple.
There are two
chairs, a chest of
drawers for song-
books, a hand-box,
a spice-holder, a
sword-rack, three
small four-legged
dinner tables (or
kakeban), a rice-
holder, fourteen
bowls, a sake-holder,

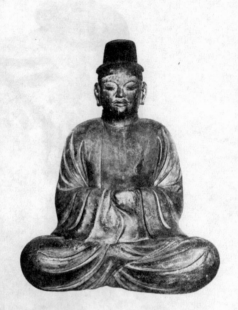

Fig. 227. Shinto Deity (N.T.)
Kyoto Onshi Museum of Art

a hot-water-tub, *temmoku-dai* or stands for a teacup, a towel-rack,
and a pillow. They are all representative gold lacquer wares of
the Momoyama Period, and are popularly known by the name
Kōdai-ji maki-e. However, the finest of them is the dinner tray.
(See page 204 and Figs. 128, 129)

Tray by Chōsei. Laminated lacquer. (Fig. 229) Daisen-in
temple. This kind of lacquer is called *tsuishu* or heaped vermilion.
The art is peculiar to China and Japan. Our tray was made by a
Chinese artist called Chōsei (Chang Ch'êng), who was a master
hand at the art living in the T'ang Dynasty. The design is

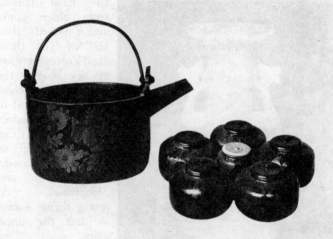

Fig. 228. Kōdai-ji Gold Lacquer (N.T.)
Kyoto Onshi Museum of Art

composed of flowers and peacocks carved in thick laminated lacquer, and signed with his name on the back. The finish is quiet and soft in feeling, such as can not be obtained in wood-carving overlaid with lacquer.

Flower Vase. (Fig. 230) Celadon. Bishamondō temple. Chinese Sung Dynasty. This celadon vase is one of

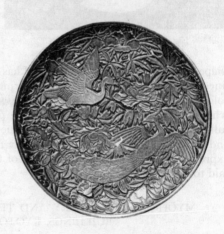

Fig. 229. Tsuishu Tray (N.T.) *Daisen-in, Kyoto*

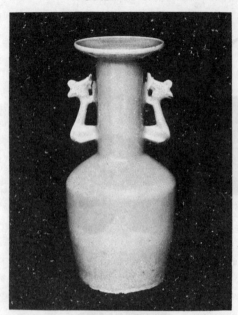

Fig. 230. Celadon Flower Vase (N.T.)
Kyoto Onshi Museum of Art

the most famous from olden times and is named "Bansei" or Ten thousand Voices. Its glossy sky blue is the representative color of the best kind of *Kinuta-de* celadon. There are three kinds of *Seiji* or celadon: *Kinuta-de*, *Tenryūji-de*, and *Shichikan-de*. Among them *Kinuta-de* has the finest color.

Incense Burner. (Fig. 231) Faience. Hōkongō-in temple. Seventeenth century. The body is modelled into the shape of a lotus flower, and each petal has a blue brim and gold lines on a red ground. The cover, formed into a lotus leaf, is colored blue and has five perforated Sanscrit characters through which the incense smoke goes out. The pedestal is also beautifully decorated with gold, red, and blue colors. In the shape and colors we see the beauty particular to faience which fully expresses Japanese taste. The artist of this excellent work is said to be Ninsei.

2. MYŌHŌ-IN MONASTERY AND THREE HISTORICAL BUILDINGS, KYOTO

The Myōhō-in is one of the famous Buddhist monasteries of

the Tendai sect. In
the monastery still
remain three histori-
cal buildings: Dai-
Shoin or Great Recep-
tion Hall, Genkwan
or Entrance Hall and
Great Kitchen, which
are all enrolled as
national treasures.

The Dai-shoin was
originally built at the
Imperial court in 1619
in honor of Tōfuku-
mon-in, the consort of
the Emperor Go-
mizu-no-o, and was
later given to this
monastery. The walls
and sliding screens at

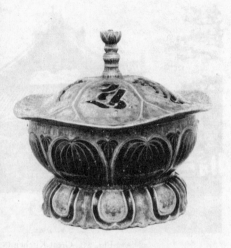

Fig. 231. Incense Burner (N.T.)
Kyoto Onshi Museum of Art

the partitions of its rooms are all painted with Chinese figures,
flowers or trees in rich colors on gold leaf. The painting is
attributed to Kanō Eishō and Eitoku. This is one of the
magnificent examples of the *shoin-zukuri* architecture developed
in the early Yedo Period.

The Genkwan, or Entrance Hall, was also built in the early
Yedo Period. The interior is divided into three rooms and on
the walls and sliding screens are painted gigantic pine trees in
rich colors on gold leaf. The picture is attributed to Kanō
Eitoku.

The Great Kitchen (Fig. 232) is traditionally said to be a
place where a dinner was once prepared for one thousand
monks. It is a stupendous wooden structure; and all the roof
constructions are seen from below. It has a large chimney at the
top of the roof. Its bold massive structure represents the idea of
Momoyama architecture.

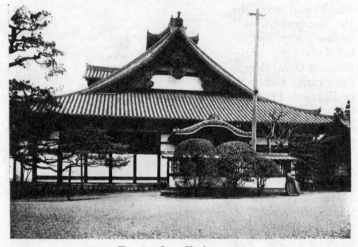

Fig. 232. Great Kitchen (N.T.)
Myōhō-in, Kyoto

3. CHISHAKU-IN MONASTERY AND ITS PALATIAL BUILDINGS, KYOTO

The Chishaku-in is the headquarters of the Chizan-ha branch of the Shingi-Shingon sect of Buddhism. The main Buddhist hall was lost by fire, and at present the Hōjō (residence of the abbot) is temporarily used as the main hall. It was originally a palatial building erected in honor of Tōfukumon-in, the consort of the Emperor Gomizu-no-o. It is said that later the building was given to the monastery and transferred here in the second year of Kyōwa (1802).

The Dai-shoin, or the Great Reception Hall, is said to have been a palatial building in the Momoyama castle erected by Taikō Hideyoshi. The building itself is quite simple but its walls and sliding screens are decorated with gorgeous paintings (Fig. 233) which are all listed as national treasures. They are the most gorgeous among many famous examples which still remain in

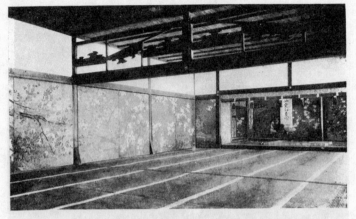

Fig. 233. Interior of the Great Reception Hall (N.T.)
Chishaku-in, Kyoto

many temples of Kyoto. The pictures are generally composed of large pines, cherries, or maples, among which are many kinds of flowering plants of all seasons on gold ground.

The Shinden or Residential Building. The west and east rooms of this building are also magnificently decorated with similar gorgeous paintings in the Momoyama style. They are likewise listed as national treasures.

4. SANJUSANGEN-DŌ TEMPLE AND ITS ONE THOUSAND GOLDEN STATUES, KYOTO

The Sanjusangen-dō is the main temple of the Renge-ō-in monastery which was founded by the ex-Emperor Goshirakawa in the year 1165. But being destroyed by fire in 1249, the present temple was rebuilt in 1266. It is an immense work of architecture of thirty-five span frontage with a side of five spans, built in the *wayō* or native style. (Fig. 234) It is one-storied, and the side-view of the building is more pleasing than the front-view of the long façade. Although it was rebuilt in the Kamakura

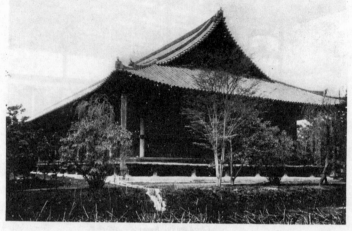

Fig. 234. Sanjusangen-dō (N.T.)
Renge-ō-in, Kyoto

Period, the architects seem to have followed the original style of the Fujiwara Period.

Various colors are used for the decoration of the interior. But except for the windows which are painted blue the outside is coated only with the usual red oxide of lead. The centre of the ceiling is coved; the rest shows the bare rafters.

Upon the central dais of the inside are placed the main image, the Thousand-armed Kwannon, and the twenty-eight attendants, all of the same date as the building itself. The rest of the interior space is taken up by one thousand smaller images of Kwannon on a wooden flooring below the level of the dais. It is a grand sight (Fig. 235); and they are all works of art.

5. KIYOMIZU-DERA, THE FAMOUS MONASTERY OF KWANNON, KYOTO

The Kiyomizu-dera monastery stands on a hill with beautiful surroundings, and can be approached through a terrace street in

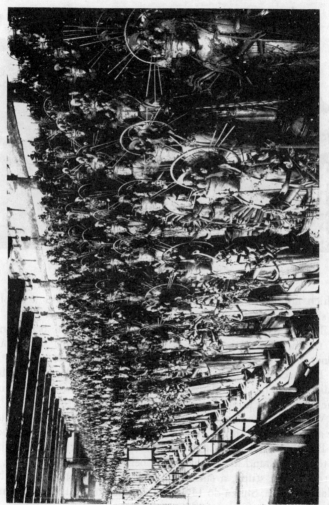

Fig. 235. Interior of Sanjusangen-dō Temple (N.T.)
Renge-ō-in, Kyoto

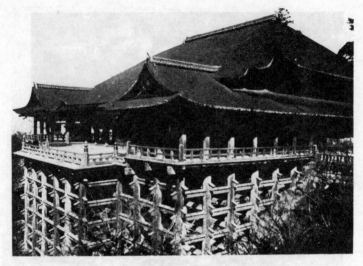

Fig. 236. Main Temple (N.T.)
Kiyomizu-dera, Kyoto

which famous porcelain wares called Kiyomizu-yaki are sold in shops on both sides.

The monastery is said to have been founded at the beginning of the ninth century by Saka-no-ue Tamuramaro, a famous general.

The present buildings were all rebuilt in much later ages. Its main temple has been dedicated to Kwannon and it has become one of the most popular Buddhist temples in Kyoto.

When one comes to the upper extremity of the terrace avenue he approaches a tall red gate called Niō-mon where two statues of Buddhist guardian kings are placed. On the other side of the gate, there stand at the hillside a belfry, the Sam-mon gate, a three-storied stupa, a sutra depository, the Tamura Hall, the Main Temple, Shaka-dō Hall and Amida-dō Hall, each having a beautiful spot for its environment.

Teh belfry, a national treasure, is situated on the left as one

enters the Niō-mon gate. It was erected in 1607, and its powerful construction represents the style of the Momoyama architecture.

The Sam-mon gate, a national treasure, standing at the top of the stone steps, was built at the same time as the belfry. Its design is rare and beautiful.

The Main Temple, a national treasure, was rebuilt by the third Shogun, Iemitsu, in the year 1633. (Fig. 236) It stands on the top of a cliff. The principal part of the building is nine spans by seven, to which are added pentroofs, an entrance porch, and two wings between which a stage is constructed with a passage extending from either side. The stage and the passages have railings and are supported by many long columns connected with the horizontal members over a deep precipice. They present a unique feature as will be seen in our photographic reproduction. The roofs are all covered with the bark of the *hinoki* wood and have variety in size, shape and height, making a beautiful harmony with their natural environment. As a whole the building is an excellent example of renaissance architecture built in the early Yedo Period, and is highly admired for its beauty.

6. CHION-IN, THE HEAD MONASTERY OF THE JŌDO SECT, KYOTO

The Chion-in is situated at the eastern foot of Higashiyama mountain. The monastery was founded by the famous priest Hōnen who founded the Jōdo sect of Buddhism in Japan in the second half of the twelfth century, and wrote a famous treatise called Senjaku Hongwan Nenbutsu Shū, on the doctrine of the Jōdo sect for the Minister on the Right, Fujiwara Kanesane. The treatise is still highly esteemed by the adherents of this sect which is one of the influential Buddhist sects in Japan. The sect has about 6,900,000 believers and 58,000 priests.

The monastery is composed of the Sam-mon, or the main gate, the Miei-dō, or Main Hall, the Shū-e-dō or the Assembly Hall, the Amida Hall, the Sutra depository, Kara-mon gate, the larger and smaller Hōjō Halls, the Belfry and the Seishi-dō Hall. These

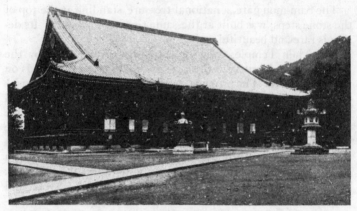

Fig. 237. Main Hall (N.T.)
Chion-in, Kyoto

buildings are arranged on a magnificent scale in the extensive precinct of the monastery as we see them now. They were mostly rebuilt under the patronage of the Tokugawa Shoguns in the Yedo Period.

The Sam-mon, a two-storied gate, stands high upon the top of the stone steps at the entrance of the monastery. The pious people, looking upon the gate, feel uplifted and think that they are approaching the Pure Land of Buddha Amida. The gate was erected by the second Shogun Hidetada in the year 1619. It is constructed of plain, massive wood with complicated bracket groups under the eaves. However, the interior of the second story is decorated in rich colors. All the beams are painted with Chinese mystic animals, and the ceiling is painted with a dragon in clouds and Buddhist angels. Upon the dais along the inner wall are enthroned the image of Shaka-muni with sixteen figures of Rakan, or Buddhist disciples, and some other figures.

This is a typical example of the largest kind of Buddhist gate built in the early Yedo Period.

The Main Hall (Hon-dō or Miei-dō) is dedicated to the priest Hōnen, and is the largest and the most important temple of this monastery. (Fig. 237) The building was erected in the tenth year of Kwan-ei (1633) by the third Shogun, Tokugawa Iemitsu. The temple has a façade of eleven spans with nine spans on each side, and a single-story with a tiled roof in *irimoya* style. Its massive pitch in front is quite suggestive of the greatness of the sacred building. At the inside of the entrance porches, in the front and at the rear, will be seen some beautiful carvings of such sacred beings as dragons, angels, and phoenixes; and some conventionalized flowers, such as the peony, chrysanthemums and paulownia, all in plain wood. The interior is divided into two halves, front and rear. The outer half is the place where the adorants sit and hear sermons; and in the inner half is the apse where the statue of the priest Hōnen is enshrined. In his book entitled "Impressions of Japanese Architecture," Mr. R.A.Cram said of the interior decoration of this temple, "Apart from St. Mark's in Venice and the Capella Palatina in Palermo, I know of no religious interiors that can vie with such caves of glory as Chion-in."

The temple is no doubt a typical piece of architecture of the Jōdo sect in the early Yedo Period.

The larger Hōjō, a national treasure, was built in the tenth year of Kwan-ei (1633). It has a façade of nine spans with sides of six spans each, and a single-story with an *irimoya* roof thatched with the bark of *hinoki* wood. The interior is divided into two sections, front and rear; and either section includes four rooms. The partitions of the rooms are mostly made by sliding screens. The walls and sliding screens are painted with pictures in colors. The jōdan-no-ma is the finest among them. The wall of its toko-no-ma or the large recess is painted with a picture representating a Chinese poet looking at a waterfall, which is slightly colored on gold ground. On the sliding screens are painted landscapes. The pictures are all ascribed to Kanō Naonobu, a master painter of the Kanō School. The sliding screens of the largest room, called Butsuzen-no-ma, are painted

with large pine trees and cranes on a golden ground, which are also ascribed to Kanō Naonobu.

The smaller Hōjō, a national treasure, was also built in the tenth year of Kwan-ei (1633). It has five spans at the façade and side, and a single-story with an *irimoya* roof thatched with the bark of *hinoki* wood. The interior is divided into six rooms, and the walls and sliding screens of each room are painted with landscapes in black and white. These rooms are simpler and quieter than those of the larger, richly decorated Hōjō.

These two Hōjō buildings are typical of the residential architecture of the monasteries erected in the early Yedo Period.

The following are national treasures owned by the monastery:

Illustrated History of the Priest Hōnen. Attributed to Tosa Yoshimitsu. Mounted as forty-eight scrolls. Colored on silk. Late Kamakura Period. Ten out of forty-eight scrolls are preserved in the Kyoto Onshi Museum of Art.

Amida and Twenty-five Bodhisattvas, who are coming down to welcome the souls of the dead, popularly known as "Haya Raigō." Mounted as kakemono. Colored on silk. Kamakura Period. Preserved in the Kyoto Onshi Museum of Art.

Kwangyō Mandara. Mounted as kakemono. Colored on silk. Muromachi Period.

Amidagyō Mandara. Mounted as kakemono. Colored on silk. Muromachi Period.

Gubari Amida, or Amitayus in red cloth. Mounted as kakemono. Colored on silk. Kamakura Period.

Jizō Bodhisattva. Mounted as kakemono. Colored on silk. Preserved in the Tokyo Imperial Household Museum.

Bishamon-ten. Mounted as kakemono. Colored on silk. Kamakura Period.

Peony flowers. Attributed to Senshun-kyō. Mounted as kakemono. Colored on silk. Sung Dynasty. Preserved in Kyoto Onshi Museum of Art.

Lotus flowers and herons. Attributed to Jōki. Mounted as two kakemono. Colored on silk. Sung Dynasty.

Two Chinese Elysian gardens or "Tōri-en and Kinkoku-en" Attributed to Kyū Ei. Mounted as two kakemono. Colored on silk. Ming Dynasty. Preserved in the Kyoto Onshi Museum of Art.

7. NANZEN-JI, THE FAMOUS MONASTERY OF ZEN BUDDHISM, KYOTO

The Nanzen-ji is one of the head-temples of the Rinzai sect. The site was originally occupied by an Imperial detached palace, belonging to the ex-Emperor Kameyama, which he gave to a temple in 1293; and the temple became the first of the five main Zen Monasteries (Go-san) in Kyoto. The monastery was several times destroyed by fire, and declined during a long period of years. However, when Konchi-in Sōden was appointed abbot, he was able to restore the monastery to its former prosperity because he had the great confidence of Ieyasu, the first Shogun of the Tokugawa family. In the sixteenth year of Keichō (1611) a palace building called Seiryōden was given to him, which he transferred to this temple as his Hōjō, or residence. He also received a palatial residence in the castle of Fushimi, which is called Ko-hōjō, or smaller Hōjō. In 1620 Tōdō Takatora rebuilt the Sam-mon gate. These three buildings still remain and are all enrolled as national treasures.

The Sam-mon is the magnificent two-storied gate in Zen style built in the early Yedo Period. The whole outside is of plain wood. But the interior of the upper story is decorated beautifully. The pillars and beams are painted with waves, dragons, giraffes, and clouds in rich colors; and on the dais are placed the image of Shaka-muni and sixteen figures of rakan, or arhats.

The Hōjō was originally erected in the Imperial Court in the Tenshō Era (1573–1591). It is a large one-storied building, thatched with shingles of *hinoki* bark and having an *irimoya* roof at either side. The exterior beauty of the building lies in the broad slope of large pitch of the roof, which is one of the characteristics in Japanese architecture. The inside is divided into

eight rooms. All the sliding screens at the partitions of the rooms are painted with different pictures in rich colors by Kanō painters. The building is a very important example of the palace architecture of the late Muromachi Period, that is, the sixteenth century.

The Ko-hōjō, which was originally built in the Fushimi castle, is also called the "Tiger Room" because each room is decorated with the pictures of tigers painted on sliding screens. (Fig. 238)

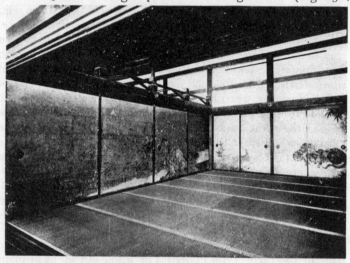

Fig. 238. Tiger Room (N.T.)
Nanzen-ji, Kyoto

The so-called "tiger rooms" remain in various historic buildings but none excels these pictures of tigers in magnitude of form and colors. They are most probably painted by Kanō Tannyū. A group of tigers is roaming among bamboo bushes painted on gold leaf. The deep green of the bamboos makes a fine sharp color contrast with the bright gold. One of the tigers, licking water from a stream, is especially famous for its ferocious look. Once it was believed that it really came out to drink water. For this

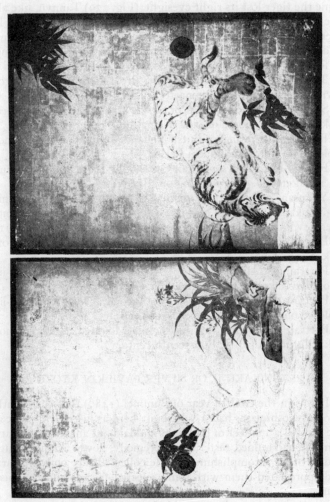

Fig. 239 Tiger, by Tannyū (N.T.)
Nanzen-ji, Kyoto

fame the tiger lost its right eyesight. (Fig. 239) Tannyū, like all the other painters of the period, never saw any real tigers. It seems he studied them from the pictures imported from China and also from skins. Thus, it lacks natural reality, but the feeling of ferocity is very skilfully expressed.

The paintings mentioned below are all national treasures owned by the Nanzen-ji monastery:

Shaka and Sixteen Deities, or Shaka Jūroku Zenjin. Mounted as kakemono. Colored on silk. Kamakura Period.

Buddha in Nirvana, or Butsu Nehan. Mounted as kakemono. Colored on silk. Muromachi Period.

Fishing in a Pond, or Kōzan Gyoshū, by Shō-sanshō. Mounted as kakemono. Ink painting on silk. Ming Dynasty.

Yakusan and Riko in discussion about Zen Buddhism. Mounted as kakemono. Slightly colored on silk. Southern Sung Dynasty. An excellent example of Chinese ink painting.(Fig.91)

Portrait of Monju. Mounted as kakemono. Ink painting on silk. Sung Dynasty.

Portrait of Daimin Kokushi, the first abbot of Nanzen-ji. Mounted as kakemono. Colored on silk. Fourteenth century.

Portrait of Nan-in Kokushi, the second abbot of Nanzen-ji. Colored on paper. Early seventeenth century.

Portrait of Daruma, by Keishoki. Mounted as kakemono. Ink painting on paper. Fourteenth century.

8. GIN-KAKU-JI, OR SILVER PAVILION, KYOTO

It was in the twelfth year of Bummei (1480) that the eighth Shogun Yoshimasa, had a villa built here as his retiring place. He erected a number of buildings and laid out an extensive garden. He had refined taste in tea-ceremony, flower arrangement, and in other accomplishments. He collected rare objects of art and appreciated them with some selected friends and connoisseurs.

His interest in art had much influence upon the development of art in his time. After his death the villa was given up for a

Buddhist temple which now has the name Jishō-ji. The Silver
Pavilion, Tōgu-dō Hall, and the garden are the only relics of
the original.

The Silver Pavilion is a two-storied building erected on the
borders of a pond, commanding a beautiful garden scene. (Fig.
240) The general appearance resembles that of the Golden Pavil-

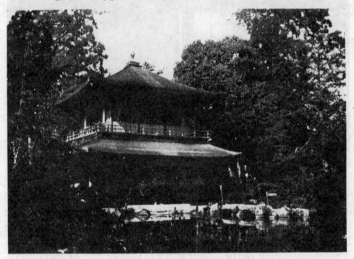

Fig. 240. Silver Pavilion (N.T.)
Jishō-ji, Kyoto

ion of Kitayama. The construction is not so highly finished as
that of the Golden Pavilion, but it has more simplicity and re-
finement. The first story is four spans by three, and the interior
is divided into four rooms. There is a verandah in front; and one
of the two front rooms is open to the garden, forming a lobby
without any sliding screens between the front columns. The
other front room is closed by sliding screens pasted over with
transparent paper on the upper part, but it can easily be opened
to the garden by sliding back the screens. All the construction
and style of the first floor belong to the *shoin-zukuri* architecture.

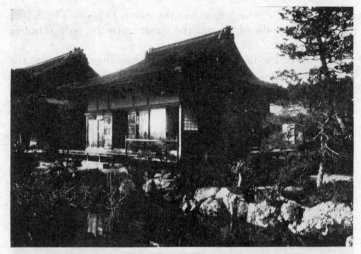

Fig. 241. Tōgu-dō Hall (N.T.)
Jishō-ji, Kyoto

The upper floor, three spans square, is surrounded with piazzas and balustrades. All the sides are closed with panelled walls; the entrance is made through a panelled door at both sides and the light is allowed through bell-shaped windows made in each side. The construction of the upper story is that of the Zen sect architecture and is entirely different from that of the first story. The interior and exterior are lacquered, and was intended to be overlaid with silver leaf, but this was not done because of the death of Shogun Yoshimasa himself. But the name Silver Pavilion originated from this. Within the upper floor is enshrined a statue of Kwannon in an artificially constructed grotto.

The architecture of the Silver Pavilion is a mixture of Buddhist and residential styles as in the Golden Pavilion. But the residential style of the first floor of the Silver Pavilion belongs to the *shoin-zukuri* style while that of the Golden Pavilion belongs to the *shinden-zukuri* style. This is the great difference between these two important architectural examples of the Muromachi

Period.

The Tōgu-dō Hall (Fig. 241) standing near the pond in the north-eastern side of the garden is an even better example of the *shoin-zukuri* architecture than the Silver Pavilion. The plan of the hall is rectangular, and the roof in *irimoya* style is covered with shingles. The pillars are square and very simple. The brackets are also of the simplest kind, called *funa-hijiki*. All the sides are surrounded with verandahs. The exterior is most simple in appearance and construction. The interior is divided into four rooms by sliding screens painted with landscape pictures in black and white. The Butsu-ma, or Buddha's room, is the largest, having eight mats. In the apse of this room are enshrined a statue of Kwannon and a figure of the Shogun Yoshimasa; the entrance is flung out by two panelled doors. The tea room at the rear right hand side is called Dōjin-sai and is famous as the oldest tea room in the history of tea-ceremony. It is a tiny room of four and a half mats, designed to accommodate four or five people. It has a square sunken fire box in the centre, and is furnished with an alcove and ornamental shelf in rustic and simple style. After retiring from the Shogunate, the Shogun Yoshimasa spent his days in this hall in appreciating rare art objects imported from China, in having incense parties, flower parties, poem parties and tea-ceremonial parties with a few selected friends.

It would be difficult to appreciate the greatness of the simplicity and rusticity expressed in such tiny and delicate architecture. But they should be appreciated in association with the studied beauty of the landscape gardening in which the building is set.

The garden is laid out in beautiful surroundings. (Fig. 242) A large pond called Kinkyō-chi or Brocade Mirror Pond is at the western skirt of a hill called Tsukimachi-yama, or Waiting-for-the-moon Hill. Stone bridges span the pond here and there and various kinds of evergreen trees and rocks of different shapes are skilfully set in to form a beautiful landscape garden. In the northwestern part of the garden is a terrace of white sand wrought into "Silver Sand Foreshore" (Ginsha-nada), and a gigantic flat-topped conical heap of sand, named Kōgetsu-dai,

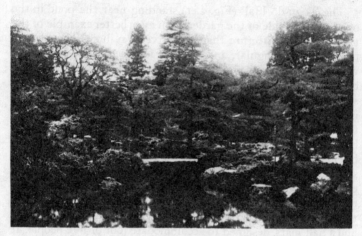

Fig. 242. Garden of Silver Pavilion
Jishō-ji, Kyoto

or the Mound that Looks towards the Moon. This is a unique feature of this garden.

The most noticeable characteristic of the garden is the well studied construction to make it fully appreciated from every angle. There is a complete and picturesque view from the Silver Pavilion as well as from the Tōgu-dō Hall. When walking in the garden one may have a beautiful attractive scene from any position. More than this, it is carefully contrived to have a particular attraction at every hour in the day and night. Special stress seems to have been put on the moon-light view. The moon floating on the still water of the pond and its reflected light on the white sand make one imagine a quiet moon-light scene at the shore. In the morning the reflection of the sunshine over the white sand through the verdure of evergreen trees on the surrounding mountain gives the fresh glory of morning.

Such was part of the luxury the Shogun Yoshimasa enjoyed after his resignation from the Shogunate.

Fig. 243. Upper Garden (I)
Shugaku-in Imperial Villa, Kyoto

9. THE SHUGAKU-IN IMPERIAL VILLA, KYOTO

The Shugaku-in Imperial Villa is situated at the western foot of Mt. Hi-ei in a northern suburb of Kyoto. The villa was constructed by the Shogun Ietsuna for the ex-Emperor Gomizu-no-o in the middle of the seventeenth century. In the early nineteenth century it underwent considerable repair according to the wishes of the ex-Emperor Kōkaku.

It consists of three gardens, somewhat detached from one another, the uppermost (Kami-no-chaya), the middle (Naka-no-chaya), and the lowest (Shimo-no-chaya); and each garden contains several buildings which occupy special places chosen to harmonize with the beauties of nature.

The lower garden is the smallest of the three, and includes two buildings, one called Zōroku-an, and the other Jugetsu-kwan. The Zōroku-an is a small tea-ceremony house which was rebuilt in the seventh year of Bunsei (1824). The Jugetsu-kwan is a

Fig. 244. Upper Garden (I)
Shugaku-in Imperial Villa, Kyoto

larger house, built at the same time and also used for the tea-ceremony. Its interior is decorated with such pictures as "Three Laughers at the Tiger Valley," painted by Ganku in black and white on the sliding screens; and cranes, rocks, and orchids painted by Hara Zaichū on the doors of cupboards.

The middle garden is separated from the lower garden on the south. It contains a dwelling house called Rakushi-ken (House of Bliss) which was built at the time when the garden was originally laid out in the middle of the seventeenth century. The name Rakushi-ken was taken from a phrase in the Book of Odes, one of the Chinese classics. The interior is divided into a number of rooms of different sizes which were once decorated in colors now quite faded.

The uppermost garden is situated at the west slope of Mt. Hi-ei. This is the largest and finest of the three, covering an area of about 50 acres. (Fig. 243) The majority of the ground is occupied by an extensive pond, called Yoku-ryū-chi, or "Pool where Dragons Bathe." On the top of a hill at the eastern bank stands a pavilion called Rin-un-tei, or "House near the Clouds," which was built in 1824. This is the highest point in the grounds which overlooks the still water of the pond. It also commands an extensive view of the city and the mountains, near and distant, on the northwest. (Fig. 244) The garden will be enjoyed most in autumn when leaves take on different shades of colors; and next, in spring, when the trees and lawn of the garden assume new, fresh garments.

10. DAITOKU-JI, THE GREAT MONASTERY OF
THE RINZAI SECT, KYOTO

The Daitoku-ji is the head monastery of the Rinzai sect. It was founded in 1319, and Daitō Kokushi, a noted Zen priest, was the first abbot. The monastery became prosperous and occupied the first rank of the five great monasteries of the Zen sect (Go-san) during the Muromachi Period. Although the temple build-ings were several times reduced to ashes by fire, each time they

were rebuilt, and some of present ones were re-erected during the Bummei Era (1469–1486)when Ikkyū was the abbot of this temple, and the rest in the Yedo Period. It is a complete specimen of a Zen monastery. The main buildings, the Imperial Messenger Gate, the Main Gate, the Main Buddhist Hall, the Preaching Hall, and the residential quarters of monks, which make up the body of the temple, are erected in this order on the axial line which runs through the middle part of the monastery precincts from south to north. The Hōjō is annexed to the Kuri on the east.

The Chokushi-mon, or Imperial Messenger Gate, a national treasure, is the first gate at the inner enclosure, and it is closed on ordinary days. The gate was originally built as the South Gate of the Imperial Palace in the 18th year of Tenshō (1590) and it was given to the temple in 1640. Between the lintel and cornice of this gate are fine carvings of pine, bamboo, plum, and peony. The free and powerful touch of chisels, as shown in them, is characteristic of the Momoyama sculpture.

The Sam-mon, or the Main Gate, a national treasure, is an impressive gate, standing next to the Chokushi-mon, and was erected in 1589 by Sen-no Rikyū, a noted master of tea-ceremony. This is a two-storied gate of five spans, having three doorways. Each side is provided with a staircase leading to the upper floor. In the upper story are enshrined the Shaka triad, accompanied by the sixteen Arhats, or Rakan. There is a dragon among clouds, painted on the ceiling by Hasegawa Tōhaku, 1539–1610, a painter of the Unkoku School.

The Main Buddhist Hall, or Butsuden, a national treasure, stands next to the Sam-mon and was rebuilt in the fifth year of Kwambun (1665). The exterior and the interior are of plain wood; but the pillars at the back of the dais are decorated with a polychromatic design on their upper parts; and the floor is tiled. On the ceiling are painted some angels among the clouds.

The Preaching Hall or Hattō, a national treasure, stands next to the Butsuden. It was re-erected in 1636 by Inaba Masanari, the Lord of Odawara. The building is double-roofed and has a façade of seven spans, with a side of six spans. The form is regular

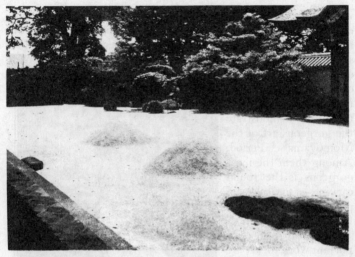

Fig. 245. Garden of Hōjō
Daitoku-ji, Kyoto

and the details display the typical features of the *karayō* style of
Zen Buddhist architecture. The outside and inside are all of plain
wood and no color design is applied. On the ceiling is painted a
large dragon in circular form by Kanō Tannyū, the master
painter of the Kanō School.

The Hōjō, a national treasure, stands in the residential quarter
of the monks, and was built in 1636. It is the residential type
of building developed in the Momoyama Period. The sliding
screens at the partitions of the rooms are painted with landscapes
of four seasons by Kanō Tannyū. The picture is black and white
on paper; its simplicity and space composition harmonize per-
fectly with the architecture. These rooms open to the garden
(Fig. 245) which is said to have been laid out by Kobori Enshū,
the famous master of tea-ceremony. It is a flat garden, composed
largely of clean sand, and so designed as to take in a fine view
of Mt. Higashi-yama, the eastern boundary of Kyoto.

The Kara-mon gate, a national treasure, is erected at the south

wall of the garden of Hōjō, and is said to have formerly belonged to the Juraku-dai mansion built by Hideyoshi. The gate, the finest architecture in the Daitoku-ji monastery, is supported by six columns, and has a charming roof. The ornaments consist

of bold polychromatic carving and elaborate metal fittings. All of them fully demonstrate the gorgeous art of the Momoyama Period. Among them the most gorgeous is the round carving of peacocks in pine trees, which is fitted on the lintel.

The following important works of art are national treasures owned by the monastery:

Portrait of Daitō Kokushi. (Fig. 246) Mounted as kakemono. Colored on silk. Late Kamakura Period. The priest Daitō Kokushi, 1292–1337, was the first abbot of the Daitoku-ji monastery, and was venerated by the Emperor Godaigo, who wrote with his own hand the eulogy which appears at the top of the painting. In the technical execution there is no trace of the

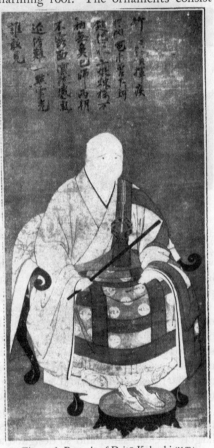

Fig. 246. Portrait of Daitō Kokushi (N.T.)
Daitoku-ji, Kyoto

Sung style of China, for the lines are slender and unaccentuated, and there is no gradation of color on the flesh and drapery. Its general style is of the Yamato-e School. The name of the artist is not known, but the portrait was undoubtedly drawn from life. This is a representative example of the portrait of a high priest whose individual personality was highly regarded and such art was very much esteemed by the leading class of people.

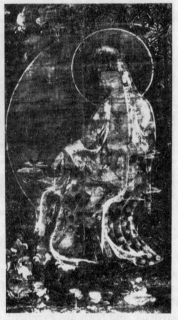

Fig. 247. Yōryū Kwannon (N.T.)
Daitoku-ji, Kyoto

Portrait of Emperor Godaigo. Mounted as kakemono. Colored on silk. The Emperor is attended by Marikōji Nobufusa, and the picture seems to have been drawn from life.

Ten Kings of Hell. Mounted as kakemono in ten pieces. Colored on silk. The pictures are rich in colors and are fine example of the kings of hell, painted in the South Sung Dynasty.

Yōryū Kwannon. (Fig.247) Mounted as kakemono. Colored on silk. Early Ming Dynasty. This type of Kwannon was much welcomed in Zen monasteries of South China, and was also imported to Japan. This one seems to have been brought from China.

11. SHINJU-AN CHAPEL, KYOTO

The Shinju-an Chapel is in the precincts of the Daitoku-ji monastery, where stand two historic buildings, Hōjō and Tsūsen-in.

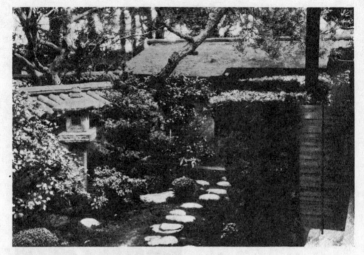

Fig. 248. Garden of Tsūsen-in
Shiujn-an, Kyoto

Hōjō, a national treasure, was originally built as a dwelling house for the priest Ikkyū in 1490. However, the present edifice was rebuilt in 1638 by Gotō Masukatsu, and its architectural style represents the residential building of the early Yedo Period. The garden is also historic, and is a fine example of tea-gardens, and both are excellent models of rustic simplicity and refinement. The sliding screens which divide the rooms are all painted in black and white by Jasoku, who was a pupil of the priest Ikkyū. In the landscape paintings, on twenty-nine large paper panels of these screens, is expressed his understanding of Zen Buddhism. The composition and the chiaroscuro of black ink happily harmonize with the simplicity of the garden attached to these rooms.

Tsūsen-in, a national treasure, was erected also in 1638, and is a good example of residential buildings of rustic style in the early Yedo Period. The landscapes painted in black and white on the sliding screens of the first room are attributed to Sō-ami.

The tea room and the garden (Fig. 248) attached to this building are also famous.

The following paintings owned by the chapel are important works of art:

Shaka-muni Fasting. Attributed to Jasoku. A national treasure. Mounted as kakemono. Slightly colored on paper. Muromachi Period.

Kwannon in a White Robe. A national treasure. Mounted as kakemono. Ink painting on paper. Muromachi Period. Kwannon of this style was popular with Zen Buddhists of the Muromachi Period.

Nocturnal march of Hundred Demons or Hyakki Yakō. A national treasure. Attributed to Tosa Mitsunobu. Mounted as makimono. Colored on paper. Muromachi Period.

12. KOHŌ-AN CHAPEL, ITS GARDEN AND TEA ROOM

The Kohō-an chapel is in the precinct of the Daitoku-ji monastery, and was originally built in 1612 by Kobori Enshū, the famous tea master.

Its Hon-dō, or Buddhist Hall, Sho-in, or Reception Hall, and Bōsen, or Tea Room were all designed by him. However, they were destroyed by fire in the Kwansei Era (1789–1800), and shortly afterwards rebuilt after the original patterns by Matsudaira Fumai, also a famous tea master. They are built in accordance with the cult of the tea-ceremony and are now all enrolled as national treasures. The beauty of simplicity appears in the design of the alcove and shelves at the recesses of the rooms. The walls and sliding screens are decorated with landscape painting in black and white by Kanō Tannyū and Tanshin, which reproduces a quiet atmosphere of nature in the small rooms.

The garden attached to these buildings was designed by the artistic imagination of Enshū. The part of the garden, which faces the Sho-in, is designed to represent the Eight Famous Views of Lake Biwa. The large flat vacant space at the side of Hon-dō

Fig. 249. Garden of Hon-dō
Kohō-an, Kyoto

may seem insignificant but it plays an important rôle in giving
a quiet atmosphere to the composition of the garden. (Fig. 249)
The garden is recognized as one of the master works of flat
gardens (*hiraniwa*) which developed in the Yedo Period.

13. KIN-KAKU-JI OR THE GOLDEN PAVILION, THE FORMER VILLA OF THE SHOGUN

In the year 1397 the Shogun Ashikaga Yoshimitsu planned a
villa at this site where there had originally been a villa built by
Saionji Kintsune in the Kamakura Period. Yoshimitsu erected
thirteen fine buildings and charming gardens on a large scale
and asked the Emperor Gokomatsu to come and see his villa.
After his death the villa was converted into a Zen monastery
which came to be known as Rokuon-ji. The Golden Pavilion and
the garden are reminiscent of past glory.

The Golden Pavilion is built on the border of a large pond,

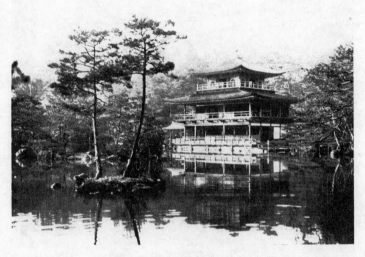

Fig. 250. Golden Pavilion (N.T.)
Rokuon-ji, Kyoto

commanding the beautiful scene of the garden. (Fig. 250) The
Pavilion is a three-storied building, the roof of which has four
hips and is thatched with the bark of *hinoki* wood. Its calm
slope, the slightly upward curve at the four corners, and the
final shaped into the form of a phoenix with outstretched wings
at the top of the roof, all unite in giving a delicate form and up-
ward feeling toward heaven. The pillars supporting the roof
and eaves are all delicate and square in shape and are harmonious
with the lightness and gracefulness of the roof. Each story is sur-
rounded with restful piazzas and balustrades. The first story has
a very spacious piazza in front. In the apse are enshrined figures
of the Amida Triad, a statue of Musō Kokushi, the first abbot
of this monastery, and a portrait statue of Shogun Yoshimitsu
(Fig. 251), the founder of the villa. To the western side is at-
tached a balcony which projects over the pond. The decoration
of the first story is quite simple; all the wood members are left

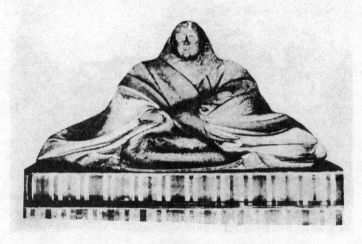

Fig. 251. Figure of Shogun Yoshimitsu (N.T.)
Rokuon-ji, Kyoto

plain, being only in some parts of the interior painted with designs in colors. The interior and the exterior of the second story are lacquered black; and on the ceiling and frieze are painted angels, sacred birds, musical instruments and clouds, in colors on lacquered ground, showing the whole angelic sphere descending from heaven. The third story is three spans square, and both the inside and outside are painted with lacquer and overlaid with gold leaf. The name of the Golden Pavilion comes from this fact; but today only a trace of the gold remains.

As a whole, the composition of the architecture is elegant and graceful, giving a new development to the palace architecture based upon old styles, such as *shinden-zukuri* of the Fujiwara Period and the *buke-zukuri*, or baronial form, of the Kamakura Period. It is especially successful as landscape architecture, being inseparably connected with the garden which forms an integral part of the architecture.

Fig. 252. Garden of Golden Pavilion
Rokuon-ji, Kyoto

The new characteristic of this garden lies in the erection of a high pavilion of three stories on the edge of the extensive pond. In the pond are several small islands, and rocks of attractive shapes. (Fig. 252) The garden is no doubt a unique extant example of the gardens built in the early years of the Muromachi Period and it was indeed a place of repose, of contemplation and of spiritual communion with nature for the Shogun Yoshimitsu.

14. KITANO-JINJA, THE SHRINE DEDICATED TO THE STATESMAN, SUGAWARA MICHIZANE

The Kitano-jinja is one of the most famous Shinto shrines in Japan and it is dedicated to Sugawara Michizane, the celebrated unfortunate statesman-scholar, who died in 903 in Kyushu where

he was exiled. After his death he was regarded as a superman who possessed miraculous virtues. The shrine was founded in 947 and the Emperor paid a visit to it in 1004. Since that time the shrine has been often honored with Imperial visits.

The present buildings were erected in the twelfth year of Keichō (1607) by Toyotomi Hideyori, the son of Hideyoshi. They consist of the main hall, the oratory, the middle gate (Chū-mon), the eastern gate (Tō-mon), the cloister, and the open-work fence.

The middle gate, a national treasure, known as Sankwō-mon, or Gate of Three Luminaries, is a beautiful example of the gorgeous gates of the Momoyama Period. The gate is in kara-mon style with four leg-pillars. The front and rear eaves have two *kara-hafu* gables over which are the *chidori-hafu* gables of triangular shape, and at either side is the *irimoya* gables. Thus the roof is very complicated. In the tympanums and in the frog-leg supporters richly colored carvings of different kinds of birds and animals are inserted. The most attractive among them is a Chinese lion (kara-shishi) in the middle of the lintel. It is roaring with its hip raised. Its active movement and rich color well represent the broad chivalrous spirit of the early seventeenth century.

The main hall and oratory, a national treasure, are the foremost examples of the style of Shinto architecture called *gongen-zukuri*. The main hall and the oratory are connected by a stone-floored chamber, all of which make one group, with an additional stage for sacred dance on each side of the oratory. These features form what is called *yatsumune-zukuri*, or eight-ridged construction. The ground plan is highly complicated. The roofs, of various sizes, heights, and forms, are grouped together, presenting an agreeable variety. They are thatched with shingles of *hinoki* bark. In construction they are quite impressive, and not lacking in elegance. For decoration, inside and outside, a great deal of moulding and carving is applied, mixed here and there with color. Altogether it is grand and vigorous, displaying features characteristic of the Momoyama Period.

The following are national treasures owned by the shrine,

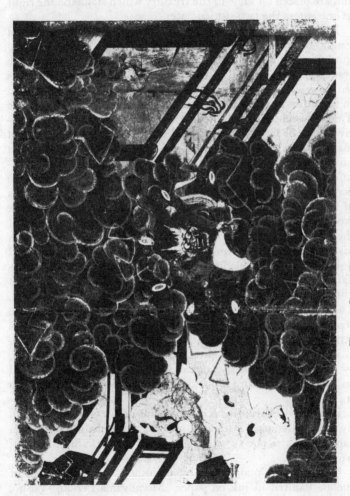

Fig. 253. Part of Kitano Tenjin Engi (N.T.)
Kitano Shrine, Kyoto

and are placed on view in the treasury which stands on the right as one enters the two-storied gate:

Illustrated History of Kitano Shrine or Kitano Tenjin Engi. Mounted as nine makimono. Colored on paper. Kamakura Period. The picture illustrates the life of Michizane, the traditions told of him after his death, and the origin of this shrine which is dedicated to his soul. The picture was painted in the interval between 1219–1221 and the style is purely of the Yamato-e School. The freedom of the drawing and the decorative value of the composition make this the most remarkable of many pictures dealing with the same subject. It won a very high rank among the master picture scrolls produced in the Kamakura Period. This is called the Kompon Engi (Original History) Scroll, to distinguish it from later reproductions or imitations of the present original. The artist is commonly supposed to be Nobuzane, but there is nothing to support this judgement. One of the interesting dramatic scenes is shown in Fig. 253. It illustrates his apparition. He is now transformed into a god of thunder and lightning, and is enabled to give vent to his unforgettable indignation against his enemies who are still living.

Illustrated History of Kitano Shrine or Kitano Tenjin Engi. Mounted as two makimono. Colored on paper. This is one of the reproductions produced in the Kamakura Period. The picture is attributed to Tosa Yukimitsu, but is older than his time.

Illustrated History of Kitano Shrine or Kitano Tenjin Engi, by Tosa Mitsunobu. Mounted as three makimono. Colored on paper. The picture is one of the masterpieces by Mitsunobu (1434–1525).

Illustrated History of Kitano Shrine, or Kitano Tenjin Engi. By Tosa Mitsuoki. Mounted as three makimono. Colored on paper. This is one of the representative works by Mitsuoki (1617–1691).

Dragon and Cloud, By Kaihoku Yūshō. Mounted as pair of byobu. Painted in ink on paper. Momoyama Period. Yūshō, 1633–1715, is a master painter in the Momoyama Period. In this picture we see the magificence of his brush in ink.

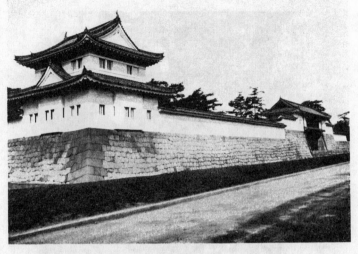

Fig. 254. Nijo Castle
Kyoto

15. NIJO CASTLE, THE FORMER PALACE OF
THE SHOGUN IN KYOTO

Nijo Castle was built by Ieyasu, the first Shogun of the Toku-
gawa, in the eighth year of Keichō (1603). From that time the
castle served as the residence of the Shogun on the occasion of
his visits to Kyoto, during a period of more than two centuries.
The castle ground is rectangular in shape, covering an area of
about 70 acres. The castle is surrounded by walls of masonry,
with towers at the corners. (Fig.254) Within the enclosure there
are five important palace buildings. These are the Kara-mon
Gate, Waiting Hall (Tō-samurai), Audience Hall (Ō-hiroma),
Black Hall (Kuro-shoin), and White Hall (Shiro-shoin); and all
are connected by galleries except the gate.

The Kara-mon Gate is decorated richly with elaborate car-

Fig. 255. Garden of Nijo Castle
Kyoto

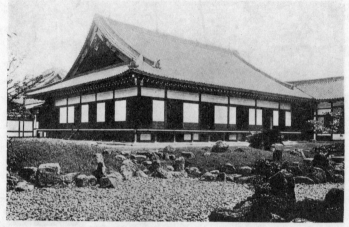

Fig. 256. Black Hall of Nijo Castle
Kyoto

vings, and is said to have been transferred here from the Momo-yama castle which was built by Toyotomi Hideyoshi in the latter part of the sixteenth century.

The Waiting Hall is approached immediately through a large porch (*kuruma-yose*). It is divided into six rooms, the largest of which has 75 mats on the floor; and the sliding screens on the three sides are painted by a Kanō master with tigers in bamboo groves on a ground of gold leaf. They are not a masterpiece, but bold and gorgeous. All the other rooms also are decorated with paintings in rich colors.

The Audience Hall was the place where the Shogun's reception was held. It contains four large rooms. Their interior is sumptuously decorated in gold and rich colors with painting and carving representing large pine trees and such birds as peacocks or pheasants which have colorful plumages. The finest of these is the elevated room (Jōdan-no-ma) where the Shogun had his seat. The west side of the room opens into a garden which is built with a number of rare rocks of fantastic shapes

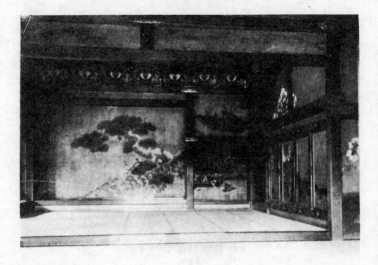

Fig. 257. Jōdan-no-ma of Black Hall
Nijo Castle, Kyoto

arranged along a pond. (Fig. 255) Its design is attributed to Enshū.

The Black Hall (Fig. 256) is the finest architecture among these palace buildings. Its elevated room, or Jōdan-no-ma (Fig. 257), is most gorgeously decorated with pine trees with snow on their trunks, the green leaves of which are contrasted with the deep crimson blossoms of a plum tree; and on the panel screens are painted cherry trees, in full bloom.

The gilt or cloisonné metal fittings used in many places and the design painted on each coffer of the coved ceiling make the room most gorgeous and decorative with pictures painted in rich colors on the walls and sliding screens.

The White Hall was used as the bedchamber of the Shogun. Its interior decoration is much simpler and more restful.

An admission card from the Imperial Household is required to see the Nijo Castle.

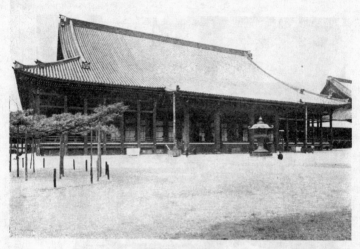

Fig. 258. Founder's Hall (N.T.)
Nishi- Hongwan-ji, Kyoto

16. NISHI-HONGWAN-JI, THE GREAT MONASTERY
OF THE SHINSHŪ SECT

The monastery was founded by Kakushin-ni, the daughter
of Shinran Shōnin, the founder of the Shinshū sect of Bud-
dhism, when she erected the mausoleum of her father at Ōtani
in Kyoto and enshrined his statue in the year 1272. However,
the actual foundation of the monastery was consolidated for the
first time when Toyotomi Hideyoshi gave it its present site, an
extensive piece of land, for the monastery in the Tenshō Era
(1575–1591).

The monastery is the headquarters of the Hongwan-ji branch
of the Shinshū sect, which has about 7,000,000 adherents and
10,000 temples throughout Japan.

When we enter either of the two front gates, there stand

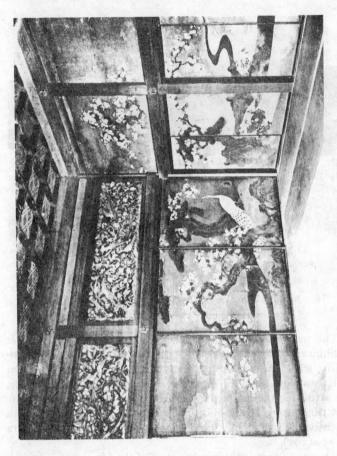

Fig. 259. Interior of White Hall
Nishi-Hongwan-ji, Kyoto

two large buildings, facing the east, side by side, connected by a corridor. The one on the right, is the Hon-dō which was dedicated in 1760 to the statue of Amida who is worshipped as the most important Buddha in the Shinshū sect. The other building on the left, larger than the Hon-dō, is the Daishi-dō, or Founder's Hall (Fig. 258), which was dedicated to Shinran Shōnin in the year 1636 to enshrine his statue. These two buildings are typical architecture of the Shinshū sect of Buddhism. They were built in the Yedo Period, and are enrolled as national treasures.

Beside these sacred buildings are a number of palatial buildings, once built by Toyotomi Hideyoshi in his Castle of Momoyama and in his residence at Juraku, all in the late sixteenth century, which have been transferred here from the original places; and all are now national treasures.

Of the palatial buildings, there stand the Room of Tigers (Tora-no-ma), the Room of Drums (Taiko-no-ma), the Room of Waves (Nami-no-ma), the Audience Hall (Taimen-jo), the White Hall (Shiro-shoin) and the Black Hall (Kuro-shoin). A noted pavilion called Hiun-kaku occupies its own quarter in the southeast corner of the ground. At the southern entrance of the monastery stands the famous gate called Kara-mon, which was once the gate of a palace building in the Momoyama castle. (See page 211 and Fig. 135)

The White Hall includes three rooms. In Fig. 259 we have reproduced part of its interior, decorated with cherry blossoms, and a white peacock which is proud of its plumage as if to vie with the gorgeous blossoms of the cherry trees.

However, the most important of these buildings is the Audience Hall which was used by Hideyoshi for receiving his generals. The room is so spacious that its floor has 200 mats; and the interior is divided into two sections, upper and lower. The upper part is furnished with an alcove or *toko-no-ma*, with shelves, cupboards and sliding panels called *chōdai-kazari*. In the left hand corner is a still more raised platform under the "writing window" with its desk ledge. Near this is a small alcove, lacquered and painted, in front of which is a bell-shaped window of un-

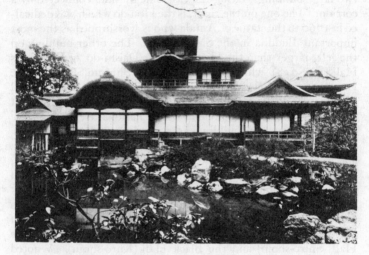

Fig. 260. Hiun-kaku (N.T.)
Nishi-Hongwan-ji, Kyoto

usual proportions. The panels, or *ramma*, over the dividing line
between the two levels of the room are elaborately carved with
storks, rushes, and clouds. Down through the centre of the
lower room run two rows of large columns which support the
roof. The walls of the larger alcove are decorated with paintings
by Kanō Tannyū on gold leaf. The wall of the lower room is
decorated with storks and large pine trees painted by Kanō
Ryōkei on gold leaf; and the ceiling is decorated with round
patterns composed of dragons and flowers painted by the same
artist in rich colors.

The Hiun-kaku, the noted pavilion, is quite a different kind
of architecture from that of the palatial buildings just described
above. Its construction and interior decoration are simple but
reposeful for a residential building. (Fig. 260) The pavilion
originally formed part of the residential buildings erected in the
late 16th century by Hideyoshi, which are known under the

name of Juraku-dai (Residence of Collected Luxuries) and transferred here in the early seventeenth century. It is a three-storied structure erected near a pond in a garden which was designed with stones and trees originally belonging to the Residence of Collected Luxuries. Its timbers are comparatively slender and the roof is thatched with the bark of *hinoki* wood. The whole appearance of the building is quite original and rich in variety. Purposely avoiding a symmetrical construction, it endeavors to enhance its beauty by contrast and balance. On each side it assumes a different aspect, giving a fresh surprise.

The interior decoration is also very quiet and reposeful. It is never sensuous but rather meditative. The walls of the alcove and the large sliding screens of the state room of the first floor are painted with large snow-clad willow trees on a paper ground slightly tinted with golden color. So this room is called the Room of Willows. The painting is attributed to Kanō Eitoku. In the next room are painted, in black and white, eight famous Chinese landscapes on sliding screens. The entrance opens from this room on to the pond, where a boat can be let in.

The interior decoration of each room is intrinsically harmonious with the simplicity of the architecture.

17. TŌFUKU-JI, THE GREAT MONASTERY OF ZEN BUDDHISM, KYOTO

The Tōfuku-ji is the head monastery of the Rinzai branch of the Zen sect. It was founded by Fujiwara Michi-ie in 1239, and the priest Shōichi Kokushi was appointed the first abbot. It was one of the five main Zen monasteries (Go-san) in Kyoto, and is still one of greatest monasteries in the city. About fifty years ago the Buddha Hall and Preaching Hall were reduced to ashes, but they are now under reconstruction. However, there still remain some historic buildings which were erected in the Muromachi Period and they are enrolled as national treasures. They are the Sam-mon gate, toilet or Tōsu, and Zendō where monks sit and meditate. Besides these buildings there remains another historic

building called Fu-mon-in in which are beautiful pictures of Momoyama style, painted on the sliding screens. (Fig. 261)

The Sam-mon gate (Fig.262)stands impos-ingly at the entrance of the monastery. It is a two-storied gate of five spans and three doorways and both sides are provided with staircases leading to the upper story. This is the earliest gate remaining of the Zen monasteries, and the general style of construction is a mix-ture of *kara-yō* and *tenjiku-yō* styles. In

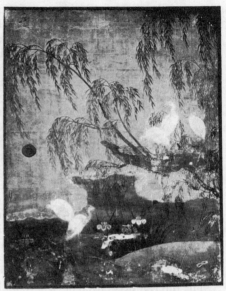

Fig. 261. Sliding Screen of the Fumon-in Chapel
Tōfuku-ji, Kyoto

the bracket system *tenjiku-yō* is combined with the *kara-yō;* and also in other respects *tenjiku-yō* is harmoniously combined with *kara-yō*. The interior of the upper story is painted in bright colors. (Fig. 263) The flat board ceiling is painted with angels. The rafters, beams, and pillars are all decorated with flowers, dragons, clouds, and waves, in colors. Such bright decoration applied to the constructive members is quite a contrast to the general principle of a Zen monastery. This is shown only in the interior of the upper story of the gate. Against the rear wall is enshrined a figure of Shaka with a crown, attended on both sides by the sixteen Rakan.

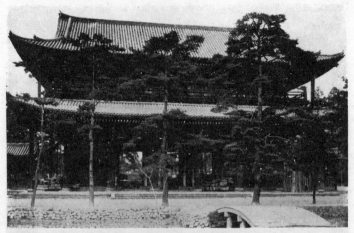

Fig. 262. Sam-mon Gate (N.T.)
Tōfuku-ji, Kyoto

Fig. 263. Interior of the Sam-mon Gate
Tōfuku-ji, Kyoto

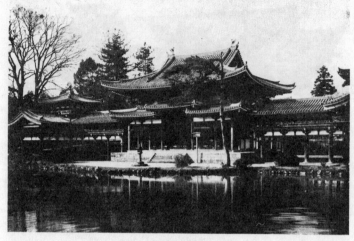

Fig. 264. Phoenix Hall (N.T.)
Byōdō-in, Uji

18. HŌ-Ō-DŌ, THE FINEST TEMPLE OF THE FUJIWARA NOBILITY

The Hō-ō-dō or Phoenix Hall is the main temple of the Byō-dō-in monastery. It stands in a small town called Uji which is in a southern suburb of Kyoto. Through the town runs a broad river of the same name, and beyond the river softly rises a beautifully undulated range of hills. Surrounded with such a picturesque landscape, the Phoenix Hall has stood at the same place ever since it was erected in the year 1053.

The place was one of the famous country resorts selected by the nobilities of the Fujiwara family, before it was converted to a temple by Yorimichi of the same family to enshrine the Buddha Amida.

The original building erected here was in the style of *shinden-zukuri* as in other cases. The *shinden-zukuri* was the architectural type of building erected as nobles' residences. Its principal apart-

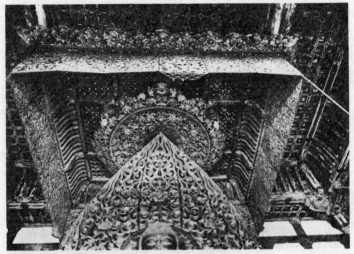

Fig. 265. Wooden Canopy (N.T.)
Phoenix Hall, Uji

ment called *shinden* or bed-chamber fronted south to take in the full brightness of the sun and opened on the pond of a beautiful garden. In a word, the *shinden-zukuri* was landscape architecture beautifully set in a garden of a conventional type.

Now our Phoenix Hall (Fig. 264) is the only existing example which retains much of the type of *shinden-zukuri*. Here we may see the finest architecture of the Fujiwara nobility dignified as a temple to the Buddha Amida. The plan is really wonderful. It consists of a main hall, wing corridors, and a rear corridor. The main hall has three column intervals in the façade and two at the sides, and is surrounded with a penthouse. Two-storied wing corridors stretch out on each side of the main hall and bend toward the front. At each angle stands a pavilion. The rear corridor is one-storied. The main roof, of *irimoya* style, extends further than the penthouse which has the central part of the façade raised higher than the rest, thus breaking the monotonous stretch of the roof. The exterior parts have a red coating, and

are decorated with gilt metal work. The decoration of the interior of the main hall is most refinedly elaborate. Pillars, walls, ceiling, and all the other spaces are filled with painted designs, mother-of-pearl inlaid work, metal fittings, and open carving. The perforated work of the wooden canopy suspended over the image of Buddha will never be surpassed by any other perforated carvings in wood. (Fig. 265)

The whole effect is indeed a marvellous example of architectural symmetry and beauty, and it looks as though it could fly up to heaven whenever it wished. The beautifully curved lines of the roofs and the soft straight lines of the pillars supporting the roofs have a wonderful harmony and unity with the two phoe-

nixes of bronze on the gables of the main roof. It also beautifully harmonizes with the surrounding landscape, which is Nature's masterpiece. After all, no words can adequately describe the noble conception and masterly execution of all these pieces of work; the elegant and dignified appearance which the whole mass presents elicits unstinted admiration from visitors, both Japanese and foreign.

On entering the Phoenix Hall one will find a large image of Amida, the most rep-

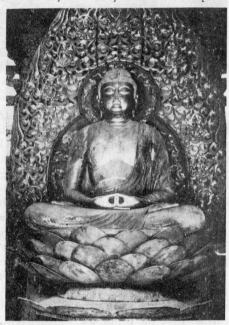

Fig. 266. Image of Amida (N.T.)
Phoenix Hall, Uji

resentative work carved by Jōchō in the eleventh century. (Fig. 266) It is made of wood and entirely overlaid with gold foil. He sits cross-legged on a lotus pedestal with his hands on his knees. The attitude is called meditative *mudra*.

He looks straight to the front, but with slightly downcast eyes, narrowly opened. His eyebrows are composed of delicate lines. The nose is of medium height. A straight line extended from both ends of the ridge of the nose passes through the middle of the figure, halo, canopy, pedestal, and the platform in a perpendicular direction, the upper end of the line finally reaching the highest point of the canopy hung over the head of the figure. It is indeed a guiding line of unity and harmony, making perfect equilibrium in its whole construction.

On the frieze around the main statue hang wonderful group figures representing fifty-two Bodhisattvas coming down from

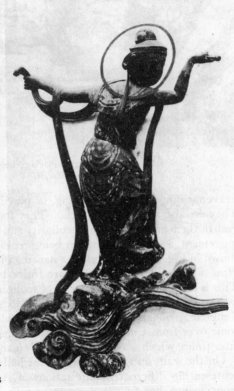

Fig. 267. Dancing Bodhisattva (N.T.)
Phoenix Hall, Uji

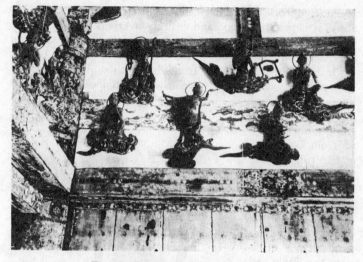

Fig. 268. Bodhisattvas Playing Music (N.T.)
Phoenix Hall, Uji

heaven, riding on clouds, dancing, or playing music. (Fig. 268) They are also attributed to Jōchō. They look very picturesque, each of them having its own peculiarity and grace of posture and movement, a similar type never being repeated. One of them is shown in Fig. 267, looking like a dancing girl poised on a cloud. How wonderful and beautiful are the body lines and motions! This is one of the best specimens of feminine beauty expressed in wood. It is indeed to the ability of Jōchō that we owe the complete nationalization of the various Buddhist types that had come over from China before his time, and also the Amida of later times, which was frankly after his manner.

On the walls and door panels of the hall are painted pictures representing different manifestations of Amida, coming down from heaven over a green range of hills, and attended by a number of Bodhisattvas, to welcome the faithful at the moment of their death. The picture is said to have been painted by Ta-

kuma Tamenari, the most famous painter of the age. In Fig. 269 we have reproduced a host of Bodhisattvas who follow Amida in worshipping attitudes. The picture is painted first in outline on gesso applied to the surface of plane wood; and then the colors are added. The composition is grand and the landscape background is most appropriate and full of meaning in connection with the doctrine of Amida expounded by Eshin Sōzu. The brush stroke is ex-

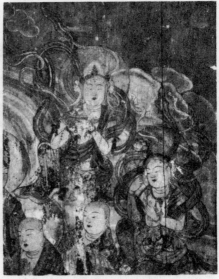

Fig. 269. Bodhisattvas Painted on a Door Panel (N.T.) *Phoenix Hall, Uji*

tremely delicate and fine, entirely in Japanese style. The color tones also are wonderful—blue, green, purple, and red—emphasized here and there with gold color of cut gold.

19. DAIGO-JI MONASTERY, ITS GARDEN AND ARCHITECTURE, KYOTO

The Daigo-ji is one of the head monasteries of the Shingon sect, and is situated in the southern suburb of Kyoto.

The monastery was founded in 874 by Shōbō (Rigen Daishi), and because of the faith of the Emperor Daigo (897–929) it added many buildings, which are grouped in two places; one on a mountain, which is called Kami Daigo, and another under the mountain, which is called Shimo Daigo. The monastery once

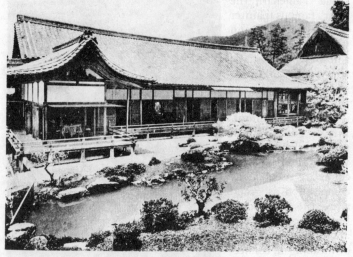

Fig. 270. Omote-shoin (N.T.)
Sambō-in, Daigo

declined, but its former prosperity was greatly restored by the Lord Abbot Gien, through the pious wish of Taikō Hideyoshi late in the sixteenth century. The Taikō's flower-viewing party at Daigo, held here in the monastery towards the end of the sixteenth century, was the most famous given in Japan for the enjoyment of cherry. blossoms, and showed the last glory of the luxurious life of Taikō.

In the lower group, the most important are the Sambō-in, or the Monastery of Three Treasures, the Kon-dō, or Golden Hall, and the Five-storied Stupa.

The present buildings of the Sambō-in were rebuilt in 1606 by the order of Hideyoshi. The ground plan is very complicated, consisting of Dai-genkwan, or Grand Porch, Aoi-no-ma, or the Room of Hollyhocks, Akikusa-no-ma, or the Room of Autumnal Grasses, the Omote-shoin, or the Front Reception Hall, Junjō-kwan, or the Temple of Purity, Miroku-dō, or the Hall of Bud-

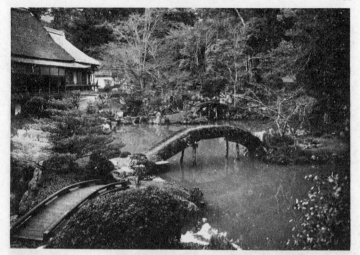

Fig. 271. Sambō-in Garden (I)
Daigo-ji, Daigo

dha Maitreya, Oku-shoin, or Inner Reception Hall, and so forth.
They stand in a splendid garden which was laid out under the
personal direction of Hideyoshi. Among them the Front Recep-
tion Hall and the Inner Reception Hall are important examples
of dwelling houses of the late sixteenth century.

The Front Reception Hall, or the Omote-shoin (Fig. 270),
takes in a full view of the garden. It is a representative ex-
ample of *shoin-zukuri* architecture, although it retains a trace
of *shinden-zukuri* architecture in its projecting verandah at the
western end. The interior of the building is divided into three
rooms, each of which opens on the garden, and all the sliding
screens (*fusuma*) are painted with pictures. The room at the
eastern end is raised and has an alcove and ornamental shelves
in the recess. On the wall of the alcove is painted a gigantic pine
tree, and on the sliding screen are painted willow trees in four
seasons. The lines of the brush are broad and strenuous but the
composition is simple, and the color scheme quiet and elegant.

The simple construction of this building and the elegant ornamentation of the interior harmonize most happily with the garden on which it opens.

The garden is most famous, for it was laid out under the actual direction of Hideyoshi, and represents one of the most luxurious gardens built in the Momoyama Period. (Figs. 271, 272)

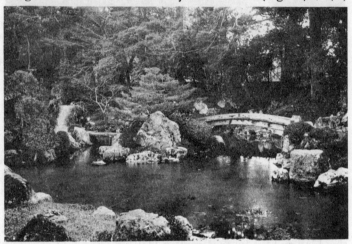

Fig. 272. Sambō-in Garden (II)
Daigo-ji, Daigo

The garden is not laid out for the purpose of strolling, but for viewing it from the inside of the Front Reception Hall all the year round. It faces the south, stretching from east to west, with plenty of light and warmth, as plants thrive best and show their living beauty in the sun. In the middle of the garden is a large pond with an island, and beyond the pond is a thick grove of large trees that gives a forest-like feeling. In its south-eastern corner a waterfall tumbles over rocks.

In the planting of trees the utmost care has been taken to get evergreen leaves all the year round; to get spring charm with some flowers among the green; and to have a great embellishment

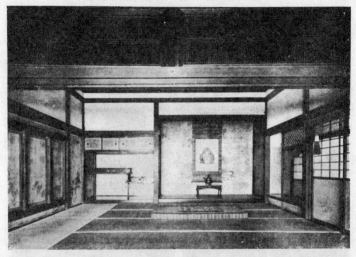

Fig. 273. Interior of Oku-shoin (N.T.)
Sambō-in, Daigo

of golden foliage in autumn. All along the water edge there are
a great number of rocks. This is the most notable aspect of the
garden. It is said that Hideyoshi ordered many a famous stone
to be brought from his own garden of the Grand Mansion at
Kyoto, which was called Juraku-dai, or Mansion of Collected
Luxuries. The variety of shape in these natural rocks must
have appealed strongly to his finest feelings. According to the
diary written by Gien, the Lord Abbot, Hideyoshi seems to
have been deeply interested in the art of rock-gardening. It no
doubt gave him ample scope for the liveliest imagination. Indeed
it must have been valuable mental training, for his constructive
faculties were called upon, sharpened, and polished.

The Inner Reception Hall, or Oku-shoin, stands at the
rear of the Front Reception Hall. The interior is divided into
four rooms. The walls and sliding screens of each room are dec-
orated with pictures of the Kanō School in black and white on
paper. The Jōdan-no-ma, or raised room for the seat of honor,

has an alcove, decorative shelves and *chōdai-kazari*, or decorative panelled doors. The decorative shelves are most beautifully designed. The building is one of the best representative dwelling houses of the late sixteenth century. (Fig. 273)

The Kon-dō, or Golden Hall, stands inside the Niō-mon gate. It is a one-storied building of the Kamakura Period with a façade of seven spans, and sides of five spans. (Fig. 274) Its

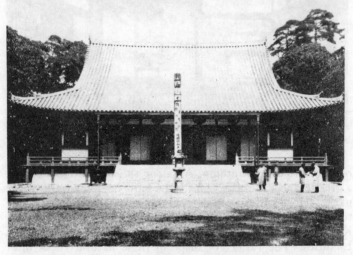

Fig. 274. Golden Hall of Daigo-ji (N.T.)
Daigo

massive structure and magnificent pitch of roof represent the characteristic features of the Kamakura architecture.

The Five-storied Stupa stands near the Golden Hall, and was erected in 951 according to the devoted wishes of the Emperor Murakami. (Fig. 275) Its height measures about 34 metres. The s.ight slope of each roof, the horizontal members of the balustrade at each story and the upward curve of each corner of the roofs, have a beautiful rhythm and proportion, which give a restful atmosphere to the stupa. The inside of the

first story is decorated beautifully with paintings which represent Buddhist figures and eight patriarchs of the Shingon sect. They are painted on gesso applied to the panels and pillars. Although most of the pictures are erased, the central capital is in good condition with its original pictures. The chiaroscuro, shade, gradation, and cut-gold work applied to the picture are worthy of note. It is indeed a rare example of interior decoration of the early Fujiwara Period.

In this monastery are preserved a great number of Buddhist paintings produced in the later Fujiwara and early Kamakura periods by priest-painters, most of which are excellent works of art and religion. These paintings and other treasures are placed on view in the treasury recently built in the precincts of the monastery.

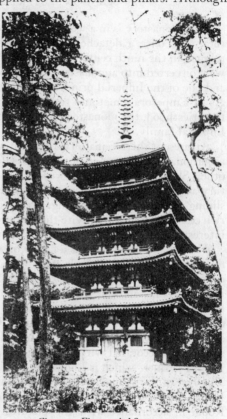

Fig. 275. Five-storied Stupa (N.T.)
Daigo-ji, Daigo

20. DAIKAKU-JI, THE GREAT MONASTERY OF THE SHINGON SECT, KYOTO

This monastery is in a western suburb of Kyoto. On this site there was once a detached palace of the Emperor Saga, who reigned in the ninth century. Later, in the year 876, the palace was converted into a monastery under the name of Daikaku-ji, and one of the Imperial princes was appointed as the first abbot. As ex-Emperors sometimes retired here after they had entered the priesthood, the monastery had a close relationship with the Imperial family.

At present there remain two residential halls that are enrolled as national treasures, one of which is called Kyaku-den, and the other, Shin-den. The former was built in the late sixteenth century and the latter in the seventeenth century. The walls and sliding screens of both buildings are decorated with pictures in rich colors, to which we invite the attention of students who are interested in the interior decoration of Japanese houses.

The Kyaku-den Hall has a façade of seven spans and sides of four spans each, and a single-story with a roof in *irimoya* style, covered with the bark of *hinoki* wood. The interior is divided into six rooms and the walls and sliding screens that constitute the partitions of the rooms are decorated with paintings in rich colors. The finest of them is the Crown Room. In this room is a landscape painting attributed to Kanō Motonobu. The panelled screens are decorated with the phoenix, paulownia and bamboo in gold lacquer, which is known as the famous "Saga maki-e." The rest of the rooms are called the Maple Room, the Bamboo Room, the Snow Room, the Hawk Room and the Landscape Room in accordance with the pictures painted on the sliding screens of each room. These pictures are painted in the gorgeous style of the Momoyama Period.

On the lower wooden panels of the sliding screens in the Bamboo and Maple Room are painted flowers and animals in rich colors, which are attributed to Kōrin. (Fig. 276)

Fig. 276. Picture on a Sliding Screen
Daikaku-ji, Kyoto

The Shin-den Hall has a façade of nine spans with sides of five spans and a single story with a tiled roof in *irimoya* style. The building was probably erected in the middle of the seventeenth century; according to the temple tradition, it was given by the retired Emperor Gomizu-no-o. The interior is decorated as gorgeously as that of the Kyaku-den Hall. The largest room is decorated with peonies bigger than natural size in full bloom on a gold ground. (Fig. 277) The picture is attributed to Kanō

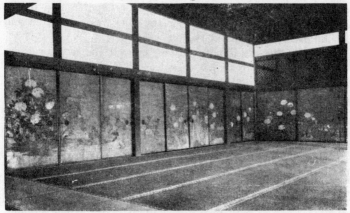

Fig. 277. Interior of the Shin-den Hall
Daikaku-ji, Kyoto

Sanraku. The other two rooms are decorated with willows, pine trees and plum trees, all in rich colors on gold leaf; but a room in the rear is decorated with pictures of cranes and bamboos, painted in monochrome, and attributed to Kanō Tannyū.

Close to the east of the monastery is an extensive pond in attractive surroundings. It was part of a garden attached to the detached palace of the Emperor Saga in the ninth century, and is now preserved by the government as a historic site.

21. KATSURA IMPERIAL VILLA, KYOTO

The Katsura Imperial Villa is situated near the Katsura bridge in the southwestern suburb of Kyoto. The villa is said to have been laid out in the later Tenshō Era (1577–1591) by Hideyoshi for Prince Tomohito, the grandson of the Emperor Ōgimachi; and the house and gardens were mostly designed by Kobori Enshū, the great master of the tea-ceremony.

However, Enshū was at this time only a boy of about twelve years old. Therefore it seems most probable that the garden was considerably changed according to the design of Enshū on the occasion of the visit of the ex-Emperor Gomizu-no-o in the Kwan-ei Era (1624–1643) when the villa was completed and Enshū had reached maturity.

Anyhow, the buildings, gardens and all the accessories are typical examples in which the ideas of the tea-ceremony are highly expressed with the studied simplicity of technical excellence.

The visitors are first allowed to see the interior of the buildings which are grouped at the north side of the garden. (Fig. 278) There are three houses: the Old Sho-in Hall (Ko-sho-in), the Middle Sho-in Hall (Chū-sho-in), and the New Sho-in Hall (Shin-sho-in). Of these the New Sho-in Hall is the finest, which was originally built on the occasion of a visit by the ex-Emperor Gomizu-no-o with his consort in the Kwan-ei Era (1624–1643). To commemorate this occasion the hall is also called Miyuki-den, or the Hall for Imperial Visit.

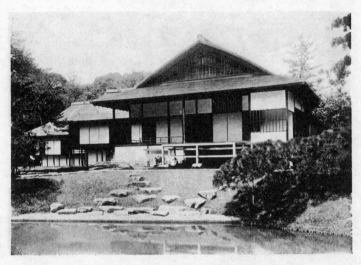

Fig. 278. General View of the Buildings
Katsura Imperial Villa, Kyoto

The Miyuki-den Hall contains about seven rooms. Its structure is quite simple, and it attempts to express the atmosphere of a mountain villa. The room of honor, or Jōdan-no-ma is the smallest, covering only three mats. Its floor is elevated and furnished with a cluster of shelves of different sizes, which are made of precious wood, affording highly interesting examples for study by the devotee of the tea-ceremony in later ages. The shelves are well known among the masters of tea-ceremony by the name "Katsura-no-tana" or the "Shelves of Katsura." (Fig. 279) The doors of cupboards, and the sliding screens of the other rooms are decorated with pictures by Kanō Tannyū in black and white. The metal fittings used to conceal nail-heads and the handles of doors and sliding screens are all made after imaginative designs of the great tea-master. Some represent crescent, flower or oars. For example, the wooden doors at the entrance have handles shaped into the flowers of the four seasons kept in vases,

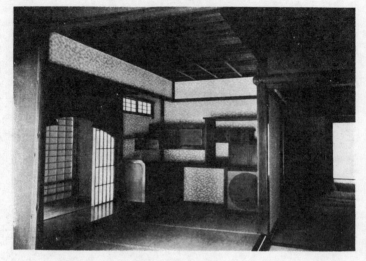

Fig. 279. "Shelves of Katsura"
Katsura Imperial Villa, Kyoto

which were made by Gotō Yūjō, the famous craftsman of metal work. (Fig. 280)

These buildings are harmoniously arranged at the northern part of the garden. The floors of these buildings are exceptionally high, and seem to have been specially designed to offer a better view of the garden from the interior. The roof is rather low, having a variety of shapes, and beautifully harmonizes with its environment when seen from the opposite of the garden.

The garden is laid out at the south of these buildings, and covers an area of about 16 acres. It has an extensive pond of complicated shape, five isles, and a number of inlets and capes. The garden is shut from off the environmental landscapes by a high fence of a bamboo grove around the outer edges. This seems to have been intended to seclude the garden from the outside world in order that one might intrinsically enjoy everything in the garden. The garden contains

four tea-ceremony houses which occupy beautiful spots in the garden. The garden path is most thoughtfully laid out to connect these tea-ceremony houses through the garden so that one may appreciate the garden from every corner.

When we enter the garden through the gate, we come soon to a quiet and beautiful part of the garden, where there is an admirable rock construction along the shore of the pond. (Fig. 281) Then stepping over a stone bridge, we come to an isle where stands a tea-ceremony house, called Shōkin-tei, or the House of Pine Tree Music. (Fig. 282) This is said to have been designed by Enshū. From here the path leads to the Middle Isle

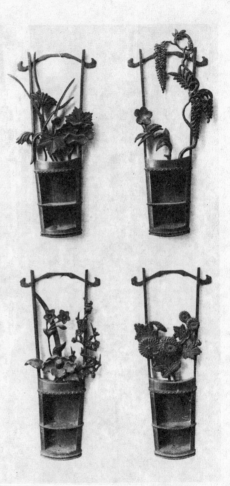

Fig. 280. Metal Handles of the Doors
Katsura Imperial Villa, Kyoto

(Naka-no-shima). Here stands a hut called Shōkwa-tei, or the

Fig. 281. Garden of Katsura Imperial Villa
Katsura, Kyoto

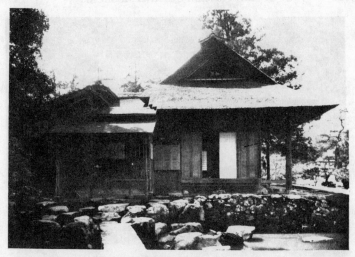

Fig. 282. Shōkin-tei Tea-ceremony House
Katsura Imperial Villa, Kyoto

Flower Viewing Arbor. Here are planted many cherry trees and a grove of maples, which assume beautiful raiments in spring and autumn. In the western part of the grounds is the Shōiken, a tea-ceremony house which contain about six rooms. The house is noted, as one of its windows is left incomplete.

Each of these different buildings for tea-ceremony is set in its appropriate environment to make it an essential part of the garden, completely harmonized with the beauty of the garden, at the same time serving a practical use in the tea-ceremony. This is a characteristic feature of the garden.

22. CHIKUBU-SHIMA SHRINE AT THE ISLAND IN LAKE BIWA

As is already well known abroad, Lake Biwa is the largest lake in Japan. It has an area of 257 square miles and a circumference of 140 miles. At its southern end lies a lakeside town

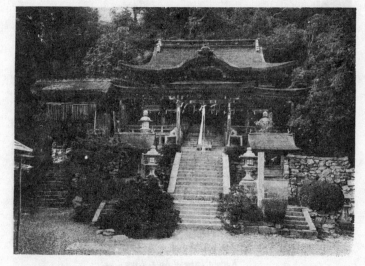

Fig. 283. Chikubu-shima Shrine (N.T.)
Chikubu-shima Island, Lake Biwa

called Ōtsu where the Tōkaido railway line passes, at a point five miles east from Kyoto.

The lake boasts of beautiful scenery along its shores with surrounding mountains, inlets, and country villages. From ancient times this beautiful scenery attracted the attention of people. They selected the eight most beautiful views and gave them poetic names, as follows:—"Curfew-toll from the temple Mi-i; clear mist throughout the village of Awazu; evening glow upon the bridge of Seta; harvest-moon shining over Ishi-yama; sailing back to the port of Yabase; night rain over the great pine tree of Karasaki; wild-geese flying down upon the beach of Katata; and late spring snow on the peak of Hira."

After taking but a glimpse of these views, we come to a legendary isle called Chikubu-shima, which lies at the northern end of the lake, thirty-six miles from Ōtsu, from which it takes about two hours to reach the isle by a fine steam boat. The island

Fig. 284. Carving between the Bracket Works
Chikubu-shima Shrine, Lake Biwa

rises eighty feet above the surface of the lake and measures about two miles in circumference. Its curiously shaped rugged rocks and dense trees make it an Elysian Isle.

On this island stands a famous temple dedicated to Benten (Sarasvati), the goddess of Music and Wealth. The temple is said to have been opened first by the Priest Gyōgi under the orders of the Emperor Shōmu about 1,200 years ago. Benten is one of the Seven Gods of Luck and one of the most popular Buddhist goddessess throughout Japan; and her temple is generally built on an isle or on artificial land surrounded with water, because she was originally a personification of the River Sarasvati in India.

Benten on Chikubu-shima Island is one of the three famous Benten temples in Japan, the other two being the one at Eno-shima (Kamakura) and the other at Itsukushima. The temple occupies the choicest site on the island, overlooking the exten-sive mirror formed by the beautiful water of the lake.

Fig. 285. Design of the Coffering
Chikubu-shima Shrine, Lake Biwa

The present edifice of the temple was originally one of the palace buildings in the Castle of Momoyama, built in 1593 by Toyotomi Hideyoshi. The building was transferred here in the year 1602 and dedicated to the Goddess Benten about 300 years ago by Hideyori, the son of Hideyoshi. It is now converted into a Shinto shrine. (Fig. 283)

The exterior beauty of this building lies in the pitch of its roof, which is thatched with the bark of *hinoki* wood. At each end of the ridge is a high triangular gable, and at the middle of the front and rear eaves is a semi-circular gable called *kara-hafu*. Such a pitch roof is peculiar to Oriental architecture, and such beautiful thatched roofs of bark have been developed only in Japan. In western architecture we see a beautiful pitch of roof only in the cupola, but it produces quite a different feeling from ours.

The pillars and bracket work in this building are not very significant when seen from outside, because they are partially

concealed by shading roofs and protecting walls, but the interior is most elaborately decorated with sculpture, painting, and gold lacquer.

We find beautifully perforated carvings inserted between the bracketworks of the narrow ante-chamber. (Fig. 284) They represent birds in peony or chrysanthemum flowers; and the panels between circular pillars are coated with peony arabesque, perforated and colored.

The inner chamber is more spacious and forms an almost square room. The pillars and various horizontal members are lacquered black and decorated with chrysanthemums and running water in gold lacquer. The technique and composition are excellent, and very representative of the beautiful Momoyama gold lacquer.

The right and left walls are gorgeously pasted with gold leaf. On the gold ground are painted pines, plum trees, and chrysanthemums on a large scale.

The ceiling likewise is gorgeous and still retains its original splendor and brilliancy. It is a coved compartment ceiling, each coffer of which has a beautiful floral design of peonies and chrysanthemus on a gold ground. (Fig. 285) The frames which form the square compartments are black and chamfered red. All the crossings of the frames are fastened with ornamental gilt metal with chrysanthemums in silhouette and chiselled work.

In this small building we see a rare example of the decorative architecture of the Momoyama Period, beautifully preserved in form and colors probably because it has been secluded in the Island from the outer world since its transference here at the beginning of the seventeenth century.

CHAPTER VI

NARA AND VICINITY

1. NARA IMPERIAL HOUSEHOLD MUSEUM

The Museum was established in 1894 to show artistic trea-
sures owned by the Shinto shrines and Buddhist temples in Nara

Fig. 286. Nara Imperial Household Museum

and its vicinity. It stands in the park. (Fig. 286) The exhibits
are divided into painting, sculpture and industrial fine arts.
They include a rich loan collection of sculpture, for which the
museum is famous. We shall take up some important exhibits of
these three different kinds of art and describe them in the fol-
lowing pages. However, they are not always on view; especially
the paintings which are changed at short intervals because of
the limited space and also because too long exposure of pictures
is not good for their preservation.

Fig. 287. Interior of the Nara Imperial Household Museum

SCULPTURE

A number of representative master works of Buddhist statues produced during the period from the seventh to the thirteenth century are placed on view in three large rooms, which occupy the major space of the whole museum.

In the first room (Fig. 287) which is the largest, are shown a number of Buddhist statues produced in the Suiko and Nara periods.

Kokuzō Bosatsu, or Bodhisattva of the Essence of the Void Space Above. Colored on wood. Hōrin-ji monastery. Suiko Period. The figure stands, carrying a vase in the left hand, and measures about 8 feet in height, occupying the largest case in the room. Its bodily structure lacks symmetrical proportion, but such is one of characteristic features of the Suiko sculpture. (Fig. 288)

The Eight Buddhist Guardian Kings or Hachibushū. Dry-lacquer. Kōfuku-ji monastery. Nara Period. The set of eight

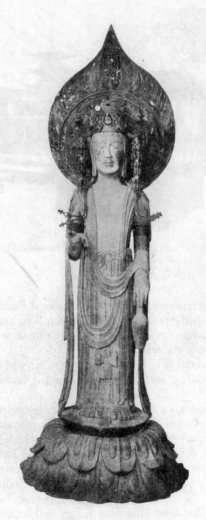

Fig. 288. Kokuzō Bosatsu (N.T.)
Nara Imperial Household Museum

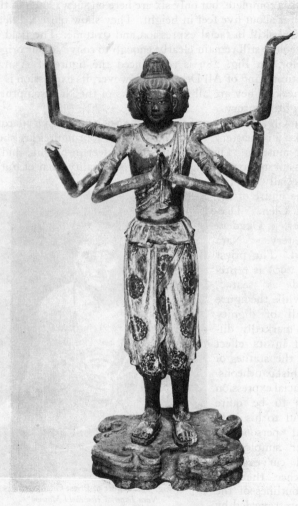

Fig. 289. Figure of Asura (N.T.)
Nara Imperial Household Museum

statues is complete, but only six are here on view. Each of them measures about five feet in height. They show quite a different technical skill in facial expression and costume. The gold and other colors still remain clearly enough to convey their original splendor. In Fig. 289 is reproduced the figure of Asura or Mightiest King of All Demons. However, its expression is soft and meek. They are all master works of the Nara sculpture in the eighth century.

Ten Great Disciples of the Buddha Shaka-muni. Dry-lacquer. Kōfuku-ji monastery, Nara Period. Only four figures are shown in the museum. They measure about 5 feet in height, and are successful in representing individual personality; that of Furuna is especially fine. (Fig. 35)

The figure of the priest Gien. Dry-lacquer. Okadera monastery. Nara Period. The priest (Fig. 290) is represented as seated, and while the figure is full of dignity it is markedly different in its effect from the statues of Buddhist pantheons. His facial expression seems to be quite faithful to his individual personality. Under simple and broad curves over the knee, the realistic outlines of the legs are revealed by

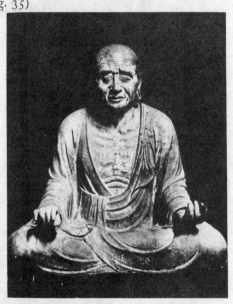

Fig. 290. Figure of Priest Gien (N.T.)
Nara Imperial Household Museum

the technical skill of the Tempyō sculptor. This is surely a

masterpiece of the portrait sculpture in the late Nara Period.

In the second room are exhibited a number of master works illustrative of the sculpture developed in the Heian and Fujiwara periods, that is, during the period of about four hundred years between the ninth and the twelfth centuries.

The Figure of a Shinto goddess, Nakatsu-hime. Colored on wood. Yakushi-ji monastery. Fujiwara Period. The figure is represented in a sitting posture. It measures about 1.2 feet in height. Its costume and the design are illustrative of those days when the statuette was produced. (Fig. 291)

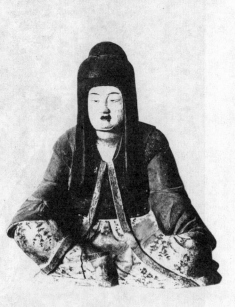

The Figure of Miroku (Maitreya). A national treasure. Wood. Tōdai-ji monastery. Heian Period. This is a statuette, but a powerful touch of the chisel is highly expressed on its surface of plain wood.

Fig. 291. Figure of Shinto Goddess (N.T.)
Nara Imperial Household Museum

The Figure of the priest Nichira. A national treasure. Tachibana-dera monastery. Heian Period. The wooden figure stands, holding a gem in the left hand, and the right hand being suspended at the side. It

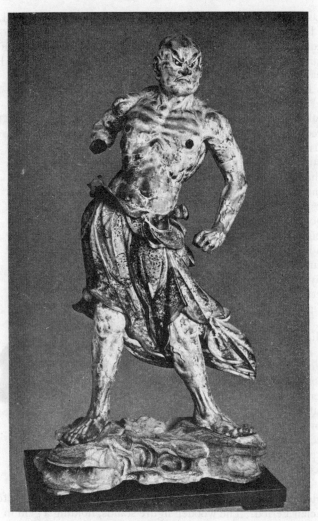

Fig. 292. Vajra Holder (N.T.)
Nara Imperial Household Museum

measures about 4.7 feet in height. This is a representative masterpiece of the early Heian Period.

In the third room are collected a number of master works produced in the Kamakura Period.

The Figure of Kongō-rikishi, or Vajra Holder. Kōfuku-ji monastery. Colored on wood. Kamakura Period. The figure measures about 5.3 feet in height. In this example (Fig. 292), we see the very type and spirit of the Kamakura sculpture at its height. It expresses power of action and life, aided by the sweep and rush of the drapery, which give a perfect rhythmic unity.

The Figures of Seshin and Muchaku, the Patriarchs of the Hossō sect. National treasures. Kōfuku-ji monastery. Colored on wood. Both measure 6.3 feet in height, and they are said to have been produced by Unkei at the beginning of the thirteenth century. We see in these figures the individual characters of the priests most excellently visualized by his genius. The facial expression is vivified by the insertion of crystal into the eyes.

The figure of Yuima by Jōkei. A national treasure. Kōfuku-ji monastery. Colored on wood. Kamakura Period. The figure measures about 3 ft. in height. This is one of the master works of the Kamakura sculpture, highly realistic in the expression of individual personality. Jōkei was the son of Unkei and a great master sculptor of the Kamakura Period.

PAINTING

The Goddess of Beauty or Kichijō-ten. A national treasure. Yakushi-ji monastery. Mounted as a tablet. Colored on the hempen cloth. It measures 1.8 feet in length. A rare example of the painting produced in the eighth century. (Fig. 28)

Amida Triad with a Boy Attendant. Hokke-ji monastery. Mounted as kakemono in three pieces. Colored on silk. Early Fujiwara period. This is an early example of Amida and his attendants, who are coming down from Heaven to welcome people. The triptych is especially famous for its beauty of delicate lines and color scheme which represent the best of the early

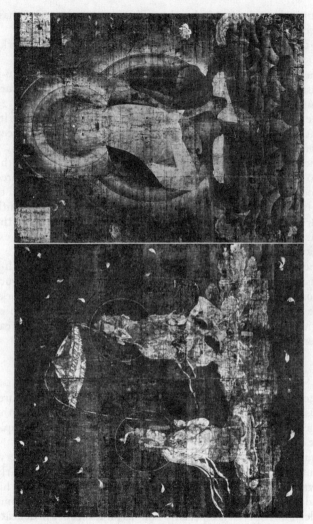

Fig. 293. Amida Triptych
Nara Imperial Household Museum

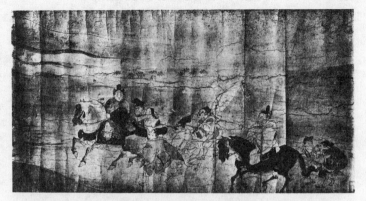

Fig. 294. Shigisan Engi (N.T.)
Nara Imperial Household Museum

Fujiwara painting, that is, about the tenth century. (Fig. 293).

History of Shigisan with Illustrations, or Shigisan Engi. (Fig. 294) Chōgosonshi-ji monastery. Mounted as *emakimono* in three pieces. Colored on paper. Late Fujiwara Period. The picture depicts the miraculous attributes of the figure of Bisha-mon-ten enshrined in the Shigisan (Chōgosonshi-ji). This is one of the oldest of the *emakimono* pictures which are extant today. The figures are all full of life and activity as will be noticed in our reproduction.

The Fan-shaped sutra, or Semmen Hokke-kyō. Shitennō-ji monastery. Mounted as tablets in twelve pieces. Colored on paper. Late Fujiwara Period. The Hokke-kyō, or the Lotus of the True Law (Saddharma Pundarika) is written over the fan-shaped paper which is decorated with pictures in rich colors. The pictures are not illustrative of the meaning of the sutra, but they represent customs and manners of the time when the sutra was written in the second half of the twelfth century. (Fig. 295) In the delineation of human figures, it represents the popular style prevalent in the Fujiwara Period. The eyes are drawn with one line and the nose with two broken lines, which are so fine and delicate that they might escape notice, yet giving a quiet feeling

Fig. 295. Fan-shaped Sutra (N.T.)
Nara Imperial Household Museum

and elegance to the whole composition of each picture. The gold and silver foils being skilfully used, the general effect is highly decorative. At the same time the picture is a unique example in the history of picture prints in Japan, because the outlines are printed, and over these outlines are elaborated all the details in colors.

The Figure of Gundari Myō-ō. A national treasure. Daigo-ji monastery. Mounted as kakemono. Colored on silk. Kamakura Period. Gundari Myō-ō is one of the Five Manifestations of Great Destructive Powers (Godairiki Myō-ō). He stands enveloped in burning flames. His body is blue, and his eyes are red and open wide. He looks even more horrible because of the blue serpents which he carries over his shoulders and limbs. (Color plt. 9) He was worshipped in a Buddhist service held to expel all the evils and demons which torture people.

In the Buddhist iconography there are three distinct manifestations for visualization of the Buddhist doctrine; namely the posture of Buddha and those of Bodhisattva and Myō-ō. The posture of Buddha visualizes the indigenous attributes of Buddhahood itself in simple form. Therefore no ornament is added

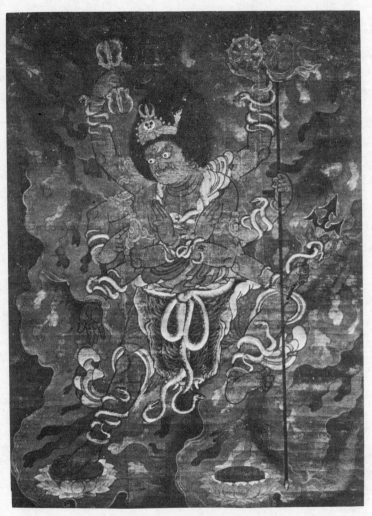

Color plt. 9. Gundari Myŏ-ŏ (N.T.)
Nara Imperial Household Museum

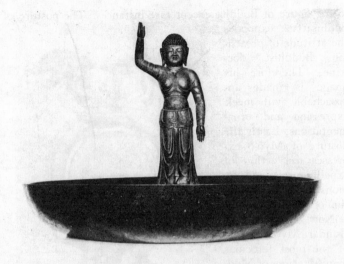

Fig. 296. Vessel with Statuette of Shaka (N.T.)
Nara Imperial Household Museum

Fig. 297. Engraving of the Vessel (Fig. 296)

to the figure of Buddha except rare instances. The posture of Bodhisattva expresses the attitude of preaching Buddhist doctrine. Therefore his image is made approachable by its meek expression and ornamentations. Lastly the posture of Myō-ō expresses the action of expelling evils and demons under the instruction of Buddha.

Now our picture of Gundari Myō-ō is one of the most ferocious manifestations of Myō-ō whose vows are to destroy all the wickedness which harms human welfare, and this is an excellent example produced in the Kamakura Period.

METAL WORK

The Vessel with the Statuette of Shaka. Tō-dai-ji monastery. Gilt bronze. Nara Period. The vessel (Fig. 296) was once used in the

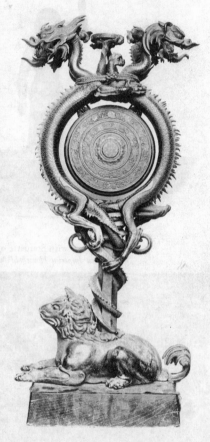

Fig. 298. Musical Instrument (N.T.)
Nara Imperial Household Museum

canonization ceremony held in memory of the birth of Shakamuni. On the outside of this vessel is engraved a unique picture

representing Chinese boys playing with lions among flowers, trees and rocks. Some boys run on the backs of lions and others make fun with running lions. (Fig. 297) Such design seems to have been produced from the Persian prototype of hunting scenes, because Persian design modified in China was at this time introduced to Japan.

The musical instrument called Kwagen-kei. Kōfuku-ji monastery. Bronze. Nara Period. The bronze figure of a lion forms the stand. Its remarkable head, the strenuous body and the curled tail are all admirably static, but ready for full activity at any moment, and show the powerful technical skill of the eighth century. (Fig. 298) But the instrument itself was a later restoration, probably of the Kamakura Period.

2. TŌDAI-JI, THE HEAD MONASTERY OF THE KEGON SECT, NARA

The Tōdai-ji monastery was founded by the Emperor Shōmu in the year 745. A colossal figure of Buddha Roshana (Vairochana) was cast in bronze for the Imperial prayer; and an enormous wooden hall was erected for it in the year 751. On the 9th of April in the following year its dedication ceremony was held in the presence of the Emperor Shōmu. (See page 38) But in the fourth year of Chishō (1180) the Main Hall and all other buildings were reduced to ashes by a conflagration during a battle. In the following year the restoration work began under the patronage of Yoritomo, the first Shogun of the Minamoto family, cooperating with pious people at large in the whole country. In the sixth year of Kenkyū (1195) all the buildings were rebuilt and the dedication ceremony was held in the presence of the Emperor Gotoba and the Shogun Yoritomo. After this about three centuries passed and the monastery was again devoured by a war fire in the tenth year of Eiroku (1567). At this time the sacred buildings were mostly burnt, including the main hall. The Daibutsu, the colossal bronze figure of Buddha, which had survived the last fire, this time lost its head, but was soon restored,

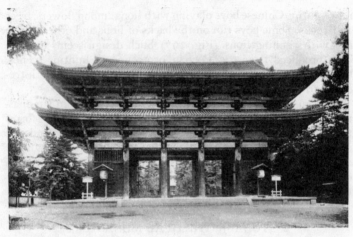

Fig. 299. Great South Gate (N.T.)
Tōdai-ji, Nara

although it was much inferior to the original. However, the hall was not restored and the Daibutsu was left weather-beaten for one hundred and thirty years until the fifth year of Hō-ei(1708), when the present hall was rebuilt as we see it now.

The great South Gate, or Nandai-mon, remains from its second reconstruction in the year 1195. (Fig. 299) The architectural style of this gate belongs to what is known by the name *tenjiku-yō*. This style was for the first time introduced from China in connection with the restoration work of this monastery in the Kamakura Period. It is a two-storied gate with the frontal measurement of five spans, and the side of two spans. Its characteristic features are visible in the columns going up through the two stories, in the seven corbelled bracket construction, eaves, and inserted bracket elbows. In outward appearance, the gate is grand and imposing, and in construction free and ingenious.

At either side of the interior of the gate is installed a famous figure of Niō. Both figures are the largest statues of Niō in Japan, having a height of 26.6 ft. and are physically unequalled in the ex-

pression of terrifying fierceness. These two statues are attributed to Unkei and Kwaikei. Although it is difficult to know which is by Unkei and which is by Kwaikei, their type and technique represent more that of Unkei. (Fig. 300)

At the inner half of the interior of the gate stand a pair of stone lions. They represent the Sung sculpture introduced into Japan in the early Kamakura Period. They were undoubtedly produced by a Chinese artist at nearly the same time as Niō.

The Great Buddha Hall, or Daibutsu-den, is of the third reconstruction, in the fifth year of Hō-ei (1708), and has recently been well repaired. (Fig. 301)Its architectural style belongs to the *tenjiku-yō*, as does that of the Great South

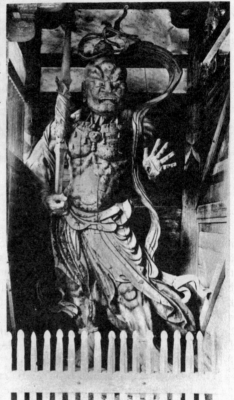

Fig. 300. Niō (N.T.)
Tōdai-ji, Nara

Gate. It is double-roofed, of hipped type; and either end of the main ridge-pole is decorated with golden kite's tail (*shibi*). Its façade and side have seven spans; the frontal measurement being about 188 ft., and the side, about 166 ft., 30 per cent less in di-

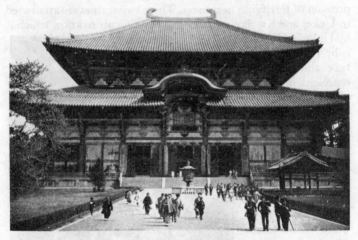

Fig. 301. Great Buddha Hall (N.T.)
Tōdai-ji, Nara

mension than the original plan. This reduction, of course, made a great difference in the magnitude of the whole structure. But the height measures about 157 ft., as much as the original. Anyhow the temple is the largest wooden building that Japan has today, and represents the greatest architecture built in the middle Yedo Period.

The floor inside is paved with stone, and in the centre sits Daibutsu, the chief Buddha of the temple, cross-legged upon a lotus pedestal on the elevated dais.

The Daibutsu is made of bronze. Its casting was started in 745 and took about five years to complete. It measures 53.5 ft. in height; the face 16 ft. in length, and the eye 3.9 ft. in length. But, as has been said, it was repaired several times and sustained many damages, especially on the upper parts. The knees and some of the lotus petals are original. On the petals are represented the Buddhist world in fine engraved lines, which afford us important materials for the study of pictures of the Nara Period.

An attendant figure at either side of Daibutsu was produced

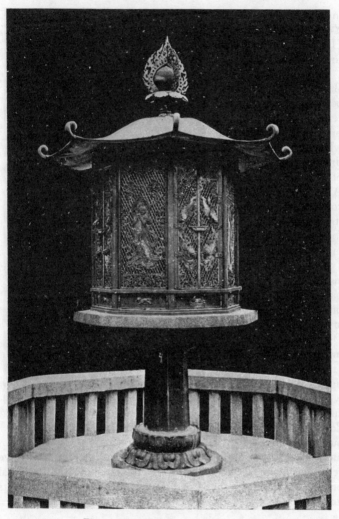

Fig. 302. Octagonal Bronze Lantern (N.T.)
Tōdai-ji, Nara

in the middle of the Yedo Period, when the Hall was reconstructed for the third time.

In front of the Great Buddha Hall is a large octagonal bronze lantern. (Fig. 302) It was produced at the time when the Daibutsu was first cast in the middle of the eighth century. Although its gilt has come off, it has retained its original magnificent form and beauty for many years. It measures 15 feet in height and has eight beautiful gilded panels which are masterpieces of the founder's art of the Nara Period. On the diamond fret in open-work, angels of graceful pose stand lightly on flowers. The wonderfully delicate curves of the figures and floral designs harmoniously counteract the

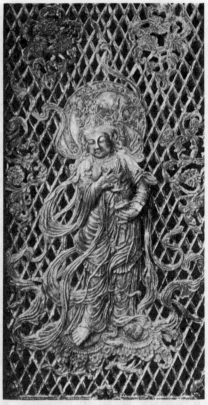

Fig. 303. Angel of the Octagonal Bronze Lantern
Tōdai-ji, Nara

hardness of the straight lines of the fret. In Figure 303 we have reproduced one of the panels. Note the soft smile and the floral ornament around the head in Figure 304 which reproduces its details.

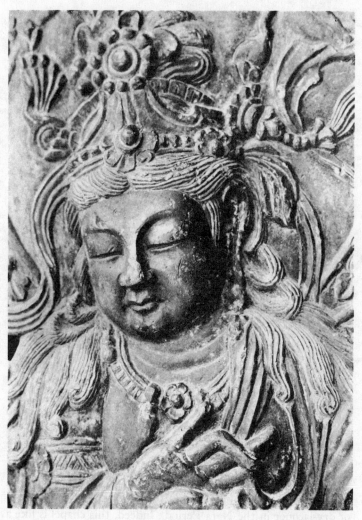

Fig. 304. Detail of the Angel (Fig. 303)

3. HOKKE-DŌ TEMPLE, NARA

Hokke-dō or Sangatsu-dō temple stands on the east of Dai-butsu and belongs to the Tōdai-ji monastery. (Fig. 305) It was erected in the 5th year of Tempyō when the Great Buddha Hall was not yet built. The temple originally measured five spans front and four deep, and had a hipped roof. However, in the

Fig. 305. Hokke-dō
Tōdai-ji, Nara

Kamakura Period, the Raidō, or Sanctuary Hall, was added to its front and the shape of the roof more or less changed. But the main part of the building still retains its original grandeur of the Tempyō architecture.

In this temple are installed Fukū Kenjaku Kwannon, the Main Buddha of this Hall, and a number of other Buddhist fig-ures. Most of them are representative masterpieces made of clay or dry-lacquer in the Nara Period. Indeed, this chapel is like a treasury of the excellent statues of the eighth century sculpture.

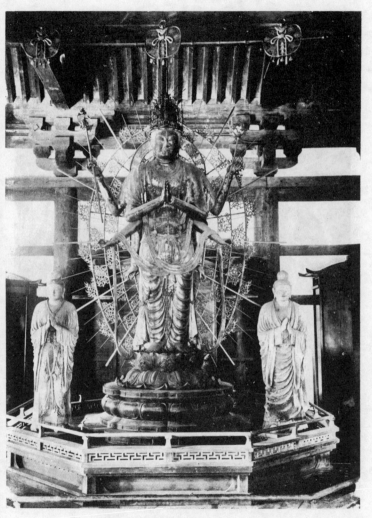

Fig. 306. Fukū Kenjaku Kwannon (N.T.)
Hokke-dō, Nara

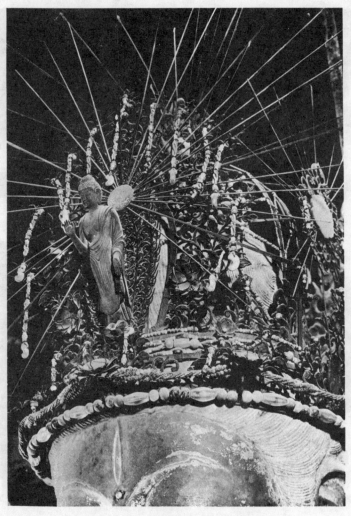

Fig. 307. Sacred Crown Worn by Fukū Kenjaku Kwannon
Hokke-dō, Nara

Fukū Kenjaku Kwannon is made of dry-lacquer. Its majestic super-human height of 3.63 metres conveys an inspiring impression of spiritual power. (Fig. 306) Its sacred crown is wonderfully delicate and excellent open work of silver with beautiful floral design, ornamented with numerous pendants of precious stones of various colors, which count about ten thousand. (Fig. 307)

On either side of the main figure stands a clay figure. One is the image of Nikkwo and the other of Gakkwo. Their artistic value is very great, and marks the culmination of Tempyō sculpture in clay.

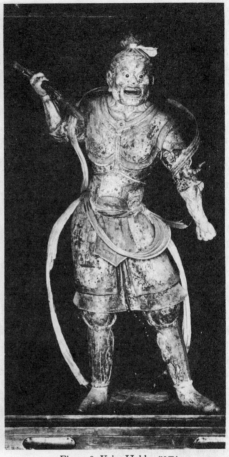

Fig. 308. Vajra Holder (N.T.)
Hokke-dō, Nara

Four Guardian Kings (Shiten-nō), standing at the four corners of the altar, are also masterpieces in dry-lacquer decorated with colors. They measure 10 ft. in height and are attributed to the priest Gyōgi.

At the rear of the altar is constructed a shrine in which is installed a figure of Shitsu Kongō-jin, or Vajra Holder. It is a masterpiece of the violent type of statue in clay. (Fig. 308) The figure measures 1.66 metres in height. It is powerful and full of motion; the left arm is straightened tensely with every muscle in play; the right hand is raised, brandishing a vajra. Of such violent types as this figure, Fenollosa remarked well when he said "the muscles and tendons of the arms and of the elevated fists are worked to the utmost perfection of the veins." It is traditionally said that in a battle the statue poured forth swarms of wasps from its mouth and had the enemy's men stung to death by its protegés. Such a tradition may have arisen because of

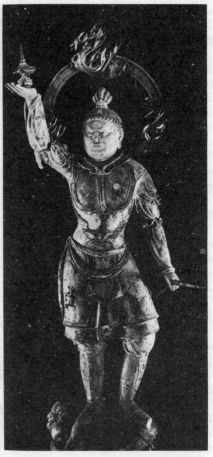

Fig. 309. Figure of Tamon-ten
Kaidan-in, Nara

the utmost passion of battle expressed in its face. The original painting over the clay has been preserved almost perfectly. The figure is on view to the public only once a year.

4. KAIDAN-IN OR THE INITIATION HALL OF TŌDAI-JI, NARA

The Kaidan-in, or Initiation Hall of the Tōdai-ji monastery is on the west side of the Daibutsu. This Hall is now famous, for it contains the clay figures of Four Guardian Kings which are set upon the great raised altar of the Hall. All these figures stand upon the bodies of misshapen brutal imps. Each measures 1.64 metres in height. The figure of Tamon-ten, one of the four guardian kings, who holds a miniature stupa in his raised right palm, is especially fine. (Fig. 309) Its stern and resolute visage is admirably rendered, as will be seen in Figure 310. All these figures had coloring, but now only a trace of it is to be seen. It is to be noticed that obsidian is inlaid for the pupils of the eye.

Fig. 310. Detail of Fig. 309

5. SHŌSŌ-IN TREASURY, NARA

The Shōsō-in stands near the Daibutsu. (Fig. 311) It formerly belonged to the Tōdai-ji monastery, the national cathedral of

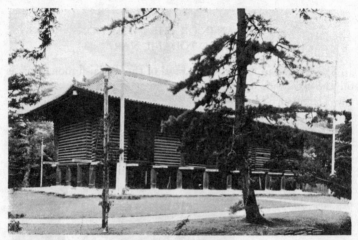

Fig. 311. Shōsō-in Treasury
Nara

Japan. The origin of the treasure house is this: when the
Emperor Shōmu died, in 765, many objects of artistic value,
which had belonged to him were presented to this state cathe-
dral and were listed in a catalogue which also remains today.
Since then they have been stored in the same house down to the
present day, together with objects used in ceremonies held in
the temple.

This wonderful treasure house is a wooden building with a
tiled roof. The floor of the entire building is supported by forty
round pillars, each 9 feet high. Therefore, under the whole floor
is a clear open air space through which anyone can pass. The
walls are made of roughly hewn triangular beams of *hinoki* laid
in "log-cabin" fashion. No mortar is used on either side. In a
country like Japan, where the degree of humidity is very high,
wooden architecture like this is most preferable, because plain
wood walls, floors, and pillars will absorb moisture readily, but it
is rapidly evaporated in the sunshine and dry air, which can enter
and circulate very easily. Anyhow it is perfectly wonderful that

this art repository with its original contents has been standing for eleven hundred and fifty years in the very same place, from the time of erection day down to the present.

The collection in this treasure house contains about 3,000 art objects of the age: various kinds of furniture, pottery, wooden and leather boxes lacquered or inlaid with gold, silver, ivory or different colored woods, masks, musical instruments, medicines, textile fabrics, writing materials, written documents, manuscript-copies of Buddhist scriptures and many other things. Indeed it includes a very extensive field of art and historical documents, all from the eighth century, and represents the best Eastern art of that time. In their decorative motives and workmanship of these ob-

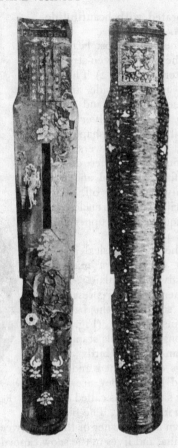

Fig. 312. Seven-stringed Psaltery
Shōsō-in Treasury, Nara

jects Byzantine, Persian and Indian influences can be recognized.

We can do here nothing more than take up a few objects to give just a glimps of the contents.

In the treasure house are various kinds of musical instruments

decorated with beautiful designs.

One of the most beautiful of these is a seven-stringed psaltery. (Fig. 312) The surface and back side are all lacquered black and inlaid with gold and silver plates cut into various shapes, figures, animals, flowers, birds and butterflies. These designs are first incrusted and then evenly polished off. The principal design is enclosed in the square at the upper part. (Fig. 43)

There is a musical instrument called Biwa made of sandalwood inlaid with mother-of-pearl, representing vine scrolls on the back of the instrument. (Fig. 313) Among the scrolls stand two human-headed birds with wings outstretched and tails raised high. They are Buddhist sacred birds called *Kala-vinka* in Sanscrit. The bird is

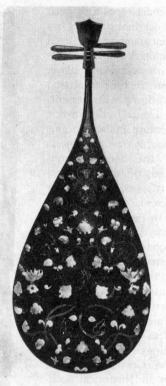

Fig. 313. Musical Instrument
Shōsō-in Treasury, Nara

known as the owner of the most sweet and sublime voice next to Buddha, and lives in the snow capped mountains, the Himalayas of India.

There is a unique example of lacquer jar. This jar is specially important on account of the material used under the lacquer. The shape of this jar is skilfully modelled in fine basketry work which may be noticed from the broken part. Over the basketry work is applied cloth, and then the object is lacquered black.

The silver design composed of birds, deer, butterflies, clouds and grass flowers is incrusted. The lid of the jar is modelled in the shape of a bird head, and is secured by a fine silver chain to the handle. (Fig. 314)

In the treasury are preserved about fifty beautiful mirrors. All of them are extremely fascinating and deserve special attention. They are polished bronze mirrors. Their forms are either disk or eight-petalled flower forms, both to be held by cords attached to the knobs at the centre of the back. They are quite thick and heavy, the largest measuring about ten inches in diameter; and are kept in wooden cases beautifully lined with padded brocade.

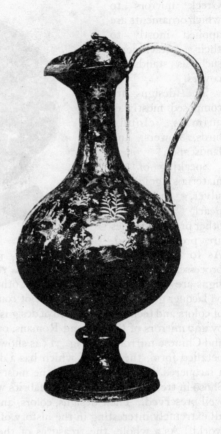

Fig. 314. Lacquer Jar
Shōsō-in Treasury, Nara

The designs are applied directly to their backs after Chinese

style, unlike those of Greek mirrors to which ornaments are applied mostly to their attachments such as stands, or covers.

The designs are composed mostly of animals, clouds, birds, flowers, and landscapes.

Speaking of the materials, gold and silver, mother-of-pearl, agate and other precious stones are profusely used. As to the technical processes, some de-

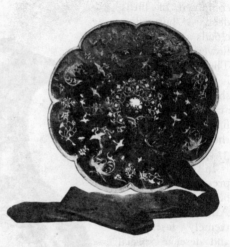

Fig. 315. Bronze Mirror
Shōsō-in Treasury, Nara

signs are cast in the same mould; but others are finely incrusted on lacquer ground. The fine spirit of composition, the richness of colors and technical precision of designs can hardly be excelled by any mirrors of Greeks and Romans, or by any later Japanese and Chinese mirrors. In Fig. 315 is shown a mirror with eight petalled form, the back of which has a delicate floral design on a lacquered ground. Probably the most wonderful among the Shōsō-in treasures are the textile fabrics which are marvellously well preserved. Their designs, colors, and technical process are all extremely interesting in the history of textile industry of the world. As a whole, the treasures of the Shōsō-in present the best of the fine artistic objects produced in Japan in the eighth century. If they were only imported objects they would not be so wonderful. But most of them were surely made in Japan. To prove this there are many first hand documents in the treasury. Japan was then very rich and qualified to imitate the flowery

life of China. Thus, Japanese could imitate Chinese culture to the fullest extent; and the treasures of the Shōsō-in most convincingly prove this fact.

What they imitated in the Nara Period became the fountainhead out of which later Japanese civilization developed.

6. SHINYAKUSHI-JI MONASTERY, NARA

The Shinyakushi-ji monastery was founded in the Tempyō Era (729–748) by the Empress Kōmyō with a prayer for the Emperor Shōmu who was suffering from eye disease.

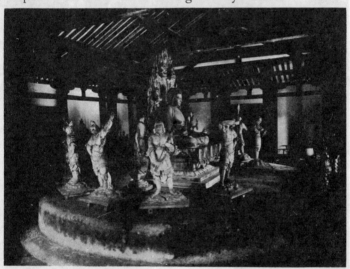

Fig. 316. Interior of the Main Hall
Shinyakushi-ji, Nara

The Main Hall of the original still stands although it has been more or less modified in later ages. It is a one-storied building of seven spans at the façade and five spans at each side, and has a tiled *irimoya* roof. The construction of the interior is simple but has a beauty of ordered symmetry. The floor is tiled, and in the

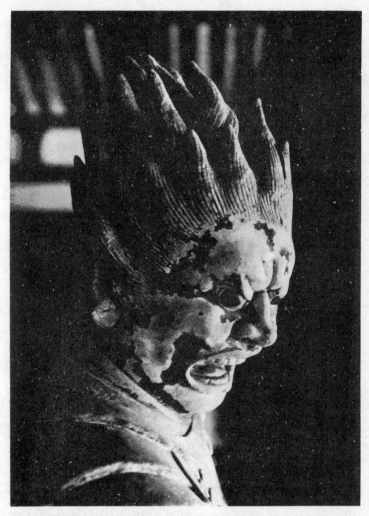

Fig. 317. Head of an Attendant of Yakushi
Shinyakushi-ji, Nara

middle of the hall is a raised circular dais upon which are placed the main Buddha and his attendant figures. (Fig. 316)

The main figure represents Yakushi or Healing Buddha. He sits cross-legged on a high pedestal placed in the middle of the dais. The figure measures 6.3 feet in height and is a rare example of wooden statues carved out of a single block of wood. It is a gracefully rounded figure, having realistic beauty of flesh in body and limbs. At the same time it expresses spiritual magnitude through its physical gracefulness. The figure is a masterpiece produced in the early ninth century.

Around the main figure stand twelve armed clay figures which were all produced in the eighth century, except one which is the recent restoration in wood. Their postures and expressions are all different from each other and very dramatic. In Fig. 317 we have reproduced one of the heads of these figures to illustrate the force and action shown in the Nara clay sculpture of the eighth century.

7. TŌSHŌDAI-JI, THE HEAD MONASTERY OF THE RISSHŪ SECT OF BUDDHISM

The Tōshōdai-ji monastery stands in a western suburb of Nara. It was founded in 759 by Ganjin, a Chinese priest of high rank, who had come to Japan with many followers a few years before, among whom were men from Persia, Champa, and Chinese Turkestan. The buildings of the monastery are said to have been built by the Persian called Nyoho who came over with the priest. However, the Kon-dō, or Golden Hall, is the only building remaining of the original. (Fig. 48)

In the Golden Hall is installed a group of magnificent dry-lacquer statues of the Tempyō Era (729–748). The main figure in the group is that of the Buddha Roshana, in a sitting posture, measuring about 10 feet in height. On either side of this figure stands Yakushi or Healing Buddha, and the one-thousand-armed Kwannon, or Senju Kwannon; the former measuring about 12 feet (Fig. 318) and the latter about 17 feet. (Fig. 319) Whoever

comes to this hall and looks upon all these works of art on the dais will be surprised at the greatness of these sacred figures. They represent the most developed type of technique in dry-lacquer art. Those who are struck with the stately dignity of the facial expressions of the statues may be able to a certain extent to realize the pure, unaffected religious sentiment of the artist.

At the rear of the Golden Hall stands the Lecture Hall (Kō-dō), which is a unique example of palace buildings of the early Nara Period. (Fig. 47)

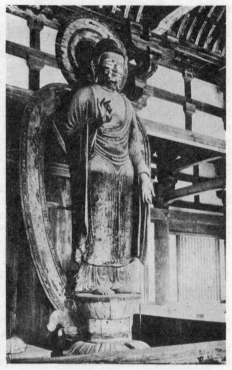

Fig. 318. Yakushi (N.T.)
Tōshōdai-ji, Yamato

In this hall are installed a number of excellent Buddhist statues in wood. The Miroku Bodhisattva, a national treasure, is the main statue in the hall. It measures about 9 feet in height, and is a masterpiece produced in the early Kamakura Period, that is, in about the early thirteenth century.

The following are also national treasures kept in this sacred hall besides the main figure:

The Two Guardian Kings, Jikoku-ten and Zōchō-ten. Wood.

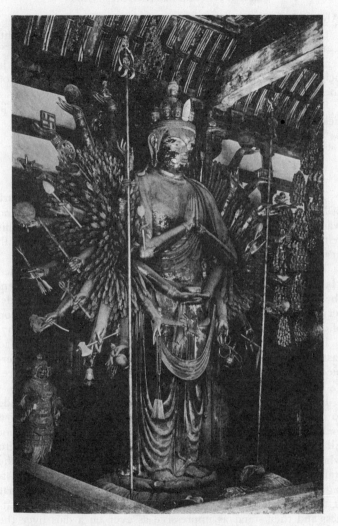

Fig. 319. One-thousand-armed Kwannon (N.T.)
Tōshōdai-ji, Yamato

About 4 feet in height. Late Nara Period.

The Figure of the Priest Gyōgi. Wood. 3.8 feet in height. Late Nara Period.

The Figure of Dai-itoku Myō-ō. Wood. About 3 feet in height. The figure has six faces, and six arms; and is seated on the back of a buffalo. Heian Period.

The Statue of Fudō, by Tankai. Wood. About 2 feet in height. Yedo Period.

8. YAKUSHI-JI, THE HEAD MONASTERY OF THE HOSSŌ SECT OF BUDDHISM

The Yakushi-ji monastery is situated in a southwest suburb of Nara. It was one of the seven great monasteries at Nara, and was founded by the Emperor Temmu in the eighth year of his reign (680) to pray for the recovery of his Empress from an illness.

The monastery contains the three-storied stupa, the Golden Hall, the Tōzen-in Hall, and other sacred buildings. Among them the three-storied stupa is the only great architecture which deserves study by students of Japanese art. However a description of it is already given in the first part of this book. (See page 67)

In the Golden Hall is enthroned the famous Yakushi Triad cast in bronze. (Fig. 320) The triad is, indeed, the great masterpiece of this period. The main figure with its pedestal measures 14 feet in height and the attendant figures 13 feet.

In 680 in the reign of the Emperor Temmu a vow was made to cast the statues for the recovery of the Empress from a malignant disease of the eyes. However, it is said that it was not till the eleventh year (697) in the reign of the Empress Jitō who ascended the throne on the death of the Emperor that the statues were completed. According to another tradition the casting of the figures is ascribed to the second year of Yōrō, that is, the year 718. In any case there is no difference in their greatness and they stand as impressive as ever on a dais over the marble platform. In these images we encounter the most perfect-

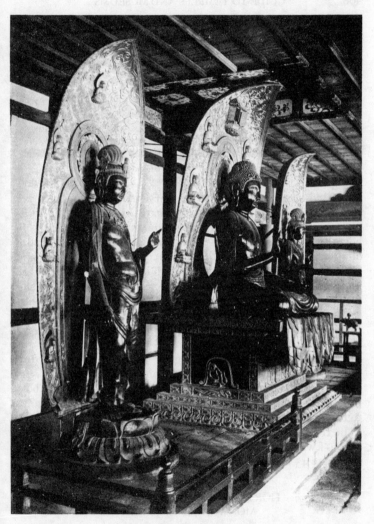

Fig. 320. Yakushi Triad (N.T.)
Yakushi-ji, Yamato

Fig. 321. Grape Design on the Pedestal of Yakushi
Yakushi-ji, Yamato

ly formed features of Buddhist atstuary. All three of them are
superb in poise, displaying a consummate art, never attained be-
fore. The attendant Bodhisattvas, leaning towards one side, sup-
port themselves on one leg,—free in attitude and yet with calm
dignity. The lower half of the body is covered with drapery, and
yet seems to be showing itself through it. The drapery-folds are
not complicated, nor are they merely conventional: they hang
softly and yet are strong in execution. Together with the double-
folding of the thin scarf, they greatly enhance the perfection of
shape in the attending statues. The form of the central figure is
also splendidly proportioned.

The pedestal of the central figure is a magnificent piece of
casting. On the four sides are four Chinese sacred animals sym-
bolizing four cardinal directions, and in front are demons in bold
relief. Its edge is ornamented with the grape design particular
to this period. (Fig. 321)

In the Tōindō Hall is enshrined the famous standing figure
of Shō-kwannon in bronze, produced in the early Nara Period.
(See page 45 and Fig. 30)

9. HŌRYŪ-JI, THE OLDEST BUDDHIST
MONASTERY IN JAPAN

The Hōryū-ji monastery stands on a flat ground, about 6 miles

Fig. 322. Entrance of Hōryū-ji Monastery
Yamato

southwest from Nara and 1 mile north from the Hōryū-ji station.
(Fig. 322)

It was founded by the Empress Suiko and the Crown Prince
Shōtoku Taishi in the year 607. It comprises about thirty build-
ings and one hundred articles of artistic merit, which were pro-
duced in different periods and are now protected as national trea-
sures. However, we are especially interested in the buildings,
which date from the time of its foundation, and in the Buddhist
statues and other objects of art that were produced in the early
days of Japanese Buddhism and have been housed in these sacred
buildings for a period of thirteen centuries.

The present Hōryū-ji monastery is divided into two enclo-
sures, the East Enclosure (Tō-in), and the West Enclosure (Sai-
in). The latter is the original main site of the monastery and
contains the Golden Hall (Kondō), Five-storied Stupa, Chūmon
Gate and the Galleries. These buildings are the oldest wooden
architecture in Japan.

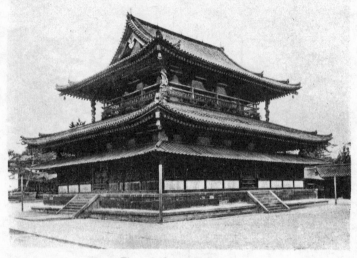

Fig. 323. Golden Hall (N.T.)
Hōryū-ji, *Yamato*

The Golden Hall and the Five-storied Stupa stand in the square enclosure formed by galleries, broken in the centre of the south side by the Chū-mon Gate, and on the north by the Lecture Hall (Kō-dō). The spacious and commanding excellence of the arrangement of these buildings and the flat clean-white sanded enclosure arouse a feeling of peace and sublimity in the hearts of visitors.

The Golden Hall, or the hall for worship, stands upon a stone platform of two levels. (Fig. 323) It has a façade of five spans and a side of four spans with an *irimoya* roof covered with tiles. Early in the Nara Period the first story was encircled with a "skirting roof," with the idea of protecting the precious statues and fresco paintings, but the angle supports of the upper roof, which are entwined with the sculpture of dragons, were of much later addition in the Yedo Period. These later additions have unfortunately injured the proportions of the original building.

But in spite of them, the extraordinary grace and refinement of the work compel a profound admiration.

The columns taper toward the top in a way which suggests the Doric order of Greece: their delicate entasis is remarkable; they support graceful brackets of the so-called "cloud form." The whole aspect of the building presents a vigorous and daring spirit. The interior is furnished with a clay dais in the centre, upon which are placed various Buddhist figures and shrines. The surrounding walls are decorated with famous fresco paintings representing Buddhas and Bodhisattvas. They were painted in the early eighth century. Red oxide of iron was used to paint the inside and outside, but the curved ceiling is ornamented with lotus-flower designs in colors.

A criticism on the Golden Hall by R.A. Cram is worth quoting here:

"Here at Hōryū-ji the technical details are almost beyond criticism. The plan of the Kondō is of the simplest type: a central space open to the cornice and covered by a ceiling of wooden beams, flat, except for a delicate coving at the sides. The clear story—if it may be called so, since it is without windows—is supported by cylindrical columns of wood; the whole, surrounded by an aisle with a sloping roof. Everything is absolutely constructional, and such ornament as there is, is applied only to the constructive details. The columns have a delicate entasis and the spacing is most refined; the bracketing is straightforward and constructional; the distribution of wood and plaster carefully studied; the vertical and lateral proportions, and the curves of the roofs and ridges are consummate in their delicacy." (Impressions of Japanese Architecture p. 34)

The fresco painting of the Golden Hall is a unique example in the history of Japanese painting. The long band of frescoing is divided into twelve sections, four of which are larger than the others; and each measures about 10 feet in height and 8.5 feet in width, forming a quadrangular composition. Each of these four walls has a painting representing a Buddhist Paradise with a Buddha seated in the centre; and the other eight smaller walls

have Bodhisattvas in a standing posture. Those four Buddhas painted on the four larger walls seem to be pictorial representations of the Buddhas mentioned in the Konkwōmyō-sutra which was then one of the most popular sutras, often recited in many state monasteries in the capital as well as in the provinces.

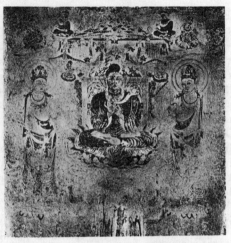

Fig. 324. Wall Painting of Amida Triad (N.T.)
Golden Hall, Hōryū-ji

The method of painting consisted in drawing outlines and applying colors to the dry finish of the wall—a sort of stucco. The outline of the body was drawn first in red lines and afterward shaded in the same color. The colors used were black, vermilion, rouge, ochre, cobalt and verdigris. Some secondary colors also were used, producing a good effect upon the general tone. The artists seem to have employed both brush and pencil. The same method seems to have been used in the wall painting of the Ajanta cave temple of India in the sixth century, as well as in the ancient Khotan of Western China. It first developed in the early T'ang Dynasty, influenced by the art of Central Asia, and was afterwards introduced into this country. The date of these paintings is therefore later than the founding of the Golden Hall and may safely be assigned to the early eighth century that is, about one century after the erection of the Hall.

The expression of the Buddha and Bodhisattvas is Indian. It recalls that of the figures at Ajanta and adds more. The posture is dignified; and the hands and fingers are drawn in an especially realistic manner. The wonderfully harmonious combination of

realism and idealism in the faces and postures of all the Budhas and Bodhisattvas, and the wonderful color scheme, the rich and deep dark claret and green colors of the garments, the reddish or purple flesh tones of their faces, and the gayer warm tints of the bodies, will fill the beholder's mind with the beauty of humanity blended with spiritual ecstacy and joy. Of the four large wall

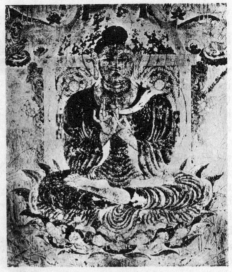

Fig. 325. Detail of the Fig. 324

paintings, the one depicting Amida's Paradise on the western wall leads the rest. (Fig. 324) When we study in detail all the artistic elements composing the picture and trace their historical significance, we shall realize what a high place they occupy in the history of Eastern Art. The middle figure sits cross-legged on a lotus throne, having both hands at the breast, in the attitude of turning the wheel of the law. (Fig. 325) This position of the hands can be seen in the Gandhara sculpture, as well as in the Gupta sculpture of Middle India, representing Shaka-muni; and the figure looks directly to the front with an immovable pose. On the palm of the right hand is depicted a chakra, the symbol of the wheel of the law, which originally belonged to Shaka-muni, the founder of Buddhism. With both hands in front of the breast and his body straight upright upon the immovable throne, the figure expresses absolute purity of mind and heart. If the figure were made of white marble, the worshippers

would be chilled by his absolute serenity, but it is painted on a wall made of earth which is most familiar to humanity; and the outlines of his body. and the robe are colored red.

The red color is the symbol of life and activity. In contrast to the red color, the lotus throne and head are colored blue and green, giving a feeling of the quietude of life. By thus harmonizing active power with meditative calmness, realism is attuned to idealism, and the absolute truth is personified in the figure of Amida.

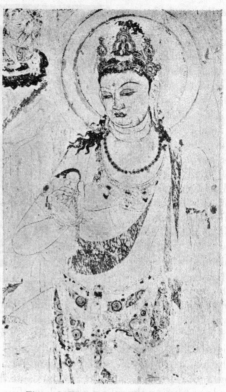

Fig. 326. Wall Painting Kwannon (N.T.)
Golden Hall, Hōryū-ji

The figures of Kwannon and Seishi on both sides of the main figure are much more human in their expression, and full of feminine beauty. (Fig. 326) They stand with hips a little swayed, disclosing the upper part of the body; the lower half is covered with filmy drapery revealing graceful body lines; and beautiful loose locks fall with wavy lines over the shoulders. Thus the two Bodhisattvas express the pulsating heart of humanity in harmony with the absolute mercy of Amida, the main figure.

The composition of the figures and their postures as well as their type are very similar to the Gupta sculpture representing a seated statue of Buddha, found in Sarnath of India (Fig. 327), and a seated figure of Buddha painted on the wall of Ajanta.

On the dais of the Golden Hall are enshrined three main Buddhist figures in bronze. One of them is the image of Shaka Triad, which is the

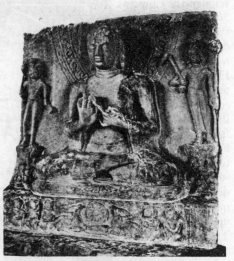

Fig. 327. Seated Statue of Buddha
Sarnath, India

most authentic work by Tori, because it has the original date and his name inscribed on its halo. (Fig. 328) This triune figure is of cast bronze still bright with gold. The main figure sits cross-legged, measuring 4 feet and 5 inches in height, and an attending Bodhisattva stands on either side. The figure represents the type of the earliest Japanese bronze work, that is, the Suiko type. It expresses archaic dignity, but its pose and lines are too stiff and very much conventionalized. Technically this figure by Tori shows his direct indebtedness to the Chinese North Wei stone sculptnre. On the back of the halo is an engraved inscription, which shows not only the name of its sculptor and date, but a prayer that reveals the beliefs and motives in those early years of Buddhist faith in Japan.

The inscription reads as follows:

"Saki-no Taikō (Mother of Prince Shōtoku) died during December of the thirty-first year of Hōkō-gwan (29th year of the

reign of the Empress Suiko). On the twenty-second day of January in the following year, Jōgū Hō-ō (Prince Shō-toku) fell ill. His consort also became ill because of the fatigue of nursing him. The consort, together with his sons and vassals in deep sorrow, united in prayer, and relied upon the Three Treasures: the Buddha, Doctrine and Priests. They decided to erect an image of Shaka-muni which would be of the same stature as the prince,

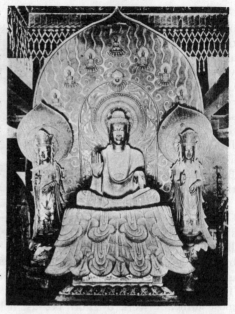

Fig. 328. Shaka Trisd in the Golden Hall (N.T.)
Hōryū-ji, Yamato

in the hope that by the power of their prayers the disease might be lifted and his life be prolonged and made happy on earth; but that he might ascend to the land of purity immediately on his demise if his life were already numbered. On the twenty-first day of the second month the Princess died, and on the next day the Prince. In the third month of the year *Mizunoto-Hitsuji* (31st year of Suiko) an image of Shaka-muni with his attendants and the appropriate furniture was completed in accordance with the original prayer. Depending on even this small merit of our faith, may we be happy in this world and serve the three sovereigns (the prince, his mother, and his wife) in the world to come, and may Buddhism flourish. May we all finally reach the Land of Bliss. May evil communication be avoided so that we may

obtain a common Buddhist Enlightenment. Shiba-Kura-tsukuri-no Owuto Tori-Busshi was commanded to make this image."

On the left side of this triad is a figure of Yakushi of similar size, which was made in 607, a little earlier than the Shaka-muni triad of 623. The style of the image of Yakushi is so similar to that of the Shaka-muni triad that it is attributed to Tori.

Over these bronze

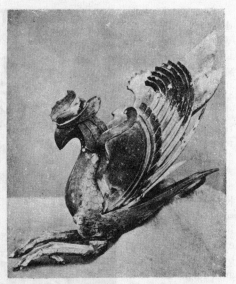

Fig. 329. Phoenix in the Golden Hall
Hōryū-ji, Yamato

figures are suspended wooden canopies or baldachins from the ceiling. The baldachin is beautifully decorated with floral designs in colors, and small figures of angels and phoenixes carved from wood are attached to the outside in rows. The phoenix has a peculiar form; its wings are gathered together as if it has come down from heaven, and it is full of life and activity. (Fig. 329) The angels all sit on lotus cups, playing various musical instruments. It has curved lines gracefully moving like scented smoke in the air, in harmony with the musical notes played in praise of the absolute truth of Buddha. (Fig. 330) All these figures were covered with gesso over which were laid red and green colors; some colors still remain.

At the back of these bronze figures on the same dais, stands a figure of Kwannon, one of the earliest examples of sculpture in wood.

Also on the same dais is a shrine in which is enshrined a unique example of a statuette representing Amida, grouped in a triad figure. (Fig. 331) The triune figure is said to have been dedicated to the Buddha Amida by the mother of the Empress Kōmyō, in the later seventh century. At first glance, one's eyes will be moved by its beautiful line and form and will get a graceful feeling. The figures are still bright with golden color and are placed upon lotus thrones that grow with twisted stems out of a horizontal bronze pond.

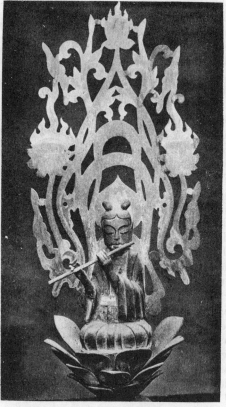

Fig. 330. Angel in the Golden Hall
Hōryū-ji, Yamato

Amida, the main figure, measures 33 centimetres in height, and sits cross-legged on the largest lotus-throne in the middle, and is looking directly to the front, with both eyes slightly opened and full of loving mercy. (Fig. 332) His eye-brows are composed of delicate curved lines. Between the eye-brows is a hole in which *byaku-gō*, the *urna*, or the symbol of the "eye divine," probably made of a gem, was originally set.

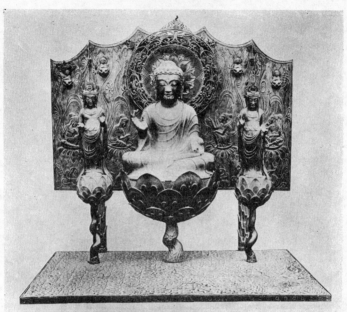

Fig. 331. Amida Triad in the Golden Hall (N.T.)
Hōryū-ji, Yamato

As regards the divine eye, the following description is in the sutra called Amitâyur-dyâna (meditation on Buddha Amitâyus):

"I pray for this only that the Sun-like Buddha may instruct me how to meditate on a world wherein all actions are pure. At that moment, the World-Honoured One flashed forth a golden ray from between his eye-brows. It extended to all the innumerable worlds of the ten quarters. On its return, the ray rested on the top of Buddha's head and transformed itself into a golden pillar just like Mount Sumeru, wherein the pure and admirable countries of the Buddha in the ten quarters appeared all at once illuminated." (Sacred Books of the East vol. 49. p. 166)

The *byaku-gō*, therefore, originated from the superhuman attribute ascribed to Buddha Gautama, the founder of Buddhism.

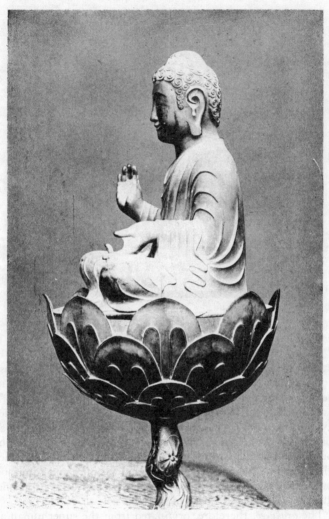

Fig. 332. Middle Figure of the Amida Triad in the Golden Hall (N.T.)
Hōryū-ji, Yamato

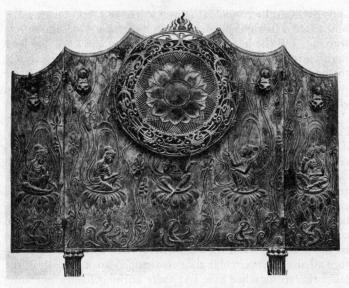

Fig. 333. Halo and Screen of the Amida Triad in the Golden Hall
Hōryū-ji, Yamato

The upright pose of his head causes the nose to form part of a straight line extending from both ends of its ridge, and passing through the middle of the figure, the screen, the halo, and the lotus throne in a perpendicular direction; the upper end of the line finally reaches the highest point of the baldachin, and the lower end to the middle part of the stand. Indeed it is a guiding line of unity and harmony, making the whole construction preserve equilibrium. His mouth is opened softly and a peaceful smile perpetually lights up his face. The artistic comeliness of his head and the gentle arrangement of the hair in graceful spiral lines are quite in keeping with the merciful expression of his face. What is revealed as a whole by such perfect unity and harmony in all the parts of its face is but the absolute mercy and perfect peace of Amida, because no special stress is laid upon any of its members The form of his body is likewise very graceful

and rhythmically rotund; it is well suited to support such a dignified face. His right hand, raised in "*abhaya mudra*," the sign of fear not, and the left hand lightly touching the knee, are both highly expressive of his inner spirituality. His dress fits closely to the body and covers both shoulders. The lines representing its folds are beautifully curved, full of rhythmic movement and attuned to the expression of his face.

At the back of the head of the main figure is a unique halo in cast bronze, wonderfully symbolic and decorative. (Fig. 333) The body of this halo consists of three main members: the lotus centre, the radial zone, and the border of floral scroll. The lotus flower in the centre of the halo is exquisitely modelled in infinitesimal relief, so as to appear like an actual flower, and it has a circular seed pod in the centre. The radial zone, surrounding border of the lotus flower, is made of wonderfully delicate crossed curves in open work. Next, in the broad circular band of the border is a floral scroll with most decorative and colorful curvature all around its circular zone also in open work. Finally at the outer rim are attached here and there burning flames ascending to heaven from the highest point of the rim.

The beautiful halo, attached to the upper middle part of the screen, occupies the place right behind the head of the main figure to symbolize the glory of the Buddha Amida. It is a noteworthy fact that this halo has a consecrated lotus flower in the centre like all other Buddhist halos, quite different from the halo of Christ, in which the Cross always appears in the centre. In the Buddhist iconography the lotus flower symbolizes the True Law of the Universe, which Shaka-muni enlightened in his own personality. We see it blooming here in this halo of Amida, in which everything is concentric to the lotus centre in a beautiful melody and finally ascends to heaven, symbolizing the human aspiration from the lower to the higher.

On either side of the main figure stands a Bodhisattva, Kwannon on the left, and Seishi on the right. The lotus thrones carrying both Bodhisattvas are subordinately smaller than that of the main figure.

Fig. 334. Detail of the Lotus Pond
Hōryū-ji, *Yamato*

The attitude of the hands of these attendant figures is similar
to that of the main figure. The attendant figures stand instead
of sitting. Moreover, their hips are gracefully swung sideways.
Therefore their postures are expressive of something more active
and more human than is shown by the main figure. The expres-
sion of loving kindness on their faces, the fillets decorated with
flowers and the flowing lines of the sacred mantles retained by
their forearms, all beautifully contribute to intensify the same
feeling of spiritual activity.

The lotus pond, out of which the three lotus thrones of the
triad figures grow, is represented on a gilded horizontal bronze
plate in low relief and engraved lines. It is highly decorative and
symbolic. The waves are represented in articulated lines and the
lotus leaves float on the waters. Some of the leaves are wide
open and others are curled up. The open leaves look like eight-
petalled flowers, and each of them has eight radiating lines from
the centre, which symbolize the Infinite Light of Amida. (Fig.
334) The lotus in the pond, expressing purity unstained by the

mud, offers its flowers as the thrones of Amida triad. Thus Amida who lives in the West End of the Universe, one thousand million miles away, is here brought down by the faith of man in terms of artistic form.

Just at the back of the triad is a screen which is composed of three vertical panels, pointed at the top into a wave form. (Fig. 333) On the lower surface are represented five blessed angels. They descend from above and sit in different postures upon lotus flowers growing with twisted stems. The upper halves of their bodies are naked and wavy locks flow over their shoulders. The different attitudes of their hands and bodies express the dreamy atmosphere of the heavenly life. The vertical spiral

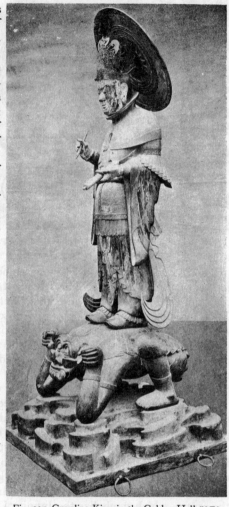

Fig. 335. Guardian King in the Golden Hall (N T.)
Hōryū-ji, Yamato

movement of their filmy mantles is suggestive of their coming down from above. Between the angels long lotus stems grow upwards, most harmoniously filling up the interstices, never trespassing upon other lines; and the leaves adapt themselves to the given spaces with oval shapes. Moreover between the lotus stems and the flying mantles of angels are hair-line carvings of clouds symbolizing the heavenliness of the Land of Amida.

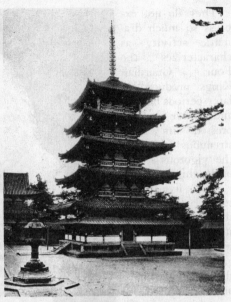

Fig. 336. Five-storied Stupa (N.T.)
Hōryū-ji, Yamato

At the four corners of the same dais, stand the Four Guardian Kings (Shiten-nō). They are carved respectively from one block of camphor wood. Their bodies are colored and some parts of their clothes are painted in addition to those that are carved. Some of cut-gold remain also. So we may imagine that they were originally bright and colorful, as we see in later figures of guardian kings. Each of them measures 4 feet and 5 inches in height. They are armored and each stands upon the back of a demon. The work belongs to the style which prevailed in the time of Suiko The life and movement are not skilfully expressed, but the stroke of the chisel is vigorous as will be seen even in our reproduction. (Fig. 335) They are signed by Yamaguchi-no Oguchi and Kunishi Tokuho and their assistants.

They do not express so much dramatic activity as characterizes the Four Guardian Kings produced in later periods but life and power are expressed in their strenuous forms by the vigorous stroke of the chisel.

The five-storied stupa (Fig. 336) stands on a double stone foundation, with a beautiful and graceful form, although it is more or less injured by a "skirting roof" which was added to the first story in a later age. It measures about 105 feet in height. The exterior is colored with a plain coating of red oxide of lead. The interior also is color-ed with a plain coating of red oxide of lead.

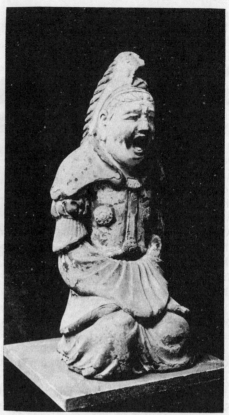

Fig. 337. Clay Figure in the Stupa (N.T.)
Hōryū-ji, Yamato

Up the middle of the interior runs the "core-pillar" on which the whole structure depends. At the centre of the first story, there is a dais made of clay, on the four sides of which are clay figures representing four different scenes relating to the life of Buddha; that is, on the north a Nirvana group, on the south a

Miroku group, on the east a Yuima group, and on the west the distribution of the Buddha's ashes. They were produced in the year 711 and are rare examples of group sculpture in clay. Some of them are replaced with poor copies recently produced; but about fifty figures of the original remain; and they are enrolled as national treasures. In Fig. 337 we have reproduced one of them, which is excellent in workmanship.

In the East Enclosure(Tō-in) where once stood the pala-

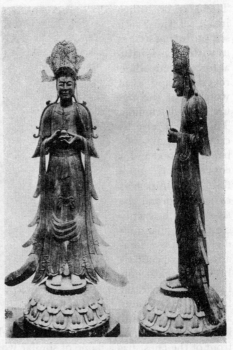

Fig. 338. Kwannon in the Hall of Dreams (N.T.)
Hōryū-ji, Yamato

tial residence of Crown Prince Shōtoku Taishi, stands an octagonal hall which is called Yumedono or Hall of Dreams. In this Hall of Dreams is enshrined the famous wooden figure of Kwannon in a standing posture, measuring 6 feet 5 inches in height. The figure is one of the best preserved and the most beautiful relics of sculpture that have come down to us from the Suiko Period and represents all the characteristics of the formalism of Korean and continental styles. It is attributed to Prince Shōtoku Taishi and is held to be the holiest statue. The dignified attitude quite overawes us, especially when looked at from the side. (Fig. 338)

There is no other image of the Suiko sculpture that strikes us with such spiritual force, compelling reverence and even worship, as this figure of Kwannon. This figure also is carved from one block of wood and is covered with gold-foil. The drapery is close fitting and the *ten-ne* or "heavenly cloth," hanging down from the forearms, has a peculiarly symmetrical outline; and the calm lines at both sides

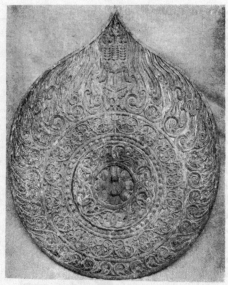

Fig. 339. Wooden Halo of Kwannon
Yumedono, Hōryū-ji, Yamato

are especially beautiful. The crown made of perforated bronze is of excellent workmanship. The gem held with both hands in front of the chest has a flame of similar workmanship in pierced bronze. The beautiful scroll lines counteract the hardness of the vertical lines of drapery.

Its jewel-shaped halo of wood is perfectly preserved. It is no doubt the most elaborate and beautiful example of halos produced in Japan. (Fig. 339) In the centre of the halo there is a lotus flower; in the middle band is honey-suckle arabesque, and finally at the brim are aspiring flames. They all ascend articulately to heaven, with the spires of a stupa which is carved at the upper part of the halo. The stupa on the halo seems to be a rudimentary trace of the worship of the tomb of the Buddha Gautama among the early Buddhists in India.

In the northeast of the Eastern Enclosure (Tō-in) stands the

Chūgū-ji nunnery. In the Buddhist Hall of the nunnery is enshrined a famous Buddhist figure of Miroku, or Maitreya, which was formerly known as Nyoirin-Kwannon. (Fig. 340) The figure is carved from one block of wood. It seems to have been plain wood work, but there is a trace of gold-foil that once ornamented it. The statue is seated on a high drum-shaped throne, with the right foot over the left knee, in medita-

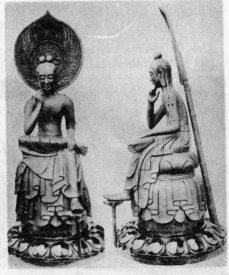

Fig. 340. Miroku in the Chūgū-ji (N.T.)
Hōryū-ji, Yamato

tive posture with the right elbow on the right knee, middle finger touching the chin. The lacquer-like patina of the surface is now wonderfully charming. The shape of the knotted hair on the head and the lock of hair drooping over the shoulders, show a development from rigid formalism to realistic form. The expression of the face is full of loving-kindness, with a smile around the eyes and the mouth. The lines of drapery are also much more fluent than those of the Tori style; and the expression is highly graceful and very human.

The nunnery has also a unique example of textile fabric, illustrating a Paradise, called Tenju-koku, which was embroidered by the court ladies when Crown Prince Shōtoku Taishi died thirteen centuries ago. (See page 30)

10. TAIMA-DERA MONASTERY, YAMATO

The Taima-dera monastery stands on the skirts of a hill at a
village called Taima, in the province of Yamato, about 30 kilo-

Fig. 341. General View of the Taima-dera
Yamato

metres south of Nara. (Fig. 341) The monastery was first found-
ed in the seventh century; but the oldest buildings now extant
are two stupas erected in the eighth century and the rest were
built in the thirteenth. In these sacred buildings there remain
a dozen Buddhist figures of highly artistic merit produced in dif-
ferent ages.

The two stupas stand on a hill on the east and the west. Both
are three-storied and typical of the Nara architecture in the eighth
century. Each measures about 80 feet in height, and is grandly
constructed as will be noticed in the west stupa (Fig. 342), and
in the details of bracket system at the corner of the eave of the
east stupa. (Fig. 343)

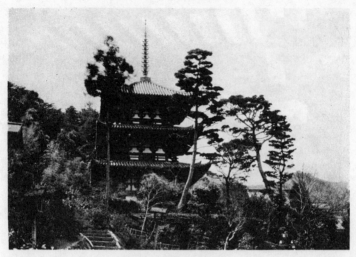

Fig. 342. West Stupa (N.T.)
Taima-dera, Yamato

The Main Hall of Mandara-dō is the largest building in the monastery, and was rebuilt in about 1243. The interior is divided into inside and outside compartments. The central dais is black lacquered and inlaid with the *hōsōge* design in mother-of-pearl. On the dais is a shrine which is decorated with lotus flowers in gold lacquer. They belong to the Kamakura Period and are good examples of the Kamakura lacquer work. In the shrine is hung a copy of the famous picture of Taima Mandara.

It is traditionally said that the picture of the original Taima Mandara was made in the eighth century from lotus thread, obtained by Princess Chūjō, as a divine gift for her exemplary devotion and piety. However, it is in a deplorably bad condition and cannot be touched without considerable damage being done to it. So a replica was made of the original in the Bunki Era, that is, the beginning of the sixteenth century. This is the one which we see now in the temple. (Fig. 344) The word Mandara (Mandala) signifies the complete assemblage of a Main Buddha and

Fig. 343. Detail of the East Stupa
Taima-dera, Yamato

his heavenly attendants.

The replica measures 9 feet in height and 13 feet in breadth. Buddha Amida is enthroned in the middle with two attendant Bodhisattvas, Kwannon and Seishi, sitting respectively on the right and the left. Near by is a group of the minor Bodhisattvas of smaller size, surrounded by a pond in which beautiful lotus flowers grow. (Fig. 345) The general feeling of the color scheme is splendid and gorgeous, the whole surface being almost entirely overlaid with gold leaf.

In the left marginal band are depicted small scenes successively illustrating episodes of the legend of Ajatasatru and Bimbisara, connected with the mercy of Shaka-muni and Amitâbha. In the right marginal band are depicted thirteen symbolical representations, through which adorants may perceive the supernatural beauty of the Paradise of Amida. In the lower marginal band are shown nine different manifestations of Amida, who are ready to deliver all the people who belong to any of the nine grades of

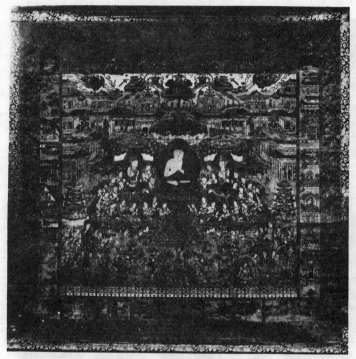

Fig. 344. Taima Mandara (N.T.)
Taima-dera, Yamato

life in the terrestrial world.

The Bothisattvas depicted in the Taima Mandara express through color and form of feminine beauty the inner joy that never fades.

From what we see of the symbolic iconography of Amitâbha and his Paradise it will be understood that in the iconographic beatitudes there are three essential qualities, the feminine beauty of hamanity, the artistic beauty achieved by culture, and the beauty of nature, all three permeated by the absolute mercy of Amitâbha and harmonized into one great whole. These icono-

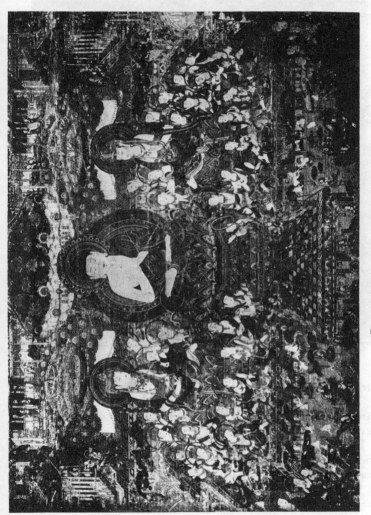

Fig. 345. Detail of Taima Mandara
Taima-dera, Yamato

graphic beatitudes in the Paradise of Amitâbha (Amida) are an important source from which emanate the spiritual and material activities of man. In other words, the iconographic beatitudes of the Amida's Paradise emphasize what are good, truthful, and beautiful in the realities of social life.

In conclusion we see that the Paradise of Amida consists of what is desired of the realities of this present life, as well as what is hoped for in the world to come; namely, present desire and future hope, in addition to the legacy of the past.

APPENDIXES

I. LIST OF MUSEUMS, TEMPLE TREASURINS
AND PRIVATE COLLECTIONS

II. A SHORT BIBLIOGRAPHY

APPENDIXES

I. A LIST OF MUSLIM TEMPLE PRIESTS
AND PRIVATE COLLECTIONS

II. A SHORT BIBLIOGRAPHY

APPENDIX I

LIST OF MUSEUMS, TEMPLE TREASURIES
AND PRIVATE COLLECTIONS

This list is divided into three groups, that is, Tokyo, Kyoto and the local districts. Museums, treasuries, and collections in each group are alphabetically arranged.

TOKYO

DAN COLLECTION 團伊能男藏品

> Location: Harajiku, Shibuya-ku, Tokyo. (Private residence of Baron Ino Dan)
>
> Contents: Japanese painting, industrial and peasant arts.

FUKUI COLLECTION 福井菊三郎氏藏品

> Location: Aoyama-Minami-chō, Tokyo. (Private residence of Mr. Kikusaburo Fukui)
>
> Contents: Japanese pottery of different kinds of all ages, and Noh costumes.

HISTRIONIC MUSEUM 演劇博物館

> Location: Precinct of the Waseda University, Tokyo.
>
> Contents: Models and color prints relating to theatrical performances.

HOSOKAWA COLLECTION 細川護立侯藏品

> Location: Takata-Oimatsu-chō, Koishikawa-ku, Tokyo. (Private residence of Marquis Moritatsu Hosokawa)
>
> Contents: Japanese painting of different ages and Chinese ancient arts.

MAKITA COLLECTION 牧田環氏藏品

> Location: Kita-higakubo-chō, Azabu-ku, Tokyo. (Private residence of Mr. Tamaki Makita)
>
> Contents: Japanese painting and porcelain.

MASUDA COLLECTION 益田孝氏藏品

> Location: Gotenyama, Shinagawa-ku, Tokyo. (Private residence of ex-Baron Takashi Masuda)
>
> Contents: Japanese painting, sculpture, and industrial arts of different ages.

MATSUOKA COLLECTION 松岡均平男藏品

> Location: Zaimoku-chō, Azabu-ku, Tokyo. (Private residence of Baron Kimpei Matsuoka)
>
> Contents: Ukiyo-e painting.

MAEDA COLLECTION 前田利爲侯藏品

Location: Komaba, Kimimeguro, Tokyo. (Private residence of Marquis Toshinari Maeda)

Contents: Japanese painting of different ages and Noh costumes.

MAEYAMA COLLECTION 前山久吉氏藏品

Location: Shimorokuban-chō, Kōjimachi-ku, Tokyo. (Private residence of Mr. Hisakichi Maeyama)

Contents: Japanese and Chinese painting, sculpture, and industrial fine arts, mostly Buddhistic.

MEIJI-TENNO MEMORIAL PICTURE GALLERY 聖德記念繪畫館

Location: Sacred ground of the Meiji Shrine, Tokyo.

Contents: Eighty pictures representing the historical events relating to the Emperor Meiji and Empress Shōken, painted by contemporary eminent painters in Japanese and Western styles.

MITSUI COLLECTION 三井高公男藏品

Location: Imai-chō, Azabu-ku, Tokyo. (Private residence of Baron Taka-kimi Mitsui)

Contents: Japanese painting and costumes.

NEZU COLLECTION 根津嘉一郎氏藏品

Location: Aoyama-Minami-chō, Akasaka-ku, Tokyo. (Private residence of Mr. Kaichiro Nezu)

Contents: Japanese painting, sculpture, and industrial arts. Chinese stone sculpture.

NUMISMATIC MUSEUM 錢幣館

Location: Togoshi, Ebara-ku, Tokyo.

Contents: Japanese and other Oriental coins of all ages.

ŌKURA ANTIQUE MUSEUM 大倉集古館

Location: Aoi-chō, Akasaka-ku, Tokyo.

Contents: Japanese arts and Chinese stone sculpture and minor arts.

ŌYAMA INSTITUTE OF PREHISTORIC INVESTIGATION 大山史前學研究所

Location: Onden, Sendagaya, Tokyo.

Contents: Japanese neolithic potteries and stone implements found in different localities.

SHIOBARA COLLECTION 鹽原又策氏藏品

Location: Hazawa-chō, Shibuya-ku, Tokyo. (Private residence of Mr. Matasaku Shiobara)

Contents: Japanese polychrome porcelain, Kaki-e-mon, Iro-nabeshima, and Ko-kutani; and ancient Chinese bronze.

TOKYO FINE ART SCHOOL MUSEUM 東京美術學校文庫陳列館

Location: Ueno Park, Tokyo.

Contents: Japanese and Chinese painting, sculpture, lacquer ware and metal work.

YAMADA COLLECTION　山田準次郎氏藏品

Location: Maruyama-chō, Koishikawa-ku, Tokyo. (Private residence of Mr. Junjiro Yamada)

Contents: Japanese weapons.

YŪSHŪ-KWAN MUSEUM　遊就館

Location: Kudan, Tokyo.

Contents: Japanese arms and armor of all ages.

TOKYO IMPERIAL HOUSEHOLD MUSEUM　東京帝室博物館

Location: Ueno Park, Tokyo.

Contents: Fine Art Department, Industrial Art Department and Historical Department.

KYOTO

HASHIMOTO COLLECTION　橋本關雪氏藏品

Location: Near the Ginkaku-ji, Kyoto. (Private residence of Mr. Kansetsu Hashimoto)

Contents: Japanese Buddhist sculpture and Chinese pottery.

ITŌ COLLECTION　伊藤庄兵衞氏藏品

Location: Hon-chō, Higashiyama-ku, Kyoto. (Private residence of Mr. Shōbei Itō)

Contents: Buddhist implements, ancient Korean tiles and Chinese clay figures.

KITANO-JINJA TREASURY　北野神社寶物殿

Location: Precinct of the Kitano-jinja Shrine, Kyoto.

Contents: Pictorial scrolls illustrating the history of the Kitano Shrine painted by master hands in different ages, and other treasures of the shrine.

KYOTO IMPERIAL UNIVERSITY MUSEUM　京都帝國大學考古學陳列室

Location: Kyoto Imperial University, Kyoto.

Contents: Archaic arts Japanese, Korean and Chinese.

KYOTO ONSHI MUSEUM OF ART　恩賜京都博物館

Location: Higashiyama-ku, Kyoto.

Contents: Painting, sculpture, and industrial fine arts of different ages, mostly borrowed from Buddhist monasteries.

SUMITOMO COLLECTION　住友吉左衞門男藏品

Location: Shishigatani, Kyoto. (Villa of Baron Kichizaemon Sumitomo)

Contents: Chinese ancient bronze.

YŪRIN-KWAN MUSEUM 有隣館

 Location: Okazaki Park, Kyoto.
 Contents: Chinese antiquities.

LOCAL DISTRICTS

ASANO KWANKO-KWAN 淺野觀古館

 Location: Teppō-chō, Hiroshima.
 Contents: Painting and industrial arts, mostly of the Yedo Period.

CHŌKO-KWAN MUSEUM 徵古館

 Location: Near Ise Shrine, a suburb of Uji-Yamada, Ise.
 Contents: Historical relics mostly related to the Ise Shrine.

CHŪSON-JI TREASURY 中尊寺寳物館

 Location: Precinct of the Chūson-ji monastery, Chūson-ji, Iwate prefecture.
 Contents: Buddhist sculpture, decorative arts and manuscript-copies of Bud-
dhist sutras of the twelfth century.

HAKKAKU MUSEUM OF FINE ARTS 白鶴美術館

 Location: Sumiyoshi, near Osaka.
 Contents: Chinese and Japanese porcelain and metal work.

HAKONE-JINJA TREASURY 箱根神社寳物館

 Location: Precinct of the Hakone Shrine, Moto-Hakone, Kanagawa prefec-
ture.
 Contents: Old weapons, sculpture and painting.

HARA COLLECTION 原富太郎氏藏品

 Location: Hommoku, Yokohama. (Private residence of Mr. Tomitaro Hara)
 Contents: Japanese painting, sculpture and industrial arts.

ITSUKUSHIMA-JINJA TREASURY 嚴島神社寳物館

 Location: Itsukushima Shrine, Itsukushima Island, Hiroshima prefecture.
 Contents: Painting, arms and armor, and other treasures owned by the
shrine.

KAMAKURA KOKUHŌ-KWAN MUSEUM 鎌倉國寳館

 Location: Precinct of the Tsuruga-oka Shrine, Kamakura.
 Contents: Loan collection of painting, sculpture, and industrial fine arts
owned by the Shinto shrines and Buddhist temples in Kamakura and vicini-
ty. Many of them are enrolled as national treasures.

KANAZAWA BUNKO LIBRARY 金澤文庫

 Location: Precinct of the Shōmyō-ji monastery, Kanazawa, near Yokohama.
 Contents: Buddhist statues, paintings and minor arts owned by the Shōmyō-
ji monastery. They belong mostly to the Kamakura or Muromachi periods.

KOTOHIRA-GŪ TREASURY　金刀比羅宮

Location: Precinct of the Kotohira-gū Shrine, Kotohira, Shikoku Island.
Contents: Buddhist painting and sculpture and arms and armor.
Note: On the sliding screens in the rooms of the historical buildings annexed to the office of the shrine, are famous landscape pictures painted by Ōkyo, the founder of the Shjiō School in the eighteenth century.

KŌYASAN REIHŌ-KWAN MUSEUM　高野山靈寶館

Location: Mount Kōya, Wakayama prefecture.
Contents: Buddhist painting, sculpture, and implements borrowed from the monasteries on Mount Kōya.

KUNŌSAN-TŌSHŌGŪ TREASURY　久能山東照宮寶物館

Location: Precinct of the Kunōsan-Tōshōgū Shrine, Shizuoka prefecture.
Contents: Arms and armor mostly those worn by the Shoguns of the Tokugawa family.

MINOBUSAN KUON-JI TREASURY　身延山久遠寺寶物館

Location: Kuon-ji monastery, Minobusan, Yamanashi prefecture.
Contents: Painting and Buddhist antiquities.

MOTOYAMA SHŌIN-DŌ MUSEUM　本山松蔭堂陳列所

Location: Hagoromo, Takaishi-chō, Osaka prefecture.
Contents: Japanese neolithic implements and arms and armor.

MURAYAMA COLLECTION　村山長舉氏藏品

Location: Mikage, Hyōgo prefecture. (Private residence of Mr. Chōkyo Murayama)
Contents: Japanese painting and industrial arts.

NAGAO COLLECTION　長尾欽彌氏藏品

Location: Kamakura (Villa of Mr. Kinya Nagao).
Contents: Japanese and Chinese porcelain, metal work and textiles.

NARA IMPERIAL HOUSEHOLD MUSEUM　奈良帝室博物館

Location: Nara Park, Nara.
Contents: Painting, sculpture, and industrial fine arts borrowed mostly from Buddhist monasteries in Nara and vicinity.

NIKKO TŌSHŌ-GŪ TREASURY　日光東照宮寶物館

Location: Precinct of the Nikko Shrine, Nikko.
Contents: Weapons, costumes and minor arts of the Yedo Period.

ŌYAMATSUMI-JINJA TREASURY　大山祇神社寶物館

Location: Ōmishima Shrine, Omishima Island, Inland Sea.
Contents: A large collection of arms and armor of the Kamakura and Muromachi periods.

SANDA MUSEUM　三田博物館

Location: Sanda, Hyōgo prefecture.

Contents: Pottery, painting and sculpture of different ages.

UENO COLLECTION 上野精一氏藏品

Location: Hirano-chō, Higashi-ku, Osaka. (Private residence of Mr. Seiichi Ueno)

Contents: Japanese and Chinese painting and pottery; and tea-utensils.

UESUGI-JINJA TREASURY 上杉神社稽照殿

Location: Uesugi-jinja Shrine, Yonesawa, Yamagata prefecture.

Contents: Weapons and old Buddhist paintings.

ZENTSŪ-JI TREASURY 善通寺寶物殿

Location: Zentsū-ji monastery, Zentsū-ji, Shikoku Island.

Contents: Painting, sculpture and other objects of art, owned by the Zentsū-ji monastery.

APPENDIX II

A SHORT BIBLIOGRAPHY

(Books written in English)

Allen, M. R.: Japanese Art Motives. Chicago, McClurg, 1917.

Anderson, W.: The Pictorial Arts of Japan. London, Low, Marston, Searle, & Rivington, 1886.

Anderson, W.: Japanese Wood Engravings. London, Seeley, 1895.

Anesaki, M.: Buddhist Art in its Relation to Buddhist Ideals with Special Reference to Buddhism in Japan. Boston and N. Y., Museum of Fine Arts, Boston, 1915.

Anesaki, M.: Art, Life, and Nature in Japan. Boston, Marshall Jones, 1933.

Anesaki, M.: History of Japanese Religion. London, Trubner, 1930.

Audsley, G. A.: Gems of Japanese Art and Handicraft. London, Low, Marston, 1913.

Audsley, G. A. & Bowes, J. L.: Keramic Art of Japan. 2 vols. London, Sotheran, 1875. [Popular edition in 1881.]

Audsley, G. A.: The Ornamental Arts of Japan. 2 vols. London, Low, Marston, Searle & Rivington, 1884.

Averill, M.: The Flower Art of Japan. N. Y., Dodd, Mead, 1930. [Reprint.]

Ball, K. M.: Decorative Motives of Oriental Art. N. Y., Dodd, Mead, 1927

Binyon, L. and Sexton, J. J. O'Brien: Japanese Colour Prints. London, Benn, 1923.

Binyon, L.: Painting in the Far East. (3rd edition, revised.) London, Arnold, 1923.

Blacker, J. F.: The A. B. C. of Japanese Art. London, Stanley paul, [date of publication unknown.]

Blacker, J. F.: Chats on Oriental China. London, Unwin, 1919. [4th Impression.]

Bowes, J. L.: Japanese Marks and Seals. London, Henry Sotheran, 1882.

Bowes, J. L.: Japanese Pottery. Liverpool, Howell, 1890.

Bowes, J. L.: A Vindication of the Decorated Pottery of Japan. Liverpool, 1891. [Printed for private circulation.]

Brockhaus, A.: Netsukes. (Translated from German by M. F. Watty) London, Allen & Unwin, 1924.

Brown, L. N.: Block Printing and Book Illustration in Japan. London, Routledge, 1924.

Bureau of Religions, Dept. of Education : Handbook of the old Shrines and Temples and their Treasures. Tokyo, Dept. of Education, 1920.

Conder, J.: The Floral Art of Japan : being a second and revised edition of the Flowers of Japan and the Art of Floral Arrangement. Yokohama, Kelly and Walsh, 1899.

Conder, J.: Landscape Gardening in Japan. Yokohama, Kelly & Walsh, 1893.

Conder, J.: Supplement to Landscape Gardening in Japan. Yokohama, Kelly & Walsh, 1893.

Cram, R. A.: Impressions of Japanese Architecture and the Allied Arts. Boston, Marshall Jones, 1930. [Reprint.]

Cutler, T. W.: A Grammar of Japanese Ornament and Design. London, Batsford, 1880.

Department of Interior (compiled by): Japanese Temples and their Treasures (Kokuhō Gwajō). 3 cartoons. Tokyo Shimbi Shoin, 1910.

Dillon, E.: The Arts of Japan. (4th edition.) London, Methuen, 1922. [Little Books on Art Series.]

Dresser, C.: Japan its Architecture, Art, and Art Manufactures. London, Longmans, Green, 1882.

Fenollosa, E. F.: Epochs of Chinese and Japanese Art. 2 vols. (New and revised edition with Petrucci's notes.) London, Heinemann, 1913.

Fenollosa, E. F.: An Outline of the History of Ukiyo-ye. Tokyo, Kobayashi, 1900.

Ficke, A. D.: Chats on Japanese Prints. London, Unwin, 1916. [Second impression.]

Fukukita, Y.: Cha-no-Yu. Tea Cult of Japan. Tokyo, Maruzen, 1932.

Gookin, F. W.: Descriptive Catalogue of Japanese Colour-Prints. The Collection of Alexander G. Mosle. Leipzig, Mr. Mosle, 1927.

Gookin, F. W.: Japanese Colour-Prints and their Designers. N. Y., Japan Society, 1913.

Harada, J.: The Gardens of Japan. London, Geoffrey Holme, 1928.

Harada, J.: English Catalogue of Treasures in the Imperial Repository Shōsō-in. Tokyo, Imperial Household Museum, 1932.

Huish, M. B.: Japan and its Art. (Third edition, Revised and Enlarged.) London, Batsford, 1912.

Imperial Household Museum (complied by): An Illustrated Catalogue of the Ancient Imperial Treasury called Shōsō-in. 2nd edition, revised. 3 vols. Tokyo, Shimbi Shoin, 1909.

Jackson, J.: A Glimpse at the Art of Japan. New York, 1876.

Japan Society, London: Catalogue of an Exhibition of the Arms and Armour of Old Japan, Held by the Japan Society, London. in June 1905. London, Japan Society, 1905.

Japanese Government Railways: An Official Guide to Japan. Tokyo, Japanese Government Railways, 1933.

Joly, H. L.: Japanese Sword Fittings. A Descriptive Catalogue of the Collection of G. H. Naunton, Esq. London, Tokyo Printing Co., 1912.

Joly, H. L.: Legend in Japanese Art. A Description of Historical Episodes, Legendary Characters, Folk-lore, Myths, Religious Symbolism, Illustrated in the Arts of Old Japan. London and N. Y., John Lane, 1907.

Koop. J. A,: Guide to Japanese Textiles. 2 vols. London, Victoria and Albert Museum, 1920.

The League of Nations Association of Japan: The Year Book of Japanese Art. Tokyo, the League of Nations Association. [Published yearly since 1627.]

Ledoux, L. V.: The Art of Japan. N. Y., Japan Society, 1927.

Migeon, G.: In Japan. Pilgrimages to the Shrines of Art. Translated from the French by Florence Simmonds. London, 1908.

Morrison, A.: The Painters of Japan. 2 vols. London, Jack and Edinburgh, 1911.

Morse, E. S.: Catalogue of the Morse Collection of Japanese Pottery. Boston, Museum of Fine Arts, Boston, 1900.

Morse, E. S.: Japanese Homes and their Surroundings. London, Low, Marston, Searle & Rivington, 1888.

Munro, N. G.: Prehistoric Japan. Yokohama, Kelly & Walsh, 1908.

Noguchi, Y.: Hiroshige. N. Y., Orientalia, 1921.

Noguchi, Y.: Hokusai. London, Elkin Mathews, 1925.

Noguchi, Y.: Korin. London, Elkin Mathews, 1922.

Noguchi, Y.: The Spirit of Japanese Art. London, Murray, 1915. [Wisdom of the East Series.]

Noguchi, Y.: Ukiyoye Primitives. London, Trubner, 1933. [Privately published in Tokyo.]

Noguchi, Y.: Utamaro. London, Elkin Mathews, 1925.

Okakura, K.: Ideals of the East, with special Reference to the Art of Japan. London, Murray, 1905.

Okakura, K.: The Book of Tea. With appendix by Sadler. Sydney, Angus & Robertson, 1932.

Pier, G. C.: Temple Treasures of Japan. New York, 1914.

Piggott, Sir F. T.: The Music and Musical Instruments of Japan. (2nd edition.) Yokohama, Kelly & Walsh, 1909.

Piggott, Sir F. T.: Studies in the Decorative Art of Japan. Yokohama, Kelly & Walsh, 1910.

Priestley, A. F.: How to know Japanese Colour Prints. N. Y., Doubleday, Page, 1927.

Sadler, A. L.: Cha-no-Yu. The Japanese Tea Ceremony. Kobe, Thompson, 1934.

Sadler, A. L.: The Art of Flower Arrangement in Japan. London, Country Life, 1933.

Sansom, G. B.: Japan, a Short Cultural History. London, Cresset Press, 1931.

Seidlitz, W. v.: History of Japanese Colour-Prints. London, Heinemann, 1910. [Translated from German.]

Strange, E. F.: The Colour-Prints of Hiroshige. London, Cassell, 1925.

Strange, E. F.: The Colour-Prints of Japan. London, Siegle, Hill, 1914. [4th edition.]

Stewart, B.: Subjects Portrayed in Japanese Colour-Prints. London, Trubner, 1922.

Tajima, S. (ed.): Selected Relics of Japanese Art. 20 vols. Tokyo, and Kobe, Nippon Shimbi Kyokwai, and Shimbi Shoin, 1899–1908.

Taki, S.: Japan Fine Art. Translated by K. Takahashi. Tokyo, Fuzambo, 1931.

Taki, S.: Three Essays on Oriental Painting. London, Quaritch, 1910.

Tamura, T.: Art of the Landscape Garden in Japan. Tokyo, Kokusai Bunka Shinkokai, 1935.

Taylor, Mrs. B.: Japanese Gardens. London, Methuen, 1912.

Terry, T. P.: Terry's Guide to the Japanese Empire. Boston and N. Y., Houghton Mifflin, 1933. [Revised edition.]

Tomkinson, M.: A Japanese Collection. 2 vols. London, Allen, 1898.

Warner, L.: Japanese Sculpture of the Suiko Period. Cleveland, Cleveland Museum of Art, 1923.

INDEX

(Asterisk () indicates the page on which the illustration is fonnd.)*